Object and Image

Object and

PRENTICE-HALL, INC.
ENGLEWOOD CLIFFS, NEW JERSEY 07632

Image

second edition

AN INTRODUCTION TO PHOTOGRAPHY

GEORGE M. CRAVEN

De Anza College

Library of Congress Cataloging in Publication Data

Craven, George M., (date)
 Object and image.

 Bibliography: p.
 Includes index.
 1. Photography. I. Title.
TR145.C89 1982 770 81–5210
ISBN 0-13-628966-5 AACR2
ISBN 0-13-628974-6 (pbk.)

TO MY FATHER, HOWARD,
from whom I learned the value
of a job well done

OBJECT AND IMAGE:
An Introduction to Photography, second edition
by George M. Craven

Editorial/production supervision: Hilda Tauber
Interior design and cover design: Lee Cohen
Art production: Gail Cocker, Diane Sturm
Manufacturing buyer: Harry P. Baisley
Cover photograph by Joe Sohm/The Image Bank

Printed in the United States of America

10 9 8 7 6 5 4 3 2 1

Prentice-Hall International, Inc., *London*
Prentice-Hall of Australia Pty. Limited, *Sydney*
Prentice-Hall of Canada, Ltd., *Toronto*
Prentice-Hall of India Private Limited, *New Delhi*
Prentice-Hall of Japan, Inc., *Tokyo*
Prentice-Hall of Southeast Asia Pte. Ltd., *Singapore*
Whitehall Books Limited, Wellington, *New Zealand*

CONTENTS

PREFACE

This book is an introduction to the world of photography—to the experience of seeing and thinking photographically, and to fundamental aspects of photographic technique. Although photography is our most widely used picture-making process, most of us are largely unaware of its potential, and this is what the book explores. It therefore has three major objectives: to help you make better photographs, to suggest some contemporary applications for them as personal expression and communication, and to consider how each of us can respond to the photographs of others more fully and rewardingly.

The book has been completely revised for this edition. The first two chapters provide a context for learning and a basis for discussing pictures in verbal terms. They briefly consider what photographs are, how they differ from other kinds of pictures, and how they have evolved to their present importance.

Chapters 3 to 6 introduce fundamental tools and procedures. Each procedure is simply and clearly set forth with step-by-step illustrations showing equipment and materials typically used and widely available. These chapters are largely self-instructive; they teach the basic technical skills that will continue to serve you well as you get more involved with this fascinating medium.

Chapters 7 to 10 discuss the most important styles and approaches of contemporary photographic work. The categories used are in no way mutually exclusive, and some of the best photographs defy such classification. But I believe they are helpful devices to sort out and understand the diversity of contemporary images. Many of the illustrations in these chapters are new to this edition, and each is carefully discussed in the text.

Since the first edition was published, the materials and methods of color photography have become sufficiently standardized to permit a discussion of them which is brief without being fragmented or oversimplified. Chapters 11 and 12 sum up the most important aspects of this more demanding but rewarding area.

Other chapters cover topics of frequent interest to new photographers, and the final chapter deals with us as viewers, and how we might respond with greater awareness to the photographs we see.

Each illustration by a credited photographer was chosen because it clarifies a particular point in the text, and because it is also a fine example of that photographer's work or an outstanding image from an important historical collection. I hope you will consider these photographs invitations to additional study and picture viewing in other books and in exhibitions. As a guide to this exploration, the bibliography in this edition has been expanded and fully annotated.

As in the first edition, my aim has been to complement rather than compete with the classroom instructor. Modern photography is an assemblage of many tools and techniques, materials and processes. Rather than be encyclopedic, I have made careful choices based on long experience with the medium and the learning process. For example, I strongly recommend the use of multiple-contrast, resin-coated photographic paper for learning basic contact printing and enlarging. Learning is more rapid with this fast-processing material, particularly when time is limited (as it is in most classroom situations), and it offers one-box-fits-all economy. Once basic printing procedures have been handled with confidence, the advantages of fiber-based and single-contrast papers for fine black-and-white prints can be rewardingly explored. Directions for working with these materials are included in Chapter 6, but they follow and supplement the main instructional sequence.

The use of view cameras and other aspects of large-format film systems are not included in this book. Although these cameras offer important advantages to photographers, they are expensive, slow-working systems which inhibit the early stages of the learning process more than they aid it. They are properly indicated for more advanced work. Excellent references to this and other specialized photographic topics will be found in the bibliography.

Like every other writer on photographic practice today, I have been faced with the problem of metric conversion. American photographic practice now employs a mixture of metric and English measurements, but I have preferred the international metric units wherever feasible to encourage their increased use. Customary American measurements, however, are given for linear dimensions of equipment and materials. True conversion involves rounding off to the nearest equivalent size (8 × 10 inches thus becomes 20 × 25 cm), and most American products are not yet produced in such sizes.

Acknowledgments

Again I am grateful to the photographers and collectors who have allowed me to reproduce their work. Their names are with their pictures; their work has made the book a richer and more instructive instrument than it otherwise could have been.

I also want to thank the many teachers, photographers, and readers who shared with me their critical reactions to the first edition. I cannot name all of them here, but two deserve special mention. Ansel Adams continues to be encouraging and supportive, as he has for many years, of efforts by others to improve photographic education. His comments were particularly helpful. The informed and constructive criticism of Jayne Merkel, of the Art Academy of Cincinnati, has helped me to sharpen the focus of the discussion in this edition.

I am also indebted to many people for the information a book such as this requires, but I particularly want to thank Vivian Walworth of the Polaroid Corporation, Martin Scott and Jack Brown of Eastman Kodak Company, Charlene Castello of Ilford, Inc., and Jerald C. Maddox of the Library of Congress for their interest and assistance. Tom Gore of Open Space Gallery, Victoria, B. C., was helpful in reaching other Canadian photographers. For assistance with many of the technical illustrations, I thank Wayne Fogle, Arthur Hayes III, Kathy Kernaghan, Jamalyn Ollinger, Babette Persons, Barbara Totten, and my son, Clarence.

Again I have had the pleasure of working with sensitive and perceptive people at Prentice-Hall. Bud Therien, Executive Editor, Humanities, shared my desire that this book appeal to the eye as well as the mind, and he understood my insistence that quality reproduction is a special necessity in a book on photography. Hilda Tauber, Production Editor, oversaw the countless details of the project with intelligence and wit, bringing her own clear light to those parts of the manuscript where mine seemed obscured. Lee Cohen brought her creative skills to the design of this edition, and Gail Cocker accomplished the task of integrating hundreds of photographs and drawings with an expanded text.

I appreciate my family's patience with me during the many months this edition was in preparation, when many other plans and activities had to be set aside. Finally, I acknowledge again my gratitude to the friends and colleagues mentioned in the first edition. Revising in no way diminishes those debts; it underscores their importance.

OBJECT AND IMAGE
What Photography Is

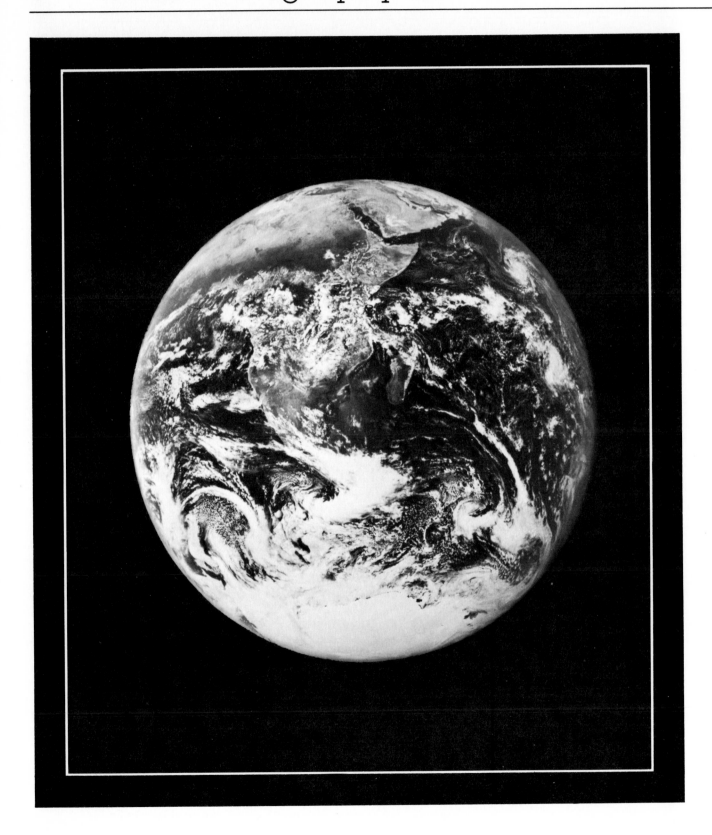

The Earth from Apollo 17, 1972. NASA.

Among all the forms of picture making devised by humans on their long journey from the cave to the moon, photography is one of the youngest and most fascinating. Why have photographs so captured our imagination? And why, indeed, do people make pictures?

The answers to these questions lie in human nature itself, for words and pictures have been fundamental to human existence since the beginning of recorded time. Words and pictures, of course, are symbols, and like all symbols, they help us to understand ourselves and the complex reality of our world. Woven into language, these symbols form the fabrics of many different cultures and have long been the basis for communication and learning.

No one knows when the first pictures were made; their origin is prehistoric. But many centuries ago pictures evolved into a universal language that formed bridges between our diverse cultures. With the introduction of photography in the middle of the nineteenth century, that evolution became a revolution affecting not only the pictures we make but also the way we see.

Reduced to its simplest dimensions, photography is a means of producing images by the action of light on a substance that is sensitive to that light. But this bare-bones definition does not begin to describe either the experience of making photographs or the tremendous impact that pictures have had on nearly every aspect of modern life. And remember that our introduction to these images or to their televised counterparts comes at a very early age. It is therefore no exaggeration to suggest that what we know about the universe, and the way we have come to understand it, are due in no small measure to

the eye of the camera. We have seen history made before our eyes. The distant planets Mars and Jupiter, and more recently Saturn's rings, have all been vividly brought into our experience through photography. Moreover, photographs of our own planet, taken from outer space, have not only reaffirmed the legends of early explorers but they also have revealed to us an earthbound environment that is beautiful, delicate, and precious. On a different but no less remarkable scale, the Swedish photographer Lennart Nilsson has revealed to us the mysterious beginnings of human life in an incredible series of photographs which includes a view of a living embryo in its mother's womb.

But photography is more than a tool of science. Confronting us at every turn, it is an inseparable part of life's most important rituals and events. Who can remember a wedding that did not include a photographer? Who has not seen a baby coaxed into a smile for a waiting camera? Photographs give us tangible reminders of what was. They function like mirrors held up to our past, turning history into convenient packages that we can possess, study, or discard. They bring distant lands and people up close, and by lifting experience out of context, photographs also make the familiar somewhat unusual. They can endow the commonplace with a new sense of importance; they can make people seem larger than life.

Small wonder, then, that photographs have fascinated people for more than a century. They increase our sense of awareness and intensify our powers of observation. What gives photographs these abilities? Such a powerful force in our lives deserves a closer look.

1

Kenneth Josephson: Matthew, 1965.

HUMAN VISION
AND CAMERA VISION

No matter how strongly it resembles actual objects or events, no photograph accurately mirrors the real world. Nor does it show things as we see them. The differences between the ways things appear to us and to the camera are not imaginary; they are very real, and anyone seriously considering picture making by photography must take them into account. But because almost anyone can pick up a camera, make an exposure, and produce a recognizable image, we are led to assume that photography is easy and automatic. Today millions of people use cameras. The vast number of resulting photographic images are snapshots—unpretentious and occasionally charming in their simple directness but too often, like our neighbor's vacation mementoes, simply a bore. For more serious picture making, photography's inherent simplicity may also be an inherent weakness.

As in any other visual art, both sight and insight are called for in making a photograph that is anything more than a snapshot. Hence some definitions are in order. First, *seeing*. Seeing is not merely looking at the world or moving about it without crashing into walls. Seeing involves looking with some effort on our part to understand what we observe. It involves some degree of *empathy*, of feeling our way into whatever we experience, so that we recognize and comprehend it more effectively. At the very least, it demands an *awareness* of what we view. In its rarest and fullest sense it may carry us to revelation and enlightenment. To whatever degree we perform it, seeing requires us to set aside our personal, usually trivial concerns, and concentrate on what is actually there. Such an effort through our various senses we call *perception*. From it we can make some judgments about what we see.

Let's consider for a moment how we see things, and how a camera image is formed. Although the human eye and the camera are both constructed on the same principle, they have different purposes. Our eyes produce a pattern of nerve stimulation in the brain, rather than a picture in our head. Our vision is binocular, which enables us to see in three dimensions: we can perceive depth. Most cameras, on the other hand, have only one picture-forming lens, and the resulting image has only two actual dimensions. Each of us sees things in some imprecise arrangement of colors, while the camera records in fixed schemes of three colors or in monochrome. It can sometimes approximate, but never duplicate, human color sensation.

Normal human vision takes in a wide field of view, but we see only part of it at any given moment, and then each part only for an instant. Our eyes are continually in motion, even when we stare at something, and there are indications that such movement is necessary for normal vision. Our total vision establishes the general arrangement of a scene, but our central vision, which is clearer, concentrates on small areas of greater importance to us than the rest. We get a clear, detailed impression of

our entire field of view only by moving our eyes to bring each part of that field successively into the area of our central vision.

The camera image usually is an instantaneous one. Generally speaking, all parts of it are produced simultaneously in a very short span of time. Indeed, the process has come to be symbolized by the "click of a shutter." Unlike the eye, the camera can, if necessary, accumulate weak light until it builds up a developable image; it can, in fact, take photographs in near darkness where the eye can see little or nothing. It can also retain one image or many successive ones, combining them by superimposition into a single impression. And by varying the time span and sequence of its exposures, time itself can be stopped, compressed, or expanded. Thus a visual world unknown to the eye can be discovered through the camera.

The camera also is indiscriminate. Left to its own devices, a camera does not order the importance of things within its view. It has no mechanism to pause on the interesting and skip over the trivial, but renders the significant and the trifling with equal accuracy and force. Witness again the snapshot; selection must be made by the photographer.

Is it too much to suggest, then, that our visual perception of the real world is imperfect? The whole process appears to be largely an unconscious one requiring very little willful effort on our part. This, of course, can be a trap, for *seeing is very selective*: we see largely what we want to see, what our mind allows us to see, and even that constantly changes. Here, then, enter our personal concerns, our prejudices, our opinions—in other words, our whole system of human values. These, of course, differ for each one of us. All affect what we see, and therefore no two individuals perceive things the same.

Incidentally, some of the same differences we notice between human vision and camera vision are encountered again, in reverse order, when we look at a photograph. It presents itself all at once—instantly—but we see the image only by degrees, and must often search for what is significant within it. We will examine this problem in the final chapter of this book.

WHAT A PHOTOGRAPH IS

Just as camera vision and human vision differ, the photographic image is unlike every other form of picture and the real world of objects and experiences. We have already considered those differences relating to vision and to the way a camera image is formed. Additional ones, however, are found in the image itself, and perhaps the most important of these concerns *light*.

Photographic images depend on light. The name *photography* itself, which was first used in 1839 by the English scientist Sir John Herschel, means, literally, writing or marking with light. In photography, the action of light on or through a substance is the central connection between what is presented to the camera and what appears in the picture. Light is the physical force which produces and reproduces the image, and because light-sensitive material must be used, both have a bearing on other image characteristics.

Two of these, *continuous tone* and *infinite detail*, serve to identify the photograph among other forms of pictures, although they are not universal characteristics of the medium. Continuous tone describes the ability of photography to record changes from light to dark—from white to black—without noticeable steps: in other words, to produce seemingly infinite shades of gray. William Garnett's photograph (page 4) dramatically reveals this quality. It is due to the manner in which most photosensitive materials respond to light, and is as instantaneous as the image formation itself. No other means of making pictures can approach photography in this respect.

Ever since photography's earliest days, lenses have been used not only to form camera images but to impart to them a wealth of detail. Wilhelm Hester's view of the Port Blakely lumber mill dock shrouded in snow (page 5) relies on detail to convey its message. Here we see an aspect of photographs felt far beyond the medium itself, for it has contributed a term to our verbal language. When we speak of certain drawings or paintings having a "photographic" appearance, for example, or of someone having a "photographic" mind, what we mean is an impression of limitless detail. This, of course, is a valuable feature of the photographic image which makes it an efficient conveyor of information. Such clarity, however, can exaggerate the importance of trivia; overwhelming detail can imply authenticity, and fact-filled images are easily equated with truth. Photographers who make such pictures, then, have a special responsibility to use this power wisely.

Another far-reaching characteristic of the photographic image which derives from the nature of the process is its capacity for endless *duplication*. Most forms of the photographic image are produced first as a negative (with tones reversed from their usual order) and, from that negative, as an unlimited number of positives. We may make one positive or any number of exact duplicates without diminishing or destroying the original image. We may also change the size: reproductions can be larger or smaller than the original. And even in those few processes which produce no negative (and are therefore called direct positive processes), the image can be rephotographed and virtual duplication continued. Office copy machines, vital tools of modern business, are built around this principle.

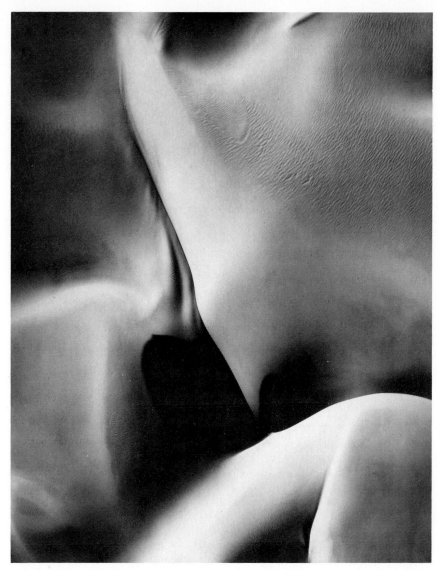

William A. Garnett: Sand Dune, Death Valley, 1954.

Likewise the printing craft, for which photography has become its virtual lifeblood.

This capacity for duplication inherent in photography has revolutionized communication and education—in fact, our entire culture. For instance, André Malraux, the eminent French scholar and historian, has claimed that the study of art history is the study of art that can be photographed. Few of us have access to many original works of art; we usually study them, like so many other things, through photographic reproductions. But until recent improvements in color photography became available, the subtle hues and intensities of many stained glass windows and Byzantine mosaics could not be adequately reproduced. Much of their message was therefore lost to scholars who knew them only through written accounts or inadequate reproductions.

Historian Daniel Boorstin has written lucidly on this substitution of *image* for *object*, which he calls the Graphic Revolution. In *The Image* (see bibliography under General Works), his brilliant essay on the art of self-deception, Boorstin explains how photography has been a major force in fostering the rapid growth of pseudo-events to replace real ones, and copies of objects and experiences to replace originals. Even more alarming is his observation that we have come to value the reproduction more than the original. Evidence of this abounds, for example, in our modern techniques of mass-merchandising goods and services; from network television, everywhere the same, to the nationwide proliferation of franchised restaurants, each serving identical, undistinguished food. Unfortunately such rampant duplication is not limited to postcards and other printed materials; it permeates our culture.

To sum up, these are the most common characteristics of the photographic image:

1. Has two real dimensions. Depth is simulated.

2. Requires light and a light-sensitive substance or surface.
3. Usually is produced instantly, and all parts of a single image are produced simultaneously.
4. Typically has abundant detail.
5. Often distinguished by continuous tone.
6. Has capacity for unlimited duplication.

Taken together, these characteristics suggest that the photograph is a unique kind of picture. Indeed it is.

PHOTOGRAPHY IS ROOTED IN REALITY

We do not need to look at a great many photographs to realize that photography, by its nature, is a language rooted in reality. The earliest photographers recognized that fact, and it quickly became a working esthetic: for nearly half a century, the degree of likeness between the object and its image was the chief criterion by which the photographer measured his success as an artist. This universal application of the photograph—to act as a more convenient substitute for the object itself—remains the principal reason why we make photographic pictures today.

The snapshot is the most obvious form of the *representational* image. The bulk of commercial photography—portraits, catalog pictures, photographs for sales and advertising in business and industry—is an application and extension of this basic idea. Photographs are made for reference, for records of all sorts. We have developed throughout society an indispensable need for such images and it is hard to imagine what contemporary life would be like without them.

Photographs of events not only capture reality; they help us remember the transitory. Memory, of course, is not static, and our way of observing events, like the events themselves, constantly changes. By isolating a moment of time as well as a

Wilhelm Hester: *Barks and Schooners at Port Blakely, Puget Sound, Washington, 1905.*
Collection: *National Maritime Museum, San Francisco.*

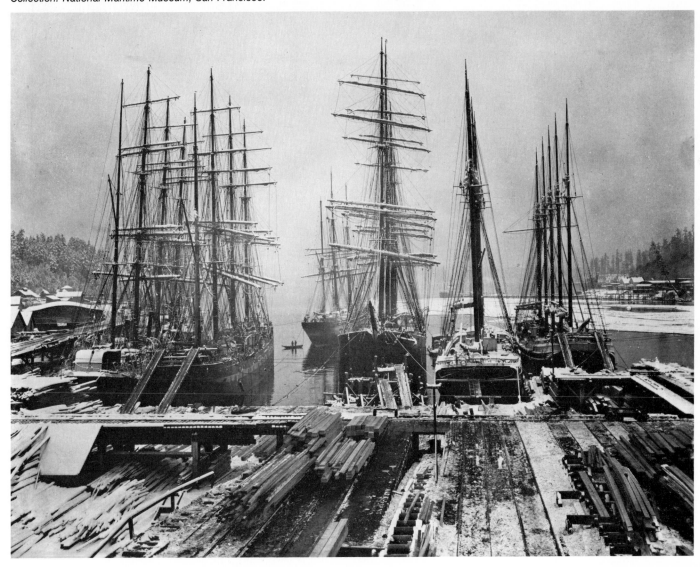

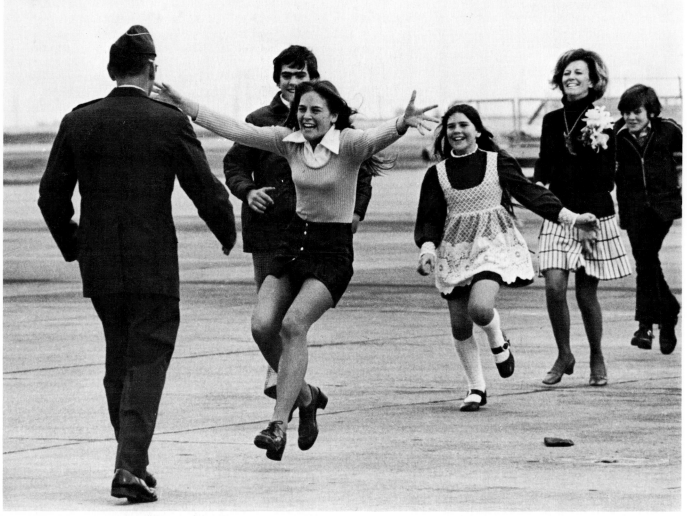

Sal Veder: POW's Homecoming, 1973. Wide World Photos.

field of view, the camera intensifies history. Sal Veder's Pulitzer Prize-winning photograph of a POW being reunited with his family provides a useful example. This single image summed up for many Americans their relief at seeing the end of the Vietnam war. Another case in point is the Jonestown massacre. Verbal accounts on radio and television may have left room for doubt, but photographs of the tragedy shocked all viewers beyond belief. Images of events, then, can take on a new sense of reality just as images of objects can.

Oddly enough, such widespread use of photographs has spawned some peculiar problems. Relentless exposure to photographic images has conditioned us to accept these pictures as literal truth. At times we even question the reality when it fails to measure up to its photographic representation. We can observe this, for example, at our favorite fast-food restaurant, where we judge the hamburger served to us by how closely it matches a color photograph on the wall. In this case, reality becomes true to the extent that it resembles its photograph!

CREATING THE ILLUSION

The act of photographing is concerned essentially with creating an illusion, and because of the interchange of functions just described, it is not hard for a photographer to fill his picture with illusory truth. For one thing, the camera can collapse a span of time into a single instant, recording more than the photographer can perceive. For another, the camera can also expand a moment into a new reality visible only in its image, as Marion Patterson's photograph demonstrates. Moreover, the photographer typically has the advantage of all the richness of tone and detail we associate with a photographic image.

When a painter wants to create an illusion of reality he must draft his image in a precise spatial arrangement and enrich it by rendering sufficient detail. The photographer, on the other hand, faces a different problem: his image is drawn, in effect, by his camera's position and his lens; choosing

them defines his picture. Once these choices are made, the photographer's task is not how to include enough detail but rather how to eliminate all that is not needed. For the painter visualizes his image as a changing series of fragments, building it element by element, adding, revising, and elaborating his theme towards its final state.

The photographer, however, usually begins with his image whole, and determines it by selective elimination. He limits his view by imposing a frame on reality, then further selects within that frame by using light and shadow to give the objects form and importance, to distill significance out of chaos—in short, to bring order and structure to his picture. The photographer's method is *analytic* rather than synthetic: it eliminates the less important so that only the essence of the visual idea remains. The photographer's initial approach, then, is exactly opposite that of the painter, even when both of them have the same end in mind—a representational im-

Marion Patterson: Wildcat Fall, Yosemite National Park, 1978.

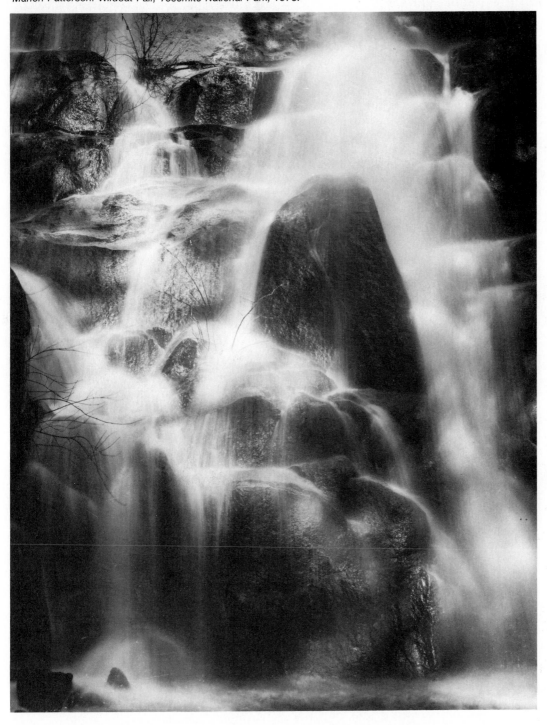

age. Indeed, the difference is aptly summed up by the common saying: "Paintings are *made;* photographs are *taken.*"

SEEING PHOTOGRAPHICALLY

Wynn Bullock was a sensitive photographer who realized that a photograph could be *made* as well as taken, that it could be created from an inner reality of thought and feeling as well as from an external world of objects and events. This idea is important to a photographer because it can free him from any need to make his image a *picture of* something; like any other artist, he may make his image simply *a picture.* By recognizing that his image is based on reality but does not reconstruct it, a photographer opens the door to an enormous range of picture-making possibilities and enjoys virtually all the freedom of image formation which artists in other media traditionally have known. If the image bears a strong resemblance to what was before the camera, it may be termed *representational.* But if it bears little or no apparent relation to its original source, it usually is designated *nonrepresentational.* In that case there is no attempt to illustrate, and the identity of what was before the camera is unimportant. Instead, the photograph is presented

as an experience in itself. Jim Millett's photograph invites us as viewers to bring our own intuition to it and expand upon his image through our own imagination. What we see in it, then, may reflect our own feelings as strongly as it reveals those of the photographer. Such a photograph functions more as a mirror than as a window, and usually it will evoke varied responses from different viewers.

Regardless of how we want our picture to function for the viewer, as photographers we eventually must conceive our image in terms of what our tools and materials can do. We must extend our perception through the working of photographic materials and processes to visualize our picture. To Edward Weston, the photographer, this was "seeing photographically," a process by which we concentrate on an object or observe an event, decide what kind of image we want to make from it, and then see the image in our mind *as a picture.* Although fine photographs occasionally result from accident or chance, many, many more are created by a photographer visualizing the image beforehand.

The title of this chapter and this book, then, implies a major concern for a relationship that is central and vital to the photographic experience. Each of these realities, *object and image,* is given meaning in terms of the other through the eye of the photographer.

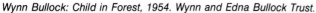

Wynn Bullock: Child in Forest, 1954. Wynn and Edna Bullock Trust.

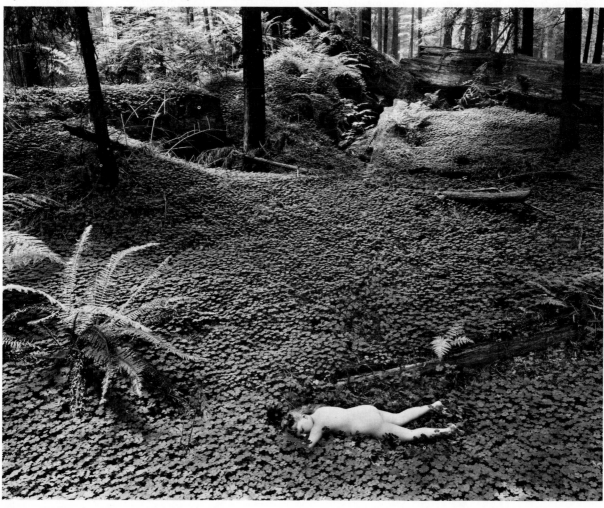

Jim Millett: Chapel Ruin with Ducks, 1978.

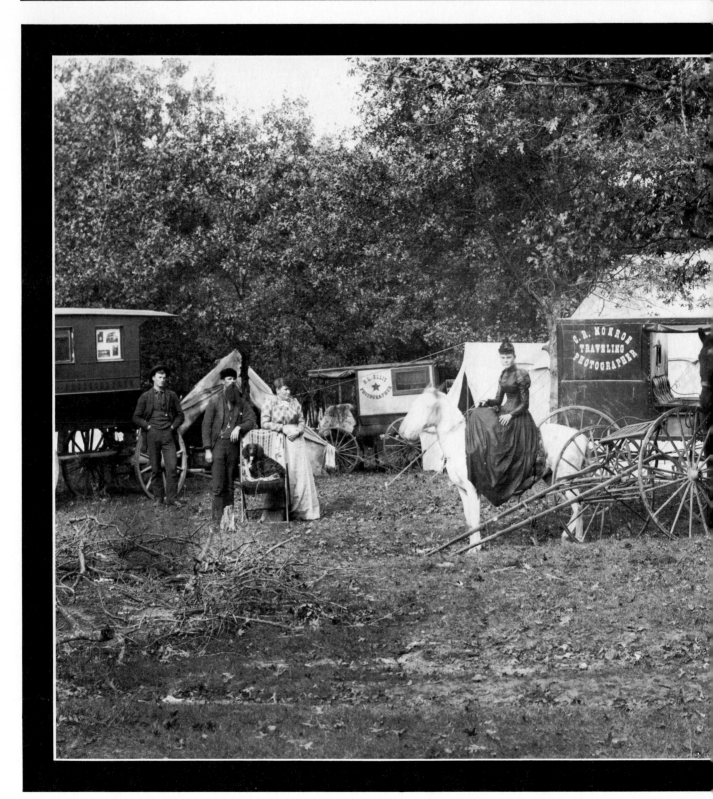

C. R. Monroe: Photographers' Wagons [n.d.]. State Historical Society of Wisconsin.

Photographs have been a familiar part of our life for so long that it is hard to imagine a world without them. But as we know, they have not always been with us, and indeed are comparative late-comers to a continually growing list of reproducible images. To consider the impact of photographs on our culture, we must take a brief look at those pictures which preceded them—not to belabor the past, but to see their origin from a proper perspective.

Although the photograph was a unique image, it did not fill a unique need. It merely did a job—representative illustration—much better than it had ever been done before, and thereby created a demand which spurred its rapid improvement and astonishing growth. Photography led to a revolution in seeing and thinking in art and communication that is still going on and has not yet been fully realized or appreciated.

Our story begins in the fifteenth century with the introduction of printing in western Europe. The first reproducible pictures on paper, which were made at that time, seem to have served two clear functions: as playing cards and as religious symbols. The former application required duplicated images because cards quickly wore out; the latter enabled the faithful to have common religious symbols at home. Soon thereafter these pictures appeared in books, which up to that time had been illustrated ("illuminated," as it was called) the same way they had been written—by hand.

With the decline of feudalism, life shifted from the countryside to cities. Growth in the cities led to trade, which in turn fostered a rising middle class of merchants, especially in Italy. Universities expanded; books quickly multiplied. Throughout the fifteenth

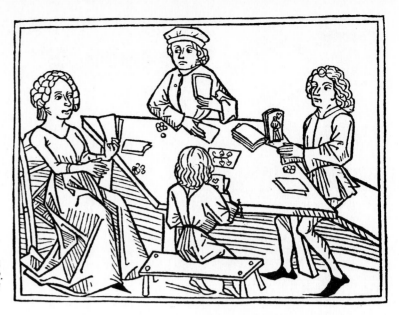

Meister Ingolt: Card Players. Woodcut from Das goldene Spiel. *(Augsburg) Günther Zainer, 1472. Lessing J. Rosenwald Collection, The Library of Congress.*

century, the collective thinking or faith that had characterized the Middle Ages gradually gave way to individual opinion, which needed facts for comparison and judgment. Artists and writers helped to supply them. They studied the world around them, portrayed man as a dignified human being, and placed him at the center of their universe. The knowledge that developed from this humanistic concern was not categorized: art, mathematics, and nature were all considered as one; the greatest scientist of the fifteenth century was a painter, Leonardo da Vinci.

At this same time, Filippo Brunelleschi and Leon Battista Alberti, the great Florentine architects, gave their people the concept of *linear perspective*, a mathematical basis for rendering space in art. This is important to our story for two reasons. First, because it laid the foundation for a natural realism, a standard of resemblance to nature in pictures. Second, as more and more unskilled people responded to nature and caught the urge to paint and draw it, a need for mechanical drawing aids grew. Many such contrivances were invented during the sixteenth century, but one of the most successful and widely used ones was a much older device, the *camera obscura*.

THE CAMERA OBSCURA

A "camera obscura" (literally a darkened room) was described as early as the tenth century by the Arabian scholar Alhazen, using a principle known to Aristotle in the fourth century B.C. for observing eclipses of the sun. Leonardo discussed it in his notebooks in considerable detail (leading many people to think he had invented it), and Albrecht Dürer, the German artist, knew of it in the early sixteenth century. A tiny hole in one side of a room admitted rays of light in such a way that an in-

verted image of what was outside the room appeared on the inner wall opposite the hole. About 1550 a lens was added to the opening, making the image brighter and clearer.

All descriptions prior to 1572 indicate that the early camera obscura was, in fact, a room. But early in the seventeenth century we find mention of a portable device—first a wooden hut, next a tent, then a covered sedan chair, and finally a small box such as Canaletto undoubtedly used to paint his sweeping views of Venice in the early eighteenth century. Antonio Guardi, Jan Vermeer, and other artists also used the camera obscura, which by 1685 had already been developed to a form that was to remain substantially unchanged for nearly two hundred years.

Throughout the seventeenth and eighteenth centuries, book illustration was dominated by woodcuts and copper engravings. The former were useful for cheap copies but could not convey shading very well. Engravings gave satisfactory reproduction but, because copper is a soft metal, they wore out quickly and were used primarily for more costly and limited editions.

Moreover, the visual medium (as Marshall McLuhan was to put it two hundred years later) had already become the message, in a subtle manner that went unnoticed by many people in the same way that we blindly accept the "truth" of a photograph today. Consider that all visual information available to the common man in the form of reproducible and therefore inexpensive pictures came to him second or even thirdhand. Master artists prepared the originals, but reproduction in prints was left to other craftsmen who translated those images into the peculiar linear construction of the engraver's medium. What came out in an engraved print often was the product of several nameless people rather than the work of a single mind or hand. At best it was only an approximation of the

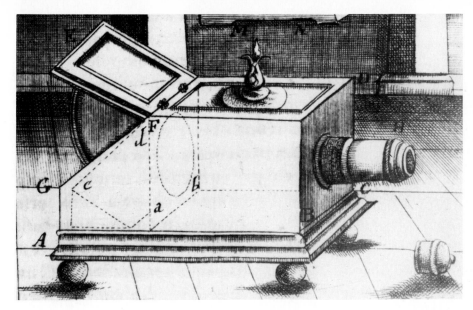

Johann Zahn: Reflex Camera Obscura, 1685. Gernsheim Collection, Humanities Research Center, The University of Texas at Austin.

original visual statement; too often it turned out to be a stylized mechanical image more descriptive of the process than the source.

The continuing growth of the middle class in the eighteenth century maintained a demand for pictures. Lithography—printing with greasy ink from the flat surface of a porous, wet stone—was invented around 1797, and at the same time wood engraving was revived. A wood engraving was cut across the grain of a block (as on the end of a board) instead of running parallel to it, as a woodcut was made. It permitted a longer printing run than did copper, while retaining most of the image detail and shading possible with metal plates. Thus popular editions of illustrated books could be printed by this method, and it remained the primary way of reproducing pictures in ink for another hundred years. Not until the end of the nineteenth century did printed picture making come fully of age. What brought it to maturity, of course, was the evolution of photography.

INITIAL INVESTIGATIONS

Almost everything that makes photography possible has been known since 1725, when Johann Heinrich Schulze, a German scientist, discovered that light darkens silver salts. Although he had no way of knowing it, this was the fundamental reaction on which virtually all photography was to depend. The only missing technical link was a suitable means to preserve the image once light had formed it. In 1777 the Swedish chemist Carl Wilhelm Scheele, who knew from earlier experiments that silver chloride (a white powder) was soluble in ammonia, discovered that this same powder, when blackened by light, changed to silver metal and would not dissolve as before. Ammonia thus could provide a workable preservative. But since Scheele

was not interested in producing pictures he did not see the application of his discovery, and the world had to wait until the nineteenth century for someone to put it all together.

WEDGWOOD AND DAVY

Two fundamental ideas make photography as we know it possible. One is optical, the other chemical. The first person to see the connection between them was Thomas Wedgwood, youngest son of the famed English potter, Josiah Wedgwood. Thomas took note of the earlier work by Schulze and Scheele, and using his father's camera obscura, tried to record images from nature, possibly as early as 1799. But his silver nitrate compound was not sensitive enough to produce a visible picture. He also experimented with white leather that he had sensitized with silver nitrate, exposing the material through leaves and paintings made on glass. Wedgwood's collaborator, Humphry Davy, repeated the camera experiments using silver chloride, which was more sensitive to light. Neither Wedgwood nor Davy produced an image with the camera, but both got impressions of small objects placed on their materials in direct sunlight. All efforts to preserve these images failed, however, as the continued action of light caused the paper and leather to darken after the objects were removed. Ill health forced Wedgwood to abandon the work. In 1805 he died without reaching his goal.

HELIOGRAPHY

The next attempt was made by a French inventor, Joseph Nicéphore Niepce, of Chalon-sur-Saône, who apparently succeeded in making a paper negative with a camera in 1816. He ran up against the same problem that had baffled Wedgwood and

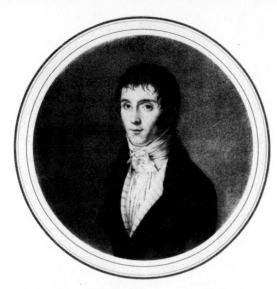

C. Laguiche: Nicéphore Niepce, c. 1795. Pencil and wash drawing. Gernsheim Collection, Humanities Research Center, The University of Texas at Austin.

Davy—the image continued to darken when removed from the camera. So he abandoned this line of work and began to look for a material that would be lightened rather than darkened by exposure. This would have resulted in a direct positive image, one in which the tones were not reversed from their usual order. Niepce turned next to plates of polished pewter metal, spreading on them a thin coating of bitumen of Judea, an asphaltic varnish. When sufficient light struck the bitumen it hardened; but where the exposure was held back by a superimposed image (he used an engraved print) in contact with the coating, or by the reflection of dark objects in the camera, the bitumen remained soluble in a mixture of oil of lavender and turpentine. Then, after exposure, Niepce used the oil to remove the soluble (unexposed) parts of the coating, revealing a faint, positive image. This he washed with water and dried.

Niepce named his process *heliography*, or sunwriting. Most of his early experiments were copies of engraved prints, but one made in the summer of 1826, according to historians Helmut and Alison Gernsheim, was a view from the window of his attic workroom. Rediscovered by the Gernsheims in 1952 and reproduced here, it is the world's first photograph, and the only surviving example of Niepce's work with the camera.

Niepce's camera was fitted with a prism, which corrected the lateral reversal of the image so that a pigeon loft of the house, which actually was on the left as one would see it from the window, appears there in the image. Other objects are discernible: the long, sloping roof of a barn, a tree beyond that, and another wing of the house on the right. The exposure required by the bitumen coating was about eight hours on a summer day, and since the sun changed position during that time, objects appear to be illuminated from both sides simultaneously. Niepce also made a still-life heliograph with the camera on a bitumen-coated glass plate about 1829, but it and a copy of an engraving obtained on glass in 1822 were later destroyed.

In 1827 Niepce was introduced to another experimenter, Louis Jacques Mandé Daguerre, through their mutual lensmaker. After two years of extremely cautious contacts and exchanges, Niepce and Daguerre formed a partnership to perfect and exploit the heliography process. Four years later, however, Nicéphore Niepce died, leaving Daguerre to carry on the work alone. Although Niepce had made photography possible, it remained for Daguerre and others to make it practical.

Nicéphore Niepce: View from his window at Gras, near Chalon-sur-Saône. The world's first photograph, 1826. Actual size. Gernsheim Collection, Humanities Research Center, The University of Texas at Austin.

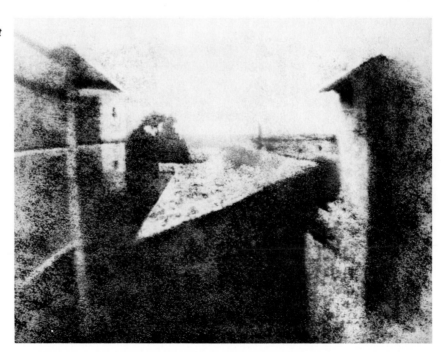

THE DAGUERREOTYPE

L. J. M. Daguerre had earlier achieved fame in Paris as the painter and proprietor of the Diorama, a theatrical presentation wherein large colored pictures could be viewed by changeable combinations of reflected and transmitted light. The illusion of realism was heightened by including actual objects in front of the picture planes, creating a setting similar to three-dimensional displays of wildlife commonly presented today in natural history museums. The Paris Diorama was such a crowd pleaser that Daguerre and his partner in the venture (who does not otherwise figure in the story of photography) opened another in London within a year.

The Dioramas achieved much of their realistic illusion because they were painted in meticulous perspective, and for that, of course, Daguerre had used a camera obscura when sketching the pictures. Since he therefore knew how laborious it was to *draw* such realistic impressions with the camera, we can imagine his interest upon learning of Niepce's efforts to "fix the image of objects by the action of light," as the latter described his pioneering work.

Seeking to improve his image quality, Niepce in 1828 had switched from pewter to silver-plated copper sheets, and found he could strengthen the contrast of his image by fuming the silvered plate

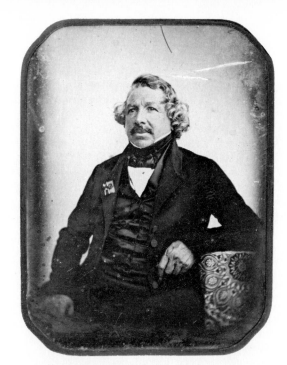

J. B. Sabatier-Blot: L. J. M. Daguerre, 1844. Daguerreotype. Collection: International Museum of Photography.

with iodine vapor. Daguerre now tried this, but the resulting silver iodide was still too low in sensitivity for reasonably short exposures. In 1835 he accidentally discovered that by subjecting his underex-

L. J. M. Daguerre: The Artist's Studio. The earliest surviving daguerreotype, 1837.
Collection: Société Française de Photographie, Paris.

posed plates to the vapor of mercury (which had spilled from a broken thermometer), the nearly invisible image could be made to appear much stronger. Two years later Daguerre succeeded in permanently desensitizing, or fixing, the plate, using a solution of table salt in hot water. His earliest successful effort was the still life reproduced here.

By January 1839, Daguerre was ready to publicize his achievement. Christening it the *daguerreotype*, he prevailed on his friend, François Arago, secretary of the French Academy of Sciences, to make the announcement. Later, after a clumsy attempt to discredit Niepce and garner all the honors for himself, Daguerre (with Arago's continued help) persuaded the French government to make the process public and to award him and Isidore Niepce (Nicéphore's son and heir) lifetime pensions. Thus spared the task of seeking financial backing, Daguerre freely shared his discovery with the world. All, that is, except England, where he had secretly patented his process five days before the French government made it free to all.

The daguerreotype, according to Arago, demanded no "manipulation which is not perfectly easy to every person. It requires no knowledge of drawing and does not depend on any manual dexterity." The popular French painter, Paul Delaroche, reacted more directly: "From this time on," he exclaimed, "painting is dead!"

Well, not quite. But it never was the same again. The public was absolutely fascinated with the new pictures; "daguerreotypomania" swept Paris. Daguerreotypes were favorably compared to Rembrandt's etchings; in their revelation of light and shade and in their absence of color, the comparison seems justified even if naively overstated. As a means of recording information, nothing so accurate had ever been seen before. But the pictures had a ghostly quality about them too, especially when made outdoors. While every detail of streets and buildings was clearly etched, no sign of life was apparent. Exposures were too long to record moving objects, but revealed every cobblestone over which they had traveled.

The chief value of the new process was for portraits, heretofore available only to the famous and wealthy. The realistic likenesses satisfied most people, and their incredibly beautiful tonal scale rendered the subtle modeling of faces by light with amazing delicacy.

The daguerreotype process was a complex one. To start, the silver side of a silver-plated copper sheet was polished as smooth and bright as possible, and then was inverted over a box containing iodine. This vaporized onto the plate, creating silver iodide, which is sensitive to light. Transferred to the camera in a lightproof container, the plate was exposed, again covered, and removed to a darkened room. There it was inverted over a vessel containing heated mercury, which deposited a white amalgam on the exposed areas. The silver iodide not exposed was dissolved with common salt or sodium thiosulfate, and rinsed away with water. Then the plate was gently dried over an alcohol lamp.

At first the daguerreotype was not sensitive enough for portraiture; exposures were simply too long. Early operators like Richard Beard, who opened the first portrait studio in London in 1841, overcame this problem by making the plates smaller to take advantage of better camera lenses, and by using chemical accelerators. Being a direct image, the picture was laterally reversed. This was soon corrected by using a prism lens on the camera, as Niepce had done many years before. Since the mercury adhered only lightly to the plate, the picture was easily damaged if anyone touched it. Protective cases were quickly introduced; each contained a paper matte as a spacer and a cover glass to protect the image, all bound up with the plate itself like a sandwich. And of course the image was unique: it could not be duplicated.

None of these limitations, however, delayed the spread of this marvelous French discovery to other countries, particularly England (in spite of the patent) and America, where Oliver Wendell Holmes called it a "mirror with a memory." Daguerre's instruction manual, according to the Gernsheims, went through 29 editions in six languages. He was made an officer of the Legion of Honor and in 1840, at the age of 52, L. J. M. Daguerre retired from national public life, leaving to others the task of perfecting his discovery.

PHOTOGENIC DRAWING

Arago's announcement of the daguerreotype in January 1839 was noted with alarm by William

Richard Beard: Portrait of an unknown man, London, c. 1842. Daguerreotype. Author's collection.

[Photographer unknown]: Margaret Aurelia Dewing, 1848. Daguerreotype. Collection: Richard Rudisill, Santa Fe, New Mexico.

John Moffat: William Henry Fox Talbot [n.d.]. Carbon print. Photo. Science Museum, London.

Henry Fox Talbot, an English scientist and scholar who had been honored by election to the august Royal Society in 1832. Several years earlier, Talbot had worked out a method for making images by the direct action of sunlight on paper. The idea for this occurred to him in the fall of 1833, in Italy, while he was trying with considerable difficulty to sketch a view. At that time Talbot was unaware of the work by Niepce and Daguerre, and had himself taken quite a different tack in pursuit of the elusive image. By 1835 he had discovered a way to coat paper with silver chloride. After two hours' exposure through various materials in contact with it, a tonally reversed image appeared on the paper, which he then preserved with a strong solution of salt water. This, of course, was the same contact method first tried by Wedgwood and Davy more than thirty years earlier, but where they had failed to preserve the photographic image, Talbot succeeded.

Next he increased the sensitivity of his paper by repeated applications of chemicals, and exposed it in several small cameras—"mousetraps," his wife called them—that were made for him by a local carpenter. One of these camera negatives, now preserved in the Science Museum in London, is a view through the central oriel window of the south gallery at Lacock Abbey, the Talbot family home near Chippenham in Wiltshire. Lilac colored, and only about an inch square, it is the earliest existing negative, and the second oldest surviving photograph in the world.

Over the next four years Talbot turned to other interests, and until the news of Arago's announcement reached him in January 1839, these early photographic experiments had been all but forgotten. Quickly realizing what was at stake, however, Talbot rushed to claim priority for his discovery before the end of that eventful month. He dispatched brief letters to Arago and others in the French Academy, and a lengthy report to the Royal Society, its English equivalent. Buried within that report was a recognition of great importance: "If the picture so obtained is first *preserved* so as to bear sunshine, it may be afterwards itself employed as an object to be copied, and by means of this second process the

Talbot's experimental cameras, 1835–39. Crown Copyright. Science Museum.

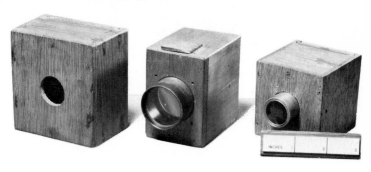

William Henry Fox Talbot: *Latticed Window,* 1835. The earliest existing negative. Actual size. Science Museum, London.

lights and shadows are brought back to their original disposition."* With this statement, Talbot introduced the negative-positive principle that has been the basis for most photographic processes ever since.

Talbot's paper to the Royal Society was widely reported by the press in February, but his *photogenic drawings*—coarse paper negatives about one inch square—simply failed to capture the imagination of a public clamoring for the daguerreotype abroad and indifferent to new pictorial developments at home. Daguerreotypes were larger (up to 6½ × 8½ in.), direct positives (as normally viewed), and much more brilliant and detailed. Meanwhile, the eminent scientist Sir John Herschel had independently conducted his own experiments. He found that hyposulfite of soda was a suitable preserving agent, and in just a few days succeeded in covering the same ground as Daguerre and Talbot. When the latter visited him on February 1, Herschel "explained to him all my processes." Talbot did not reciprocate, and when Herschel suggested that they collaborate on their future investigations, Talbot refused. On August 19 the secret of Daguerre's process was revealed by the French. Talbot saw it as a challenge, but continued his work alone.

THE CALOTYPE

Talbot was bitter at what he considered to be an inadequate response from his own prestigious Royal Society, and annoyed by the public's disinterest in his work and its acclaim of Daguerre's. Securing larger cameras with better lenses, he continued to experiment. Then in September 1840, while resensitizing a batch of photogenic paper that he had

*W. H. F. Talbot, *Some Account of the Art of Photogenic Drawing* (London: privately printed, 1839), Sec. 11.

greatly underexposed and thought could be used again, Talbot noticed the former images suddenly appear. In a way remarkably similar to Daguerre's encounter with spilled mercury five years earlier, Talbot discovered a *latent* or hidden image that could be made visible by development. Exposures were thereby reduced from two hours to a minute or less, and these improvements Talbot immediately secured by patent in England and France in 1841, and in America six years later.

The *calotype*, as Talbot called this improved process, was prepared and exposed much like a photogenic drawing. But then it was developed by reapplying a solution of gallic acid and silver nitrate to the sensitive surface of the paper, and heating the sheet to bring out the image. The picture appeared when the reapplied solution deposited additional silver on the latent image, a now obsolete process known as physical development. (It has since been replaced by chemical development, in which silver is produced by a reaction *within* the latent image rather than by an external deposit.) Once developed, Talbot's calotypes were preserved by Herschel's method—hypo—which Talbot cavalierly patented along with his own discoveries.

Because it was made on paper rather than metal or glass, the calotype was better suited to record masses of tone rather than fine detail. The best examples are characterized by vigorous use of light and dark areas in the picture. Many are landscapes and architectural views.

Calotypes (also called *talbotypes*) were largely ignored by English photographers because of Talbot's vigilant enforcement of his patents. Some amateurs worked the process privately—paper, after all, was cheaper than silver-plated copper—but the pictures often had a tendency to fade within months. Many of Talbot's own negatives are preserved at the Science Museum, and most of these are still strong and clear today. One source of good quality work was

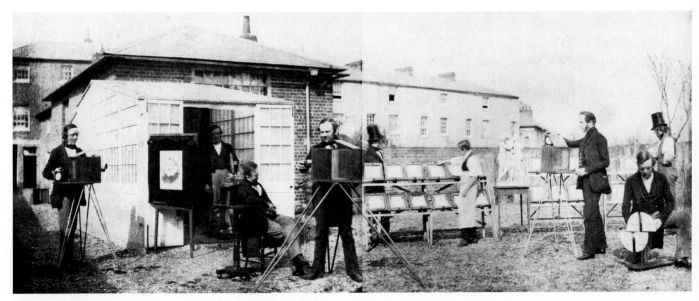

Talbot's Establishment, Reading, 1844–47. Science Museum, London.

Talbot's firm in Reading, west of London, shown in the photograph above. The photographer in the center, uncapping his lens to make a portrait, is probably Talbot himself. This is undoubtedly the first photofinishing laboratory in the world. Here in 1844 a thousand prints were made for Talbot's *Pencil of Nature*, the world's first photographically illustrated book.

Another source of excellent calotypes was the studio of David Octavius Hill, a painter, and Robert Adamson, a chemist, in Edinburgh. Talbot's process was free from patent restrictions in Scotland, and Hill was one of the first people to realize the artistic potential of the material. For five years from 1843 on, Hill and Adamson produced a remarkable collection of early Victorian portraits before Adamson's death ended the association.

Calotypes were also made in France, where Talbot had taken out a patent but failed to exploit it. In 1851 Louis Désiré Blanquart-Evrard opened a photographic printing shop in Lille similar to Talbot's in Reading. Talbot, as we have seen, had developed a latent image to make his calotype negatives, but was printing his positives from them by the older principle using the direct action of light, that is, by *printing out.* Blanquart-Evrard's prints, on the other hand, were produced like his negatives, by a much shorter exposure and *developing out* the image, the basic method we still use today. He also introduced *albumen paper,* in which the sensitive salts were dispersed in the whites of eggs. This produced a clear, glossy coating capable of retaining more detail from the negative than silver chloride paper could. Albumen paper remained in general use for more than forty years.

Hill and Adamson: John Henning and Alexander Ritchie, c. 1845. Calotype. Collection: International Museum of Photography.

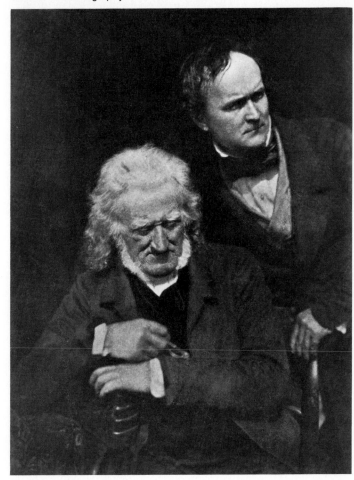

Chapter 2 / Our Photographic Heritage **19**

PHOTOGRAPHY COMES TO AMERICA

The first photograph made in America has always been an elusive image for historians. Most accounts credit D. W. Seager of New York City, who successfully made a daguerreotype in September 1839, but none of his pictures are known to have survived. The oldest existing American daguerreotype seems to have been made a month later in Philadelphia by Joseph Saxton, an employee of the United States Mint, from which the view was taken. It is reproduced here in its actual size.

Undoubtedly the most famous pioneer American daguerreotypist was Samuel F. B. Morse, a professional portrait painter, professor at New York University, and better known to most of us as the inventor of the telegraph. Morse had seen Daguerre and his work in Paris during March of 1839. With his New York colleague, chemistry professor John W. Draper, Morse began experimenting in September, teaching others as he perfected his methods.

America learned of the daguerreotype when the steamer *British Queen* docked at New York on September 20, 1839, carrying European newspapers that detailed the process. It was a favorable time for such news to arrive. The United States was in the midst of a depression that had begun in 1837, when five years of rampant land speculation fed by unregulated banking practices caused a wave of financial panic and closed every bank in the country. With unemployment high, any new idea that promised business opportunity and jobs was eagerly grasped. Daguerreotyping required little capital investment and the needed proficiency could be learned with moderate effort. Thus Morse found himself sought by others wishing to acquire the necessary skill.

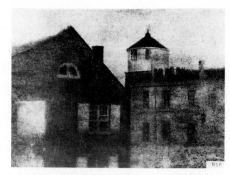

Joseph Saxton: Old Central High School, Philadelphia, 1839. The oldest surviving daguerreotype in America. Actual size. Collection: Historical Society of Pennsylvania.

Among his students were Mathew Brady, a boy from rural New York State, Edward Anthony, an unemployed civil engineer, and Albert Southworth, a Bostonian. Within a few years these enterprising men had established a new American industry.

The new craft of daguerreotyping also attracted many speculators, few of whom had any talent. Dentists, blacksmiths, cobblers, and shopkeepers could be found making daguerreotype portraits as a sideline, and results often were poor. Other operators in small towns posed as magicians, making the practice of photography little more than a con game.

Some, however, built reputations on the quality of their work. There was John Plumbe, Jr., the first to advocate a transcontinental railroad in 1837, and owner of a chain of 14 daguerreotype studios in eastern and midwestern cities. Plumbe was careful to staff his establishments with competent employees, and his growing reputation, based on views like that shown here, aided his political cause.

John Plumbe, Jr.: East Front, United States Capitol, c. 1845. Daguerreotype. The Library of Congress.

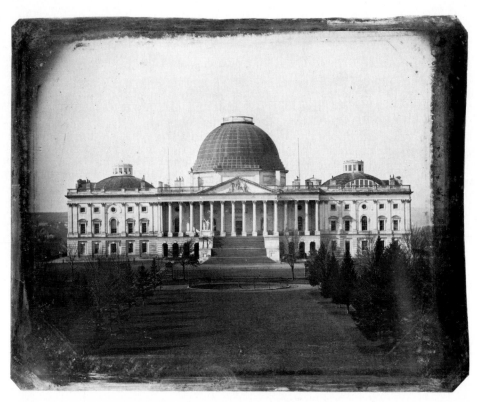

Edward Anthony arrived in Washington in 1843. With his partner, J. M. Edwards, he began photographing members of Congress and publicly exhibited these pictures as a National Daguerrean Gallery in New York City. Fire destroyed this collection in 1852, and Anthony, who had earlier sold his gallery interest, then formed a new partnership with his older brother, Henry, to sell daguerreotype supplies. Their firm of E. and H. T. Anthony and Company remained the major American supplier of photographic materials for half a century.

Albert Southworth and Josiah Hawes of Boston produced remarkably natural daguerreotypes, like that of Chief Justice Lemuel Shaw of the Massachusetts Supreme Court, reproduced here. They claimed that they exposed all plates themselves, never using "operators," and since they took many poses at each sitting, they were able to assemble a major collection of portraits and views. The collection is now preserved in three museums.

MATHEW BRADY

By far the most famous of all early American photographers was Mathew B. Brady. His studios in New York and Washington daguerreotyped the great and near great of a prosperous but deeply troubled era. The Mexican War of 1846–1847 had given the United States vast territorial gains, and these in turn produced a westward outlook and migration that were dramatically stimulated by the discovery of gold in California in 1848. The trouble, of course, was that peculiar institution—slavery—which supported a southern economy based almost entirely on cotton, and which reared its ugly head as each new western territory came up for inclusion in the union.

More than any other early American photographer, Brady sensed the usefulness of photographs as historical records of a changing time. By 1850 he had organized his business so that he could afford to photograph people and events because he felt they were important. Brady's publication of a *Gallery of Illustrious Americans*, 12 lithographs skillfully copied from daguerreotypes he made of John J. Audubon, John Calhoun, John Charles Fremont, Zachary Taylor, Daniel Webster, and others, was conceived and heavily subsidized by the photographer himself. He and his Washington studio manager, Alexander Gardner, photographed nearly every President and other government officer of cabinet

Southworth and Hawes: Lemuel Shaw, 1851. Daguerreotype, actual size. Collection: The Metropolitan Museum of Art, Gift of I. N. Phelps Stokes, Edward S. Hawes, Alice Mary Hawes, and Marion A. Hawes, 1938.

Levin C. Handy: Mathew B. Brady, c. 1875. Daguerreotype. The Library of Congress.

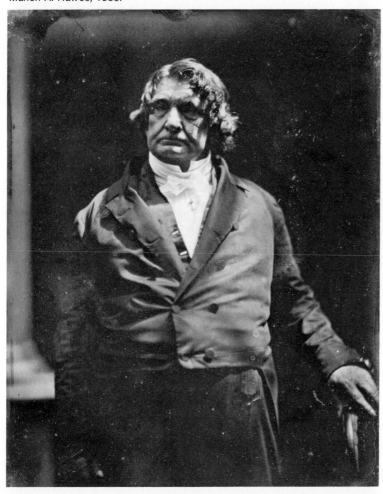

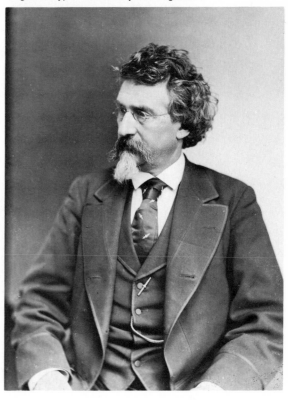

rank or above, from John Quincy Adams to William McKinley.* Undoubtedly Brady realized the social and historical value of the photographic image, and when the first major skirmish of the Civil War erupted at Bull Run in 1861, Brady was there.

By July of 1863, Gardner had left Brady's studio and had set up his own, taking two more of Brady's best employees (T. H. O'Sullivan and J. F. Gibson) with him. These three made the first photographs of the Gettysburg battlefield, before the dead had been buried. People were shocked by these images: few had ever seen such carnage before. And Brady's photograph of the gutted Gallego Mills at Richmond, burned by retreating Confederate troops in April 1865, is no less effective. There are few more eloquent pictorial expressions of the ultimate futility of war from any conflict, before or since.

Brady and his staff, incidentally, were not the first cameramen to photograph warfare. A few daguerreotypes survive from the Mexican War (c. 1847) but they show no combat. Roger Fenton,

*William Henry Harrison died in 1841, a month after his election and before Brady had established his business. Many notables were photographed after their terms of office had expired.

sent to the Crimean War in 1855 by an English publisher, returned to London with more than three hundred photographs of military encampments and other details, but his pictures are not combat views either. Why? Aside from the obvious personal danger of working under fire, Fenton and the Civil War photographers in the United States all used the wet collodion process to record their views. A brief description of the process will explain its unsuitability for combat work.

THE COLLODION ERA

Collodion was made by treating absorbent cotton with nitric acid to form nitrocellulose, and then dissolving that in a mixture of ether and alcohol to form a clear, viscous liquid. When spread on glass and allowed to dry, it became a tough film. In 1851 an English sculptor and photographer, Frederick Scott Archer, adapted the process to making negatives. Archer added potassium iodide to his collodion and, before the coating had dried, dipped the plate into a silver nitrate bath. This formed a suspension of silver iodide all over the collodion surface. Then he exposed the plate *while it was still*

Mathew B. Brady: Ruins of the Gallego Flour Mills, Richmond, Virginia, 1865. Albumen print, 16.5 × 21 cm. Collection: The Museum of Modern Art, New York.

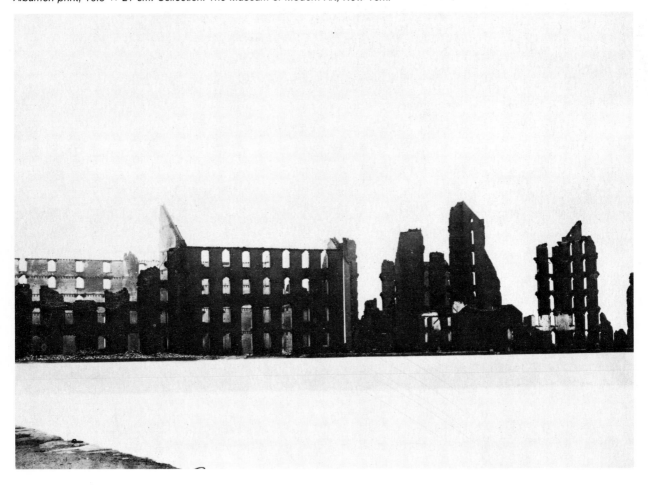

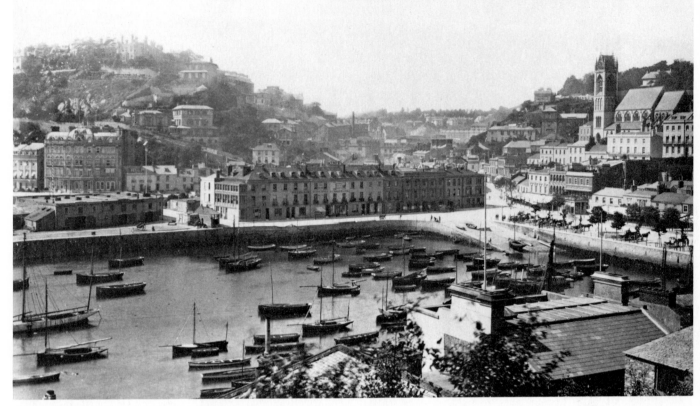

Francis Bedford: Torquay, England, c. 1860. Albumen print. Author's collection.

wet, before its sensitivity diminished. Development was by pyrogallic acid with subsequent processing by conventional means.

Collodion was easier to work with than the daguerreotype method, and much more sensitive than the calotype. It yielded a negative image on glass, from which unlimited numbers of high quality paper prints could be made. Adopted universally about 1855, the collodion process, or *wet plate*, as it was popularly known, became the common negative material until 1880. The plates were printed on albumen paper. Francis Bedford's view of Torquay, an English holiday town, shows the excellent tonal quality that could be obtained.

Archer did not patent his process in England, and freely shared its details with all who inquired. Talbot, however, claimed that collodion was merely a variation of his calotype, and prosecuted those who used it commercially without paying his fee. One such defendant was Silvester Laroche, a London studio operator. Laroche threatened countersuit, and moved to block the upcoming renewal of Talbot's calotype patent. A jury found Laroche innocent of infringement, and with collodion thus beyond his legal grip, Talbot let the calotype patent expire. Meanwhile Daguerre's English patent had also run out, so by 1855 photography in England could be practiced by anyone. In 1857 Archer died prematurely, unrewarded and virtually unrecognized for his discovery and his generosity.

American daguerreotypists, like those in England, were quick to adopt the wet process. Archer's invention, patented here in 1854 by James Ambrose Cutting of Boston, produced a weak collodion negative on glass. When placed on a black cloth it appeared to be a positive, and in this form it thus became a cheaper substitute for the daguerreotype. Most were no larger than 8.3×10.8 cm ($3\frac{1}{4} \times 4\frac{1}{4}$ in.) and were matted and cased just as daguerreotypes were. In America these small collodion positives were called *ambrotypes*. The portrait by C. R. Moffett of Mineral Point, Wisconsin (page 24, top left), shows the negative-positive effect (here the left half is seen by transmitted light; the right half is backed by black paper).

The immensely popular *tintype* was a modification of the same process, with the collodion poured over a piece of metal that first had been lacquered with a dark-colored varnish. Tintypes were not as fragile as glass and could easily be mailed. Because they usually were small and could not be duplicated, however, they were similar to daguerreotypes in their appeal, but much cheaper to produce. Most were portraits, casually and quickly made. Tens of thousands of them still survive.

It was still another form of the collodion image, however, that finally rendered the daguerreotype obsolete. In 1854 Adolphe-Eugène Disdéri in France patented the *carte-de-visite*, or visiting card photograph, so named because the print was pasted on a

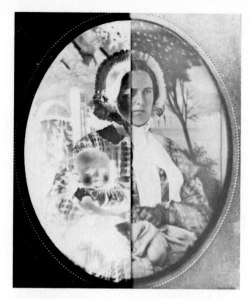

C. R. Moffett: Woman and Child, Mineral Point, Wisconsin, 1858. Ambrotype showing negative and positive aspects. Author's collection.

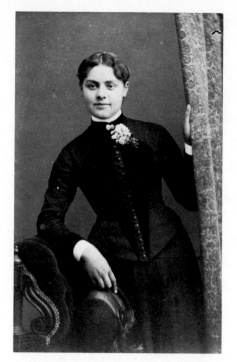

T. Partridge: Unknown girl, South Devon, England [n.d.]. Carte-de-visite. Author's collection.

card mount 10 × 6.5 cm (4 × 2½ in.), similar to what we now call a business card. Multi-lens cameras equipped with devices to reposition the 16.5 × 21.5 cm (6½ × 8½ in.) collodion plate between exposures enabled studio operators to quickly take eight pictures and process them as one. The resulting albumen print was cut up and mounted.

Most of the early card photographs were full-length portraits, and the style remained popular for decades. People left them as calling cards; they became "the social currency, the sentimental 'green-backs' of civilization," as Oliver Wendell Holmes put it. Photograph albums, introduced in 1861 expressly for collecting and storing such cards, soon became a fixture in nearly every American parlor. A larger card style, the *cabinet photograph*, appeared in England in 1866. At first it was used for publicity pictures of royalty and theatrical people, but soon it, too, swept the world.

Adolphe-Eugène Disdéri: Uncut print from carte-de-visite negative, c. 1860. Collection: The International Museum of Photography.

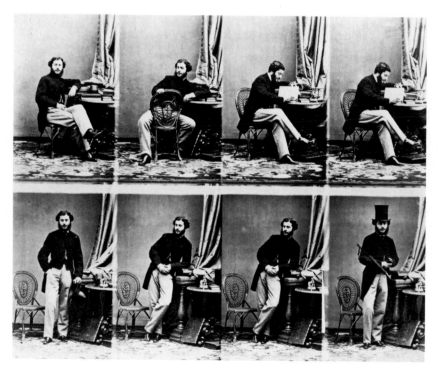

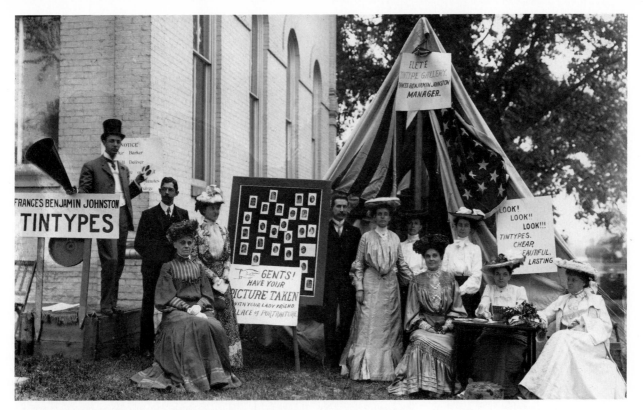

Frances Benjamin Johnston: Her Tintype Gallery and "Studio" at a County Fair in Virginia, 1903. The Library of Congress.

James Fairclough: Unknown woman, County Durham, England [n.d.]. Cabinet photograph. Author's collection.

THE AMERICAN WEST

A decade before the Civil War, daguerreotypists had accompanied geographic expeditions as they charted rivers and mountains across the unsettled land. Most of the images made by these pioneer cameramen are known only from sketchy mention in government reports; few plates have survived. Other photographers worked eastward from the Pacific coast. R. H. Vance and Isaac W. Baker joined the forty-niners in the California goldfields, and Carleton E. Watkins was among the first to photograph Yosemite Valley in the 1860s.

After 1865 America again turned its attention westward. Expeditionary teams now surveyed for mineral resources, ethnological knowledge, and other specific purposes. Alexander Gardner and Captain Andrew J. Russell, fresh from the war, hired on with the Union Pacific Railroad to document its route survey and construction which had been brought to a standstill by wartime shortages of men and iron. Russell's view of the Granite Canyon fill west of Cheyenne, Wyoming, clearly shows how quickly and poorly some parts of the first transcontinental line were rushed to completion. Many miles of the line were rebuilt after the historic meeting of the rails at Promontory, Utah, on May 10, 1869. Russell and two other photographers, A. A. Hart from Sacramento and Charles Savage from Salt Lake City, recorded that dramatic event.

Isaac W. Baker: Murphy's Camp, California, 1853. Daguerreotype. Collection: The Oakland Museum.

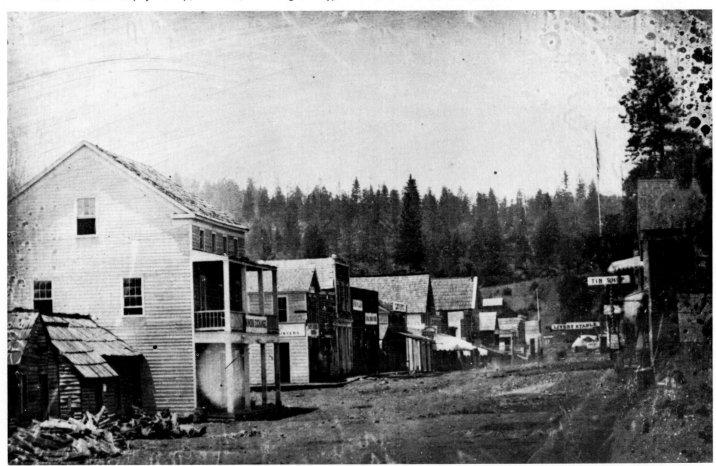

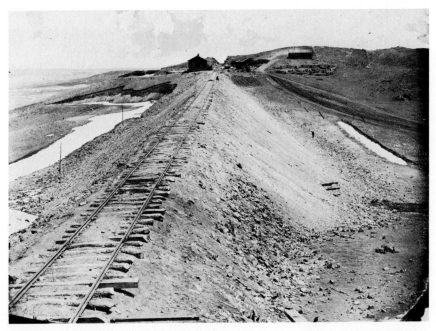

Andrew J. Russell: Granite Cañon Embankment, Union Pacific Railroad, Wyoming, 1869. Russell Collection, The Oakland Museum.

Carelton E. Watkins: Yosemite Valley from the ''Best General View.'' No. 2. c. 1866. The Library of Congress.

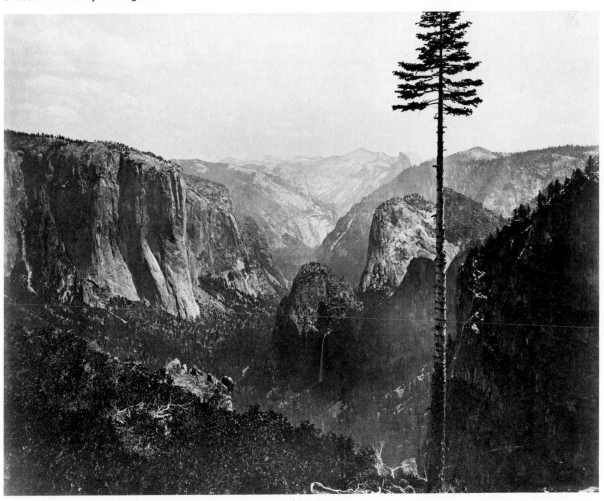

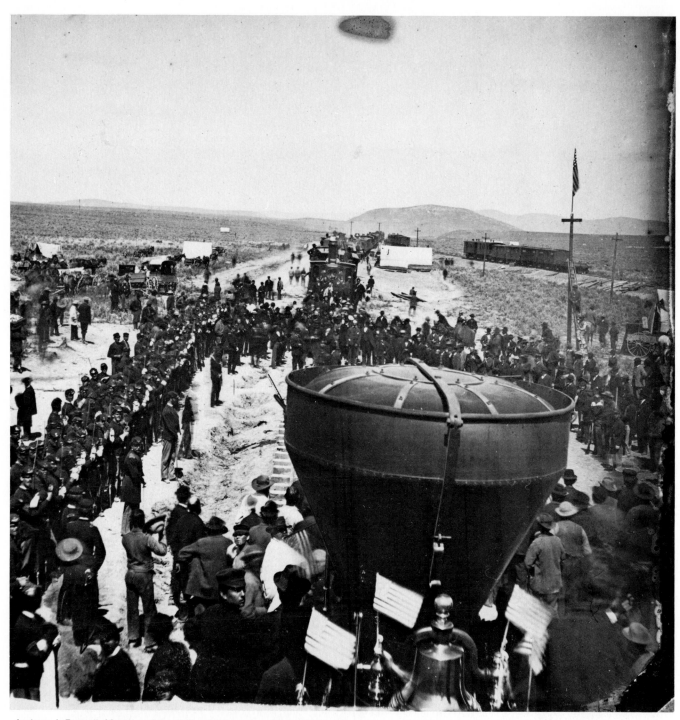

Andrew J. Russell: Meeting of the Rails at Promontory, Utah, 1869.
Russell Collection: The Oakland Museum.

Timothy O'Sullivan, who like Gardner had worked for Brady in wartime, went to California in 1867 with the Clarence King survey party. They headed eastward from the massive granite wall of the Sierra Nevada, across the great basin of Nevada and Idaho. In 1871, after a few months in Panama with a survey team seeking routes for a canal, O'Sullivan joined Lt. George M. Wheeler's expedition in the Southwest. The party crossed Death Valley and tried to explore the Grand Canyon of the Colorado by boat (O'Sullivan's tiny darkroom is seen here aboard one of the craft). Two years later, O'Sullivan again accompanied Wheeler through Arizona and New Mexico; this trip yielded him some of the most strikingly beautiful images of the American West.

T. H. O'Sullivan: Black Cañon of the Colorado, 1871. The Library of Congress.

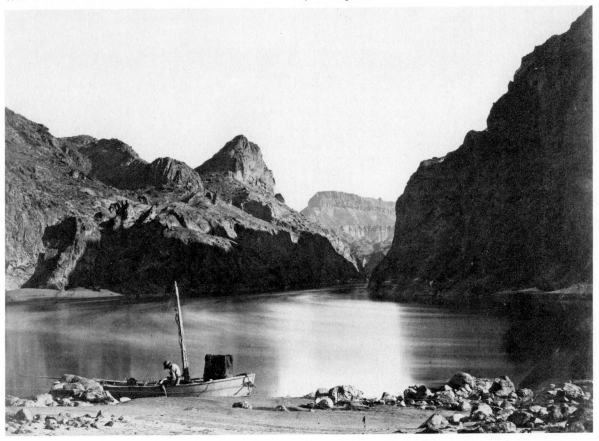

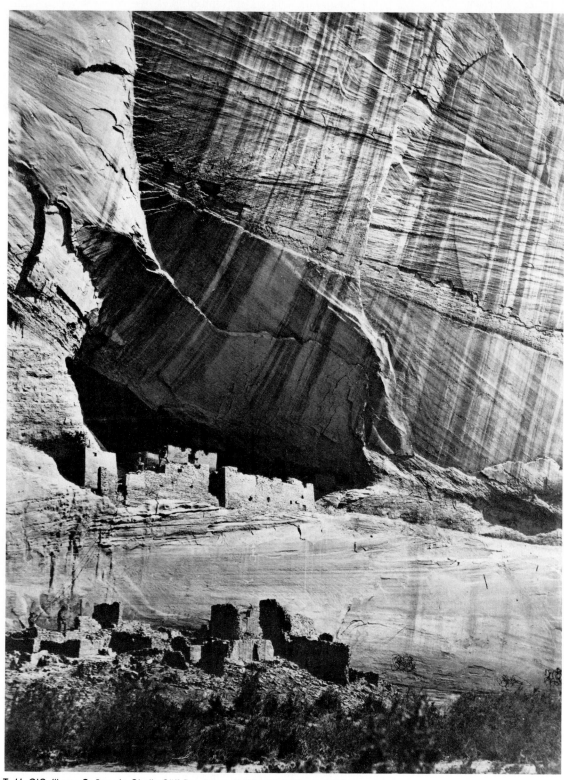

T. H. O'Sullivan: Cañon de Chelly Cliff Dwellings, 1873. The Library of Congress.

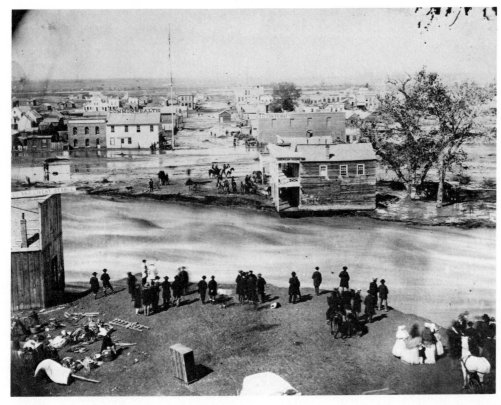

George D. Wakely: Cherry Creek
Flood, Denver, Colorado, 1864.
The Library of Congress.

There were dozens of other territorial and frontier photographers whose work survives. L. A. Huffman photographed from horseback in the Montana Territory, and George D. Wakely was among the early settlers of Denver. J. C. H. Grabill of Deadwood, Dakota Territory, made remarkable views of the Plains Indians. The Sioux encampment near Brule, reproduced here from Grabill's print, was probably photographed soon after the Battle of Wounded Knee. Territorial photographers like these were a special breed: they missed little that was significant in an expanding and rapidly developing area, and they were skilled specialists in their pioneer communities.

J. C. H. Grabill: Sioux
Encampment near Brule, Dakota
Territory, 1891. The Library
of Congress.

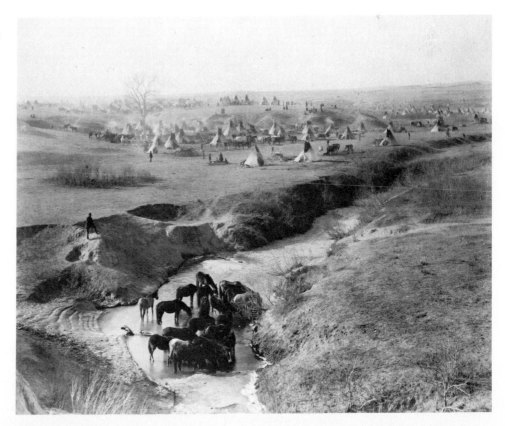

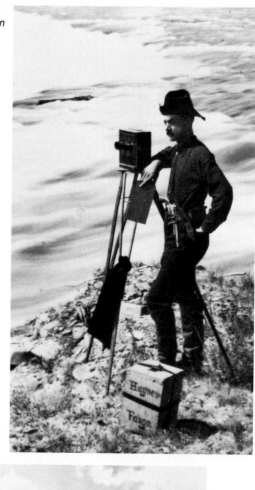

Of all the frontier cameramen, however, the best known was William Henry Jackson, who worked his way west from Omaha and was the official photographer to the Hayden Surveys from 1870 to 1879. The 1871 trek explored the natural wonders of the Yellowstone region, and Jackson's photographs, displayed to the Congress in Washington, were instrumental the next year in creating Yellowstone National Park. For several years after 1875, Jackson, headquartered in Denver, photographed the Rocky Mountain region. Occasionally he used a 51×61 cm (20×24 in.) wet plate camera, enduring the trials of working with such messy and cumbersome apparatus to produce a collection of superb views. After 1860, however, most western photographers, such as F. Jay Haynes, made paired stereoscopic negatives. These three-dimensional pictures were the height of fashion in more settled areas of the country and an important source of income for cameramen on the frontier.

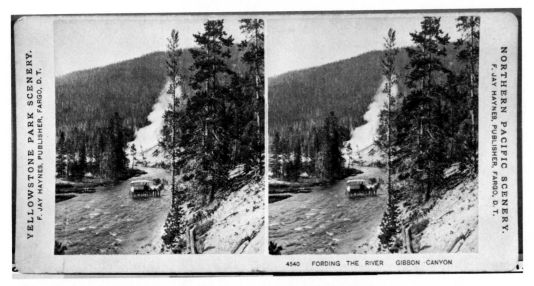

*F. Jay Haynes: Fording the River Gibbon Canyon, Yellowstone National Park,
c. 1880. Collection: Mrs. Bonnie Douglas, Jackson, California.*

THE GELATIN PERIOD

The detail and clarity of these century-old western photographs obscures how difficult it was to make collodion negatives in the field. Pictures by Timothy O'Sullivan (see also pages 29 and 30) give us a clue: everywhere the cameraman went, his darkroom had to go too, for collodion plates had to be sensitized, exposed, and developed on the spot. If the coating dried, it would lose its sensitivity.

In 1871 Dr. Richard Leach Maddox, an English physician and amateur photographer, solved this annoying problem when he replaced collodion with *gelatin*, an equally clear but *dry* vehicle for the silver salts. Seven years later, another Englishman,

Charles Bennett, discovered how to increase their sensitivity a hundredfold, and gelatin plates were enthusiastically received the world over.

Three advantages were immediately realized. First, photographers were freed from the hassle of wet collodion; the darkroom could be left behind as they journeyed into the field. Second, because dry plates did not require coating just before exposure or developing immediately thereafter, they could be made and sensitized at a central factory and shipped to the user. Thus an industry was born. Third, the tremendously higher sensitivity of gelatin emulsions made photography of action feasible.

*T. H. O'Sullivan:
Steamboat Springs, Nevada, 1868.
The Library of Congress.*

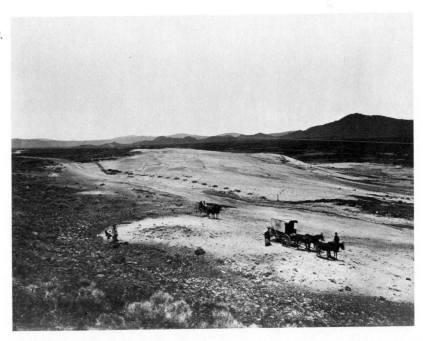

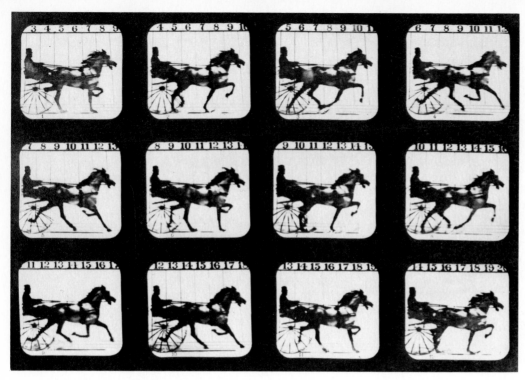

Eadweard Muybridge: Abe Edgington Trotting at 2:24 Gait, Palo Alto, California, 1878. Muybridge Collection, Stanford Museum.

THE PURSUIT OF ACTION

Photographers, of course, had been acutely aware that the long exposures required by the early processes failed to record moving objects. In this regard, collodion held an unfulfilled promise; but gelatin plates, with their much higher sensitivities that permitted shorter exposures, removed the barrier, and the pursuit of action began.

Today we recognize Eadweard Muybridge's famous and ingenious photographs of Leland Stanford's trotting horses done in 1878 as one of the first deliberate attempts to analyze movement with the camera. Muybridge was not the first, however, to have the idea: for five years previous, a French physiologist, Etienne Jules Marey, had conducted similar experiments, but without the aid of photography. Marey immediately recognized the value of Muybridge's work. So did the noted painter Thomas Eakins, of Philadelphia. Eakins's photographs, made

with a device of Marey's design, show his figures outdoors, in sunlight, against a plain, dark background. Successive exposures on the same film did not fully expose the background, and thereby permitted each momentary position of the subject to be adequately recorded, revealing a choreography of movement.

Many of Muybridge's images were possible only with equipment of his own design. The earliest cameras had no shutters; exposures were made by uncapping and recapping the lens. In 1869 Muybridge invented one of the first shutters, and by 1878 he had devised a means to make exposures as brief as 1/1000 second. His zoopraxiscope, a projection machine that resynthesized motion from still photographs, led directly to the development of the cinema, and he is therefore regarded by many as the father of motion pictures.

Thomas Eakins: The Pole Vaulter, c. 1884–85. Collection: Philadelphia Museum of Art.

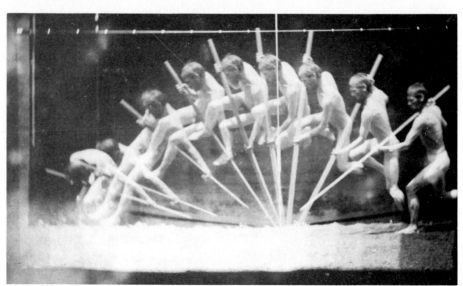

ROLLFILM:
Photography for Everyone

Although gelatin emulsions made instantaneous exposures possible, the fragile, heavy glass plates still made outdoor photography cumbersome. This time an American amateur photographer came up with a solution. George Eastman was a bank clerk in Rochester, New York. "At first I wanted to make photography simpler merely for my own convenience," he recalled, "but soon I thought of the possibilities of commercial production." In 1879, Eastman (who had switched from collodion to gelatin plates the year before) invented a machine to coat the plates, and within a year he was manufacturing them for photographers elsewhere. His ultimate goal, however, was to go one step farther: to replace the glass plate with an unbreakable film. Eastman's first effort, a flexible but opaque, paper-based product, was marketed in 1885. He realized, of course, that a transparent, flexible base for the gelatin emulsion was needed, and in 1886 he hired a young chemist, Henry Reichenbach, to find it.

In May of 1887, Rev. Hannibal Goodwin of Newark, New Jersey, applied for a patent on a flexible, transparent rollfilm made of nitrocellulose. More than two years elapsed before the patent was granted, and in the meantime Reichenbach had patented a similar product. Eastman began making the film, and in 1888, he produced a small, lightweight, rollfilm camera, the *Kodak*, to use it. The public response was immediate and overwhelming.

Noting the success of Eastman's new products, Goodwin's heirs (he died in 1900) and the owners of his patent sued Eastman, charging infringement. After 12 years of legal proceedings that eventually went against him, Eastman settled the matter. The inventor of the Kodak, however, could well afford

[Photographer unknown]: Bathers, c. 1888. Snapshot taken with No. 2 Kodak. Collection: The International Museum of Photography.

the decision. His combination of a small hand camera and dry rollfilm was simple to use and made photography practical for everyone. The tools and materials we use in photography today stem directly from that epochal achievement.

By the turn of the century, people everywhere were taking their own photographs. Legions of "button pushers" in Europe and America turned photography into a fad. Camera clubs were organized, and popular photographic magazines appeared. Others, however, worked independently.

Original Kodak Camera (roll-holder removed), 1888. Courtesy Eastman Kodak Company.

Eugène Atget: Street Musicians, Paris, c. 1910.
Author's collection.

An obscure Parisian, Eugène Atget, recorded with a rare poetic vision the people he knew best and the city he loved.

SOCIAL AWARENESS

While a few people like Atget were using the camera to record daily life, others were using the camera to change it. The failure of the Irish potato crop in the 1840s and a succession of European revolutions had nurtured a rising wave of immigration to America in the decades that followed. Photographs sent to the old country by newly settled Americans showed them to be well fed and relatively prosperous, and so the immigrants came.

Many of them settled in New York City, their port of entry, jobless, often destitute, forced to live like animals in unbelievably squalid housing where crime was rampant.

All this seemed unnecessary and intolerable to Jacob Riis, a police reporter for the New York evening *Sun*, who covered the tenements and their misery. Riis knew these ghettoes well since he had come as an immigrant himself in 1870. In a now classic illustrated book, *How the Other Half Lives*, published in 1890, he campaigned effectively for housing reform. His photographs, crudely reproduced by an early photomechanical process, were revealing and compassionate.

Lewis W. Hine, a photographer who was also trained as a sociologist, had a similar concern for human welfare. In 1908 he undertook a crusade

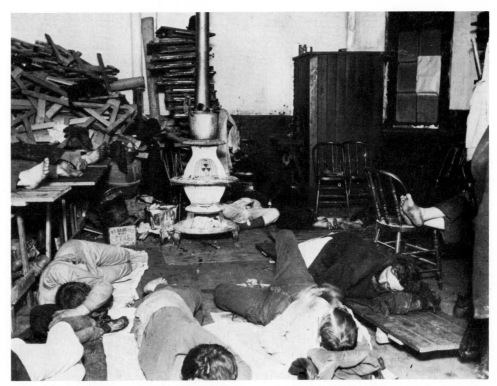

Jacob Riis: Men's Lodging Room in the West 47th Street Police Station, c. 1891.
Collection: Museum of the City of New York.

Lewis W. Hine: Boy Breakers, South Pittston, Pennsylvania, 1911.
The Library of Congress.

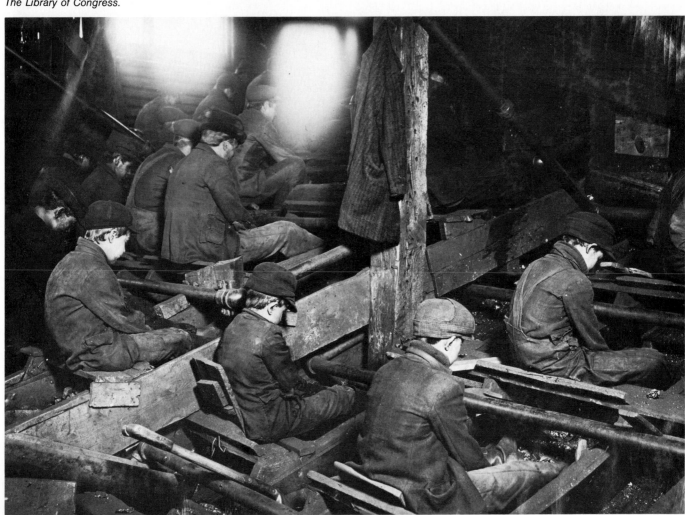

with his camera to expose the exploitation of children in American industry. Hine's determined effort aided the passage of child labor legislation. Later he photographed extensively for the American National Red Cross.

IS PHOTOGRAPHY ART?

The question was addressed in England as early as 1853, when scores of amateurs took up the camera. By imitating painters' compositions, they sought to gain acceptance from those in traditional art circles. Some, like Julia Margaret Cameron, the first notable woman photographer, posed her children and friends in romantic, Victorian tableaus. But the more avid practitioners, such as Oscar Rejlander and Henry Peach Robinson, labeled their efforts

Oscar Rejlander: The Two Ways of Life, 1857.
Collection of the Royal Photographic Society, London.

Henry Peach Robinson: Caroling, 1887. Lent to the Science Museum, London, by the Royal Photographic Society.

Peter Henry Emerson: Gathering Water Lillies, 1886. Collection: The International Museum of Photography.

"high art." Rejlander printed his tour-de-force, *The Two Ways of Life*, from more than thirty separate negatives. This famous allegorical composition contrasted sensual delight on the left with industry and charity on the right, and appears to have been based on Raphael's sixteenth century *School of Athens* in the Vatican. H. P. Robinson's later pictorial scene was equally synthetic but less ambitious; only three negatives were combined.

Robinson issued prints by subscription. The popularity of his work provoked another English amateur, Dr. Peter Henry Emerson, to protest such artifice and argue for a direct way of seeing and working. In *Naturalistic Photography*, published in 1889, Emerson suggested a reasoned approach to camera work that stressed characteristics unique to photography: a clarity and richness of tone that was possible only with a direct, unmanipulated image. Although his prints were rich and beautiful, Emerson was not a persuasive critic, and he soon abandoned the controversy to his opponents.

A decade later an American amateur, Alfred Stieglitz, took up the cause. Stieglitz was editor of the Camera Club of New York's prestigious quarterly journal, *Camera Notes*, in which he published the finest pictorial photography he could find from European as well as American exhibitions. American camera clubs, however, typically served their members as social rather than artistic vehicles, and their exhibitions or "salons", as they were called, displayed photographs full of painterly artifice. Through his influence in *Camera Notes*, Stieglitz sought to counter this trend. He also championed new techniques. Most American photographers used bulky plate cameras on tripods; Stieglitz showed them what could be done with a hand camera—and patience.

THE PHOTO SECESSION

Few club members, however, shared Stieglitz's zeal or his crusading attitude. Facing diminished support from within, he resigned as editor and with twelve other dedicated photographers, founded the Photo Secession in 1902 as an independent exhibiting group. Within a year he produced the first issue of a new and fiercely independent quarterly, *Camera Work*, with superb reproductions of photographs in each issue, and by 1905 he had opened in New York a gallery which championed the avant garde in photography and other arts.

The Photo Secession demonstrated the difference between photographs as records of fact and photographs as personal expression. They showed that criteria appropriate to the former could not suffice for the latter. Stieglitz's influence grew enormously, eventually getting photography recognized as a fine art in its own right, and on its own terms.

Other exhibitions followed. Sensing the battle won, Stieglitz increasingly promoted painting and sculpture in his gallery, and in 1915 some of the Secessionists withdrew to form the Pictorial Photographers of America, an exhibiting group with more traditional tastes. Their first president was Clarence H. White, a respected member of the Photo Secession and one of photography's foremost teachers. Stieglitz continued as before. He recognized independent photographers like Paul Strand, whose work was direct and intense. Another independent was Charles Sheeler, a painter who often used the camera as a note-taker for his clean-edged, highly detailed images. In the words of Edward Steichen, also a member of the Photo Secession, "Sheeler was objective before the rest of us were."

GROUP f/64

The integrity and intensity of work by photographers like these inspired still another controversy a

Charles Sheeler: *Bucks County Barn,* 1915. Collection: The International Museum of Photography.

generation later. In 1932 an informal association of fewer than ten people formed around Edward Weston in California. Calling themselves Group f/64, they made and exhibited expressive photographs in the direct approach, while arguing their convictions in the press with others who favored impressionistic and manipulated pictorial styles. Through the work of photographers like Ansel Adams, Imogen Cunningham, and Weston himself (page 122), the direct, clear style of Group f/64 was shown to be vital and basic. Although practiced everywhere, by the 1950s it had become strongly identified as a "West Coast School." More important, it provided an esthetic foundation for the best documentary and journalistic work of the next three decades, and today it remains a major expressive course.

Since 1960, numerous improvements in the technology of photography have given image makers the means to explore many new directions and to cover more familiar territory with unparalleled ease. Photographers also are freely adapting long-obsolete materials or processes to their needs, and their rest-

less search is already demanding some fundamental redefinition of the photographic language. The more significant developments in contemporary photography, and their importance to us as image makers, will be considered in other chapters of this book.

In recent years, students of photographic history have shown a good deal of interest in recreating many of the vintage processes that are part of our photographic heritage. The daguerreotype process employed mercury, which is quite hazardous to health, although few workers realized it at the time. And potassium cyanide, a deadly poison, was sometimes specified as a fixer for collodion plates. These chemicals should not be casually handled under any circumstances, and attempts to recreate processes requiring them are therefore not recommended. Many other nineteenth-century methods, however, may safely be repeated with modern materials, and William Crawford's book, *The Keepers of Light* (see bibliography, under Technical Manuals), gives all the details.

3
THE CAMERA

Every camera is essentially a lightproof box with a lens at one end and a light-sensitive film inside at the other. Its function has remained unchanged since the earliest days of photography: to gather light rays reflected from a scene or subject, and project them as an image onto a light-sensitive surface where a picture can eventually be made.

To do this, every camera, simple or complex, has these fundamental parts:

1. A **lens** to gather the light and form an image.
2. A **film** which is sensitive to light, and which records the image as a negative or positive.
3. A **viewing system** or **viewfinder** which shows you what the picture will include.
4. A **focusing mechanism** which adjusts the position of the lens to make its image sharp.
5. A **shutter** which determines when the exposure is made and which times the passage of light to the film.
6. An **aperture** or **diaphragm**, located within the lens, which controls the amount of light reaching the film.
7. A **film-advancing mechanism** which replaces exposed film with fresh after each picture is taken.
8. A **lightproof chamber** or **box** which protects the film from all light except that which comes through the lens during an exposure. It also contains all other parts listed above.

Although all cameras are similar, they also have important differences which stem from their basic design. There are four major types, usually distinguished by their viewing system or mechanism:

1. Viewfinder cameras.
2. Single-lens reflex cameras.
3. Twin-lens reflex cameras.
4. View cameras.

Recognizing these basic types is the key to understanding how they work.

VIEWFINDER CAMERAS

In a viewfinder camera, you see the subject through a small but brilliant window that frames it as you hold the camera up to your eye [3-1]. By looking *through* this window, you can use the camera as an extension of your eye, observing your subject continuously, and perhaps even interacting with it. Such viewing is direct and simple, and this design is therefore often found in inexpensive cameras intended for snapshots or casual picture making. But it is not limited to such cameras; many skilled photojournalists use cameras of this design too.

By itself, however, the viewfinder is only a framing device: regardless of how the camera's lens is set, the viewfinder image is always in focus. Better cameras of this design usually have a *rangefinder* built into the viewfinder as a focusing aid. Typically, the rangefinder is a pair of small mirrors or prisms placed about three inches apart within the camera [3-2]. One mirror is semi-transparent (you can see your subject through it) and does not move. The other mirror or prism pivots as the camera's lens is focused, resulting in two images of the subject which coincide to form one when the lens is focused on the same distance. Without a rangefinder, focusing must be done by estimating the distance to the subject and then

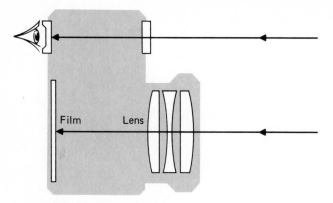

[3-1] *Viewfinder Camera Design.*

setting the lens accordingly. With a rangefinder, however, focusing is quick and accurate.

The viewfinder camera, however, has one serious flaw. Its viewfinder and its taking lens are in different places, and therefore do not frame exactly the same area of a subject. This problem, known as *par-*

allax error **[3-3]**, is most serious at close working distances—within 1.5 meters (about 5 ft.)—and it makes these cameras difficult to use for closeup work unless expensive accessories are added. Another minor problem with such cameras is that although they invite you to carefully observe your subject, they do not help you to visualize it *as a picture*: what you see in the viewfinder, of course, is the *object* rather than its image. This type of camera, then, may be better suited to a photoreporter than to an artist who may be more concerned with graphic qualities.

Today most viewfinder cameras are 16 mm pocket cameras like the Kodak Instamatic and Ektralite series; more than seven million of these are sold each year. But numerous fine 35 mm viewfinder cameras, like most of the legendary Leica family, are also widely used. All are compact, lightweight, and rapid working, and because they contain relatively few moving parts, they usually are quiet and reliable.

[3-2] *How a rangefinder works. When the camera lens is not focused on the subject distance, the image seen in the rangefinder is split in two and offset as shown. When the lens is focused on the subject, however, the two halves of the image are aligned.*

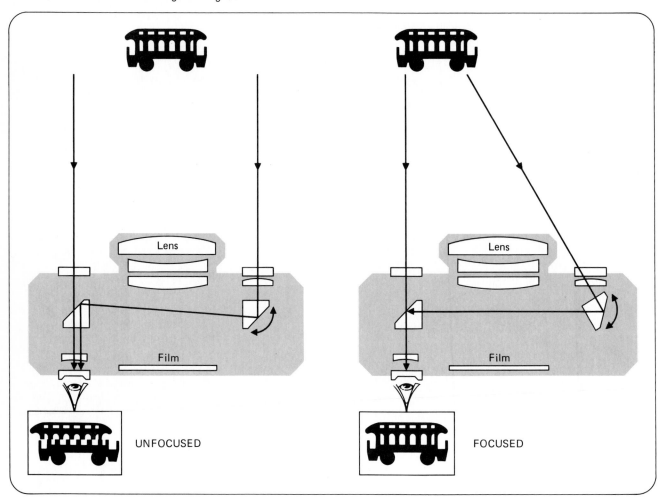

UNFOCUSED

FOCUSED

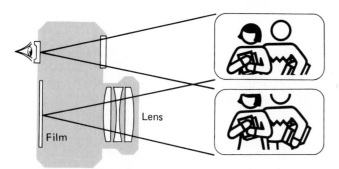

[3-3] *Parallax error. At close range, the viewfinder and the camera lens frame different parts of the subject.*

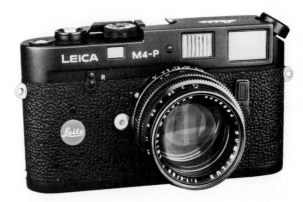

Leica M4-P Camera. Courtesy E. Leitz, Inc.

Kodak Ektralite 30 Camera. Courtesy Eastman Kodak Company.

SINGLE-LENS REFLEX (SLR) CAMERAS

Single-lens reflex cameras let you frame and focus your subject directly through the camera's lens [3-4], thereby eliminating the parallax problem of the viewfinder type. They also let you quickly adjust the focus and see how much of the framed area is sharp, another distinct advantage over the viewfinder or rangefinder design.

To combine viewing and taking functions in a single system, however, the SLR camera requires a movable mirror behind its lens. In its lowered position (A) the mirror directs light upward to a ground glass viewing screen, and then into a prism that corrects the inverted image left to right and turns it right-side up before passing it on to your eye. In its raised position (B), the mirror lets the light pass directly back to the film, but it momentarily blocks out the viewing system.

A pair of small, reversed prisms or a microprism grid often is incorporated in the viewing system to

[3-4] *Single-lens Reflex (SLR) Camera Design. Mirror is normally in position A for viewing but pivots rapidly to position B for exposure.*

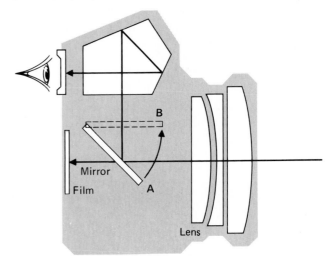

assist you in focusing. These devices work like a rangefinder, but they are more difficult to use in dim light or at close distances. In such situations, rangefinder focusing usually works better. In adequate light, however, the combined viewing and focusing system of the SLR works well with any kind of lens. Most of these cameras therefore have interchangeable lenses and other accessories (such as motorized winders and film advancers) which make them useful in a wide variety of picture-making situations. A single shutter located in the rear of the camera near the film plane serves all lenses. Most SLRs also contain an exposure metering device that senses the light through the camera's lens (page 00). Modern electronic technology has made such meters sensitive and accurate.

What are the disadvantages of an SLR camera? As a rule, SLRs are bulkier and heavier than viewfinder-rangefinder cameras, and they contain more moving parts. This makes them more expensive and more likely to need repairs. The mirror produces a loud, distracting "click" whenever a picture is taken, and the mirror's movement also makes these cameras difficult to hold still at slower shutter settings.

But because they are so adaptable and convenient, single-lens reflex cameras are immensely popular with serious photographers. Dozens of brands are available in the 35 mm format, and these are ideal for making color slides as well as prints of any kind. The Canon AE-1, Minolta XD 5, Nikon EM, Olympus OM-1, and Pentax ME Super are just a few of many popular examples.

SLR cameras are available in larger formats too. The Hasselblad and Rollei 66 make negatives 6×6 cm (2¼×2¼ in.) on 120-size rollfilm. The Mamiya RB67 and Pentax make 6×7 cm (2¼×2¾ in.) rectangular pictures. These cameras, and the better 35 mm varieties, are designed as modular systems: that is, they feature interchangeable lenses, viewing components, and other accessories. The Hasselblad and Rollei 66 have interchangeable film magazines, which permit you to switch films in mid-roll (from black-and-white to color, for example) with a single camera body and lens. Such cameras, of course, are bulkier, heavier, and more expensive than their

35 mm counterparts, but they are superbly crafted photographic tools capable of making superb quality images. The Bronica ETR and Mamiya 645, which make pictures 4.5×6 cm (1¾×2¼ in.), are less costly, but only the Bronica has interchangeable film magazines in this format.

Olympus OM-1 Camera.
Courtesy Olympus Camera Corporation.

Hasselblad 500 C/M Camera.
Courtesy Victor Hasselblad, Inc.

Canon AE-1 Camera. Courtesy Canon USA Inc.

Mamiya 645 Camera.
Courtesy Bell & Howell/Mamiya Co.

TWIN-LENS REFLEX (TLR) CAMERAS

Twin-lens reflex cameras have separate lenses for viewing and recording, mounted one above the other so that they focus together **[3-5]**. The image formed by the upper lens is reflected off an angled mirror to a ground glass viewing screen, where you can see it as a two-dimensional picture. Because this mirror does not pivot, as in the SLR, a second lens containing the shutter and aperture does the actual picture-taking below. Since these lenses are closely matched, what you see on the ground glass is more or less what you get on the film.

The differences between the two images, however, can sometimes be disconcerting. The ground glass image. although right-side up, is reversed from left to right. The twin-lens reflex, like the viewfinder camera, suffers from parallax error, particularly at close working distances, and on most TLR cameras you cannot interchange lenses as you can on a single-lens reflex.

Yet the advantages of a twin-lens reflex camera should not be overlooked. You get an image 6 cm (2¼ in.) square, large enough for thoughtful study before exposure and for superior printing later. These features make the TLR a good choice for portraits. It can also be used for general work at waist level or on the ground. In dim light, the hood surrounding the ground glass can be depressed to form an eye-level finder, and you can then hold the camera up to your eye the way you can the viewfinder type. Since most twin-lens reflex cameras are uncomplicated, they are usually rugged and dependable. Moreover, their straightforward, boxy shape makes them easy for many physically handicapped people to hold. And all this comes at a reasonable price.

The Rolleiflex is the most famous twin-lens reflex; the Rolleicord, Yashicamat, and Mamiyaflex (which does have interchangeable lenses) are closely patterned after it.

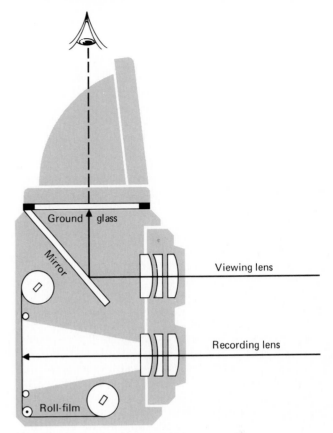

[3-5] *Twin-lens Reflex Camera Design.*

Ground glass

Mirror

Viewing lens

Recording lens

Roll-film

Yashicamat 124G Camera.
Courtesy Yashica, Inc.

View cameras are basically expandable chambers or boxes; a lens and shutter on the front and a ground glass viewing screen at the rear are connected by an accordion-like bellows [3-6]. In principle they are the simplest and oldest cameras of all, directly descended from the *camera obscura* of Renaissance times (page 12).

The modern view camera, however, is a precise photographic instrument. Larger and heavier than most other types (4×5 and 8×10 inches are standard picture sizes), it requires a tripod or stand for steady support. It is not designed to be hand-held as other cameras are.

With the view camera you must compose your image on the ground glass. Although this image typically will be larger than with reflex or viewfinder cameras, it will also be dimmer, reversed left to right, and upside down. To see the image you will usually need to place an opaque focusing cloth over the ground glass and your head. There are no built-in exposure meters, focusing aids, or other automatic features on this camera: you must work out these problems yourself each time you use it.

The view camera, however, has several incomparable advantages over other types. Foremost among these is control of the image: you can interchange lenses and freely adjust both the lens and film positions to eliminate distortion, to control perspective and focus, or to produce an image of a designated size. No other type of camera gives you such ability. This combination of precision and flexibility makes the view camera ideal for product photography, architectural work, or any other application where large, detailed images are required (see Chapter 15). View cameras use film in large, flat sheets that can produce brilliant photographs in black-and-white or color. Each sheet of film can be

Calumet 4 × 5 View Camera. Courtesy Calumet Photographic, Inc., Bensenville, Illinois.

independently processed, and because each film (in a special holder) replaces the ground glass just before exposure, you can record on the film precisely what you see.

Using a view camera is a slow, deliberate process, but if you are patient it can be amply rewarding. It is a superb tool for learning to see photographically: being able to study the ground glass with both eyes helps make you aware of the image *as a picture*. The view camera thus encourages discovery, builds discipline, and effectively separates the image of a photograph from its subject in the real world. Burke & James, Calumet, Cambo, and Sinar are among several brands available. View cameras and lenses are usually sold separately; together they can represent a sizeable investment.

[3-6] *View Camera Design.*

Lens

Ground glass or film holder

INSTANT PICTURE CAMERAS

Instant picture cameras made by Polaroid and Kodak include special rollers that initiate processing as the film is removed from the camera. These cameras use unique films in pack, roll, or sheet format. Polaroid cameras that use SX-70 film units and Kodak instant cameras have mirrors in their optical systems to orient the images so that the prints will not be laterally reversed. Polaroid SX-70 cameras have an unusual folding reflex viewing system which permits the camera to collapse into a thin unit when not in use [3-7].

Some instant picture cameras have fixed focus, some are focused manually, and certain Polaroid instant cameras have automatic focusing using reflected sound waves. All Polaroid cameras that use SX-70 film have automated exposure and processing systems powered by a battery built into each film pack. This battery also provides all electrical power needed by the camera, including power for a motor which ejects the print after exposure. At this writing, the Kodak instant picture cameras and the Polaroid SX-70 cameras make only color photographs, but numerous other Polaroid cameras can use either color or black-and-white films.

Other unusual aspects of these remarkable systems center on the film unit mechanisms and their processing cycles, and these are more fully discussed in the Appendix.

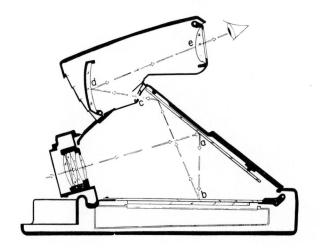

[3-7] *SX-70 Camera, open and closed.*
Courtesy Polaroid Corporation.

Polaroid SX-70 Land Camera. Courtesy Polaroid Corporation.

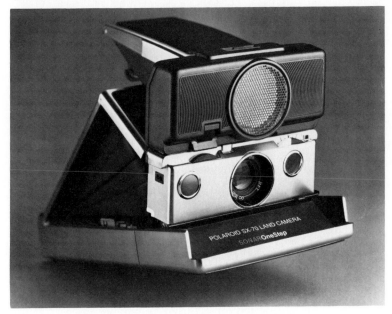

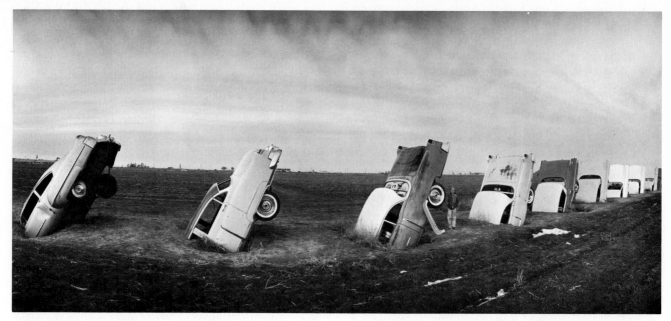

James Alinder: Ten Half-buried Cadillacs, Amarillo, Texas, 1976.

OTHER SPECIALIZED CAMERAS

Two other specialized types of cameras are used widely enough to warrant your awareness of them. The *Nikonos* is a 35 mm camera designed to be used underwater. Its lenses are adapted to the refractive characteristics of water and it contains few moving parts so that if it should accidentally flood, cleaning is relatively simple. These features make it popular with skin divers.

Another specialized type of camera makes extreme wide-angle photographs such as Jim Alinder's example here. The Brooks *Veriwide* and Panon *Widelux* are capable of sweeping, panoramic views.

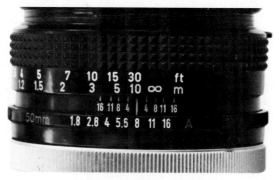

Focusing scale on lens mount.

THE CAMERA'S MAJOR CONTROLS

Each major type of camera described on the preceding pages is distinguished from other types by its *viewing system*, which shows you what the picture will include. Another important control is the *focusing mechanism*, which measures the distance from the camera to the subject and shows when the lens is sharply focused on it. You focus adjustable cameras by ground glass, by rangefinder, or by setting a scale on the lens mount or focusing knob (see illustrations).

Two more controls on the camera directly affect how your picture will look and also are important to properly expose the film. These are the *shutter* and the *aperture* or *diaphragm*. We will discuss each in detail.

Focusing knob on camera.

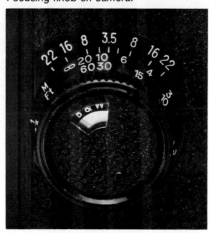

THE SHUTTER

The shutter is a device you open and close to determine the length of time that light will reach the film. Early cameras did not have shutters. The photographer uncapped the lens and recapped it minutes or seconds later when he thought sufficient light had reached his plate. But as plates and films became more sensitive, the time required for exposure rapidly decreased. The hand-held lens cap simply wasn't quick enough, so a mechanical invention—the shutter—replaced it.

Most shutters are located either within the camera's lens (*leaf shutter*) or in the camera's body just in front of the film (*focal-plane shutter*).

Leaf Shutter

A leaf shutter consists of a series of metal blades or leaves, arranged inside the lens like the petals of a flower so that they overlap and prevent light from entering the camera. A large spring provides the power, and it must be set by a cocking lever or by the film-advancing mechanism. Pressing the release button then opens the shutter leaves to start exposing the film. After a preset length of time (usually from 1 second to 1/500 second), the leaves quickly close, terminating the exposure. Leaf shutters are relatively quiet and can be synchronized with flash units at any time setting (see page 220). In larger cameras they tend to have fewer time settings than in smaller ones.

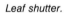

Leaf shutter.

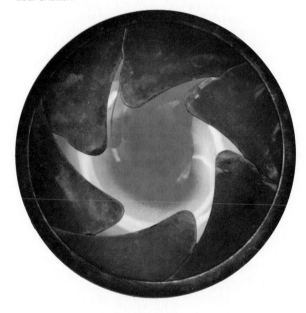

Focal-Plane Shutter

A focal-plane shutter consists of two opaque, flexible curtains in the rear of the camera body that overlap to keep light from reaching the film. These

Focal-plane shutter.

curtains are connected in such a way that when you push the release, the first curtain moves aside and uncovers the film, permitting light to reach it. After a preset time elapses, the second curtain follows the first, covering the film and terminating the exposure. At 1/30 second or longer, all of the picture is exposed at once. At shorter times, however, the second curtain follows more closely after the first; this creates a slit between them which exposes only part of the film at any given moment as it moves across it. The sequence is illustrated in **[3-8]**.

A focal plane shutter typically has more time settings (1/1000 to 1 second or longer) than a leaf shutter does. Its location just in front of the film does away with the need and cost of separate shutters in each interchangeable lens. Most SLR cameras therefore use this type. Focal-plane shutters, however, have a limitation with flash: because only part of the film might be exposed at any given instant, electronic flash can be synchronized with these shutters only at longer time settings when the entire frame is uncovered (page 220). But focal-plane shutters are mechanically simpler than leaf shutters, have fewer moving parts, and are therefore generally more reliable. Most move as described above, from side to side. A few, however, move from top to bottom of the frame.

The Shutter Dial

The shutter dial controls the length of time that the shutter stays open and thereby determines *how long* light will reach the film. The numbers on the dial represent *fractions of one second*, but only the denominator of the fraction is shown. A typical shutter dial can be set for these times: 1, 2, 4, 8, 15, 30, 60, 125, 250, 500, 1000. Remember that these numbers represent fractions: 1 is one second, 2 is ½ second, 4 is ¼ second, 500 is 1/500 second, and so on.* *Each setting therefore provides half or double the exposure time of adjacent settings. Stated another way, if you move the shutter dial from 125

*Some older cameras may have a slightly different sequence: 1, 2, 5, 10, 25, 50, 100, 200, 400. Larger format cameras may not have all these settings.

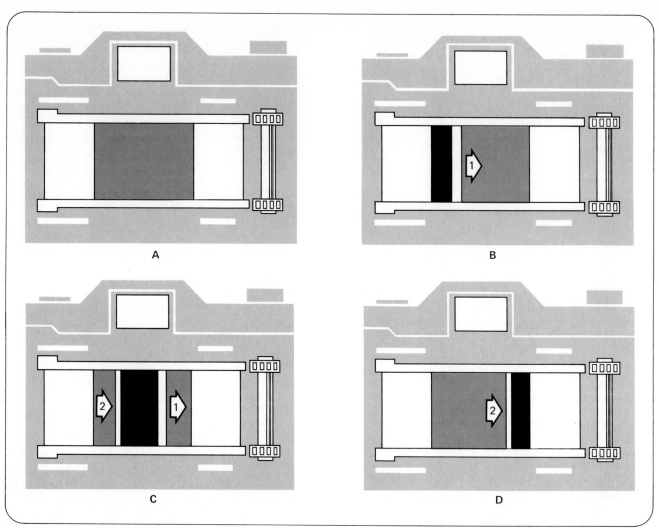

[3-8] *How a focal-plane shutter works. A pair of flexible, opaque curtains is positioned inside the camera just in front of the film. One of these curtains normally covers the entire film opening (A). Exposure begins when the first curtain opens, uncovering part of the film (B). As the first curtain exposes more of the film area, the second curtain is released to begin covering the opening (C). Exposure time is adjusted by changing the gap between the two curtains. Exposure ends when all of the film area is recovered by the second curtain (D).*

to 250 you cut the time in half. On the other hand, if you change from 125 to 60, you double the exposure, and changing from 60 to 15 increases the exposure four times.

The shutter dial should be set squarely on the desired number, and the dial will often be notched slightly to make this easy. On most cameras, setting it between two numbers will not give intermediate exposure times.

The shutter scale or dial may also include B and T settings. When set at B, the shutter will remain open as long as the release button is held down.* Thus the B setting is useful for exposures lasting longer than one second. The T setting (*time*) is similar, but it requires two actions of the shutter release—one to open the shutter and another to close it.

Some 35 mm SLR cameras and Pocket Instamatics have electronic shutter controls in addition to or in place of manually set ones. When you press the release button of such a shutter, the blades open and a light-sensing device built into the camera soaks up enough light for proper exposure. Then this device automatically closes the shutter blades, terminating the exposure.

Shutter dial.

*The initial B stands for *bulb* and is a throwback to the days when nearly all camera shutters were operated by squeezing a rubber bulb at the end of a long air tube. The name survives to designate a similar action on modern cameras.

THE SHUTTER AND MOVEMENT

Whenever an object moves in front of your camera, its image formed on the film inside will also move. If the object moves very slowly and the shutter opens and closes quickly, the image on the film will be relatively clear. But if the object moves rapidly and the shutter is open for a long time while the camera remains still, the image will be blurred. By selecting your shutter time with this in mind, you can use the camera to capture motion by "freezing" the action, or to reveal a different aspect of that movement by producing an image that is simply not visible to the unaided eye.

If your subject moves at a moderate speed, for ex-

ample, and you set your shutter at 1/500 second, the image will be rather clear (photo A). The same object photographed at 1/60 second will be somewhat blurred (photo B). At 1/8 second with a still camera, the moving object will be noticeably streaked (photo C). However, if you move your camera to follow the moving object, tracking it, the image will remain relatively clear against a blurring background (photo D).

The speed of an object and the shutter setting are not the only factors that affect your result when you photograph motion. What matters most is how the image moves on the film. If an object moves from side to side (or top to bottom) through the picture frame, its image will rapidly change position (photo E). But if the object moves toward you, even at the

Objects photographed in motion. **A:** *1/500 sec.* **B:** *1/60 sec.* **C:** *⅛ sec.* **D:** *Camera panned at ¹/₁₅ sec.*
E: *Motion at right angle to camera.* **F:** *Motion toward camera.* **G:** *Motion at 45° angle to camera.*

A

B

C

D

E

F

G

same speed, its image will not move as rapidly on the film. Hence motion toward (or away from) the camera can be photographed at moderate time settings and still remain clear (photo F). If the movement is at about a 45 degree angle, the effect will be between the other two (photo G). Varied impressions of movement can be photographed with these techniques. See pages 7 and 142 for additional examples.

Whether your object is moving or not, the shutter setting affects exposure. While it is open, the amount of light that reaches the film is cumulative: the longer the shutter stays open, the more light will reach it. In a real sense, then, the shutter controls light as it controls time.

THE APERTURE

The aperture (also known as the *diaphragm, stop,* or *f/ stop*) is an opening formed by a series of pivoting metal leaves in or near the lens. As these leaves pivot, they change the size of the opening; thus they are a remarkable mechanical imitation of the iris diaphragm in the human eye. The camera aperture has the same purpose: by opening—getting larger—it admits more light to the camera. By closing—getting smaller—it admits less. The aperture leaves are mechanically independent from the shutter blades in the lens, although they may be similar in appearance and located close to each other.

In early cameras, apertures were made by inserting small metal plates called *stops* into the lens barrel. Each plate had a hole of a different size cut into it; changing plates thus changed the amount of light passing through. Waterhouse stops, as they were known (after their inventor) are now obsolete, but lens apertures are still called "stops," and we say a lens is "stopped down" when its aperture is very small.

Aperture settings are designated by a series of numbered openings or f/ stops. The f/ numbers usually found on modern lenses are: f/1.4, 2, 2.8, 4, 5.6, 8, 11, 16, 22, 32, 45, 64. These numbers express the diameter of the lens opening as a fraction of its focal length (see page 202).

Not all stops appear on all lenses; most contain only part of the sequence. The largest opening is f/1.4 and thus this setting admits the most light; each

succeeding number in the series designates an opening half as large, admitting half as much light. Note that *larger numbers designate smaller openings;* as you move the aperture setting to each larger number, you cut the light passing through the lens in half. As you move the same control to each smaller number, you double the light passing through **[3-9]**. You can also set the aperture in between two numbered stops for an intermediate effect, but the important principle here is that *each f/ number in the series admits half or double the light of each adjacent one.* All aperture settings are similarly related.

The maximum aperture (smallest f/ number) of any lens depends on its design, and occasionally that maximum falls in between the more familiar settings. Hence the largest aperture on many lenses is f/3.5; apertures of f/4.5, 4.7, or 6.3 may be found occasionally on older lenses.

The maximum aperture is also used to designate the "speed" of a lens; this and its focal length are usually marked on the lens mount. Thus a lens designated f = 1:2.8/80 mm is described as an 80 millimeter, f/2.8 lens. Note however, that *lens "speed"* is different from *shutter speed:* the speed of a shutter refers to its time setting, whereas the speed of a lens refers to its maximum aperture, which admits the most light.

[3-9] *Relation between f/ numbers and aperture openings. Note that an f/4 setting (A) admits four times as much light to the camera as an f/8 setting (B).*

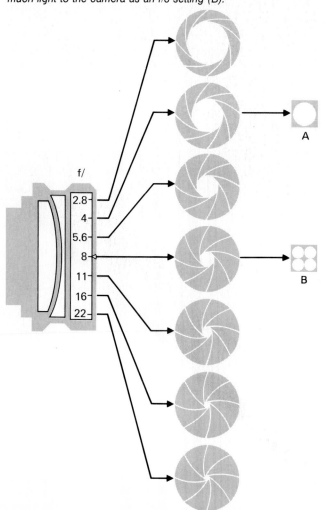

Aperture.

THE APERTURE AND SHARPNESS

Although the primary function of the aperture is to control light, it also plays a major role in extending or limiting the area of sharp focus in the picture. The range of object distances from which this sharply focused picture is formed is known as the *depth of field*. In the illustration below, for example, all of the objects are in sharp focus, because the lens was set at a small aperture, f/16. Small apertures tend to bring a deeper area into focus simultaneously; large apertures, on the other hand, tend to shrink the sharp area to a narrow band, leaving the rest of the framed view out of focus. The bottom picture was made at f/2.8, and the sharp area is clearly limited.

You can see this effect directly in the viewfinder of an SLR camera by pressing a preview button or lever located near the lens or prism housing. This permits the aperture to close momentarily to the preset opening, where it will show you a dimmed but sharpened image. When you release the button, the aperture will return to its fully opened position for brighter viewing. In a view camera, the depth of field can be seen directly on the ground glass. In viewfinder and twin-lens reflex cameras, however, it must be judged on a depth of field scale adjacent to the focusing knob or ring (see illustrations); it cannot be seen directly in these cameras since their viewing systems do not contain adjustable apertures.

View photographed at f/16.

Aperture set at f/16.

View photographed at f/2.8.

Aperture set at f/2.8.

HOW THE SHUTTER AND APERTURE RELATE

The shutter setting and the aperture work together to control the amount of light reaching the film. Consider for a moment how you fill a glass with water from a faucet: if you open the faucet fully, the glass fills quickly. Close the faucet so that the water only trickles out, and the glass takes much longer to fill. The shutter and aperture relate in the same way. In typical situations, a large amount of light (large aperture) needs only a short exposure time (shutter setting). Lesser amounts of light require longer times to produce the same effect. Thus, f/4 at 1/500 sec., f/5.6 at 1/250 sec., and f/8 at 1/125 sec. all deliver the same amount of light to the film. In this sequence, for example, as the aperture *decreases in size*, the shutter setting *increases in time* by the same factor. The settings f/11 at 1/60 sec. and f/16 at 1/30 sec. are similarly related. We can therefore say that each of these combinations is *equivalent* to the others because they all deliver the same total amount of light energy to the film.

Shutter and aperture combinations, then, are your basic exposure controls. In the next chapter we will consider several different ways which modern cameras provide to help you determine correct shutter and aperture settings.

HOLDING YOUR CAMERA STILL

As we saw on page 53, different shutter settings affect how the camera records movement in the subject and how you can interpret that movement in the pictures you make. Shutter settings also can minimize or amplify any undesired movement of the camera during exposure. At 1/500 or 1/1000 sec., for example, a slight shaking or movement of the camera will probably go unnoticed in the resulting image. But if your shutter is set for longer times such as 1/60 or 1/30 sec., any movement of the camera will show as blurring in the picture.

The amount of blurring or lack of sharpness in the picture will also depend on how small your negative is and how much you enlarge it in printing. The more you enlarge, the more noticeable any unsharpness will be.

Careful camera holding will minimize most of these problems. The accompanying illustrations suggest several ways to use your body to steady your camera. Bracing your body against any convenient tree, doorway, fence, or railing will also help.

The best way to prevent unwanted camera movement is to secure it on a steady tripod, as shown on page 57. A tripod, of course, limits your camera's

How to use your body to steady your camera.

mobility, but this small sacrifice usually is worth the dividend it pays in sharper, clearer pictures. Most tripods have an adjustable center column that will permit you to raise or lower the camera, and a pan head that will allow you to pivot the camera from side to side or up and down. The center post can often be removed and replaced upside down, so that you can secure the camera close to the ground. Whichever way you use the center column, try not to extend it too far from its junction with the tripod legs. The entire rig will be more steady that way.

A cable release is inexpensive and useful to absorb the small shock or bump that can occur when you release the shutter. Most cable releases screw into the release button itself, but a few cameras require an adapter that covers the button instead.

Camera on tripod.

WHICH CAMERA FOR YOU?

There is no such thing as a universal camera, so the choice of one for your own use ultimately becomes a personal one: which camera is best for you?

As we have explained in this chapter, all cameras are variations of a few fundamental designs. Each type has its advantages and its drawbacks. The most popular cameras by far are the simplest to use: the Instamatic or pocket cameras of the "aim and shoot" variety that take film in quick-loading,

sealed cartridges, and that require few decisions from the user other than framing and snapping. If you expect to take pictures casually and infrequently, such a camera may be all you need.

But the limitations of such simple cameras quickly become obvious. Other types of cameras generally are more efficient to use and are much more adaptable to individual needs and interests, and three of them have formed a classic trinity among generations of serious photographers everywhere. These are the 35 mm single-lens reflex, the 6 cm square twin-lens reflex, and the 4 × 5 in. view camera. More recently, the 6 cm square single-lens reflex has nudged into this popular group.

When trying to decide which camera is best for you, several questions ought to be thoughtfully considered. The first has to do with performance: what do you expect the camera to do for you? Consider your needs in light of the advantages and limitations of the four basic types discussed earlier in this chapter. If color slides are your primary concern, for example, a 35 mm SLR would probably be a better choice than any other type. If precision, sharpness, and maximum image quality are more important, the larger format SLRs and view cameras should be examined. In any case, a few important questions need to be answered by actual trial. How does the camera feel in your hands? If you wear glasses, can you see the entire viewfinder with them on, and can you read the numbers on the camera's controls without removing them? Once a basic type is chosen, decide which features and conveniences you need and which you can do without.

Then the final question: how much money can you afford to invest in your choice? This answer may determine whether you should look for a new camera or a used one. Cameras, lenses, and other major accessories depreciate in value much like automobiles, and a used camera purchased from a reputable dealer can often be an outstanding value for a beginning photographer. Check the camera thoroughly for damage and wear (see pages 58–59), and be sure you have the option to return the camera if it proves unsatisfactory.

ADDITIONAL TIPS

Clear pictures require a clean lens, and cleaning must be done with care to avoid scratching the surfaces. First, remove any dust by lightly whisking the lens with a sable brush or a wad of lens cleaning tissue. Fingerprints and grease should next be removed with a sheet of lens cleaning tissue moistened with a drop or two of lens cleaning solution (these inexpensive materials are available at any photo shop). Wipe the lens with a gentle, circular motion, and let the fluid dissolve the grease as it slowly evaporates. Clean only the front and rear surfaces. Don't try to take the lens apart; that's a job for a trained technician with proper tools.

Before loading your camera with film, check it for dust inside the chamber or bellows. Dust that settles on the film in your camera will produce tiny black specks in your prints or slides. You can remove this dust with a little dry compressed air, or with an inexpensive squeeze-blower brush.

Always load your camera in subdued light, indoors or in the shade; don't load it in bright sunlight. Before closing the camera back, be sure that the leader of 35 mm film is correctly engaged in the takeup spool, or that rollfilm is properly positioned and tensioned (some rollfilm cameras have starting marks for this).

In very cold weather, cameras, like eyeglasses, steam up when taken from the cold into a warm room. Allow time for this condensation, which also forms inside the camera, to evaporate before you use it. Finally, avoid storing your camera in hot places such as glove compartments or window ledges of automobiles. The best places are cool, dry, dust-free, and dark.

HOW TO CHECK A USED CAMERA

Any used camera should be thoroughly checked by the buyer before final purchase arrangements are made. Many dealers will permit such a customer test within a few days, with full credit or refund if the camera proves unsatisfactory but is returned in the same condition that it was obtained. The main items that you should examine and test are:

1 / **Camera body**—*check for impact damage and light leaks, particularly around the back and bottom.*

2 / **Shutter**—*check for proper mechanical operation and relative accuracy of the settings.*

3 / **Lens**—*test for image sharpness.*

4 / **Rangefinder** (*if any*)—*check for accuracy.*

While it is desirable to check internal flash synchronizers and exposure meters, these devices vary according to the type of camera and are best examined by a dealer or technician who knows the equipment and has the proper testing aids. Most dealers can perform or refer you to this service.

TESTING PROCEDURE

The following procedure will enable you to test a camera for the four items listed above with a minimum of time, trouble, and expense. Although especially appropriate to used cameras, the procedure obviously can be applied to new ones as well. In addition to the camera, you will need a tripod, cable release, slow film (ISO or ASA 32–50), an 18% gray card, a good 8X magnifier, a black crayon or marking pen, and a couple of sheets of newspaper. Proceed as follows:

1 / *Examine the camera body for dents or scrapes that might impair the movement of any adjustable part. Cock and release the shutter on each of its settings; watch particularly for failure to close on longer time settings such as ½ and 1 second. The release on the camera body should work smoothly without binding. Clean the lens and film chamber, and load the camera with Kodak Panatomic-X, Ilford Pan-F, Kodachrome 25, or a similar slow film.*

2 / *Secure the camera on a rigid tripod or stand, and use a cable release for all exposures.*

3 / *In **overcast daylight** or **open shade,** tack or tape a double-paged sheet of classified ads from a newspaper to a wall or other flat surface, and frame this in the camera so that it fills the finder and so that the camera back and the newspaper are parallel. The camera's lens should be pointed squarely at the center of the newspaper target. Focus carefully on the sheet.*

4 / *Expose frame No. 1 at the **maximum** aperture. Use a meter for correct exposure, or carefully apply the Daylight Exposure Guide on page 73.*

5 / *Expose frame No. 2 at the **critical** aperture, two stops smaller than the maximum. Again, use correct exposure.*

6 / *Expose frame No. 3 at the **smallest** marked aperture. Correct the exposure for this reduced amount of light.*

7 / *Replace the newspaper with an 18% gray card. Move the camera in close, filling the frame with the gray tone.*

*The image need not be in focus; the lens in fact, should be **focused on infinity**. Expose frames No. 4 through No. 12 at shutter times of ¼, ⅛, 1/15, 1/30, 1/60, 1/125, 1/250, 1/500, and 1/1000 second respectively, **adjusting the aperture to give each frame a correct equivalent exposure**. This should be done under the light conditions indicated; avoid early or late daylight hours as the light intensity rapidly changes at those times.*

8 / *If the camera has a rangefinder, perform the following test on an additional frame or on a separate roll of film if necessary. Take a newspaper page with a bold headline or advertising banner that runs all the way across the page (rather than over a column or two). Mark a heavy black line with the crayon or pen vertically through the headline near its center. Tack it up as before, but this time place the camera tripod so that it is about 3 or 4 feet from the page, with the lens axis at about a 45° angle to it. Focus **carefully** on the crayon mark with the rangefinder, and expose a frame with meter and cable release as before, **using the maximum aperture**. For greater accuracy, repeat this test using a picket fence (mark one central picket) about 25 feet away, in fading daylight. Again, the maximum aperture **must** be used.*

9 / *Develop the exposed black-and-white film as recommended by the manufacturer or by your usual procedure for this material. If you used Kodachrome 25 film, have it processed by your local photo dealer.*

Examine the dry negatives or slides by transmitted light (against a window or on a light table) with an 8X magnifier. Be sure that the film is held flat.

Irregular black patchy areas or streaks at random locations on the film are evidence of light leaks in the camera body. These marks along the top of the film strip, for example, indicate leaks along the bottom of the camera.

Frame No. 1 should be examined carefully for sharpness. The central area should be acceptably sharp; corners, however, may be less so. Some older lenses produce an image that is sharpest in a slightly concave, saucer-shaped plane, rather than a flat plane like the film is. If the corners are sharp but the center of the frame is fuzzy, the lens focusing scale or rangefinder should be checked for mechanical error.

Frame No. 2 should be acceptably sharp all over the frame. If this image is unsharp in places, reject the lens.

Frame No. 3 should be slightly less sharp than No. 2 overall, but better than No. 1. Corners should be sharp.

Frames No. 4 through No. 12 should have the same apparent grayness in the negatives. Serious unevenness usually can be spotted visually, but a densitometer, if available, will provide a more precise evaluation.* It is not essential that each shutter setting give the actual indicated time; what **is** important is that each be correct **relative** to the others. Actual times, if desired, can be ascertained by a repair technician with appropriate equipment, but most camera shops are not equipped to provide this service.

If the rangefinder test was made, examine that frame with the magnifier. If the letter with the crayon mark through it is the sharpest point in the headline, the rangefinder is correctly adjusted. If the crayon mark is not sharp but another point on the headline is, the rangefinder is out of adjustment and should be corrected by a competent service technician.

In 35 mm cameras with removable takeup spools (such as the Leica III Series), make sure the film actually is being transported when the advance lever or knob is operated. To do this, load the camera in the usual manner and position the film for the first exposure. Then turn the **rewind** knob or crank gently to take up the slack film in the cartridge. Thereafter, when the film is advanced, the rewind control should move also. If it does not, the film is not advancing and the takeup spool may be slipping on its core. The effect is noticed, as a rule, only with 36-exposure loads. The spool may require shimming to correct this fault and insure proper transport.

One final note: insist on **written** estimates before ordering extensive repairs to older used cameras. Skilled labor, of course, is the major factor in the cost of such work, and the charge may be too great considering the value of the camera. **You** be the judge, **before** the work is done.

*Densitometer readings from all adjacent frames (except $\frac{1}{8}$ and $\frac{1}{15}$ second) should be the same; a variance of .1 in the reading indicates a 33% error in shutter time.

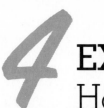 # EXPOSURE
How Light Affects Film

Larry Gregory: Sunset, Malta, Illinois, 1975.

Photography, as we noted earlier, depends on light. Its name, in fact, is derived from two Greek terms meaning "to write with light." In the camera, light "writes" by striking the sensitive film. Relating the brightness of this light to the sensitivity of the film is a matter of exposure.

In the early days of photography, calculating an exposure was relatively simple. Exposure times were long and varied because photographers coated their own plates, and these plates were not very sensitive. Most photographs were therefore made only in bright daylight, by trial and error, until the photographer gained enough experience to be confident in his work. Indeed, it was considered a mark of superior craftsmanship and ability if good pictures could be made, as many studios claimed on the backs of their prints, "in cloudy and rainy weather."

Today, with modern films that are hundreds of times more sensitive than the plates of a century ago, we can make photographs in all kinds of light. What we need is a more precise way to measure that light, to designate the sensitivity of our film, and to relate them correctly.

Four variables are involved in every photographic exposure:

1. The intensity of light falling on the subject, or the luminance of that subject's reflection to the camera.
2. The sensitivity of the film to this light.
3. The length of time that we expose the film. This is controlled by the camera's shutter.
4. The amount of light we admit. This is controlled by the aperture.

Let's consider each of these factors and see how they work together.

THE NATURE OF LIGHT

Like heat, sound, and electricity, light is also a form of energy. It moves outward in all directions from its source much like ripples or waves on a pond, but in a three-dimensional sense—that is, in all directions rather than a single plane. In this respect, light behaves very much like television signals, radio waves, X-rays, and other forms of radiant energy that are part of the *electromagnetic spectrum*. Our concept of this spectrum, first described by the Scottish physicist, James Clerk-Maxwell, is based on our ability to detect these waves and distinguish one kind of wave from another. Radios and TV sets are two familiar kinds of detectors. Our eyes, of course, are a third, and the radiant energy that they can detect is what we call *light*.

If we represent a light wave as an oscillating line, the distance from one crest to the next is called its *wavelength* [4-1]. By this measure we can sense how vast the electromagnetic spectrum appears to be [4-2]. At one extreme are certain radio waves whose crests are several miles apart. X-rays, on the other hand, may vibrate a billion times in the space of a single millimeter.*

Light waves occupy a very small part of the spectrum—between about 400 and 700 nanometers in wavelength. Beyond that section in the direction of longer wavelengths lie infrared or heat rays, microwaves, TV, and radio signals. Radiation with

*To measure such short wavelengths, *nanometers* are more convenient units. A nanometer (nm) is one millionth of a millimeter (.000001 mm), or 10^{-9} meters.

wavelengths shorter than light includes ultraviolet rays (that cause sunburn), X-rays, and radiation associated with nuclear reactions.

Our eyes see different wavelengths within the narrow band of light as different *colors*. The shortest wavelengths we call violet, the longest ones red; all other colors of light lie between these two on the spectrum. When all wavelengths of light are mixed together in sufficient intensity, we see the result as

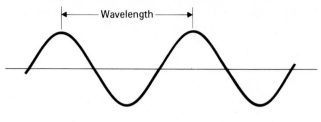

[**4-1**] *Wave motion.*

[**4-2**] *The electromagnetic spectrum.*

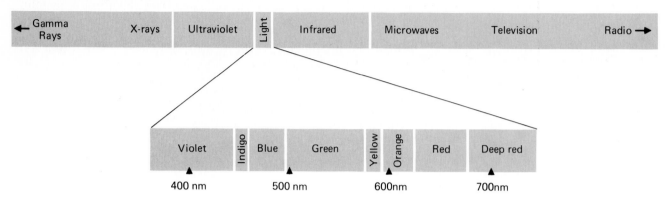

white light. At lesser intensities the same mixture appears *gray*. When the intensity is too low for the eye to detect, or when most of the light falling on a surface is absorbed and almost none reflected, the result appears *black* to us. When light is not present, of course, we see nothing.

Photography as most of us practice it makes use of five basic physical properties of light [**4-3**]:

1. Light *radiates* from a luminous point-source *in straight lines*, spreading outward in all directions (A).
2. Light can be *reflected*. A matte (dull) white surface reflects most wavelengths striking it, but scatters those reflections in many directions (B). A mirror reflects light in the same way but does not scatter it.
3. Light falling on a black surface will be *absorbed*. Because almost none is reflected to our eye, that surface appears black (C).
4. When light passes from one material such as air, to another such as a triangular piece of glass (a prism), its waves are bent (D). This bending is called *refraction*, and it is the basic principle on which lenses work.
5. Light can be *filtered*. In any mixture of two or more wavelengths such as white light, certain waves can be absorbed by a substance while others are allowed to pass freely through it (E). This will be further explained in Chapter 13.

The wave theory can explain these actions of light and can demonstrate most of its properties. But when a ray of light, traveling as a wave, strikes the film in our camera, it causes a change in the light-sensitive coating that cannot be satisfactorily explained as a wave effect. However, if we think of light as a stream of particles rather than a wave, its

action in film is easier to understand. Our basis for this idea comes from two German physicists: Max Planck, who proposed a quantum, or particle, theory to explain the movement of energy, and Albert Einstein, who adapted that theory to the behavior of light. Light particles or *photons*, as Einstein called

[**4-3**] *Physical properties of light.*

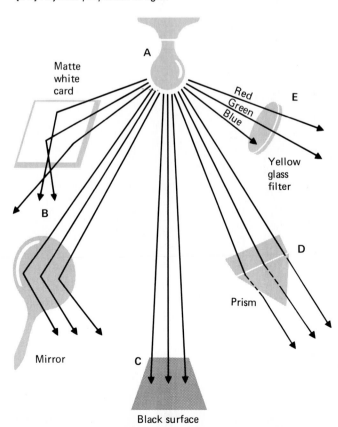

them, seem to act more like matter than like waves of energy. When a photon of light (an extremely small amount) strikes sensitive molecules in photographic film, it begins a complex chain of events that only recently has been observed through the electron microscope, and which is not yet fully understood. This quick succession of events results in microscopic physical and chemical changes that form a latent or invisible image (page 75).

HOW WE SEE LIGHT

Light occurs in two general forms, natural and artificial; in a spectrum of wavelengths that we see as colors; and in various other degrees of intensity, clarity, and direction.

Natural light comes from the sun; daylight, which is a combination of direct sunlight and its reflection from the atmosphere, is its most common form. We perceive daylight as coming from above: our sense of it "falling" on objects is so firmly fixed in our minds that we may find it difficult to think of light coming from other directions as natural. Moreover, when we create light artificially, we usually try to simulate the natural kind. Natural light, then, is fundamental to our perception of reality.

Natural light also has certain characteristic colors. Direct sunlight is rich in red and yellow; we tend to

think of it as "warm." Light reflected from a clear, overhead sky is much stronger in blue and violet than red or yellow; thus we regard it as "cool." Daylight contains different mixtures of sunlight and skylight at different times of day, and its dominant hue can therefore vary from warm to cool. In black-and-white photography this is not much of a problem, but in color photography it is often troublesome. For although the color of the light may vary, the response of color film to that light is always the same. Color slides made at certain times of the day may therefore be too orange or warm, while slides made in the shade may appear distinctly blue.

Our eyes, on the other hand, respond to daylight of all types in much the same way. We tend to think of sunlight and skylight, whatever the mixture, as *white* light, when in fact it is quite bluish if overcast or yellowish if the direct rays of the sun are dominant. Our eyes adapt themselves quickly and automatically to these differences, but our films do not.

LUMINANCE RANGE

Light varies tremendously in intensity. Objects differ in the degree to which they reflect and absorb light. Taken together, these two facts account for a great range of brightnesses in the light that subjects

Astronaut Edwin E. Aldrin, Jr. on the Moon. Apollo 11, 1969. NASA.

reflect to our eyes, and in a similar range of luminances that they reflect to the camera.*

A simple demonstration will illustrate these points. Take two pieces of construction paper or similar material, one white and the other matte black. Place them both in direct sunlight. One should reflect about twenty times more light than the other. If measured under skylight only, without direct sunlight, the range will be about the same, although the actual levels of reflected illumination will be lower than they were in the sun. Now place the white paper in deep shade and the black piece in the sunlight; the white one will reflect only about twice the light of the other. Next, reverse the papers so that the white one is sunlit and the black one is in shadow; the *luminance range*, or difference between the illumination levels they reflect, might now be as great as 1:200.

Because this luminance range can vary so much, we need to be able to measure it so that our film can be properly exposed.

PHOTOGRAPHIC FILM

Modern photographic film, like the reaction that light produces within it, is both simple and complex. Taken out of the camera, it looks simple enough—a piece of shiny plastic material, dark on one side, light gray on the other, and ready to roll up as soon as we let go of it. Even a microscopic cross-section [4-4] gives few clues to its remarkable nature. Most of the thickness we feel when we handle it is *film base*—a flexible support for the thin, light-sensitive emulsion where the image is formed. Film base must also be optically transparent and tough, yet unaffected by water and the chemicals used in processing. Two materials meet these requirements well: cellulose triacetate and polyethylene terephthalate. The former is made from wood

[4-4] *Cross-section of black-and-white photographic film.*

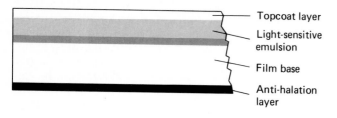

- Topcoat layer
- Light-sensitive emulsion
- Film base
- Anti-halation layer

Intensity is a measure of light coming from a source and *falling on* an object. *Brightness* describes a similar quality of light *reflected by* an object and *perceived* by the eye; it is thus subjective. *Luminance* describes this same aspect of light reflected by an object to the camera. Exposure meters measure luminance.

pulp, the latter from ethylene glycol and other petroleum-based chemicals. Both are now used worldwide in film manufacturing.

THE SENSITIVE EMULSION

Many compounds of silver are photosensitive. They tend to break down or decompose under the influence of light, and virtually all photographic processes depend on this effect. The most useful of these compounds are the *silver halides*—combinations of silver with chlorine, iodine, or bromine. The last mentioned, *silver bromide*, is the most important. Silver bromide crystals are extremely small— about 500 to 4000 nanometers (.0005 to .004 mm) wide. For photographic use they are held in a suspension of *gelatin*, which keeps them separated from one another and disperses them evenly across the film surface.

Gelatin, in fact, plays a very special role in the manufacture of modern photographic materials. Made from the hides, hooves, and bones of calves and pigs, gelatin is a remarkable material. Liquid when hot, it cools and dries to a hard, smooth layer that freely permits light to pass through it. Gelatin controls the size and dispersion of silver bromide crystals when the emulsion is made, and it holds these crystals and the image that results from them firmly in place. In cold water gelatin swells but does not dissolve, thereby permitting other dissolved chemicals, such as developers, to pass through it and get to deeply situated crystals as well as those near the surface. Since 1878 gelatin has been a universal emulsion material.

Gelatin is also used for the thin, topcoat layer that protects the emulsion from mechanical damage such as scratching in the camera. Another application for it is found in a thin, colored, anti-halation layer on the back of the film base. When a bright source of light is included in the picture area, rays from that source striking the film at an angle (as they will everywhere except in the center of the frame) might travel through the base and reflect off its far side, reexposing the emulsion in a wider area than a direct ray would. This effect is called *halation*; it produces fuzzy highlights in a picture and reduces image sharpness. The dyed gelatin coating on the back of the film absorbs such stray light and prevents it from reflecting back to cause halation.

FILM SENSITIVITY

Films differ from one another in several ways. Some are for color prints, others produce color slides. Still others produce negatives for prints in black and white. Within each of these three basic

types there are other differences, and the most important of these is sensitivity to light. When photographers want to describe how sensitive a film is to light, they generally use the term *film speed*. This speed or sensitivity is expressed as a number on a scale published by the International Standards Organization. The film speed is therefore known as an ISO rating.*

The ISO (ASA) rating is supplied by the manufacturer and can be found on the film carton. The higher the ISO number, the greater will be the film's sensitivity. As this sensitivity increases, less light will be needed for exposures, or shorter exposure times may be used. For example, many black-and-white films are rated ISO (ASA) 125/22°; others are rated 400/27°. The film rated 400/27° is therefore about three times more sensitive to light than the 125/22° type.

Speed, or sensitivity, is governed by the size of silver bromide crystals in the emulsion and by the presence and concentration of other chemicals. Fewer but larger crystals mean a higher film speed with relatively lower contrast. A dispersion of many small crystals, on the other hand, will yield a less sensitive emulsion with greater contrast. Sometimes a small amount of silver iodide is added to the bromide to increase sensitivity.

GRAININESS

As sensitivity increases, so does graininess. Graininess results from the grouping or clumping of the larger silver bromide crystals in faster emulsions, and it is most noticeable when a negative is greatly enlarged. High speed films contain large crystals because when these crystals are developed, they produce more silver metal than smaller crystals do, and thus can form a usable negative with a minimum of exposure. Graininess is increased if a film is overdeveloped, or if processing temperatures increase.

On the other hand, in slower films the grain structure is finer and less noticeable. Such films can record sharper images and resolve finer detail with their smaller crystals, but they have less sensitivity to light.

Some fine grain films have super-thin emulsions which reduce internal light scattering to improve image sharpness. In some of these films the anti-halation dye is coated on top of the film base, directly under the emulsion, where it prevents halation during exposure and becomes transparent and colorless during development.

If high quality lenses are used on the camera and enlarger, and appropriate camera handling and processing are used, the advantages of these thin-emulsion films can be dramatic. But because their thinner emulsions contain fewer silver halide crystals, they have lower film speeds and very little tolerance for error in either exposure or development. Special developers may be required with some of these films to realize their advantages, and manufacturers' recommendations should be closely followed.

COLOR SENSITIVITY

Today most black-and-white films are sensitive to all colors of light, but this has not always been the case. Silver halides, by their chemical nature, are sensitive to ultraviolet, violet, and blue light, but not to green or red. Early photographers like T. H. O'Sullivan had to contend with this when working outdoors. Their plates would properly record brown and green landscape hues only with long exposures, during which skies became relatively overexposed and printed out uniformly white (page 29). Today such blue-sensitive emulsions are used only for printing papers and a few special-purpose films.

By adding certain dyes to the emulsion when it is made, its spectral sensitivity can be extended to other wavelengths of light. *Orthochromatic* emulsions are sensitive to violet, blue, and green light. They are not sensitive to red, however, and thus can be handled and developed under red safelights. These emulsions, called simply *ortho*, are also used primarily for printing papers and special-purpose films.

When an emulsion is sensitized to red as well as green light, it is designated *panchromatic*, or simply *pan*. This gives it a balanced response to all colors, with gray tones closely corresponding to the value of similar colors seen by the eye. Most of our films are panchromatic, and therefore must be developed in total darkness.

This same dye-sensitizing process can extend the spectral response of film beyond light wavelengths into the *infrared* region of the electromagnetic spectrum, up to about 1350 nanometers, making photography by invisible infrared radiation possible. Infrared rays can penetrate hazy atmospheric conditions where light rays cannot, and photographs made by them have many applications in

*Until recently, film manufacturers world-wide used ratings based on a similar standard published by the American National Standards Institute (ANSI), which was formerly known as the American Standards Association (ASA). Until the changeover is complete, the old designation of ASA for film sensitivity will remain in widespread use. In Europe, films were also rated for many years on an equivalent German scale, Deutsche Industrie Norm (DIN). On this logarithmic scale, an increase of 3° indicated a doubling of the film speed. The new ISO ratings combine the former ASA numbers with their DIN equivalents, thus: ISO 125/22°. The first part of the ISO number is the same as its equivalent ASA rating.

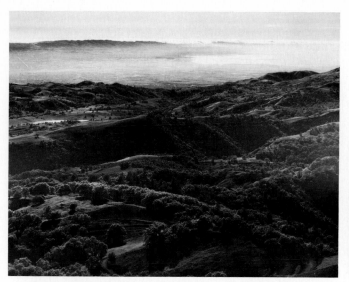

Santa Clara Valley from Mount Hamilton, California, 1968. Infrared photograph.

The same view made on panchromatic film.

landscape and aerial work. The photograph above (left) was made on infrared film. For comparison, the same view was recorded on ordinary panchromatic film (right).

X-RAY SENSITIVITY

Films are also sensitive to X radiation, and security measures employed at airports have made this sensitivity a major concern for photographers. The human body can tolerate X-ray doses that would ruin photographic film, so screening units used for people and luggage should not be considered safe for undeveloped films. Fogging (non-image exposure) from X-rays is most noticeable on color films and high-speed black-and-white materials, but any film can be ruined if the unit is powerful enough, and this can be a serious problem at many airports outside the continental United States. To make matters worse, doses are cumulative; multiple screenings therefore increase the hazard.

The best way to minimize this risk is to carry your film with you when boarding an aircraft. Always request a hand search of your camera or film cases, and don't ship film in baggage or suitcases that will be checked. If several X-ray inspections must be tolerated, however, place the film in protective, X-ray shielding bags available from photo dealers.

CONTRAST

As we have already noted, contrast in black-and-white films is related to speed and graininess. Higher-speed films tend to produce less contrasty images. Slow, fine-grain films (such as Kodak Pan-

tomic-X or Ilford Pan F) will produce negatives of moderate contrast when processed as recommended. But there also are films made especially to produce high-contrast images—those where black-and-white tones are more evident than shades of gray. These films tend to have relatively low speeds, and are used for reproduction, microfilming, and many applications in the printing industry. A few, such as Kodalith Ortho Type 3, are also used in photographic design work, and some of these applications are outlined in Chapter 10. Except for a few special-purpose films made for laboratory work, films are not designed to produce low-contrast results.

INSTANT-PICTURE FILMS

Instant-picture films made by Kodak and Polaroid provide a processed, permanent image in seconds (black and white) or minutes (color). Although some of these films can be used only in special cameras intended for them (page 49), many Polaroid black-and-white and color films can be used in conventional 120 and 4 × 5 format cameras with special adapters or film holders. Because these instant-picture materials are all fundamentally different from other films and papers, they are discussed in the Appendix.

CHOOSING YOUR FILMS

Which type of film, then, is best? From a practical standpoint, photographers usually divide general-purpose films into three speed groups: fast, medium, and slow. Fast films are those with ISO (ASA) ratings of 400/27° or more (see table). Al-

(Top): Boxcar photographed on three different films. Left to right: ISO 1250/32°, ISO 125/22°, ISO 32/16°.
(Bottom): A central portion of the boxcar photographed with each type of film.
Compare the sharpness and tone reproduction of these images.

though they are less able to show fine detail than other types are, fast black-and-white films are somewhat more tolerant of variations in exposure and development and can be "pushed," or exposed at higher-than-normal ISO ratings, with the help of high-energy developers (page 76). These films are widely used by news and magazine photographers who often must work in difficult lighting conditions. As a rule, high-speed films should be used only when their extra sensitivity is needed.

GENERAL PURPOSE FILMS AND THEIR ISO (ASA) RATINGS

	Black-and-White Films		Color Negative Films (for prints)		Color Slide Films	
FAST FILMS	Kodak Royal-X Pan	1250/32°	Kodacolor 400	400/27°	Ektachrome 400	400/27°
	Agfa Agfapan 400	400/27°	Fujicolor 400	400/27°		
	Ilford HP5	400/27°				
	Kodak Tri-X Pan	400/27°				
MEDIUM-SPEED FILMS	Ilford FP4	125/22°	Kodacolor II	100/21°	Ektachrome 200	200/24°
	Kodak Plus-X Pan	125/22°	Fujicolor F II	100/21°	Ektachrome 160	160/23°
	Kodak Verichrome Pan	125/22°			Agfachrome 100	100/21°
	Agfa Agfapan 100	100/21°			Fujichrome RD 100	100/21°
SLOW FILMS	Ilford Pan F	50/18°			Agfachrome 64	64/19°
	Kodak Panatomic-X	32/16°			Ektachrome 64	64/19°
	Agfa Agfapan 25	25/15°			Kodachrome 64	64/19°
					Agfachrome CT-18	50/18°
					Kodachrome 25	25/15°

Instant-picture films are listed in the Appendix.

Slow films are those with ISO ratings of 64/19° or less. They require more exposure than other types, but their long tonal scales, finer grain, and moderately high contrast make them ideal for use when highly detailed images or rich tone quality in the print are wanted, or when extreme enlargement is planned.

Medium-speed films range from ISO 80/20° to 250/25° and these are well suited to general photographic work. They are less contrasty than the slow films and less grainy than the fast ones. Medium-speed films are excellent choices for a beginning photographer.

With practice and experience, however, many photographers find that they can bridge the medium-speed group altogether (except for color negatives), using a slow film for general work and a fast film when its extra speed or flexibility are needed. Whichever type of film you choose, take time to discover what it will do for you before switching to others.

The division of films into three speed groups is somewhat arbitrary and mainly serves as convenient labeling. ISO (ASA) ratings are the most useful measurement of film sensitivity, and the most practical guide to choosing your black-and-white films. When you choose color films, however, other considerations became equally important, and these are discussed in Chapter 11.

EXPOSURE METERS

Once we know the intensity of light on the subject and the film sensitivity, only two questions remain: how much light should reach the film, and for how long? The best way to answer these questions is to use a device which measures the light and relates it to the film sensitivity: an *exposure meter.*

Most modern cameras conveniently have an exposure meter built into them, and separate, handheld meters are available if the camera does not. A reliable exposure meter can become your most trusted photographic tool, helping to make your technique systematic and your results repeatable. The major types of meters are described on these pages; their use is explained on pages 71–72.

HOW METERS WORK

At the heart of most exposure meters lies a small light-sensing device that controls the flow of a tiny electrical current in a circuit. These meters require a power source, usually a dime-sized mercury battery that will last a year or more, and a moving pointer (galvanometer) or a set of LEDs (light-emit-

ting diodes) built into the meter or camera viewfinder to indicate the desired information. Cadmium sulfide (CdS) photoresistors have been used in such meters for many years. They are small enough to be built into camera viewing systems, but they respond slowly to sudden changes in luminance and some can be temporarily desensitized if pointed directly at a bright light source. Silicon cells have similar advantages, but they must be filtered against infrared rays and they require more complex and expensive electronic circuits in the camera.

Gallium arsenide phosphide diodes (GPDs) a recent innovation, overcome most of the problems with the other types, showing better response times than CdS cells and greater stability in extreme temperatures than silicon units. They also measure very dim light more accurately. Like silicon cells, GPDs require sophisticated, electronic camera circuits.

As we have noted, all of the above devices regulate the flow of current from a battery in response to the light that falls on them. Other meters use selenium cells which generate their own electricity when light strikes them, and since they require no other power source, selenium circuits are the simplest of all. But selenium meters have their drawbacks too: in dimly lit interiors or at night, selenium meters are less accurate than the other types mentioned. A large light-sensing cell is required to generate a measurable current, and this effectively limits selenium designs to hand-held meters large enough to contain them.

Meters in Cameras

Meters built into cameras measure reflected light—luminance reflected to the camera by your subject. Most are directly coupled to the shutter and aperture controls. Through-the-lens (TTL) meters are best: they measure the light that actually exposes the picture, and are found in all better SLR cameras. If you change the lens or add a filter to it, the TTL meter automatically takes this into account.

Some internal meters, however, have their light sensor on the outside of the camera body. There it can measure only the light reflected to the camera, and cannot deal with the changes mentioned above. This type of meter is usually found on viewfinder cameras and other cameras of simple design.

How large an area does the meter actually measure? Again, this depends on the camera's design. Some read the entire area shown in the viewfinder frame, *averaging* all the luminances within it [4-5(A)]. Others are similar but are more sensitive to the center of the frame; these are called *center-weighted* (B). Still other meters sense only a small *spot* in the center, ignoring everything else beyond it (C). Your camera's instruction book should indicate which pattern its meter reads. In any case, the

[4-5] *Sensing areas of meters in cameras.* **A:** *Averaging meter reads entire picture area.* **B:** *Center-weighted meter reads entire area but is more sensitive to a central zone.* **C:** *Spot meter reads only a small spot in the center of the picture.*

[4-6] *Viewfinder displays of meters in cameras.* **A:** *Shutter and aperture settings shown at bottom of window.* **B:** *Selected aperture shown at top; automatically determined shutter time illuminated by LEDs at left.* **C:** *Match-needle meter; + and − indicate zones of over and underexposure respectively.*

most important parts of your subject must briefly be located in the sensing area for proper exposure determination.

Meters built into cameras are shutter-priority, aperture-priority, or match-needle type. A *shutter-priority* meter requires you to select a shutter setting; the meter then indicates the proper aperture for correct exposure, and sets it automatically. This mode is advantageous when you want to photograph action, such as sports events, or when you wish to deliberately blur the motion in your picture (pages 53 and 142). You retain control of the shutter time to get the desired effect, and the meter merely finds the aperture for correct exposure.

An *aperture-priority* meter, on the other hand, requires you to select the aperture first; the meter then indicates the proper shutter setting for correct exposure and sets it automatically. This mode is useful when you want great depth of field in your picture, as in landscape views, or when you wish the focus to be selective—when you don't want everything sharp (pages 55, 134, and 135). In this mode you control the aperture (and thus the depth of field), while the meter selects the shutter time for correct exposure.

A few cameras, usually the most expensive SLRs, permit you to select either priority mode. With these cameras you can thus keep creative control of the most important adjustments when you want to, but also enjoy automatic response to routine situations.

Cameras which do not have priority metering are usually of the *match-needle* type. With these you must center a moving pointer on a short scale, or align a second pointer with the first in the viewfinder. When the single pointer is centered, or when the two pointers coincide, the correct exposure is set.

Since both the shutter and aperture are thereby adjusted, neither has priority over the other.

Many SLR cameras display the chosen shutter and aperture settings in the viewfinder window. Some indicate the actual shutter time and f/ number; others show whether the exposure selected is correct, over, or under by means of a moving pointer or an LED display. If the meter is the match-needle type, the moving pointer and scale will be seen. Typical viewfinder displays are diagrammed in [4-6].

All of the meters described above are coupled in some way to the shutter or aperture controls. Other meters built into cameras, however, are not so connected, and with these you must read the meter and then set the aperture and shutter controls separately by hand. Such meters are simple, and usually are found in less expensive cameras.

Hand-held Meters

Most hand-held meters, like those built into cameras, measure the luminance reflected from a scene but have an advantage over the built-ins because they allow you to read selected parts of your subject from close range without disturbing the camera. This makes it easy to take separate readings of light and dark areas of the subject, a technique which can give more accurate and useful exposure data than a single reading can (see Luminance Range Method, page 71). Because hand-held meters are not coupled to camera controls, they contain an exposure calculator which correlates the luminance reading with the ISO (ASA) rating to indicate correct shutter and aperture settings.

Hand-held meters have other advantages. A single meter obviously can be used with several cam-

Gossen N-100 hand-held exposure meter.
Courtesy Berkey Marketing Companies.

area or spot is outlined in this viewing frame; you aim the meter at your subject and read the exposure settings in the eyepiece or on the meter's body (see diagrams, **4-6**). Spot meters are useful to measure large objects at a distance (across a river, for example, or very small objects at close range. You can also use them when a small part of your picture is extremely important (you can take your reading from that part alone), or when important things in your picture are surrounded by sharply contrasting light values, which you can similarly exclude.

Incident Light Meters

Although almost all hand-held meters measure reflected light, most can be converted to read the intensity of *incident light*—light coming from a source and falling on a subject—as well. Incident light meters are popular with motion picture film makers and with still photographers who work in studios where the ratio of highlight brightness to shadow brightness can be controlled. Since incident meters measure the *intensity* of light *falling on* a subject (rather than its reflection to the camera), these meters must be held at the subject position and aimed back toward the light source or camera. Meters built into cameras (with rare exceptions) cannot measure incident light. In practice, however, most still photographers work more often with light as they find it, and a reflected light meter is therefore more useful to them.

eras, and meter repairs, when necessary, do not take the cameras out of service. But there are drawbacks too: these meters are fragile, easily damaged by rough handling, and they take additional space in the camera bag or case. Good ones represent a sizeable additional investment.

Most hand-held meters measure an area that corresponds more or less to what a normal camera lens includes in its view. Within this area, the meter *averages* all the luminance values it senses. If you hold this meter near the camera and point it at your subject, then, it will give you relevant exposure information. This techique is simple and works well for a majority of picture situations (see Single Readings, page 71).

HOW TO USE EXPOSURE METERS

As we noted earlier, all meters built into cameras and almost all hand-held meters measure *reflected light,* averaging the different luminances they sense. Because of this averaging, all reflected light meters read their subjects as a medium gray tone or value, regardless of the actual colors there. If you point the meter at a white wall, for example, it will yield exposure information that will result in a medium gray wall in the print. If you aim the meter at a dull,

Spot Meters

Some meters measure only a very small part (typically a 1° angle) of the scene before them, and these are called *spot meters*. A spot meter has an eyepiece like a camera's viewfinder. The sensing

Hand-held spot meters. Courtesy Minolta Corporation and Pentax Corporation.

Sekonic Auto-meter, an incident light meter. Courtesy Copal Corporation of America.

Incident light meters are held at the subject and aimed at the light source. They measure the light falling on the subject rather than the light it reflects to the camera.

Reflected light meters are held at the camera and aimed toward the subject so they "see" more or less what the camera lens does. See text for cautions.

black object, again it will give exposure data resulting in a medium gray photograph. The meter cannot distinguish between white and black, or between red and green; it only measures the luminance reflected to it.

There will be times, then, when you must *interpret* meter readings to make allowance for this inflexibility. The suggestions which follow will help you do this. In each case, the aim is to get exposure settings that will produce the result *you* want, rather than the meter's inflexible standard.

Single Readings

The easiest way to use a meter is to take a single reading of the subject from the camera position. The meter then integrates the light reflected from all objects within its field of view, and averages these reflected luminances to a medium gray value. This method is simple, quick, and generally satisfactory with subjects that are "average" themselves, that is, subjects that are not dominated by extremely light or dark values. You should avoid reading large, dark areas such as open doorways, or large, bright backgrounds such as sunlit snowbanks, since these will sway the meter off its averaging measurement. Moving closer to your subject to meter only the important areas will help: the camera can then be moved back to frame the desired picture. If you are photographing a landscape, tip the meter or camera down slightly so that its reading favors the land rather than the brighter sky.

The Luminance Range Method

Although a single, overall reading usually works well, a pair of close-up readings measuring the

lightest and darkest important objects or areas— the *luminance range*—works even better. First read the luminance of the darkest important object in your scene that you wish to photograph with texture or detail. Then similarly read the lightest important, detailed object. If you are making negatives, select an exposure halfway between the two readings, or favor the darker object a bit to be certain that you expose the shadows adequately. Detail in the brighter areas (highlights) can be strengthened in printing, but shadows without detail will always print as empty voids. For color slides, use the median exposure as suggested above, or slightly favor the lighter object to avoid washing out its color. Any reflected light meter can be used in this manner, but a spot meter is ideal for it.

Substitute Readings

If your subject is not easily accessible for close readings, more convenient objects with similar reflecting characteristics may be substituted. Nearby trees, for example, can be metered in place of more distant ones. A white handkerchief will conveniently substitute for anything you expect to appear white in your print. Black cardboard, often supplied as photographic paper packaging, similarly can be substituted for deep shadow areas. Be sure you place the substituted item in the same light and at the same angle as the original one.

Gray Card Readings

For more uniform measurement, some photographers prefer to use an 18% gray card as a substitute for average subjects. This card, supplied as a "Neutral Test Card" by Kodak and also available in some

To meter an 18% gray card, hold the meter close enough so it "sees" only the gray card, but be careful it does not cast a shadow on the card. Hold the card parallel to the surface being photographed.

of their Dataguides, offers a convenient photometric "middle gray" tone on one side and a 90% white on the other. It is called an 18% gray card because although it appears medium gray in brightness (halfway between white and black), it actually reflects only 18% of the light striking it (luminance), absorbing the rest. Its white side similarly reflects 90% of the incident light.

The gray card must receive the same illumination as the subject. Hold it parallel to the surface being photographed; outdoors, avoid tilting it back where it might pick up too much blue light from the sky overhead.

Skin-tone Readings

Meter readings may also be taken from the palm of your hand. Typical Caucasian skin reflects about twice the light of an 18% gray card, so if close-up readings are taken from such skin, expose one f/ stop larger than the meter indicates.*

The main points to remember when using an exposure meter are summarized in the table below.

Skin tone is metered much like a gray card. The meter must not cast a shadow on the skin. To meter Caucasian skin, use one f/ stop larger than the meter indicates. See text.

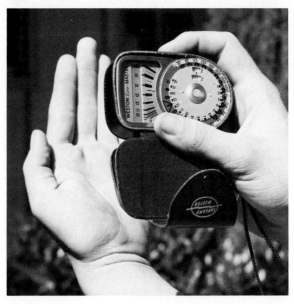

*The Weston Master and Euromaster exposure meters, although no longer manufactured, make this correction automatically if the "C" position on their dials is used instead of the normal red index marks. See photograph above.

HOW TO USE EXPOSURE METERS

METERS BUILT INTO CAMERAS

1 / Set the ISO (ASA) rating of your film in the ASA window of the camera. Like a computer, the meter must be properly "programmed" to give you valid information.*
2 / Select the shutter time (or aperture) you prefer to use.
3 / Focus the lens, and read the appropriate areas of your subject.
4 / Adjust the aperture (or shutter) until the correct exposure indication appears in the viewfinder.

HAND-HELD METERS

1 / Set the calculator dial for the ISO (ASA) rating of your film.†
2 / Aim the light-sensitive cell toward the subject, and press the pointer release to get a reading on the luminance scale.
3 / Set the calculator index to this luminance reading.
4 / The correct shutter and aperture settings will now be adjacent to each other on the dial. Set the camera's controls accordingly.

*On Instamatic cameras, inserting the film cartridge automatically sets the ISO (ASA) rating.
†Before using a hand-held meter, check the zero setting. When no light strikes the cell, the meter **must** read zero. Adjust this if necessary (see the meter's instruction manual), and repeat this check periodically thereafter.

EXPOSURES WITHOUT A METER

Although a luminance meter is your best guide to correct exposure in most situations, daylight exposures for typical subjects outdoors can be determined from the table below if a meter is not available. Daylight varies in intensity according to a number of factors, and many of these factors are common enough to be easily quantified. On a typical sunny day, the intensity of daylight will not vary much from place to place, nor will it change much from one such day to the next. Thus it is possible to estimate this intensity under typical weather conditions with sufficient accuracy to be useful, yet arbitrarily enough to be simple.

At the beginning of this chapter we noted four variable elements in every photographic exposure: (1) light intensity, (2) film sensitivity, (3) shutter setting, and (4) aperture setting. The table below relates these four factors over a range of daylight conditions that is fairly predictable.

Once you choose a shutter time and f/ stop from the table, of course, any *equivalent* combination may be substituted. For example, average subjects in bright sunlight can be photographed on Plus-X Pan film with an exposure of 1/125 sec. at f/16. But 1/500 at f/8 and 1/60 at f/22 are equivalent; these combinations may also be used. Within the limits indicated, this daylight table will give you good advice for average situations, and it's simple enough that its main features can be memorized.

DAYLIGHT EXPOSURE GUIDE FOR AVERAGE SUBJECTS

Set the shutter time equal to 1/ISO rating (example: for ISO (ASA) 125 film, set the shutter at 1/125 second). Then use the following apertures for the light conditions described.

Bright or somewhat hazy sun: strong shadows	**f/16**
Hazy sunshine: weak, poorly defined shadows	**f/11**
Overcast but bright: no shadows visible	**f/8**
Overcast but dark: high fog, light rain, gray sky	**f/5.6**
Heavy overcast: thick fog, heavy rain, dark sky	**f/4**
Open shade on sunny day (subject entirely in shade under open sky)	**f/5.6**

Use this guide for average subjects from about an hour after sunrise until about an hour before sunset. Adjust the exposure for subjects that are darker or lighter than average, for backlighted subjects (where light comes directly toward the camera from behind the subject), and for extreme North and South latitudes. For example:

For average subjects in light sand or snow, use one f/ stop smaller.
For light-colored subjects, use one f/ stop smaller.
For darker-than-average subjects, use one f/ stop larger.
For backlighted subjects, use two f/ stops larger.
For extreme North and South latitudes, use one f/ stop larger.

BRACKETING

Another aid to correct exposure determination in uncertain or unusual situations is a technique called *bracketing*. This requires three exposures of the subject on separate frames. Give the first frame the exposure indicated by the meter or table, and other frames half and double the first. For instance, if an exposure of 1/125 at f/8 is indicated, expose one frame at those settings. Expose a second frame for 1/125 at f/11, and a third for 1/125 at f/5.6. Of course you may hold the aperture constant and vary the shutter time instead. And the bracketing may be extended to one-fourth and four times the indicated exposure if you wish. Choose the resulting negative or slide that has the best range of tones or colors. Avoid using negatives that have clear shadows (caused by too little exposure) or dense, gray highlights (caused by too much). Similarly, avoid selecting color slides that have deep black shadows (too little exposure) or weak, washed out highlights (too much).

5 PROCESSING THE FILM

"You press the button, we do the rest." With that famous slogan, George Eastman introduced the rollfilm camera to the world nearly a century ago and made it possible for virtually anyone to make photographs. Today, of course, everyone does. Modern cameras with automatic exposure systems and other convenient features have made it easy for us to concentrate on taking pictures, and with photofinishing services available through every market, drug store, and mailbox, most of us have been happy to follow Eastman's advice and leave the processing of our film to others.

Doing this, however, trades off creativity for convenience, because after we have taken a picture with the camera, we can still exercise a great deal of control over its outcome. In photography, the opportunity to be creative doesn't stop with exposure of the film but carries through every subsequent step to the final print.

THE LATENT IMAGE

If a good deal of mystique still seems to surround the photographic process, perhaps it is because when light strikes our film in the camera it produces no visible change in it. An invisible or *latent image*, however, is produced in the light-sensitive emulsion. From a microscopic viewpoint, this emulsion is a deep layer of gelatin in which are scattered millions of silver bromide crystals. Each of these crystals, if greatly magnified, would appear to be a three-dimensional arrangement of alternating silver and bromine particles called *ions*—electrically charged atoms—and the entire crystal structure would look something like a triangular lozenge or cough drop.

We noted earlier that when light strikes a photographic film, it behaves more like a stream of particles than a wave. When a photon of light strikes one of these crystals, it sets off a sequence of events that results in the formation of tiny particles of silver metal. Energy from the photon of light releases electrons from the bromine ions, and these negatively charged, free electrons move about the crystal until they are caught and held at certain points in the structure called *sensitivity specks*. There they attract positively charged silver ions, which join the electrons at the specks to form atoms of silver metal. As more light is absorbed by the crystal, more electrons and silver ions are attracted to these growing sensitivity specks, and more silver metal is formed.

This formation of tiny silver particles on exposed silver bromide crystals, visible only with an electron microscope, is called

Electron photomicrograph of an exposed silver bromide crystal at the beginning of chemical development. Reproduced by permission of Eastman Kodak Company and the American Society of Photogrammetry. © 1966, 1981.

1μm

75

the *latent image.* *Latent* means lying hidden and undeveloped, which describes this silver pattern perfectly. Development, the next step in the photographic process, will begin in this same pattern, amplifying the effect of light a billion times, and that will make the image visible.

PROCESSING THE FILM

Processing the film makes the latent images visible, brings them to full intensity, and makes them permanent. The sequence for black-and-white materials is relatively simple and is described on these pages. Color film processing involves additional steps and is outlined in Chapter 12.

There are five major steps in black-and-white processing:

1. **Developing,** which makes the latent images visible.
2. **Rinsing,** which stops the development.
3. **Fixing,** which removes the light sensitivity from the emulsion and hardens it.
4. **Washing,** which removes all dissolved chemicals from the film or print.
5. **Drying,** which completes the process.

Let's take a closer look at each step.

DEVELOPING

The developer reduces exposed silver bromide crystals to tiny particles of silver metal. Concentrated in the emulsion, these particles absorb light and appear dark, producing the familiar, gray-toned image we call a *negative.* To be useful, the developer must discriminate between exposed and unexposed silver bromide crystals, for it if did not, all of these crystals would be reduced to silver and that would produce a totally black film on which we could see no pictures.

Developers come as powders to be dissolved in water or as concentrated liquids that only need to be diluted to use. Most black-and-white film developers are one of three basic types: general purpose, fine grain, or high energy. The most popular of each type are listed in the table.

General-purpose developers produce negatives of excellent printing quality with most films. They are best for all-around use and are particularly good choices for beginners. Some, such as D-76, are economical in large quantities, and are provided by many school and college photography labs.

Fine-grain developers, as their name implies, produce negatives with a finer grain structure than

most general-purpose developers do. This makes them useful with small negatives that will require substantial enlargement when printed. With some fine grain films (page 65), these developers can produce brilliant, crisp negatives that contain fine tonal gradation and detail.

High-energy developers can be used to process film exposed in very dim light. With these developers it is often possible to triple the effective film speed (ISO), but under these conditions you should not be surprised if your pictures look grainy and lack some detail.

COMMONLY USED FILM DEVELOPERS

General-purpose Developers	Fine-grain Developers	High-energy Developers
Edwal FG-7	Ethol UFG	Acufine
Ilford ID-11	Ilford Microphen	Diafine
Kodak D-76	Kodak Microdol-X	
Kodak HC-110		

One-shot or Replenished Use?

The best way to use most black-and-white film developers is to dilute them as directed, use the solution once, and then discard it. With this procedure you get a fresh solution of full strength for each use, and with 35 mm and rollfilms, the small volume of developer needed is not expensive. For consistent, reliable results, "one-shot" is the best way to go.

If larger quantities of developer (2 liters or more) must be used, however, "one-shot" methods can be costly and wasteful. In such cases, some general-purpose developers can be used over and over if you add a *replenisher* solution to the developer after each use (page 92). The amount of film developed and the amount of replenisher added must be accurately measured, but if you do this with care, you can develop large quantities of film economically.

Time, Temperature, and Agitation

Like most chemical reactions, development occurs faster as the temperature is raised. For each temperature there is an optimum time, and this should be carefully observed. Other factors also affect the result, but the time-temperature relationship is fundamental. The frequency and consistency of agitation also affect the development rate; the more frequent or vigorous the agitation, the greater the development. As the developer reduces

silver bromide crystals in the emulsion to silver metal, the bromide ions diffuse out of the emulsion and tend to collect on the film surface. Periodic agitation clears away this buildup, which would otherwise inhibit development. The bromide ions are held in solution, eventually being discarded with it.

STOPPING DEVELOPMENT

After most developers, a simple water rinse will suffice to stop the developer's action. However, an *acetic acid stop bath* is more efficient since it quickly neutralizes the alkaline developer. A stop bath should always be used following a high-energy developer. Some stop baths contain an indicator dye which changes color when the solution is exhausted, but if this feature is not desired, an equally effective stop bath can be prepared by adding 25 ml of 28% acetic acid to 1 liter of water (1 oz of the acid to 32 oz of water).*

The exposed areas of the film will now have a visible silver image. Unexposed areas, however, will still be full of light-sensitive silver bromide, and any light striking the film at this point would ruin it.

FIXING

Removing this unused light sensitivity after development is called *fixing*. Fixing dissolves the silver bromide, leaving the silver metal image in an otherwise transparent emulsion. With its sensitivity gone, the film is now protected against further change by light.

Fixers are supplied in both powder and liquid forms. Some liquid fixers are fast-working and are well-suited to film processing. Powdered formulas (which need to be carefully dissolved in warm water) work more slowly, but are a bit more economical.

Throughout the preceding steps, the emulsion has permitted water and chemicals to flow into and out of the gelatin layer, swelling and softening it. If we touched the film now, we could damage the emulsion and the picture. Most fixers therefore contain a hardener to toughen the gelatin so that the film can be safely handled with reasonable care.

*To prepare a 28% solution of acetic acid, dilute 3 parts of glacial (99.5%) acetic acid with 8 parts of water. *Glacial acetic acid is poisonous and irritating. Protect your eyes from splashes and observe all precautions on the label. Always pour the acid into the water, never the opposite.*

WASHING AND DRYING

Washing removes fixer and dissolved silver compounds from the film, leaving only the pure silver image in clean gelatin. Removal of these soluble compounds is necessary to make the image permanent; if they remained in the emulsion they would cause the silver image to ultimately break down into other silver compounds, discolor, and fade.

The rate at which effective washing takes place depends to some extent on the temperature, but it is largely governed by the molecular structure of the gelatin emulsion itself. Increasing the flow of clean water faster than the gelatin can absorb it will not improve the washing or reduce the time required for it. As long as clean water is supplied to the film surface at a steady rate, washing will proceed until the concentration of fixer and dissolved silver salts in the emulsion is virtually nil.

Chemical washing aids, such as Heico Perma Wash or Kodak Hypo Clearing Agent, may be used to help remove the soluble compounds from the emulsion. They also save large amounts of water by greatly reducing the washing time. With some of these products, the total washing time can be reduced from 30 to about 3 minutes.

After washing, the film is bathed briefly in a wetting agent such as Kodak Photo-Flo Solution. This reduces the surface tension of water remaining on the film, and helps it drain off without leaving spots. It also permits faster drying.

The film should then be hung to dry, undisturbed, in a clean, dust-free place.

HOW TO PROCESS ROLLFILM

Once the process begins it goes rather quickly, so before you start, assemble everything you will need.

Here's what you need to process rollfilm (see illustration, page 78).

1. Your exposed film.
2. Processing tank and reel (or apron).
3. Cartridge or bottle opener (for 35 mm).
4. Scissors.
5. Bottles of developer, stop bath (if used), fixer, and washing aid.
6. Photographic thermometer.
7. Plastic funnel.
8. Measuring cylinder (same capacity as tank).
9. Timer (your watch will do nicely).
10. Two wooden, spring-type clothespins.
11. Concentrated wetting agent (Photo-Flo).
12. An 8 × 10 in. tray or a plastic dishpan for temperature control.

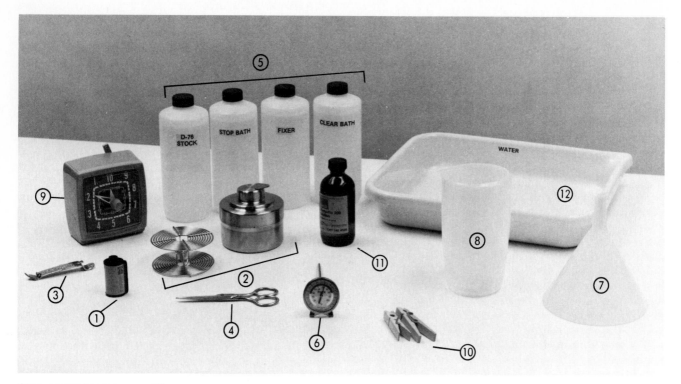

What you need to process rollfilm.

1. Exposed film.
2. A processing tank and reel.
3. Cartridge or bottle opener (for 35 mm).
4. Scissors.
5. Bottles of developer, stop bath (if used), fixer, and washing aid.
6. Photographic thermometer.
7. Plastic funnel.
8. Measuring cylinder (same capacity as tank).
9. Timer (your watch will do nicely).
10. Two wooden, spring-type clothespins.
11. Concentrated wetting agent (Photo-Flo).
12. An 8×10 in. tray or a plastic dishpan for temperature control.

PROCESSING TANKS

The processing tank must be loaded in *total darkness*. A small, windowless room or closet usually will meet this requirement, particularly at night, but it must be *totally dark*. A small table in this room will be helpful. Once the tank is loaded and closed, the rest of the process may be done in normal room light. At home, a kitchen sink or bathroom basin will be convenient and adequate.

Types of Tanks

The stainless-steel, spiral-reel tank is preferred by most serious photographers for processing roll and 35 mm film. This type of tank fills, empties, and transfers heat quickly; it cleans easily, dries rapidly, and because it can be inverted it permits smooth, even development. It has only two shortcomings: its spiral reels are difficult for a beginner to load and it is moderately expensive, especially in larger sizes.

The Paterson plastic tank has most of the advantages of the steel type. It, too, may be inverted for smooth, even development, and its plastic reel is

Stainless-steel film processing tank with spiral reels. Courtesy Honeywell Photo Products.

Paterson processing tank and reels. Courtesy Braun North America.

Consistently good film processing depends on control of three important factors: *time, temperature,* and *agitation.* Careful attention to these three points will insure predictable and repeatable results. Don't be casual about them. Start timing, for example, as you fill the tank. When time is up, empty the tank as quickly as possible. Be consistent about this from roll to roll.

The temperature of the developer and all other solutions, including the running water washes, should be as close to 20°C (68°F) as possible, preferably within a degree or two. Check this with a good thermometer made for photographic work, and if you accidentally drop your thermometer, check it against another of known accuracy before you use it again. Most developers may be used at temperatures other than 20°C, but those above 25°C (78°F) should be avoided since they might cause reticulation—a permanent, rippled swelling of the gelatin emulsion. At temperatures below 18°C (65°F), some of the chemicals in the developer become inactive and cannot give proper results. Avoid this situation too.

As we noted earlier, agitation redistributes the by-products of development and moves fresh developer into contact with the film emulsion. The more frequently you agitate, or the more vigorously you do it, the greater the rate of development, resulting in darker, more contrasty negatives. Again, *consistency* is important. Like most photographers, with a little experience you will work out your own agitation pattern. Once you do, stick to it, agitating your tank the same way each time you process.

From here on, specific procedures will vary somewhat according to the kind of film, tank, and chemicals you use. Most of this information is supplied with the products themselves; follow it with care. A typical working sequence is shown step by step in the illustrated procedures.

easier to load than the steel type. Both the Paterson tank and the steel types are designed as modular systems so you can stack several rolls of the same kind of film in one large tank for simultaneous processing. Paterson tanks cost about the same as steel tanks of the same capacity.

The Kodak plastic tank is the easiest tank for a beginner to load, and since proper loading is essential for good results, this is a real advantage. Instead of a reel it uses a crinkle-edged plastic apron. This tank cannot be inverted, however, and you must agitate it very carefully for even development. One roll of 120 film or two rolls of 35 mm film can be loaded in this popular and inexpensive tank.

Kodacraft miniature rollfilm developing tank, aprons, and weight. Courtesy Eastman Kodak Company.

LOADING 35 MM STEEL-REEL TANKS

Have all tank parts, scissors, the film, and a bottle opener within reach. **Total darkness is required.**

1 / open the cartridge

Hold the cartridge at the protruding end, and pry off the other end cap with a bottle opener. Remove the spool of film.*

2 / cut off the narrow leader

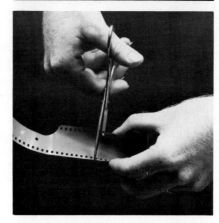

With scissors, trim the end square about an inch or two beyond the tongue. Hold film **only** by the edges.

3 / position the reel for loading

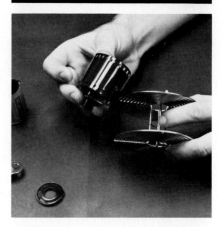

Hold the reel in one hand and press down the small spring clip at its center (if reel has no clip, locate the open channel with your index finger).

4 / start loading the reel

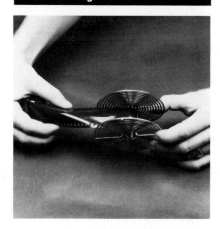

Unwind about three inches of film and bow it slightly. Insert this end under the clip (or into the open section), centering it with your thumb and finger as shown.

5 / continue loading the reel

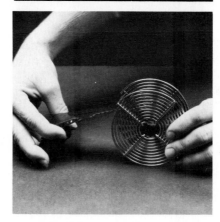

Place the reel on edge on a clean table, and turn it slowly, letting it load itself. Don't try to push the film in—let the reel pull it in as you bow the film slightly.

6 / cut off the spool

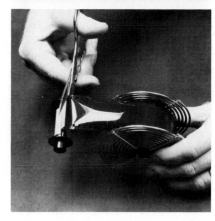

Finish loading the reel by rotating it until the end of the film snaps into the spiral grooves.

7 / check the loaded reel

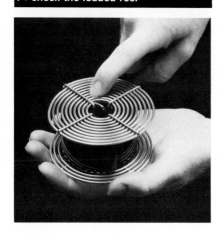

Hold the reel in one hand and tap the flat side with your finger. A slight rattle indicates the film is correctly loaded. If you can hear no rattle, the film might be touching itself in the reel, and this will cause undeveloped spots. Unwind the film and reload the reel to avoid this.

8 / place the loaded reel in the tank

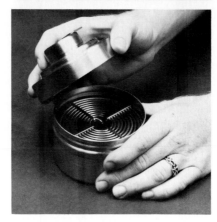

Press the cover firmly onto the tank. The room light may now be turned on.

*Instamatic cartridges (110 and 126) can be opened **in the dark** by holding their two ends, one in each hand, with your thumbs on the cartridge label. Then **bend** the cartridge **back** over your thumbs until it breaks, remove the roll of film from one end, and separate it from its paper backing. Proceed as above for 35 mm film.

LOADING 120 STEEL-REEL TANKS

Total darkness is required. *Have all tank parts, the reel, and the film close at hand where you can find them in the dark.*

1 / unroll the film

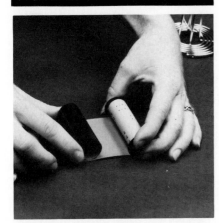

Break the seal and unroll the backing paper. The film will remain in a tight roll as you continue pulling the paper.

2 / separate the film from the paper

Fold back the paper where the end of the film is attached to it. **Slowly** tear the paper from the film. Discard the paper and spool.

3 / start loading the reel

Secure the taped end of the film under the clip. Center the film with thumb and forefinger. From here on, try to handle the film only by its edges.

4 / finish loading the reel

Slowly rotate the reel on edge on a clean table, and let the reel pull the film into it as it turns.

5 / check the loaded reel

Tap the reel with a finger to check for proper loading. If the film rattles, it's OK.

6 / load the tank

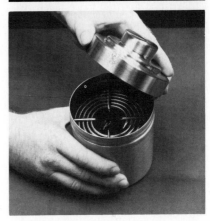

Place the reel into the tank and press the cover on firmly. Room lights may now be turned on.

LOADING THE KODAK PLASTIC TANK

1 / get the tank ready

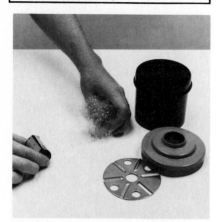

Make sure the transparent plastic apron is clean, dry, and the same width as your film. (A 127-size apron is supplied with some of these tanks. Do not use it for 35 mm film—it is too wide and will ruin the film.) Keep the tank, lid, and stainless steel weight close by.

2 / prepare the film

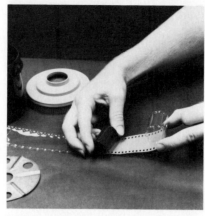

In total darkness, open the 35 mm cartridge and cut off the narrow tongue as you would do for other tanks. With rollfilm, unwind the paper backing and separate it from the film.

3 / begin loading the apron

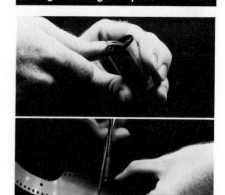

Unwind the apron and place the loose end of the film near the grommets. Start rolling up the apron. Handle the film and apron only by the edges.

4 / finish loading the apron

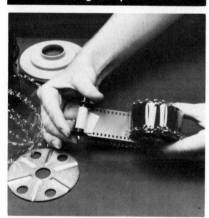

Continue rolling up the crinkle-edged apron until all the film is in it. Cut off the spool from 35 mm film before you finish rolling.

5 / place the loaded apron in the tank

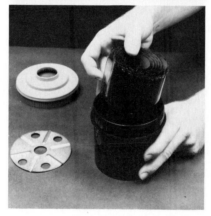

Let the film and apron spiral loosely in the tank.

6 / add the weight

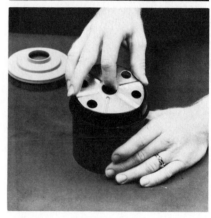

Tap the film and apron inside the tank with the weight to align them evenly. Leave the weight on top of them.

7 / cover the tank

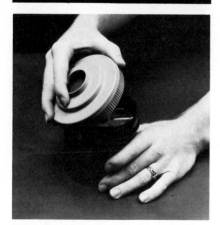

Press the lid firmly onto the tank. Room lights may now be turned on.

PROCESSING THE FILM

1 / prepare the developer

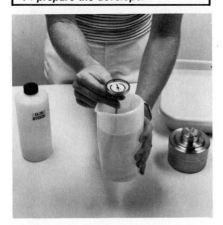

Prepare enough solution to fill your tank. Dilute the film developer as directed (D-76 is diluted with an equal volume of water) and check the temperature of the diluted solution.

Also fill the sink or dishpan with enough water at the same temperature to immerse the lower two-thirds of the tank (but not the tank lid). This water bath will be used to stabilize temperature during development.

2 / set the timer

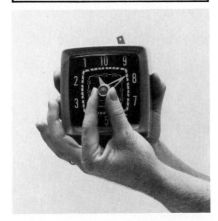

Select the proper development time from the tables on page 86. For other developers, see instructions packed with them.

3 / start the timer and fill the tank

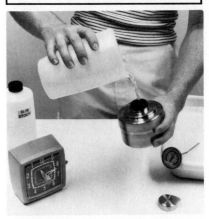

Start the timer and pour the developer slowly into the tank without stopping. Tilt the tank slightly for easier filling. Continue pouring until the tank is full.

4 / release air bubbles

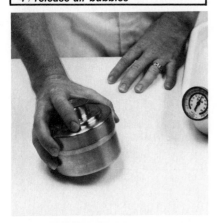

Tap the tank sharply on a sink or countertop to release air bubbles which may form on the film surface. This will allow the developer to reach all parts of the film.

5 / agitate the tank

Cap the tank and hold it with your thumb on the cap. Then gently turn it over and back continuously for 30 seconds. (The Kodak tank cannot be inverted; swing this tank in a gentle, figure-8 pattern.) Repeat for 10 seconds each minute.

6 / maintain the temperature

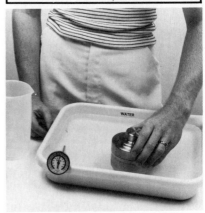

After each agitation cycle, return the tank to the water bath.

/ continued ⟶

7 / pour out the developer

Just before development time is up, remove the cap from the pouring opening **but do not remove the tank cover.** When time is up, empty the tank, discarding the used developer.

8 / pour in the stop bath

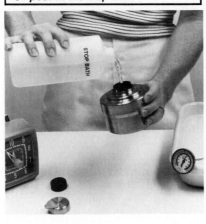

Fill the tank with water or stop bath. Be careful not to remove the cover.

9 / agitate for one minute

Tap the tank as before to release air bubbles, then agitate for one minute by inverting as before.

10 / discard the used stop bath

Although this solution may be reused, it is inexpensive and easier to store as a fresh concentrate. Don't remove the tank cover yet.

11 / fill the tank with fixer

Reset the timer for 5 minutes, pour in the fixer, and start the timer. Agitate occasionally as you did with the developer in step 5.

12 / pour out the fixer

Return the fixer to its bottle: it can be reused and later recycled.

13 / wash the film

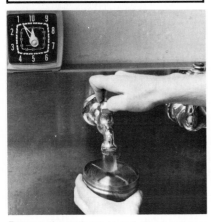

Remove the tank cover and direct a stream of water at 20°C (68°F) into the core of the reel. Let the tank overflow for one minute, then empty it.

14 / fill the tank with Perma Wash

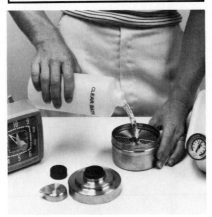

Immerse the film in this solution for one minute, then pour the Perma Wash back into its bottle (it can be reused until it becomes cloudy). Kodak Hypo Clearing Agent may be used the same way.

15 / wash the film again

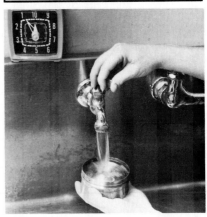

Let the tank fill with water as before, and overflow for one minute (5 minutes if Kodak Hypo Clearing Agent was used in the preceding step). While the film is washing, prepare a tankful of wetting agent as directed on its label.

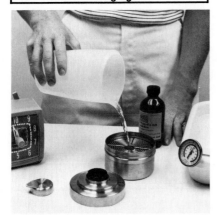

Empty the wash water and fill the tank with Photo-Flo solution. Turn the reel gently to stir the solution for about 30 seconds.

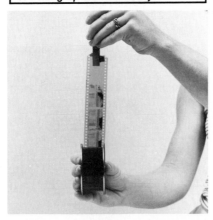

Quickly but gently unwind the film, lifting one end as you go. Attach a clip or clothespin to this end and hang the film in a dust-free location. At home, a tub or shower enclosure is a good place.

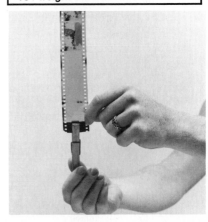

Attach a clothespin to the bottom of the film and let it hang undisturbed until dry. As the film dries it will curl, but it will flatten out again when completely dry.

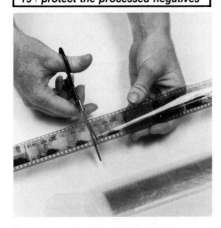

Cut the dry negatives into strips and slide them into negative preservers, one to a sleeve. **Handle the film only by its edges.**

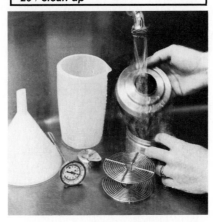

Wash everything you have used—all tank parts, reel or apron, thermometer and measuring cylinder, and rinse off the outside of your chemical bottles. Dry the reel or transparent Kodak apron before using them again.

KODAK D-76 OR ILFORD ID-11 DEVELOPER

Dilute the developer stock 1:1 with water (1 part developer stock, 1 part water). Use the diluted solution once, then discard it. Agitate the tank continuously for first 30 seconds, then for 10 seconds each minute thereafter.

	AGFA Agfapan 25 KODAK Panatomic-X KODAK Verichrome Pan ILFORD Pan F	AGFA Agfapan 100 KODAK Plux-X Pan ILFORD FP4	AGFA Agfapan 400 KODAK Tri-X Pan ILFORD HP5	
18°C	9 minutes	8 minutes	13 minutes	65°F
20°C	8 minutes	7 minutes	11 minutes	68°F
21°C	7½ minutes	6½ minutes	10 minutes	70°F
22°C	6½ minutes	6 minutes	9 minutes	72°F
24°C	6 minutes	5 minutes	8 minutes	75°F
25°C	5 minutes	4½ minutes	7 minutes	78°F

The above times will produce medium-contrast negatives. Increase times for more contrast; decrease them for less.

KODAK MICRODOL-X DEVELOPER

Dilute 1 part developer stock with 3 parts water, use the diluted solution once, and then discard it. Agitate tank continuously for first 30 seconds, then for 10 seconds each minute thereafter.

	AGFA Agfapan 25 KODAK Panatomic-X KODAK Verichrome Pan ILFORD Pan F	AGFA Agfapan 100 KODAK Plus-X Pan ILFORD FP4	AGFA Agfapan 400 KODAK Tri-X Pan ILFORD HP5	
18°C	17 minutes	15 minutes	Not recommended	65°F
20°C	15 minutes	13 minutes	Not recommended	68°F
21°C	13 minutes	11 minutes	19 minutes	70°F
22°C	12 minutes	10 minutes	18 minutes	72°F
24°C	11 minutes	9½ minutes	15 minutes	75°F
25°C	9 minutes	7¼ minutes	13 minutes	78°F

The above times will produce medium-contrast negatives. Increase times for more contrast; decrease them for less.

SUMMARY OF BLACK-AND-WHITE FILM PROCESSING

The best temperature for steps 1 through 7 is 20°C (68°F).

Step	Solution	How Prepared	Time	Agitation
1.	Developer	See tables above or instructions on package	See tables above	See text, page 83
2.	Stop Bath	28% Acetic Acid diluted 1 : 20, or plain water may be used	1 minute	Constant
3.	Fixer	As directed on label for films	5 minutes	Intermittent
4.	First Wash	Running water	1 minute	(Waterflow)
5.	Washing Aid	As directed on label for films	1 minute	Constant
6.	Final Wash	Running water	1–5 minutes	(Waterflow)
7.	Wetting Agent	Photo-Flo as directed on label	½ minute	Constant
8.	Drying	Air dry, not over 38°C (100°F)	Until flat	None

EVALUATING YOUR NEGATIVES

How do your negatives look? Film processing is a sequence of events rather than a single step, so each visible effect can have several causes, including those related to exposure in the camera. Most can easily be identified by checking several aspects of the processed film and by going back over your procedures. The examples shown on these pages compare good negatives with the most common problems encountered in film processing.

Three good negatives are shown below. The one on the left was made in contrasty lighting, with strong, dark highlights and clear shadow areas readily apparent. The negative on the right was taken in flat, even lighting, with no shadows apparent. The center negative represents a scene in hazy sunlight, typical of negatives that lie between the other two.

Each negative has shadows, highlights, and many gray tones which are visibly separated from each other. Detail is present in all areas; no significant part of the image is completely transparent or opaque. Technically good negatives, then, have these readily identifiable characteristics: a variety of gray tones with no single shade of gray dominant, and detail in all important areas, from highlights to shadows.

PROBLEMS RELATED TO CAMERA WORK

overexposure

Dark, gray tones everywhere in the image, with little variation or detail visible. **To correct:** Reshoot with smaller aperture or shorter exposure time.

underexposure

Highlights (skies) may have adequate tone but shadows are clear without detail. **To correct:** Reshoot with larger aperture or longer exposure time.

light leaks

Vertical (35 mm) or horizontal (6 cm formats) black streaks across film caused by light leaking into camera back or cartridge. **To avoid:** Load cameras only in subdued light, and make sure back closes firmly and completely.

clear film with edge numbers

Camera was improperly loaded so film did not advance, or shutter did not operate and film was not exposed. **To avoid:** Check these mechanical aspects of camera before reloading. If no edge numbers are visible, the developer was probably contaminated or exhausted.

PROBLEMS RELATED TO PROCESSING

irregular opaque or clear areas

These indicate improper loading of the tank or reel. Parts of the film touched, resulting in undeveloped (clear) or completely unprocessed (opaque) areas. This is a common problem with steel spiral reels. **To avoid:** Be sure reel is clean and dry, and practice loading it (page 80) with an unexposed roll of film which you can later discard.

cinch marks or "moons"

Small, dark, curved marks on negatives. Another common problem with steel spiral reels, caused by excessive handling of the film when loading. Creasing or bending the film leaves these pressure marks when it is developed; they appear as light "moons" in the print. **To avoid:** Handle the film only by its edges when you are loading the reel.

insufficient developer

Frames only partially developed. **To avoid:** Check tank capacity and measure enough developer to fill it completely.

trapped air bubbles

Small, round, clear spots randomly scattered. These are caused by air bubbles which were not dislodged from film when development started. **To avoid:** Tap the tank more vigorously (page 83, step 4).

uneven development

Streaks in sky near sprocket holes, or dark, uneven tones along film edges. Uneven development resulting from too much agitation. **To correct:** Take it easy when you agitate your tank.

overdevelopment

Highlights too dark but shadows still clear. Film developed too long, temperature of developer too high, or tank was agitated far too much. **To correct:** Check these factors again.

underdevelopment

Entire negative, including edge numbers, looks weak and gray. Film not developed long enough, developer too cold, or insufficient agitation was given. Can also be caused by exhausted, oxidized, or contaminated developer. **To correct:** Check above factors and time-temperature tables (page 86). If your developer is tea-colored, replace it with fresh solution.

insufficient fixing

Image is visible but lighter areas and borders have a milky-gray appearance. This signals incomplete fixing, perhaps from exhausted fixer. **To correct:** If you notice this immediately after processing, you can usually refix the film in fresh solution and rewash it without damage. If allowed to remain unfixed, however, the negatives will soon discolor and fade.

dust and fingerprints

Small, black, hair-like marks, most visible in clear areas such as skies, indicate dust. Fingerprints are more obvious. **To avoid:** Hang the wet film to dry in a clean, dust-free place, and don't handle it while it is drying. As soon as the film is dry, cut the negatives into strips and place them in preservers or envelopes.

HOW EXPOSURE AND DEVELOPMENT RELATE

The proof of a good negative, of course, is in the printing. Poor negatives like those shown above that exhibit errors in exposure or processing, will produce prints which only repeat these problems rather than overcoming them. Changing exposure and developing times, however, can sometimes improve a negative's tonal scale, and this, in turn, can make better prints possible.

What happens when exposure and development times are increased or decreased? The group of nine negatives on page 90 shows the result characteristic of each change. Compare each of the eight negatives

around the "ring" to the center one. Notice how *highlights* (darkest areas) of each tend to darken more as development lengthens (2), but lighten as development is shortened (8). Shadows (lightest areas of the negative) change similarly, but to a much less degree.

Exposure changes, on the other hand, affect *shadows* more directly; decreasing exposure (4) weakens them, whereas increasing exposure (6) makes them darker. Highlights are affected less by exposure changes than by development changes. Notice, too, how these factors interact. *Decreasing*

Negatives 2, 5, and 8 were all normally exposed. Negatives 1, 4, and 7 were given 1½ stops less exposure; negatives 3, 6, and 9 were given 1½ stops more than normal. Negatives 4, 5, and 6 were normally developed. Negatives 1, 2, and 3 were developed twice the normal time; negatives 7, 8, and 9 only half of the normal time. Compare the center negative, number 5 (which is normally exposed and developed), to the other eight around it. The differences are further discussed in the text.

1 / underexposed, overdeveloped

2 / normally exposed, overdeveloped

3 / overexposed, overdeveloped

4 / underexposed, normally developed

5 / normally exposed, normally developed

6 / overexposed, normally developed

7 / underexposed, underdeveloped

8 / normally exposed, underdeveloped

9 / overexposed, underdeveloped

A

B

Subject with moderately high contrast. **A:** *Print from normally exposed, normally developed negative.* **B:** *Print from overexposed, underdeveloped negative.*

C

D

Subject in open shade, where contrast is low. **C:** *Print from normally exposed, normally developed negative.* **D:** *Print from underexposed, overdeveloped negative.*

both exposure and development (7) produces negatives with little detail and poor tone separation. *Increasing both* (3) creates an excess of silver everywhere; printing times will be longer (next chapter), and tone separation does not improve.

However, these same factors can be played off against each other with useful results. For example, when film is overexposed and underdeveloped (9), shadows and highlights both retain detail and tone separation. This procedure is helpful when the subject is very high in contrast (**A** and **B**). When the exposing light is flat, as on an overcast day, or when subject values are similar throughout the picture, underexposing and overdeveloping the film (1) extends the tonal range of the negative, and a richer, more lively print will result (**C** and **D**).

These procedures work well with most black-and-white films and general-purpose developers. They will also work with color slide (transparency) films (page 190), but not with color negative materials. Changing the developing time of color negative films causes undesirable color changes that make good prints difficult or impossible to obtain from them (page 191).

THE CHEMISTRY
OF PHOTOGRAPHIC PROCESSING

Development

As we noted earlier, the first step of processing is to make the latent image visible, and this is known as development. The developer contains several chemicals dissolved in water. Its most important ingredients are called *developing agents*, and their task is to reduce the exposed silver bromide crystals to silver metal by causing these exposed crystals to disassociate their constituent ions. To do this, the developing agents give up some of their chemical energy to the silver ions in those crystals, producing silver metal; in the process, the developing agents themselves are oxidized to a less active state. Development begins at the sensitivity specks in each exposed crystal (page 75). Like most chemical reactions, it proceeds faster as the temperature is raised. The longer the developer works on the film, the more it breaks down the exposed crystals of the latent image to produce silver metal.

The developing agents used most often today in black-and-white processes are hydroquinone, Metol (Elon), and Phenidone.* Hydroquinone produces intense black tones in a negative. Metol and Phenidone work more softly, and produce many shades of gray. Most modern developers therefore combine Metol or Phenidone with hydroquinone; this combination works better than any of the developing agents used alone, and produces an ideal range of densities and contrast in most films and papers.

Almost all developing agents work best in an alkaline environment, usually provided by the addition of sodium carbonate, sodium hydroxide, or borax to the solution. In such alkaline solutions, developing agents have a tendency to oxidize, or combine with oxygen from the air, and this weakens their ability to reduce silver bromide. Sodium sulfite is commonly used to retard this oxidation. When present in large quantity, as in D-76 developer, sodium sulfite also tends to reduce the size of silver grains in the emulsion and thus contributes to a fine grain effect, but it is primarily a preservative.

Most developers also contain potassium bromide, which prevents the developing agents from acting on unexposed silver bromide crystals and thus prevents indiscriminate silver formation unrelated to the latent image. Such non-image silver is called *fog*; the potassium bromide thus functions as an antifoggant.

Typical developing solutions, then, contain developing agents, an alkali, a preservative, and an antifoggant.

*Elon, Metol, and Phenidone are trademarks.

Replenishment

If a developer is used and reused, the strength of its developing agents and alkali diminishes, while the amount of bromide increases. Adding a *replenisher* solution to the used developer corrects this imbalance and restores the developer to its original activity level. Replenishers therefore contain somewhat higher concentrations of developing agents and alkalis than developers do; potassium bromide, on the other hand, is often omitted from replenishers since the used developer usually contains enough of it already. By carefully adding a replenisher solution in proportion to the amount of film developed, you can greatly extend the capacity and useful life of many developers, especially where large quantities of solution are involved.

Fixation

Fixers must dissolve the silver bromide in the emulsion without affecting the silver metal forming the image. Sodium thiosulfate has been used for this purpose for many years, but ammonium thiosulfate works faster and washes out more readily.* Either compound converts the silver bromide to silver thiosulfate, which is highly soluble and easily washed out of the gelatin if the concentration of silver is not excessive, that is, if the fixing solution is not overworked.

A good way to avoid overworking the solution, especially when fixing prints, is to use two fixing baths in succession, dividing the total fixing time between them. In a two-bath process, most fixing occurs in the first bath while the second acts as insurance to fully dissolve undeveloped silver salts. The first bath thus does the "heavy" work and exhausts more rapidly. When its capacity has been reached (as determined by a simple chemical test available from Kodak and other manufacturers), it is replaced by the fresher second bath, and a new second bath (with full capacity) is prepared. With this arrangement, about twice the usual number of films or prints can be treated. For large volumes of work, then, the two-bath fixing method is both more efficient and less expensive. But even if only a few films or prints are involved, the method helps to produce more permanent images.

Most fixers also contain aluminum to harden the gelatin emulsion, typically in the form of potassium aluminum sulfate (potassium alum). Since alum hardens best in an acid solution, acetic acid or boric acid also is added, and sodium sulfite is included to prevent the precipitation of colloidal sulfur.

*Sodium thiosulfate was used to dissolve silver salts as early as 1819 by Sir John Herschel, who called it, inaccurately, "hyposulphite of soda" (see Chapter 2). Today photographers still refer to it as "hypo." Correctly speaking, "hypo" is sodium thiosulfate, but the term is loosely applied to any fixing solution.

Fixing baths, then, typically contain four ingredients: a thiosulfate to dissolve the silver salts, alum to harden the gelatin, an acid to make the hardener efficient, and a preservative to keep the solution clean-working.

Washing

Washing insures survival of the silver image by displacing the thiosulfates and other dissolved compounds from the film or paper. A steady flow of fresh water will diffuse most of the thiosulfates from a gelatin emulsion, but paper fibers tend to release thiosulfates much more slowly. Raising the temperature speeds up this process, but introducing sodium sulfite, sodium chloride, or similar salts to the unwashed material dramatically increases the displacement rate of the thiosulfates, particularly from paper fibers, and thus makes the subsequent washing much more efficient. In practice this saves time and water. Sea water, which contains such salts, may be used for washing films and papers, but it must be followed by a fresh water wash to remove the sea salts.

Commercial washing aids such as Perma Wash, Hypo Clearing Agent, and other similar products are more convenient. Some of these products are called hypo eliminators, an attractive but erroneous label. Such products eliminate nothing, and in fact add their own dissolved chemicals to those already in the unwashed film or paper. Although they shorten the washing process and improve its effectiveness, they are not substitutes for it. Washing is the only effective way to remove dissolved chemicals and thus make the silver image permanent.

The fixing and washing measures outlined above will insure a chemically stable photographic image, capable of surviving long enough for most applications. If negatives or prints are to be preserved for half a century or longer, however, archival processing methods must be used. Details of such methods are beyond the scope of this introductory book, but an excellent reference for them (Weinstein and Booth) will be found in the bibliography under General Works, and an Archival Processing Kit for black-and-white prints is currently marketed by Ilford.

RECYCLING THE SILVER

As fixing baths are used over and over, they accumulate increasing quantities of silver thiosulfate and other soluble silver compounds. This growing concentration of silver represents an important economic resource. Long a valuable element, silver is now a critically scarce one as well, and its continued availability for photographic use depends in part on recycling this costly metal. Since used fixing baths are a convenient source of it, reprocessing these solutions to remove the silver is a useful conservation measure.

Like other heavy metals, silver in high concentrations can be harmful to bacteria used in sewage disposal systems. By removing it from fixing solutions before discarding them, we not only help to conserve a rapidly diminishing resource but we also reduce the pollution of our water systems.

Silver is removed from used fixing baths by electrolysis. Recovery systems are available from Kodak and other manufacturers. Although not practical for small volumes of fixer, such as an individual home darkroom would likely produce, these systems are used by most commercial studios and processing laboratories, and by many school and college departments where the volume of fixer is sufficient to warrant recovery. Remember: the silver can be recovered only if the used fixer is saved.

HANDLING PHOTOGRAPHIC CHEMICALS

Most photographic chemicals are safe to handle if used with a little common sense. Keep them out of your mouth and take care not to splash liquids in your eyes. Powdered chemicals should be handled in adequately ventilated areas so that their dust does not hang in the air. Spills of any kind should be wiped up or rinsed away immediately.

Some developers, particularly those containing Metol, may irritate the skin of some people on contact. This allergic reaction can usually be avoided by using tongs or by wearing rubber gloves. In severe cases, of course, a physician should be consulted.

When you prepare chemicals, store them in glass or hard plastic bottles with tight-fitting plastic caps. Always label and date each bottle so you will know the freshness of each solution. Unused developers can often be kept several weeks (see product labels or literature for specific data), while most stop baths and fixers can be stored for a month or two without difficulty.

Many developers are mixed as *stock solutions* to be diluted with water when used. Stock solutions keep better than diluted ones, and require less space. Labels should always indicate whether a bottle contains a *stock solution* (concentrate) or a *working solution* (ready to use). And since developers readily oxidize, store them in filled bottles; transfer smaller quantities to smaller bottles as you use them. Developers kept in partially filled jugs with large amounts of air inside quickly go bad.

Finally, keep all tanks, trays, measuring cylinders, and other chemical handling equipment spotlessly clean. The simple habit of washing every utensil after each use will go a long way toward making your darkroom a clean and healthy place in which to work.

6 PRINTING AND ENLARGING

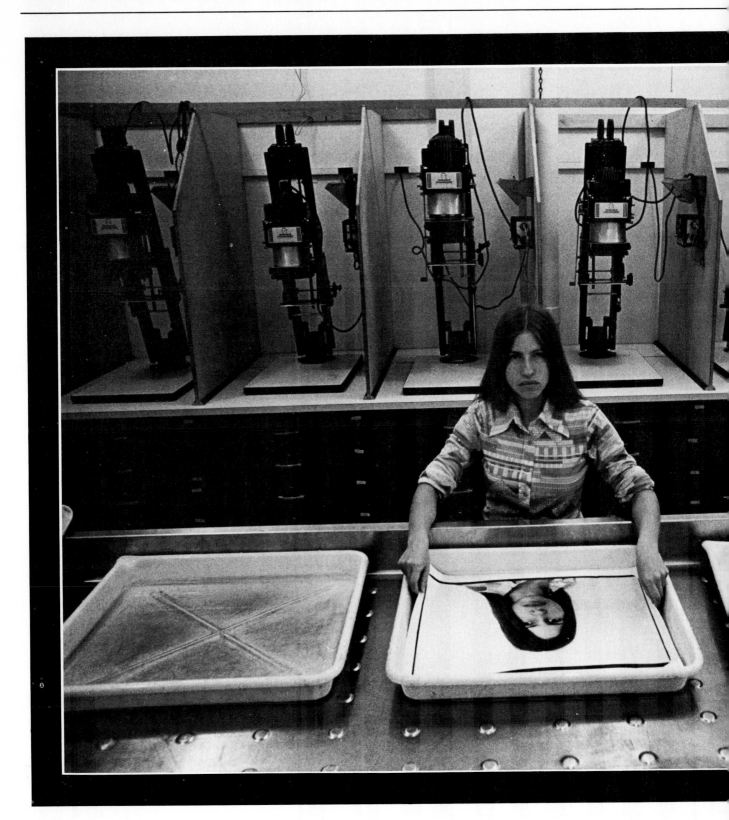

Lorna Reichel: [*untitled*], 1977.

If visualizing a photograph seems to be an art, and exposing and processing film a science, nowhere in photography do these concerns come together more directly than in making the print. The experience of making a fine photographic print is both a sensitive visual exploration and a disciplined scientific process. Like processing film, printing involves an orderly chemical sequence, but it also offers us the opportunity to be creative and selective in much the same way that camera work does.

Photographic printing has all the attraction of traditional print making by other means, such as screen printing, lithography, and engraving. All of our creative effort can be applied to make an individual statement, yet once arrived at, that statement can easily be duplicated. This principle has been fundamental to photography since Talbot produced the first negative; even if only one print is desired, the capacity for duplicates is there.

Furthermore, contemporary photographers have produced a rich variety of work which has blurred traditional boundaries between print-making processes. Screen printing, lithography, etching, and engraving are freely combined with the photographic process. This chapter, however, is concerned with a contemporary approach to traditional, black-and-white, silver print making. Other processes of current interest that are not too complex are discussed in Chapter 10, and color printing is briefly outlined in Chapter 12.

In photographic printing we customarily take a *negative*, whose light and dark values are reversed from their original order, and make *another negative* image by

passing light through the first. A negative of a negative, of course, is a *positive;* both terms, in fact, were given us by Sir John Herschel in 1840 and we still use them today.

THE DARKROOM

A darkroom is required for printing and enlarging, and typically it is organized into dry and wet areas, a functional division which should be observed at all times. The enlarger is the major item in the dry area (see illustration). The other items shown—a safelight, package of photographic paper, contact frame (or enlarging easel), timer, contrast-control filters, dusting brush, and, of course, the negatives to be printed—complete an efficient, workable setup.

The wet area contains the trays of chemicals and related items used to process the prints (see illustration). Although a sink with running water makes this area more efficient, the primary requirement is

Darkroom dry area setup.

1. Enlarger.
2. Safelight.
3. Photographic paper.
4. Contact frame (for contact prints) or enlarging easel (for enlargements).
5. Timer.
6. Contrast-control filters.
7. Camel's-hair brush (for dusting).
8. Negatives to be printed.

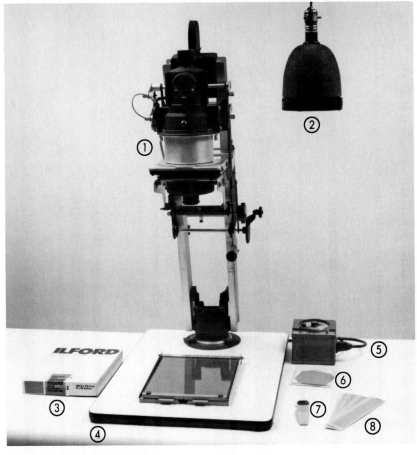

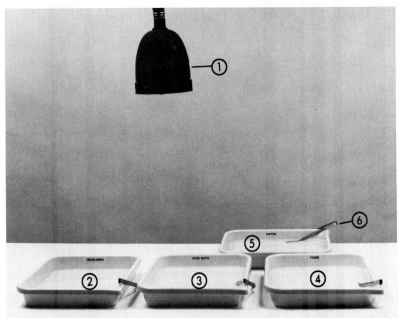

Darkroom wet area setup.

1. Safelight.
2. Tray of developer.
3. Tray of stop bath.
4. Tray of fixer.
5. Tray of water.
6. Print tongs in each tray.

a water-resistant table; washing and drying the prints can be done elsewhere in ordinary light. The darkroom should also have adequate ventilation— at the very least, an exhaust fan designed so it will not admit light.

SAFELIGHTS

The entire darkroom should be light-tight, or capable of total darkness. If this is assured, white walls will provide maximum reflectance for safe illumination inside. Most black-and-white photographic papers are sensitive primarily to blue light, and they may therefore be safely handled in yellow or orange illumination provided by safelight lamps with proper filters.*

There are two types of safelights in general use. One consists of a filter or colored glass in a lamp-house containing an ordinary light bulb of low wattage. The other type uses the intense but pure yellow light of a sodium-vapor lamp, and is more suitable for large darkrooms. It is important to note that safelights, as a rule, are not absolutely safe. Most will expose enlarging paper left under them too long or placed too close to the lamp. For general black-and-white work, equip the safelight with a 15 watt bulb and a Kodak Wratten OC filter, and position it as least 1.2 meters (4 ft) above the trays or enlarger table.

THE ENLARGER

The cornerstone of virtually all contemporary photographic printing processes is the enlarger. A good one can be a remarkably versatile tool, serving numerous functions in addition to its more obvious ones. A poor enlarger, on the other hand, will only serve to limit your vision in the same way that any shoddy tool affects the work done with it. Furthermore, using an inadequate enlarger can negate all the effort and fine craftsmanship you expended earlier to visualize your picture and obtain a good negative.

The enlarger works like a camera in reverse. Instead of reducing the larger dimensions of the real world to a few square inches of film as the camera does, the enlarger expands the image produced by the camera so that we can discover all that the picture contains, give it our personal interpretation, and print it large enough to create an impression in others who will view it. Because modern cameras increasingly rely on small formats such as 35 mm, the enlarger has become a very important link in the sequence of tools we use to move from our original impression of an object to the final expression of its image.

*Exceptions are papers designed for making black-and-white prints from color negatives. These papers are panchromatic, and must be handled and developed in total darkness.

Omega Pro-Lab 4×5 Enlarger, Courtesy Omega Division, Berkey Marketing Companies.

Beseler 67C Enlarger, and Beseler 23C II Enlarger. Beseler Photo Marketing Co.

The enlarger is a vertically oriented projector with the same essential parts that a camera or any other projector has: a lens to form and project the image, a frame to hold the negative in the correct position, and a bellows or cone to connect them. In addition, it has another key part not found in cameras: a source of light.

Any good enlarger has three essential characteristics:

1. It must project a clear, sharp image of all parts of the frame.
2. It must distribute light evenly over the entire projected area.
3. It must be sturdy, and free from vibration or slippage of its adjustable parts.

Condenser Enlargers

Most enlargers contain a milky-white light bulb as the illumination source [6-1]. This softens the light, which is then typically collected by a set of *condenser lenses* that spread it evenly across and direct it straight through the negative below. In some condenser enlargers, if you change negative sizes you may have to replace the condensers with larger or smaller ones, or reposition a *variable condenser* within the enlarger head. With a fine quality enlarging lens, this arrangement can project images that have excellent contrast and crisp definition. Condenser enlargers are efficient and popular; those shown on page 97 are a few of several excellent models available.

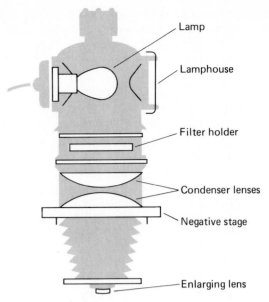

[6-1] *Optical system of a typical condenser enlarger.*

Diffusion Enlargers

Some enlargers do not use a condenser system. Instead they pass the light through a sheet of opal or ground glass which scatters and further softens it before it reaches the negative [6-2]. Diffusion enlargers, as these are known, project less contrasty images than condenser types do, but the diffusion system can hide small scratches and similar imperfections in the image, and grain is less noticeable with it. Although this arrangement results in some loss of fine detail, it often produces elegant tonal quality in the print.

Variable condenser in enlarger head.

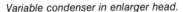

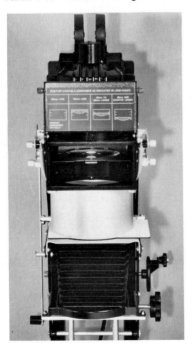

[6-2] *Optical system of a typical diffusion enlarger.*

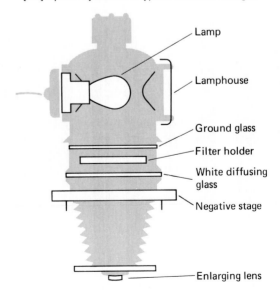

Enlargers designed primarily for black-and-white photography have a filter holder in the lamp or condenser housing into which you must place colored filters needed to work with variable-contrast papers. This same filter holder can be used to adapt the enlarger to color printing (page 192).

Variable-contrast printing filters are supplied in two forms: as thin, dyed, acetate squares which must be cut to fit the enlarger's holder, or as flat, plastic frames which usually fasten under the lens instead. Acetate filters are inexpensive but easily soiled; the other form is more durable but more costly. Either kind is satisfactory for general work, but the acetate form is used in the lamphouse where it colors the raw light before it reaches the negative; there it does not interrupt the projected image, and thus cannot soften or distort the latter. Either type, of course, must be kept clean.

If an enlarger is designed primarily for color printing, it will have a set of three colored filters built in. These filters, adjustable in intensity, make color printing efficient, and they can also be set to do black-and-white work. This kind of enlarger is further explained in Chapter 12.

The enlarging lens is a special type of lens (page 206) with f/ stops just like those on the camera. If you have a fine quality lens on your camera, you should have an equally fine one on your enlarger. An excellent enlarging lens can cost as much as the enlarger itself.

The focal length of the enlarger lens must be properly matched to the size of the negative (see table). With shorter focal lengths, the corners of the projected image may be unsharp or cut off entirely. Longer focal lengths, on the other hand, provide greater coverage and a straighter optical path for the projected image, and this helps to insure sharpness from corner to corner. If the focal length is too long, however, magnification will be limited. As a general rule, for quality work, the focal length of the enlarger lens should be somewhat longer than the diagonal dimension of the negative.

Used enlargers and enlarging lenses are available from many photographic dealers. Like used cameras, they can be a good investment for a beginning photographer. Check them with care for the essential characteristics previously listed.

FOCAL LENGTH OF ENLARGER LENSES

Negative Size or Format	Focal Length of Enlarger Lens
35 mm	50– 65 mm
4.5 × 6 cm (645)	75– 80 mm
6 × 6 cm (2¼ × 2¼ in.)	75– 80 mm
6 × 7 cm (2¼ × 2¾ in.)	90–100 mm
4 × 5 in.	135–150 mm

PHOTOGRAPHIC PAPERS

Photographic papers are manufactured in great variety, and there are two major groups of them for black-and-white work.* As we might expect, papers are layered products similar in many ways to film [6-3]. The most prominent layer is the paper base, which serves as a support for the light-sensitive emulsion, and which also distinguishes one major group of photographic papers from the other.

One type of base is produced from wood pulp that has been processed to high standards of purity and quality. *Fiber-base paper*, as this is known, can withstand long immersion without disintegrating as ordinary paper would, but because this paper absorbs water and chemicals during processing, it requires careful washing to remove these solutions.

The other type of base uses a similar fiber paper stock coated on both sides with polyethylene resin. These coatings make the base waterproof, effectively sealing it from chemical penetration. *Resin-coated (RC) paper*, as this type is called, has other advantages which reduce its processing time and make it popular for many kinds of photographic work.

Fiber-base papers have a layer of barium sulfate (baryta) applied to them to give them a smooth, white surface on which the emulsion is coated. Resin-coated papers achieve their white surface from titanium dioxide pigment in the upper resin layer.

Fiber-base and RC papers each have several other identifying characteristics, and because there are so many kinds, these features are listed here as an aid

*Papers for color photography are discussed in Chapter 12.

[6-3] *Cross-sections of photographic papers.*

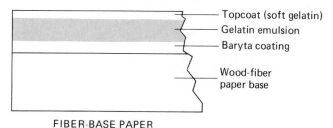

FIBER-BASE PAPER

- Topcoat (soft gelatin)
- Gelatin emulsion
- Baryta coating
- Wood-fiber paper base

RESIN-COATED (RC) PAPER

- Topcoat (hard gelatin)
- Gelatin emulsion
- White polyethylene resin
- Wood-fiber paper base
- Clear polyethylene resin

to understanding labels and selecting products. The best guide to how an image will look on a particular paper, however, is a sample book of papers which many photo dealers carry.

PHOTOGRAPHIC PAPER CHARACTERISTICS

1. Weight, the thickness of the paper base. Among fiber-based papers, *single weight* is commonly used for commercial work. *Double weight* is more expensive but more durable, permitting easier handling of large prints without damage. A few other weights are available for special purposes. Resin-coated papers are usually supplied on a *medium-weight* base.

2. Tint, the color of the paper base. White is standard, but a few fiber-base papers are made in others such as cream, ivory, and buff.

3. Speed. Just like films, some papers are more sensitive to light than others. ISO numbers used for films are not applied to papers, but similar data usually is supplied with products. Paper emulsions contain crystals of silver bromide and silver chloride, or chloride crystals alone. Silver chloride emulsions are very slow and are used for contact printing (where the negative and print are the same size) with bright light sources. Other papers contain both silver chloride and silver bromide, and are used for enlarging. If chloride crystals dominate the mixture, the paper is moderately slow and warmish in tone, but with bromide crystals dominant the paper is cold-toned and fast. These papers are also used for contact printing under the enlarger.

4. Tone, the color of the developed image. This varies from a warm, brown-black through neutral to cold, bluish-black. Slightly warm-to-neutral blacks are typical.

5. Surface Texture. This affects reflective characteristics of the paper and therefore its depth of tone and image contrast. Glossy finish is the most common and versatile. On fiber-base papers, it can be dried to a high gloss or a lustrous, brilliant finish, and for this reason it is favored by many workers. Other surfaces such as matte, semi-matte, luster, and pearl are widely used, and special textures (silk, tweed, tapestry) are available on a few fiber-base papers used mainly in the portrait trade.

6. Contrast, the exposure scale or printing grade of the paper. *Graded papers* are made in several contrasts numbered from 0 (very soft) through 6 (extremely hard). Grade 2 is considered medium or normal contrast. To get a useful range you must buy separate packages of each contrast grade needed.

Variable-contrast papers are adjustable from soft through hard with colored filters. Thus only one package of paper is needed. Graded papers produce a somewhat greater range of contrasts, but variable-contrast papers are more economical for general work. For more discussion of contrast, see pages 106–109.

7. Processing Mode. Most photographic papers are intended for wet processing by the methods outlined later in this chapter. A few types, however, are designed for *stabilization processing,* which produces a damp-dry print in 10–15 seconds. The image is *stabilized* rather than fixed; it will last long enough for many uses, but is not permanent.

Some resin-coated papers have developing agents (page 92) incorporated in the emulsion for high-speed processing in compact machines. These papers, which produce permanent images in a minute or less, are rapidly replacing stabilization materials in many commercial applications.

NOTE: *For the procedures that follow, the primary choice is* **variable-contrast, resin-coated photographic paper.** The ease of handling this material is helpful for a beginner, and the time saved by its quick processing can be put to productive use. In a typical class situation where time is limited, more printing, hence more learning, can be accomplished. Moreover, the variable-contrast feature makes possible one-box-fits-all economy.

At this writing, the following black-and-white, variable-contrast, RC papers are available:

Ilford Ilfospeed Multigrade: glossy and pearl surfaces.
Kodak Polycontrast Rapid II RC: glossy (F), lustre (E), and matte (N) surfaces.

MAKING A CONTACT SHEET

A contact sheet is a print made by placing the negatives so that their emulsions and the paper emulsion are in firm contact with each other, and then exposing the paper through these negatives. Contact sheets are useful as a convenient record of your work and as a means for selecting those negatives that will make the best enlargements. An entire roll of 120 or 35 mm film can be printed on a single 8 × 10 in. sheet of photographic paper. You'll save much time and material in later steps by first making contact sheets of your work and studying them.

To work efficiently, besides an enlarger you will need a *contact frame* or *film proofer.* If the latter is not available, you can easily improvise one with 8 × 10 in. pieces of polyurethane foam and plate glass, both ¼ in. thick. Set up the enlarger, timer, and contact frame as illustrated on page 96. Clean the contact frame glass with a damp paper towel or soft cloth.

Exposed prints are processed through much the same sequence as film is handled, and four trays will be needed for the wet area of the darkroom, as shown on page 96. First comes development, to render the latent image visible. Kodak Dektol is a standard paper developer. Mix it to make a *stock solution* (see glossary), then dilute the stock as needed to prepare a working solution for the first tray. Use 1 part Dektol stock solution to 2 parts water (1:2). (If you use Ektaflo Developer Type 1, which is in concentrated liquid form, dilute this 1:9 to make a working solution.) Fill the tray about an inch deep.

Because most developers are alkaline, a mild acid is used as a *stop bath* to stop development when it has fully revealed the image. Use an indi-

cator stop bath as directed on the label, or dilute 50 ml of 28% acetic acid with 1 liter of water (1 part 28% acetic acid with 20 parts water).* Pour this solution into the second tray.

Fill the third tray about half full of fixer solution.

Any kind of fixer (prepared as the label directs for paper) may be used.

The fourth tray should be filled with water. Use this tray to collect and hold fixed prints for washing and drying later.

*To prepare a 28% solution of acetic acid, dilute 3 parts of glacial (99.5%) acetic acid with 8 parts of water. *Glacial acetic acid is poisonous and irritating. Protect your eyes from splashes and observe all precautions on the label. Always pour the acid into the water, never the opposite.*

MAKING A CONTACT SHEET

1 / set up the enlarger

Place the empty negative carrier in the enlarger and a medium contrast filter (Kodak No. 2 or 2½, Ilford No. 3 or 4) in its holder.

2 / illuminate the contact frame

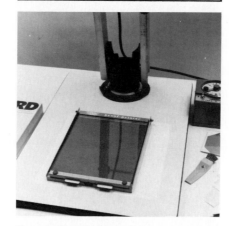

Turn on the enlarger and focus a rectangle of light about 10 × 12 in. on the baseboard. Center the contact frame in this area. Now turn off the enlarger light.

3 / set the lens aperture

If you have 35 mm negatives, set the lens at f/8. Use f/16 for 120-size film. Now **turn off the room light.**

4 / take out a sheet of paper

Remove a sheet of paper from its package. Reclose the package at once.

5 / put the paper into the frame

One side of the paper is shiny and usually curls inward; this is the **emulsion side** and it must always face toward the enlarger light. Place it **face up** on the contact frame pad.

6 / lay the negatives on the paper

Dust each negative strip and lay it **face down** on the enlarging paper. The face or emulsion side of the negative curls slightly inward as a rule. (Let the safelight reflect off each side; the emulsion is always the **duller** of the two sides.) Some contact frames let you clip the negative strips at one end under the glass.

/ continued ⟶

7 / expose the paper

Lower the glass over the negatives and paper, and give a trial exposure of 10 seconds. Subsequent prints may require more or less time.

8 / remove the paper

Carefully remove the exposed paper from the frame. Try to leave the negatives undisturbed so you can make another print if the first one is too light or too dark.

9 / develop the print

Slide the exposed print **face up** into the developer tray, making sure it is quickly and evenly wet.

10 / rock the tray slowly

Rock the tray slowly by repeatedly lifting one corner an inch or so to keep the developer in motion for 1 to 1½ minutes.

11 / lift, drain, and transfer the print

When time is up, lift the print with tongs, drain it a few seconds, and transfer it to the stop bath tray.

12 / place the print in the stop bath

Rock continuously in the stop bath for 15 seconds, then transfer the print to the fixer.

13 / fix for 2 minutes

Treat the print in the fixer for 2 minutes, agitating periodically. Then transfer it as before to a tray of water.

14 / rinse the print in water

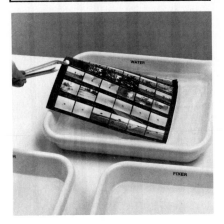

Rinse the print briefly in the water tray. You may leave it there while you make others, and treat all of them together through remaining steps. Room lights may be turned on now if your paper package is closed.

15 / evaluate the contact sheet

Examine the wet contact sheet in room light for those frames most likely to produce good enlargements. If you remove a print from the sink or wet area for inspection elsewhere, always carry it in a tray to avoid dripping chemicals on floors.

Look for frames that convey the strongest impression you have about your subject. An image with these qualities will usually be evident even in its small form on a contact sheet, although you may have to use a magnifier to see all details. Additionally, look for sharply focused frames with a good balance between highlight and shadow tones. At first, these will be the easiest frames to print successfully, and the fun and confidence you'll get from making a good enlargement are rewarding indeed.

When you have made your choices, the contact sheet may be returned to the water tray for continued processing with the enlargements later.

MAKING A TRIAL ENLARGEMENT

1 / place the easel on the baseboard

Replace the contact frame with the enlarging easel. Some easels make prints of one size only, such as 8x10. Others have sliding bands which can be adjusted for other shapes.

2 / insert the negative

Remove the negative carrier from the enlarger head and carefully center the selected negative in it **emulsion side down.**

3 / clean the negative

Lightly dust each side with a negative brush to remove dust particles. If not removed, they will enlarge too.

4 / position the carrier in the enlarger

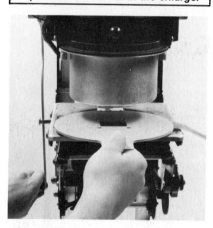

Lift the lamphouse and center the negative carrier under the condenser lenses.

5 / open the lens aperture fully

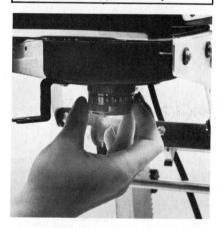

Open the lens aperture to its largest setting to give the most light for focusing and framing. Turn off the room light and switch on the enlarger light.

6 / adjust the enlarger head

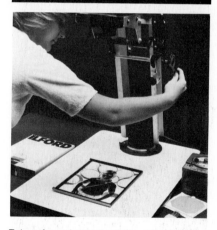

Take a few minutes to discover how the enlarger works. Raise or lower the entire head (rear knob) to make the image larger or smaller.

7 / check the focus

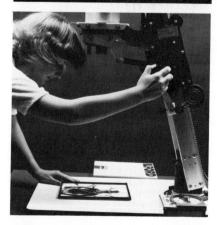

Focus the lens (larger knob) and note how the enlarged image quickly becomes sharp, then unsharp again.

8 / adjust the easel

Shift the easel around on the baseboard to frame the best part of your image rather than the whole picture area. Just as you did with the camera, fill the frame with important elements and crop out nonessentials.

9 / recheck the focus

Look for fine details or lines in the image, and be sure they are sharp. A focusing aid, shown here, may be helpful; focus until the grain is clear.

/ continued ⟶

10 / reduce the lens aperture

Stop down the lens about halfway (to about f/11). Then turn off the enlarger light.

11 / load the easel with paper

Insert a fresh sheet of enlarging paper in the easel and lower the bands. Reclose the paper package.

12 / set the timer

Set the timer for 2 seconds to make a series of exposures.

13 / make the first exposure

Cover most of the easel with a piece of cardboard, revealing about an inch of the paper at one end. Give a 2-second exposure.

14 / make the next exposure

Move the cardboard aside about an inch and give a 2-second exposure again. Be careful not to touch the paper in the easel.

15 / repeat across the sheet

Continue uncovering the sheet in 1-inch steps, giving each step a 2-second exposure. Then push the button two more times to add a 4-second exposure to the entire sheet.

16 / remove the exposed sheet

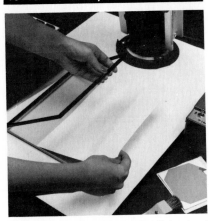

The series of exposures on it will begin at 6 seconds and increase in 2-second steps.

17 / develop the trial enlargement

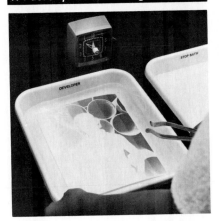

Develop the print just as you did the contact sheet (page 102) for 1½ minutes with continuous agitation. Watch the time carefully; you want accurate information now.

18 / stop development, then fix the print

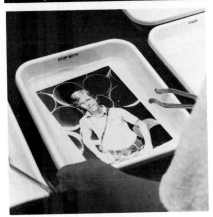

Rinse the print in the stop bath for 15 seconds, then transfer it to the fixer for 2 minutes, with occasional agitation.

19 / examine the test print in room light

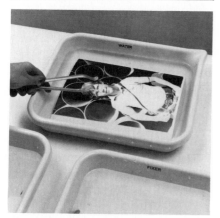

Rinse the print in water and evaluate it in white light. A good test print will look too light at one end and too dark at the other.

20 / determine the best exposure

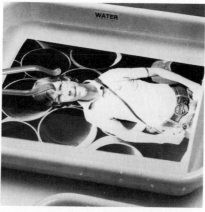

Count from the lightest step, which was 6 seconds. Darker steps represent longer times. If the entire print is too dark, make another with a smaller aperture (f/16 instead of f/11). If the print is too light everywhere, use a larger aperture.

21 / make a verification print

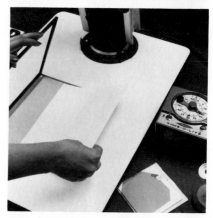

Reset the timer to the chosen time and turn off the room light. Insert a new sheet of paper in the easel and expose it. Some photographers call this a workprint.

22 / process this print

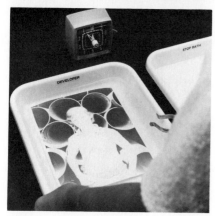

Develop the print exactly as you did the test print earlier. Touch it as little as possible with the tongs as you gently agitate the tray.

23 / transfer the print as before

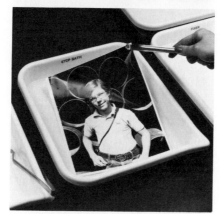

Lift the print with tongs, drain, and transfer to the stop bath and fixer as before, agitating gently in each tray. If the print is too light, make a new one with more exposure; if too dark, with less. Don't change the developing time.

24 / fix the print

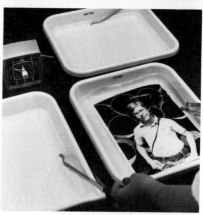

Immerse the print in the fixer and agitate the tray gently for 2 minutes. When fixing is completed, room lights may be turned on if your paper box is tightly closed.

25 / transfer print to the water tray

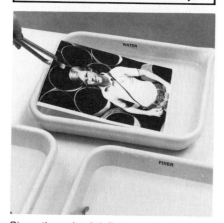

Rinse the print briefly to remove excess fixer, then transfer it to a larger tray for washing.

26 / wash the prints

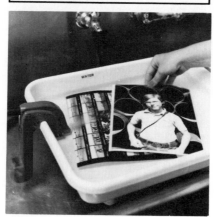

Wash RC paper for 4 minutes in running water. The tray siphon shown here, which attaches to any tray and faucet, is efficient and inexpensive. A continuous change of water in the washing tray is very important.

27 / remove surface water and dry

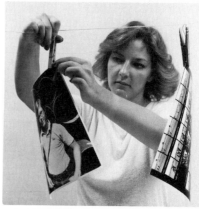

Sponge or wipe excess water from the print, then hang it from a corner with a spring clothespin to dry in the air. A hair dryer may be used to speed drying. Do not use belt dryers or blotters.

SUMMARY OF BLACK-AND-WHITE PRINT PROCESSING WITH RESIN-COATED (RC) PAPER

The temperature of all solutions should be about 20°C (68°F).

Step	Solution	How Prepared	Time	Agitation
1.	Developer	Dektol 1 : 2 or Ektaflo Type 1, 1 : 9	1–1½ minutes	Constant
2.	Stop Bath	28% Acetic Acid 1 : 20	15 seconds	Constant
3.	Fixer	As directed on label for prints	2 minutes	Intermittent
4.	Rinse	Still or running water	1 minute	Intermittent
5.	Wash	Running water (separate from above step)	4 minutes	Constant
6.	Remove excess water from print surfaces	Use squeegee or sponge		
7.	Dry	Air dry; do not use drum or belt dryers		

IMPROVING THE WORKPRINT

JUDGING PRINT DENSITY

Study the trial prints and workprints you have made. You can see that as you increase the exposure, you make the image darker. Shadows darken first, then middle tones, followed by even the brightest highlights. Increasing the exposure increases the print's overall darkness or *density*. Conversely, reducing the exposure reduces the overall density and makes the print lighter.

If a small change is indicated, change the *exposure time*; if a large change is needed, change the *aperture*. One stop larger will double the exposure; one stop smaller will cut it in half.

JUDGING PRINT CONTRAST

In the prints you have made you will note many shades of gray. Each gray tone represents a different exposure of the paper caused by different image tones in the negative from which the print was made. The range of these exposures actually given the print, from the darkest area to the lightest area within it, is its *exposure scale*. Ask any photographer what this is, however, and he'll say *contrast*, its visual equivalent.

We are all familiar with the contrast of a black-and-white TV picture, and we use the term the same way in photography. Take any photographic print and look for two things in it. First, find the lightest area in the picture that is important with respect to the subject and its meaning. This area may be large or small, but it must be important; not some insignificant background detail or patch of sky. Next locate the darkest area in the print that is similarly important, ignoring tiny dark shadows. *The difference between these lightest and darkest important areas is the contrast of that print.*

If this difference is great, as from near white to deep black, we call the contrast *high* or *hard. High contrast prints* appear to be dominated by black and white tones (see example). If this same tonal difference includes only a few shades of gray, however, we say the contrast is *low* or *soft. Low contrast prints* appear to have an overall gray cast (see example). They may be generally light or generally dark, but in either case you will notice an absence of white and black together in the same print.

We usually try to make a print that lies somewhere between these contrast extremes. A typical *medium* or *normal contrast print*, then, will contain blacks, whites, and numerous gray tones; the aim is to achieve a balance between them.

High-contrast print.

Low-contrast print.

Medium-contrast print.

Printed with a Kodak #1 filter.

ADJUSTING PRINT CONTRAST

Variable-contrast papers are made with two emulsions combined on a single base. One of them is sensitive to green light and produces low contrast images with many shades of gray. The other emulsion is sensitive only to blue-violet light and yields high contrast images with fewer gray tones but more intense blacks. Because the two emulsions are combined, they handle and process like a single coating.

When variable-contrast paper is used, as we have specified in these procedures, we change the contrast by changing the filter in the enlarger. This alters the color of the exposing light, thereby changing the paper's response.

Ilford Multigrade filters are numbered 1 through 7; Kodak Polycontrast filters are numbered 1 through 4 but they also include the half steps. Any brand of filters may be used with any brand of variable-contrast paper, although different brands of filters should not be intermixed since this may produce unevenly spaced contrast steps.

Earlier we recommended a medium-contrast filter (Ilford 3 or 4, Kodak 2 or 2½) for the contact sheet and first enlargement. Filters in the center of each set's range reproduce the exposure scale of a negative pretty much as is, without increasing or decreasing the contrast. Lower number filters always produce less contrast in the print; higher number filters produce more.

As you make the first print or enlargement from each new negative, look for these differences in tonal range. Make your first print with the mid-range filter (from which you can move up or down as indicated) unless you feel sure from viewing the negative that a different filter is needed. With a little practice you will be able to see these tonal differences in the negative before you enlarge it, or on the enlarger easel, and expose your initial trial print with the appropriate filter.

Here's a tip: time your exposure of the paper to produce a faintly detailed white in the highlights of the picture with full development. Having done that, if the shadows are too gray, reprint with a *higher number* filter; if the shadows are too black and too many details seem to be lost in them, reprint with a *lower number* filter. Exposure times with different filters are approximately equal, except when the highest numbered ones are used. These require longer times. The Kodak and Ilford filter sets contain a simple calculator for this purpose.

Printed with a Kodak #2½ filter.

Printed with a Kodak #4 filter.

OTHER WAYS TO CONTROL CONTRAST

Another way to control the contrast of your prints is to use graded RC paper. *Graded papers* are printed without filters in the enlarger, that is, with white light. They are single emulsion papers, made in several contrasts numbered from 0 through 6 or *extra soft* through *extremely hard*, respectively.

Low-numbered grades have long exposure scales. They require much longer exposures to produce a black tone than to yield a very light gray, and are best suited to high-contrast negatives which have a great range of tones in them.

High-numbered grades, on the other hand, have short exposure scales. They produce their black tones with relatively smaller increases in exposure than other grades do, and are therefore suited to low-contrast negatives which appear uniformly gray.

Intermediate grades, of course, are for negatives of medium or average contrast. These negatives usually contain a few weak shadows, a few dense highlights, and many shades of gray in between.

The table here shows graded RC papers currently available.

Graded RC papers require no filters, work equally well in condenser or diffusion enlargers, and span a greater contrast range than variable papers do. These are their major advantages. A single package, however, contains only one grade, so several packages must be kept at hand to deal with varied negatives.

On the other hand, with variable-contrast paper, one kind of paper can be used for both flat and contrasty negatives—a more economical method. Because they are so adaptable, variable-contrast papers are suited to both single-sheet and continuous-roll processing. In the latter use, individual prints are made in rapid succession on a continuous roll of paper, and processed in special equipment as a continuous strip. The pictures are cut apart automatically after they are dry.

GRADED RESIN-COATED PAPERS

Paper Name	Grades Available
Agfa Brovira Speed	1 through 5
Ilford Ilfospeed	0 through 5
Kodak Kodabrome II RC	1 through 5
Luminos Lumifast	1 through 4
Unicolor B&W Resin Coated Paper	1, 2, 3, and 6

Larry Gregory: Hancock Village, Massachusetts, 1976.

PRINTING ON FIBER-BASE PAPER

Many photographers who use resin-coated paper for commercial and routine work prefer *fiber-base papers* for making fine prints. These papers are made in a variety of surfaces, tones, and contrast grades, and in several weights and colors (page 100). They have long been standard photographic print materials.

Because of their varied characteristics, fiber-base papers can produce prints of great beauty, subtlety, elegance, and permanence. These papers contain emulsions of soft gelatin. This permits slower developing, which in turn allows some manipulation of the developing process to which RC papers do not respond. Many fiber-base papers react well to various chemical toning processes, giving the print maker additional control of the color of his image.

Fiber-base papers are exposed the same way resin-coated papers are, but from that point on the handling differs.

DEVELOPING

Standard paper developers such as Dektol produce neutral black tones on most papers, but other developers such as Selectol, Ektonol, or Ektaflo Type 2 may also be used. These give warmer tones.

Develop fiber-base papers in Dektol 1:2 for 3 minutes with constant agitation; this will allow the shadows of your picture to reach maximum black. With other developers, use the *maximum* recommended development time. If the print will be toned, however, shorter developing times (with longer exposures) will often produce better toning later.

STOPPING DEVELOPMENT

As with RC papers, an acid stop bath should be used with fiber-base papers. An indicator stop bath or a solution of 28% acetic acid diluted 1:20 is recommended.*

FIXING

Because these papers have soft gelatin emulsions, a hardening fixer must be used (most prepared fixers are the hardening type). A fresh, rapid-acting bath (usually sold as a liquid concentrate) will fix prints in about five minutes; slower fixers (prepared from powder) take up to ten minutes.

*To prepare the 28% acetic acid, see note on page 101.

With either type, overfixing should be avoided as this makes subsequent washing less effective.

If space permits, two fixing baths used in succession are better than one for processing fiber-base paper. Divide the total fixing time between the two baths (3 to 5 minutes in each) for more efficient and economical fixing.

CLEARING

Fiber-base paper, which has no resin layers to make it waterproof, absorbs large quantities of fixer. In addition, the baryta layer in these papers tends to retain thiosulfate ions from the fixer, further complicating their removal. Washing fiber-base paper, then, is a much more difficult job than washing resin-coated paper, and it requires additional processing steps. The first of these is a *clearing bath*.

Clearing baths usually contain a mixture of potassium and sodium salts which convert the thiosulfate ions remaining in the paper to more soluble forms without removing them. Typical products include Beseler Ultraclear HCA, Edwal Hypo Eliminator, Heico Perma Wash, and Kodak Hypo Clearing Agent. Directions for using these products usually call for the prints to be rinsed in running water to remove the excess fixer, then treated in the clearing bath for about three minutes, and followed by a wash in running water again to remove both the converted fixer and the clearing agent.

As we noted earlier, these so-called eliminators or clearing baths remove nothing from the paper. They simply make the retained fixer more soluble, thereby permitting its more efficient removal by the wash water in the *next* step. In practice, a 3-minute immersion in a clearing bath can reduce the washing time for fiber-base paper by 60–80%, saving both time and water. The step-by-step procedure which follows details a typical sequence using Heico Perma Wash.

WASHING

Washing, of course, removes all remaining soluble salts from the emulsion and paper base. Converted by the clearing agent, these salts now dissolve out readily, as does the clearing agent itself. A continuous change of water in the washing tray is necessary, and this can be achieved by a tray siphon (pictured here) which attaches to any tray and faucet, does an excellent job, and is inexpensive. Washers which rock or rotate are generally more efficient for large quantities of prints. Whatever the setup, it is desirable to remove some of the contaminated water from the bottom of the tank or tray, because fixer released from the paper tends to sink if the flow of fresh water through the container is not sufficient to remove it.

The weight (thickness) of the paper determines the washing time, as shown in the table on page 112. If single and double weight papers are washed together, the entire batch must be treated as if it were all double weight. Temperature is important, too. Release of fixer is impeded by cold water below 18°C (65°F), and additional time should be allowed. Temperatures above 25°C (77°F), on the other hand, permit efficient washing of paper but may soften the gelatin emulsion. The 18–25°C range is best.

Once a batch of prints has begun to wash, no unwashed prints may be added to it without recycling the entire batch for the full washing time.

Kodak tray siphon. Courtesy Eastman Kodak Company.

All times in minutes

First Wash or Rinse	Clearing Bath and Time	Washing Times		
		Single Wt. paper	Double Wt. paper	Mixed SW and DW paper
1	Beseler Ultraclear HCA 2 minutes	10	20	20
1	Edwal Hypo Eliminator 3 minutes	10	20	20
3	Heico Perma Wash 3 minutes	3	5	5
1	Kodak Hypo Clearing Agent 3 minutes	10	20	20
——	None	30	60	60

DRYING FIBER-BASE PAPER

Fiber-base papers may be dried by first removing the surface moisture from both sides of the prints and then placing them face down on clean, lint-free photographic blotting paper. A blotter roll, available from photo dealers, is convenient and practical (page 114, step 11). Or the damp-dried prints may be placed face down on clean cheesecloth or nylon window screen stretched over a wood frame. The "Open Air" archival print dryer, shown here, is one such device, portable and well designed. Glossy paper may also be dried in this manner to produce a smooth, lustrous surface without a high gloss, and this method is preferred by many artists.

When large quantities of prints are regularly processed—as in commercial, school, and college labs—heated rotary dryers are often used to dry prints continuously. Special procedures must be followed with any of these costly machines; pretreatment of prints in a conditioning solution such

"Open Air" archival print dryer. Courtesy Depth of Field: Photographic Innovation.

as Pakosol is often recommended to keep them from becoming brittle. This solution may be reused for many prints, but if it becomes dirty or contaminated by unwashed prints, it must be replaced at once.

Pakonomy 26 print dryer. Courtesy Pako Corporation.

Ilfospeed 5250 Print finisher/dryer for RC paper. Courtesy Ilford, Inc.

ARCHIVAL PRINTS

Although the procedures detailed in these pages will give prints that are sufficiently permanent for most uses, fiber-base papers can be specially processed for superior longevity, and this is one reason why they are preferred by most fine print makers for artistic black-and-white work. If you want the print to last half a century or more without change, archival processing is necessary. Ilford makes a special Archival Processing Kit for this purpose, and an excellent source of additional information (Weinstein and Booth) will be found in the bibliography, under General Works.

PROCESSING FIBER-BASE PAPER

1 / Develop the print in Dektol 1:2 (Ektaflo Type 1, 1:9) for **exactly 3 minutes** with constant agitation, just like RC paper is handled (page 102, steps 9 and 10).

2 / Stop development by agitating the print for 15 seconds in a diluted acetic acid stop bath (page 102, step 12).

3 / Fix fiber-base paper in a fresh bath of hardening fixer for **5 to 10 minutes** (follow the **minimum** recommended time). Then proceed as follows to complete the process.

4 / **rinse the prints**

After the prints have been thoroughly fixed, transfer them to a tray of water and briefly rinse them to remove excess fixer from their surfaces.

5 / **first wash**

Wash the prints in running water or with a tray siphon for 3 minutes. Be sure they separate from one another.

6 / **perma wash**

Immerse the prints one at a time, face up, in a tray of Perma Wash solution (or other clearing agent) for 3 minutes. Agitate or interleave them continuously during this treatment.

7 / **final wash**

Return the prints to the washing tray for 3 to 20 minutes (see table, page 112), again making sure they do not stick together.

8 / **print conditioner (optional)**

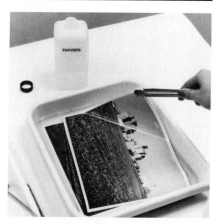

If a print conditioner such as Pakosol or Perma Flat is used after the final wash, immerse the clean prints one at a time, face up, for a few minutes.

/ continued ⟶

Place the print face down against a hard, smooth surface, and remove the excess moisture from the back with a rubber squeegee. Hold one end of the print as you draw the blade across the back of the sheet.

If a rotary dryer is available, lay the prints face up on the belt and smear a few drops of conditioner on their surfaces. This will help to produce a high gloss on glossy paper.

You may dry any fiber-base paper to a dull or semi-glossy finish by laying the squeegeed prints between clean, lint-free photographic blotting paper or screens. A blotter roll, shown here, is convenient and easy to use. Or the prints may be placed **face down** on the belt of a rotary dryer.

SUMMARY OF BLACK-AND-WHITE PRINT PROCESSING WITH FIBER-BASE PAPER

The temperature of all solutions should be about 20°C (68°F).

Step	Solution	How Prepared	Time	Agitation
1.	Developer	Dektol 1 : 2 or Ektaflo Type 1, 1 : 9	3 minutes	Constant
2.	Stop Bath	28% Acetic Acid 1 : 20	15 seconds	Constant
3.	Fixer	Hardening fixer prepared as instructed on label for prints	Minimum recommended	Intermittent
4.	Rinse	Water	30 seconds	Constant
5.	First Wash	Running water	3 minutes	Intermittent
6.	Clearing Bath	As directed on label	3 minutes	Constant
7.	Final Wash	Running water	3–20 minutes	Intermittent
* 8.	Conditioner	As directed on label	3 minutes	Intermittent
9.	Wipe Off	Use rubber squeegee		
10.	Dry	Blotters, screens, or rotary dryers —see text		

*Optional

LOCAL IMAGE CONTROL: DODGING AND BURNING

Once you have obtained a satisfactory print by using the proper exposure and contrast filter (or paper grade), take a closer look at local areas within the picture. If the overall exposure and contrast seem about right but some small areas are too dark or too light, the exposure can be manipulated to correct this. You will frequently find that when the print is generally good, a strong highlight such as a sky area or a reflection in water may be too light, or an important shadow or distant face, perhaps, too dark. If the problem seems to be local, its correction is local, too.

Small areas that are too dark in the first print may be lightened by *dodging*. You can do this most easily by placing your hand in the light beam of the enlarger just above the paper during its exposure, and moving your hand so that its shadow masks the selected area for *part* of the exposure. If the area needing correction is very small, use a *dodging wand*—a piece of opaque paper taped to the end of a thin stiff wire.

If your first print contains areas that are too light, however, these must be locally darkened by additional exposure. After you make the overall expo-

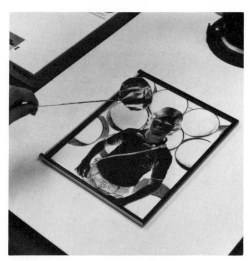

Dodging.

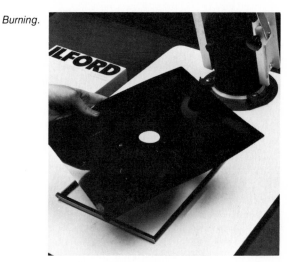

Burning.

sure, hold a piece of cardboard with a small hole cut out of it over the area to be darkened, just above the easel, and give extra exposure time there. This technique is called *burning*; you can also do it with your hands by using them to shade all parts of the image you do *not* want to darken. The accompanying illustrations show the result of both techniques.

A few points about manipulations like these ought to be kept in mind. First, they are used *after* the basic exposure and contrast have been determined; second, the hands or cardboard dodging

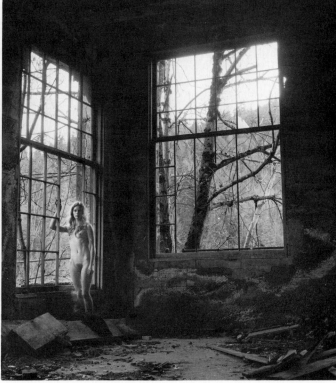

Tom Gore: [untitled], 1972. The print on the left was exposed for 16 seconds "straight"; the one on the right was dodged and burned as indicated in the diagram. Note the tone differences.

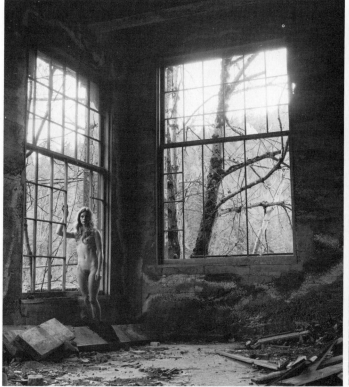

masks must be vibrated or otherwise kept in *constant motion* to prevent a shadow line from forming on the print; and third, whatever method or combination of methods you use, *keep the whole process simple.* Many experienced photographic printers literally do a dance with their hands over the easel during the print's exposure, although often the mask and wand are just as easy to use.

Here, too, lies another advantage of variable-contrast paper. You may change filters as you mask, printing most of your image, say, with the No. 2½ filter, then using a higher filter to add contrast to a small area as you mask out the rest of the picture. *Use the lower number filter first,* and be careful not to disturb any other part of the enlarger setup as you change filters. A rigid enlarger is required.

All of these techniques take practice to do well, so don't be discouraged if your first results are not exactly what you want. You may have to make several trial exposures, and burning times may seem unreasonably long. This is not unusual, but if you need too much manipulation to get a desirable print, your negative is probably not as good as it ought to be. Techniques like these are not cure-alls. They can make a good print immeasurably better, but they cannot correct significant faults in a negative. Only a new negative can do that.

PRINT FINISHING

Prints intended for exhibition or serious study should be *mounted* on illustration board to isolate them from their surroundings and keep them flat. Exhibition prints and those intended for reproduction or publication must be *spotted* to remove dust and similar imperfections from their images. Finally, fragile surfaces of many photographic papers require protection against abrasion if prints are stacked or frequently handled.

DRY MOUNTING

Dry mounting binds together porous materials such as paper without moisture or solvent-type adhesives, and is the best way to back prints with more substantial material. It may be used with any such materials that are not damaged by moderate heat, and is particularly suitable for photographs. An absence of moisture helps prevent wrinkling, and a lack of volatile solvents (such as those in rubber cement) avoids chemical reactions that could damage the photographic image.

A photograph being dry mounted is sealed to the mount with a sheet of thermoplastic material called *dry mounting tissue* sandwiched between them. Heat melts the sealing material, binding the photographic paper and the mount. Moderate pressure applied with the heat keeps the materials flat.

For resin-coated papers, use Seal Colormount Tissue, "Scotch" Brand Promount #572, or Kodak Dry Mounting Tissue Type 2. For fiber-base papers, the Scotch and Kodak products work very well; Seal MT-5 Tissue is also recommended. Most materials are available in standard sheet sizes and in continuous rolls, 50 and 100 cm (20 and 40 in.) wide. Promount Tissue makes a reversible bond: the picture can be repositioned if necessary by reheating it. The other products all produce a permanent seal: once mounted the materials cannot be separated without damaging them.

A dry mounting press and tacking iron, both thermostatically controlled, are convenient for the process. Allow them about 10 minutes to reach the proper temperature (see table, page 117). You will also need a paper trimmer, a sheet or two of clean, brown kraft wrapping paper as large as the press, and a metal ruler or straightedge. For mounting RC paper, a teflon-coated release sheet is also useful.

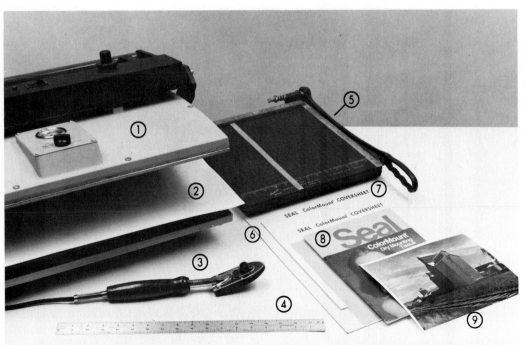

What you need to dry mount.

1. Dry mounting press.
2. Brown kraft wrapping paper.
3. Tacking iron.
4. Metal ruler or straightedge.
5. Paper trimmer.
6. Illustration board.
7. Teflon-coated release sheet (for RC paper).
8. Dry mount tissue.
9. Photograph to be mounted.

White, cold-press illustration board of medium thickness is recommended for the mount, although any good quality board may be used. This is obtainable from art supply stores. The mount generally should be about 5 to 10 cm (2 to 4 in.) larger than the print in each direction. Alternatively, you can bleed-mount the print so that the picture and mount are the same size. The photographs on these pages show the procedure, step by step.

MOUNTING PRESS TEMPERATURES FOR HEAT-SEALING MATERIALS

"Scotch" Brand Promount # 572	82°C	180°F
Seal Colormount Tissue	99°C	210°F
Kodak Dry Mounting Tissue Type 2	99°C	210°F
Seal MT-5 Dry Mount Tissue	107°C	225°F

DRY MOUNTING A PHOTOGRAPH

1 / preheat the materials

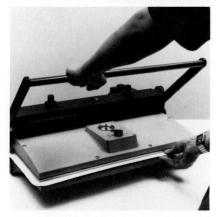

Begin by preheating the kraft paper, mount board, and the photograph to drive out moisture (do not preheat RC paper—it doesn't need it). Place the materials in the press for 30 seconds under light pressure.

2 / lay the print face down

Be sure all materials are absolutely clean and free from dust or grit. Lay the print to be mounted **face down** on a clean, dry, hard surface, and place a sheet of mounting tissue over it.

3 / tack tissue to print

Fasten the mounting tissue to the back of the print with the tacking iron in the center only, sticking a spot about the size of a half dollar.

4 / trim excess tissue

Trim the photograph and tissue together, face up, taking care that the tissue does not overlap or extend beyond the edges of the print. Lay a straightedge over the print close and parallel to the edge you are trimming, and press firmly on it as you cut. Any print borders may be trimmed off in this step.

5 / position the print on the mount

Now place the trimmed photograph and tissue face up on the mount, position it securely, and raise one corner in a broad curl (so you won't crack the emulsion).

6 / tack the print to the mount

Tack the tissue to the mount with the iron, working outward toward a corner with a single stroke. Leave the extreme corner free—don't tack it. Without shifting the position of the photograph, tack the other three corners the same way.

/ continued ——————➤

7 / insert in the press

Place the kraft cover sheet (release sheet for RC paper) over the photograph and mount, and insert the entire sandwich into the press, face up. Close the press completely for about 30 seconds, then open it. With RC paper, close the press lightly for a moment to warm it, then completely for 30 seconds to seal the print.

8 / remove print and check seal

Remove the mounted print and place it under a heavy weight (such as a phone book or steel plate) as it cools. When cool, **gently,** lightly, flex it; this will verify the seal. If your work comes unstuck, return it to the press for more time. That will usually correct the trouble.

9 / bleed mounting

If you want to bleed-mount your print (without a larger mat) trim only the excess tissue in step 4. Then proceed as before. After you remove your work from the press and cool it, complete the trimming of the photograph and the mount together. If the mount is a heavy board, make these cuts with the print **face down** on the cutter table. Position it with care.

10 / using a household iron

If a dry mounting press is not available, small prints up to about 8 × 10 in. usually can be successfully mounted with an electric household iron. Its tip may be used for tacking. Be sure the iron is clean, dry, and not set for steam; use a low temperature setting (try permanent press). Prepare the work and tack it in the usual manner, but make the final seal by starting the iron in the center of the print, moving slowly outward in a spiral pattern. Seal the corners last.

COLD MOUNTING

Another way to mount your prints is by cold mounting, which uses a positionable adhesive material and pressure to make the seal. No heat is needed. Coda Cold Mount, "Scotch" Brand Positionable Mounting Adhesive, and Seal Print Mount materials can be moved around to reposition the print on the mount before it is sealed by pressure from a small plastic squeegee or a roller press. Falcon Perma/Mount 2 material and Ilford Mounting Panels have contact adhesive on both sides; these materials cannot be repositioned. Cold mounting procedures are similar to those shown above, except no heat is involved.

Although cold mounting is quick and convenient for RC papers, hot mounting is more durable and is preferred for fiber-base materials. Whichever method you use, remember these points: heat (not pressure) makes the seal with heat-sensitive materials. A faulty bond is usually caused by too short a time or too low a temperature. *It is extremely important to keep all surfaces clean.* One tiny piece of grit will make a dent or bubble in the print surface, and this mark will be permanent. Most important, remember that *the photograph and its mount together form a single statement.* A sloppy mounting job will weaken the strongest photographic image. Don't let all of your earlier effort be undermined in these final steps.

SPOTTING

No matter how careful we are in the darkroom, a little dust usually manages to stick to our negatives and this shows up as tiny white specks on our prints. These should be removed by *spotting* with Spotone retouching dyes, which come in a set of three colors. By mixing them, the tone of any photographic paper can be matched. You will also need a fine, tapered tip, sable brush, size 00 or 000.

The easiest way to use these dyes is to shake the bottle and work with the residue left in the cap, as shown here. If colors must be blended to match the tone of your paper, you can do this in a saucer with a drop or two of water. Set the open bottle well aside so it won't spill on your print. Moisten the tip of your brush with saliva, pick up a bit of dye, and fill the white spot on the print with color. Use the dye very sparingly; build the color up slowly with repeated applications rather than applying it all at once. Any kind of photographic paper—matte or glossy—may be spotted in this manner. The dye goes *into* the emulsion rather than on it, and if the brush is only damp-dry, the gloss will not be affected. The dye itself, of course, should not be noticeable; most other spotting colors on the market are pigments that remain visible on the print surface. Like other manipulations, spotting takes practice, easily done on discarded prints. And spotting should always follow dry mounting; heat might change the color of the dye.

PROTECTING FINISHED PRINTS

Like most other forms of photographic images, prints are fragile; they must be adequately protected from anything that might damage their delicate surfaces or cause them to deteriorate. There are three sources of trouble: chemical damage, which primarily affects the print emulsion and the paper base; physical damage, which affects the print and the mount; and simple neglect, the most difficult trouble to deal with.

Chemical damage to the print emulsion can be minimized by careful and appropriate processing. Proper storage thereafter in chemically neutral surroundings can protect the print from airborne pollutants and other risks. Physical damage to the mounts and the delicate print surfaces can likewise be controlled by proper storage and intelligent handling. Neglect, however, is more insidious; when no one cares, no one is responsible, and a print loosely passed around or mixed with other papers will soon lose its identity, its value, and its life.

Unmounted prints such as workprints and those for commercial use may be conveniently stored in empty photographic paper packages. Don't mix sizes, however, for this allows smaller prints to slide against others when the box is placed on edge.

Spotting a print.

Never fasten photographs to other things with paper clips; they leave their own impression in the picture. And never stack prints face to face without a separator between them.

When you store mounted prints together, place a cover sheet over the delicate surface of each photograph. For short-term storage, any clean, soft paper will do. For long-term storage of fine prints, however, pure, white tissue will give better protection against chemical and physical damage. Mounted prints are best stored in portfolio boxes with interleaving tissues. The Light Impressions Portfolio Box, shown here, is an excellent storage and display unit, and is reasonably priced. These portfolios and other excellent mounting and storage supplies are available from Light Impressions, P. O. Box 3012, Rochester, NY 14614.

Portfolio box. Courtesy Light Impressions Corp.

7 THE DIRECT APPROACH

The direct approach to making a photograph encourages us to discover the most important aspects of a subject, visualize them as simply and directly as possible, and present them in a photograph as forcefully as we can. This approach to the image employs methods that we identify more strongly with photography than with any other means of making pictures. These methods include forming a clear, incisive image with a lens, recording that image directly on film without manipulation, and then processing and printing the negative to produce the strongest visual impression possible.

Photographs made in this manner usually are rich in continuous tone and detail. They often use *light* as a designing element to reveal significant form and texture, to define space, and to unify the image as a picture. The work of Ansel Adams and Edward Weston contains many examples.

Using this direct approach, then, we can create an illusion of reality so strong that the presence of a camera, and sometimes even that of the photographer who directed it, can go unnoticed: we can bring to the viewer of our pictures an extraordinary sense of *being there.* In effect, our photograph says to its viewer, "You are here. You (rather than the photographer) are witness: you are seeing this object or event. And since seeing is believing, what you see must be true." Photographs made like this create a feeling of *presence;* our willingness to equate seeing with believing reinforces it.

We can observe this phenomenon in any popular magazine or TV commercial. Photographs document facts; they convince those who doubt. Photographs in advertising and package design persuade people to buy goods and services by vividly describing those commodities and by making them attractive and desirable. In other words, photographs help to create a want or need by stating facts and arguments more convincingly than mere words can do. Jacob Riis, Lewis Hine, and others discovered this power of the camera more than half a century ago (Chapter 2), and ever since, photographers have become indispensable allies to politicians, advertisers, and business people—in short, to anyone who would change human behavior. These people realized that when the camera is used directly to its full potential, the resulting photographs seem to do what photographs do best: communicate a wealth of visual information, accurately, efficiently, and convincingly. Such photographs, moreover, are least suggestive of pictures that could be made better by drawing or painting; direct photographs have an unquestionable photographic appearance.

Today we take such images for granted; from drivers' licenses to billboards, direct photographs are part of our daily life. Snapshots, ubiquitous and often charming, are the most common and unsophisticated examples. Common, of course, because they are produced by the millions. And unsophisticated because people taking snapshots typically are more conscious of what happens in front of their cameras and less aware of the photographs which will result. The contents and meaning of such photographs usually are not discovered until later when they scrutinize their prints—an altogether different experience. Casual photographers, then, rarely visualize their products—photographs—because they are too preoccupied with the

process—picture taking. Predictably, their snapshots of El Capitan or the World Trade Center are like thousands of others.

Creative photographers, however, are primarily concerned with what their pictures mean. Photographing creatively therefore requires us to confront our subject and to perceive an image or idea from that encounter. Our inspiration may come from something (or someone) in front of the camera, from another picture, or from deep within ourselves. The next step is to visualize the image—to think about it in pictorial terms—and then, by using appropriate techniques and methods, to make a photograph that we believe will most effectively convey our idea to a viewer. Throughout this process, which may be slow and deliberate or quick and largely intuitive, creative photographers keep the end result—the photograph—in mind. Unlike snapshooters, creative photographers follow through.

SELECTION: The Primary Step

More often than not, the direct approach is most successful when it is used to visualize a single object or idea with the greatest possible strength. Edward Weston's *Artichoke Halved* is a powerful example: here there is little doubt about what this photograph seems to be saying. On one level of communication, its message is clear. There may be other levels, of course, and some of these may be obscure, but a primary meaning is evident. Any guideline for working in the direct approach, then, may usefully begin with a suggestion to *concentrate on visualizing a single idea*—on seeing one thing, as clearly as possible. Because the world as we find it usually is more chaotic than orderly, photographers habitually begin by sorting out. We must cull and detach from our environment the raw material

Edward Weston: Artichoke Halved, 1930. Collection: The International Museum of Photography.

of our picture. This act of selection may be intuitive or carefully reasoned; it may be instantaneous or involve a succession of decisions. However it is done, it involves all that we see, all that we know, and all that we have experienced. Since the camera alone cannot choose one thing or reject another, *selection* is the most important decision that we photographers can make. It is the primary step in all forms of photographic visualization.

FRAMING THE SUBJECT

Whenever we point a camera at something we hang a frame on the real world. We select what is significant within our field of view and locate it within the framework of the picture's edges. Thus we isolate the image from all that lies beyond that frame. Set apart in that manner, our image takes on a new significance. John Szarkowski, in *The Pho-*

tographer's Eye, points out how important this act of isolation is to the photographer:

> To quote out of context is the essence of the photographer's craft. His central problem is a simple one: what shall he include, what shall he reject? The line of decision between in and out is the picture's edge. While the draughtsman starts with the middle of the sheet, the photographer starts with the frame.*

We can demonstrate this by overlapping two L-shaped pieces of cardboard to form an adjustable frame. Move this cutout slowly around in front of one eye, and notice the effect. Things that become isolated together within this frame, like Alma Lavenson's Indians, takes on a stronger relationship to each other. Holding the frame close to the eye will show the effect of a wide-angle lens. Objects close at hand occupy a large part of the space; larger in

*From *The Photographer's Eye* by John Szarkowski. Copyright © 1966 The Museum of Modern Art, New York. All rights reserved. Reprinted by permission of the publisher.

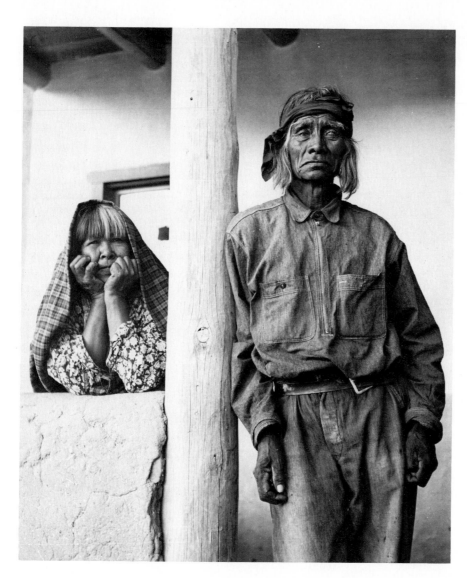

Alma Lavenson Wahrhaftig: San Ildefonso Indians, 1941.

scale, they may seem more important. Moving the frame to arm's length has the same effect as increasing the focal length of the lens or further enlarging the negative. Now fewer things, at a greater distance, compete for our attention.

Framing objects apart from their surroundings causes other things to happen. By surrounding two objects as we have noted, and eliminating everything else, the frame establishes a new relationship between them. It shapes the *space* around objects, too, as Aaron Siskind shows us in *Martha's Vineyard 108*. And then there is that "line of decision"—the picture's edge. The edge cuts objects in two and discards one segment; the part may be used to suggest the whole, or the picture may simply show an uncommon fragment of a common object.

Fragments tend to extend a viewer's perception beyond the confines of the picture itself; things that are visible in the photographic image allude to others which are not. Because of their cut-off feature the picture's edges become important elements in its structure and geometry. Ignoring these edges weakens snapshots, where the effort too often seems unconsciously directed to centering people or objects within the frame. We should take care, then, when composing a view with the camera, and again when cropping the negative in the enlarger for final printing, to *use the framed space of the picture format fully.*

CLOSING IN

Another way to fill the frame with our subject is to get closer to it. Photography, as we know, can record an immense amount of detail. Closing in helps to reduce this abundance of detail without diminishing its clarity. The direct approach to making photographs encourages us photographers to see things from a short range, to get to know our subjects intimately. Don Worth, who is as much at home in a greenhouse as in a darkroom, finds this approach well-suited to his work (page 120). It lets him concentrate on how things really look, without irrelevant objects diluting the intensity of either his vision or his picture. And we can visualize our pictures, of course, the same way: most cameras allow us to focus directly as close as 1 meter (3¼ ft), and even closer with special lenses or attachments (page 207).

FORM AND LIGHT

Form—the shape of objects within the frame—does not always dominate a directly perceived photograph, but so often it is such an important part of the image that it becomes a picture's major organ-

Aaron Siskind: Martha's Vineyard 108, 1954.

izing element. In representational work, where the image resembles the object photographed, we usually try to reveal the form of our object or the significance of our event by isolating it and presenting it in a graphically effective manner. Form in any picture depends on the artist's point of view and, of course, on the nature of the objects themselves. But in photography, it also depends on *light*. Light shapes the appearance of objects. Light together with shadow, the absence of light, can separate those objects from their surroundings, reveal their form, and thus create an illusion of depth within the two-dimensional image.

Our ability to distinguish an object from its environment (sometimes called a figure-ground relationship) can be strengthened in a photograph by careful attention to light and shadow. Michael Semak's image here gains much of its dramatic power from this simple photographic device.

Light can also function as a powerful magnet to unify a picture. Our eyes tend to find brighter values more quickly than darker ones, and to study them longer. In Ed Cismondi's photograph from Mykonos, for example, we notice the brightly etched walls before we discover the doorway be-

Michael Semak: Italy, 1971.

Ed Cismondi: Mykonos, Greece, 1969.

Ansel Adams: Sierra Nevada from Lone Pine, California, 1944. Collection: The International Museum of Photography.

low. We see this same phenomenon at work in Ansel Adams's famous photograph of the Sierra Nevada, which John Muir, many years before, had called "the range of light." The snow-covered mountains attract our eyes first; we discover the grazing horses later. But the photograph is not that simple. The dark mass of the lower ridge and its undulating profile also compete for our attention, forming a counterpoint to the sunlit crags above, and evoking the magic of a spectacular mountain landscape on a cold winter morning.

We can strengthen our pictures graphically by taking advantage of this phenomenon at opportune times. For example, if an object and its immediate surroundings can be framed so that dark areas occupy the corners of the picture, the impression conveyed by the photograph will be one wherein the center is more revealing than the corners, because it is well within the frame and because it is brighter. This helps to unify the picture, to give it a sense of completeness when we view it.

Sometimes the same effect can be introduced by the photographer if it does not occur naturally. The corners can be slightly darkened by *burning* when the print is exposed (page 115). If done carefully and sparingly, the technique will not call attention to itself. The viewer may thus continue to explore the frame, undiverted by corner tensions, and the essential unity of the image is thereby preserved.

LIGHT AND TEXTURE

Sunlight, when not diffused by haze or clouds, is strongly directional. The focused beam from a studio spotlight has a similar quality. We can use such directional light with its attendant shadows to emphasize surface qualities of an object or material and thus more accurately define our subject. Surfaces, of course, often tell us much about what lies beyond or beneath them, and of all the ways to render them graphically, photography is unsurpassed.

Again, a simple demonstration is convincing. Point any directional light source (a flashlight will do nicely) at a board fence or a brick wall. The light illuminates the surface evenly within its circle, just as car headlights appear on a closed garage door. We can see the surface, its color, and perhaps the pattern of its makeup, but we cannot see its structure—its tactile quality: we can only imagine how it *feels*. Now move the light close to the wall surface and aim it nearly parallel to that plane. Instantly the light picks out the raised portions; the

third dimension of that surface, however slight it is, becomes vividly apparent. Seen very close, the light appears to bathe higher spots, while their intervening valleys lie in shadow. From farther back, however, highlights and shadows resolve into a revelation of *texture*, that quality of a surface which gives it a richness of character and a stronger identity, and gives its viewer a heightened sense of awareness.

Whether created on a grand scale in nature or on a more intimate one by the hand of man, textured surfaces are revealed by light in exactly the same way. The light must come from one direction, preferably the side or rear (in relation to the subject), and must rake or skim across the surface rather than strike it directly. Morley Baer's photograph of barn doors demonstrates this point. His focus, of course, had to be needle sharp: that all-important sense of being able to "feel" the textured surface would have been lost in an unsharp image. This is because the bits of light and shadow that make up texture are very small; if unsharp they would be invisible. Also, the tonal scale that shades the textured surface must be properly recorded to complete the illusion of reality. Neither highlights nor shadows can be lost, and that requires correct exposure in the camera.

The *mood* of a photograph can be struck by yet another aspect of light. Lewis Baltz used the long shadows and harsh light of a Nevada morning to emphasize the basic inhospitability of the landscape. Beyond the bright lights of Reno and Las Ve-

Morley Baer: Barndoors, Jalama Beach, 1951.

Lewis Baltz: Lemon Valley Looking Northeast, 1976. From the Nevada Portfolio. Courtesy Castelli Graphics, New York.

gas, this *is* Nevada, more than a hundred thousand square miles of it. Baltz's photographs pull no punches.

On the other hand, soft, diffuse light, typical of overcast or foggy days, usually has a flattening effect that minimizes other contrasts within a scene. Thus closely visualized portraits and objects such as Brett Weston's tree detail will take on a subtle but vital feeling more in tune, as a rule, with the photographer's actual impression of them. Landscapes made in such light, however, may look dull and dreary because without shadows to vary the brightness range and strengthen the impression of depth, only a formless, gray scene is recorded. This monotonous gray tone, though, can be relieved by other factors such as snow or water to reflect light within a scene, or by the presence of dark forms to add life and contrast to the picture, as Canadian photographer Ken Straiton demonstrates. Water, in fact, has always drawn photographers to it because it is a natural reflector of light and is symbolic of life itself. In Harry Callahan's *Detroit,* for example, reflections framed within the grasses themselves reinforce and extend the vital rhythms of this scene. Fog, incidentally, imparts a sense of mystery to a photograph just as it does to nature. Including the light source itself in the picture, as in Larry Gregory's *Sunset* (page 60), can have a similar effect; it also tends to unify the composition.

The important point is to be aware that there are numerous ways to use light in photography, quite apart from its physical role in the recording process. Whenever light will help reveal the essential qualities of a subject, or convey the significance of an event or idea in our photographs, it should be used vigorously and imaginatively.

Brett Weston: Aspen Tree, 1972.

Ken Straiton: [untitled], Vancouver, 1978.

Harry Callahan: Detroit, 1941. Courtesy Light Gallery, New York.

TOWARD A CLASSIC TECHNIQUE

Our definition of the direct approach to photography has so far considered only the problem of visualizing an image in the camera. An unrecorded image, however, is not yet a photograph. We must employ suitable materials and methods—our technique—to complete the task.

Most serious photographers argue that questions of technique must remain subservient to expression at all times. They believe, quite simply, that the ends to which the photographic process is used should determine one's choice of tools and methods. In some of the variant and non-silver processes outlined later in this book, technique and statement are so directly interrelated that they cannot be considered separately. In the direct approach, however, this is not the case. Its classic simplicity makes it easier to consider ends apart from means; this, in turn, allows us to keep the emphasis where it belongs—on *what* we are saying, rather than how.

If our technique is going to serve us well, there are at least three things it should do for us. First, and most important, it should give us the freedom to express our vision and present our statement as effectively as we can. It should be consistent with our ideas and our personality, as individual as each of us is, yet as flexible as we need to interpret what we see. Second, it should provide us the means to do this under a broad range of working conditions. We should be able to make a photograph anywhere we see one. Third, our technique should give us the discipline and confidence necessary for consistently good results. Only then may we consider ourselves free to make photographs creatively.

Any technique consistent with a straightforward approach should be as simple and direct as possible. It should make the fullest possible use of *light* and the response of film and paper to it. After all, this is what separates photography from all other

Lynn Lown: 78·12·11·5 (Forest Fire), Jemez Mountains, New Mexico, 1978.

picture-making processes, and what distinguishes photographs from all other kinds of pictures. By choosing our sensitive materials wisely and using them with care, we can produce photographs with a range of continuously changing tones from brilliant white to jet black. Long tonal scales are essential to brilliant prints, and a brilliant print commands a sensation of intense presence more effectively, as a rule, than a softer one does. A brilliant print sings joyfully!

What makes a print brilliant? Why do one photographer's prints seem vibrant and alive, while another's appear muted and lifeless? Choice of materials has some effect. Glossy papers can produce richer shadow tones and a longer tonal scale than matte (dull) papers can (but they don't guarantee such results; dead, gray prints can also be made on glossy papers). Good craftsmanship in exposing and processing the negative is unquestionably desirable. But a vital requisite of a brilliant print, and one frequently overlooked, is the presence of clean white and deep black areas in the picture. They need not be large in size, nor relatively important in subjective terms. The only essential requirements are that they *be there*, in the print, *and noticed* by the viewer's eye.

Black and white symbolize many opposites. They stand for despair and hope, misfortune and opportunity (as Lynn Lown's photograph suggests). But in addition to this important symbolic role, black and white are the key tones or values of the traditional silver image. They are visual anchors. And they are tonal absolutes, the only ones in the photographic image; all other tones are relative to them. Each of these absolutes can readily be defined in practical photographic terms. *White* is the clean, pure reflection of the white paper base, undimmed by any visible deposit of silver in the emulsion after processing. White, then, is the result of processing unexposed photographic paper. *Black*, on the other hand, is the impression we get from the darkest and heaviest deposit of silver that an exposed and fully developed print will yield. Any other value, by definition, is a shade of gray.

Regardless of how many shades of gray we can see in a photographic print, our impression of a print's tonal scale eventually hinges on these two absolute values—white and black. If gray tones are the only ones present, the print will look muted and unexciting. But if its tonal scale stretches from one extreme to the other, an appearance of brilliance will be unmistakable.

Making a photograph with a long tonal scale is not difficult, but neither is it automatic. It requires an understanding of how our sensitive materials work, a feeling for what the tones of the print convey to a viewer, and the discipline that comes from

practice and which rewards us with the ability to produce the images we want again and again. In the previous chapters we have outlined a technique for black-and-white photography that is practical and to the point. With sufficient practice you can refine these procedures to make them more expressive of your skill and more responsive to your ideas. Such refinement will help you explore new areas in photography with vigor, imagination, and confidence.

The Zone System

With these objectives in mind, many seasoned photographers make their working methods systematic, and some of these systems include visualizing the image as well as executing the photograph. Any system that does this has the incomparable advantage of tying *seeing* and *photographing* together, providing a rational means to progress from a visualized image to a finished picture. One of the best and most famous systems of this kind is the *Zone System* set forth many years ago by Ansel Adams, and periodically refined by Adams, Minor White, and others. It provides a common language for relating the *subject*—what is in front of the camera—with the *negative*, the *print*, and the photographer's own interpretive *ideas*. Thus it is a major aid to visualizing the picture at *any* stage during its evolution. Unlike other techniques which relate exposure and development to visible results in a negative, the Zone System permits us to visualize our own expressive print as we consider various possible interpretations of a subject before our camera. The method is a systematic yet flexible tool, and is superbly explained and detailed in *The New Zone System Manual* by White, Zakia, and Lorenz (see bibliography under Technical Manuals). If you are interested in developing a systematic photographic technique, and are willing to work at it, you should study this manual with care.

It bears repeating that any technique, whether a simple, empirical procedure or a methodical one like the Zone System, is only a means to an end. It offers a way, not a goal. The direct approach, like any rationale, is a means rather than an end. If the procedures of this approach become goals in themselves, our photographs will quite likely become sterile, unoriginal, and ultimately of little meaning. A technically brilliant negative is rewarding only if it produces an effective, compelling print. The print, in turn, will function the same way only if we as photographers have something to say. But the directly visualized image produced by the interaction of light, lens, and photographic materials can help each of us define our personal objectives in using photography, and this is the first step toward developing an individual style.

THE REPORTORIAL APPROACH

© *Larry S. Ferguson: Self-portrait, Omaha, Nebraska, 1979.*

If the direct approach is concerned with the essence of an object or idea, the reportorial approach is concerned with its *context* as well—not only with the irreducible fact of the matter, but also where it occurred, and when. Reportorial photography considers how an object is related to surrounding objects: it places an object in *space*. The reportorial approach also considers how an event is connected to what preceded and what follows the moment of exposure: it acknowledges a continuum of *time*.

SPACE AND TIME

Photography does not transcribe space or time but alters them in subtle ways. A camera image has its own structure imparted to it by the lens, and when we approach our subject we must take this into account. We may think of *space* as the arrangement of everything (including the primary object) within our view, an area we'll later reduce to concrete dimensions by the camera frame. Or we may be more selective and limit our perception to a single plane that our lens can isolate.

Similarly, we must understand what surrounds our subject in *time*, for every exposure, long or short, is only a moment plucked by our camera from an irreversible sequence of events. Although this sequence in real time is inevitable, the meaning it gives our pictures is not. A photograph may suggest that what is momentarily pictured actually has been that way for some time, or that the view may continue unchanged thereafter. Consider, for example, Walker Evans's photographs of the American South. Are they documents of particular places at certain moments of time,

133

Walker Evans: Black Barber Shop, Atlanta, 1936. The Library of Congress.

Ted Benson: Engineer Ed Hale and F Units in Stockton, California, 1978.

or are they universal statements? Once a moment has been isolated by a camera, it becomes suspended in the present—it is here and now. Sal Veder's POW returning to his family may now be only a memory, but it is fixed forever in the photograph *POW's Homecoming* (page 6).

The camera's shutter, like its viewfinder frame, is a selector for us to use with judgment based on our awareness and perception of space and time. Henri Cartier-Bresson, the legendary photojournalist, has suggested that in the real world of objects and events there is rarely a second chance; we photographers deal in things that are continually vanishing.

DEPTH OF FIELD AND SELECTIVE FOCUS

We interpret space with a camera by controlling how our lens forms the image. As the camera frames objects at different distances from the lens, some of those objects will be rendered sharper than others (page 55). This area of greatest apparent sharpness is called the *depth of field*, and it includes everything between two limits, near and far, of acceptable clarity in the image.

When Ted Benson photographed engineer Ed

Hale as he was about to retire after forty-one years of railroading, he wanted his picture to relate the veteran engineman to the locomotives on which he had spent so much of his working life. By focusing on the engineer from a close viewpoint and by using a moderately large aperture, Benson limited his depth of field and effectively separated man and machine. Although he included both in his picture (showing the relationship between them), he directed our attention primarily to the engineer.

Eric Kronengold's graveyard photograph also achieves its striking effect by *selective focus*. The dark tombstone shapes in the background help establish the setting, but the flower-laden cross in the foreground is the key element here.

Focusing selectively to emphasize a person or an object, then, is a useful technique for organizing the space of a picture and for making one person or object in a picture more important than another. The effect can be seen in any camera with a through-the-lens viewing system: objects at one distance will be sharp and clear, but others nearer and farther away will appear less sharp, or fuzzy. The transition is gradual, and is most noticeable when the focused object is at close range, or when large apertures are used. Under these conditions the depth of field is shallow, focus is selective, and foreground and background are easily separated.

As the lens is stopped down to smaller apertures, or focused on objects at greater distances from the

Eric Kronengold: [untitled], 1974.

Walker Evans: Bethlehem, Pennsylvania, 1935. The Library of Congress.

camera, the depth of field *increases*. The aperture of many SLR cameras can be momentarily stopped down to preview the depth of field at various settings. On TLR and viewfinder cameras, however, this cannot be done; but almost all cameras (except view cameras) contain a depth of field indicator on the focusing scale (page 55).

Photographers often face a different problem: how to get most or all of the image sharp. Larry Ferguson's photograph of Omaha (page 132) and Walker Evans's classic image of Bethlehem, Pennsylvania, presented such a challenge. Ferguson created an illusion of unlimited space in which to identify his participation in a documentary project. By rendering both the foreground and the distant landscape sharp and clear, he tied the two areas together and unified his picture.

Similarly, Evans lets us imagine the lives of the people who lived in these row houses, hemmed in by the blast furnaces beyond, and laid to rest in the foreground graves close by the places where they lived and worked. No single object here was more important than any other, so Evans unified the space by focusing it sharply throughout. If he had focused selectively on either the large cross or the steel mill, he would not have been able to show the important connection between them. Evans, then, conveyed meaning through the *context* of objects in his picture. The photograph speaks of a place and a time; it echoes the past and documents a way of life.

Hyperfocal Focusing

Ferguson and Evans brought their entire fields of view into sharp focus by using *hyperfocal focusing*. The accompanying illustrations explain how this works.

Earlier we noted that the range of object distances which focus sharply together at a given setting of the lens is known as the *depth of field*. When the lens is focused on infinity (a very distant area designated by the symbol ∞ on the focusing scale) distant objects will be sharply focused, but the depth of field will not include nearby objects as well. The upper photograph shows this. The nearest plane that is included in the sharply focused region is known as the *hyperfocal* plane, and the distance from the camera to that plane is the *hyperfocal*

distance. As we also noted earlier, the depth of field increases as the lens is stopped down. The hyperfocal plane therefore moves closer to the camera as smaller apertures are used.

In the lower photograph, however, the lens has been focused on the hyperfocal distance (at f/8). Now foreground as well as background objects are sharp, and *the depth of field extends from half the hyperfocal distance to infinity.* As before, the depth of field is greater at smaller apertures. So by using the smallest aperture consistent with exposure requirements, and by focusing on the hyperfocal distance, you can get the *maximum depth of field.* Other photographs made with this technique can be found on pages 130, 136, 140, and 200.

Photograph focused at infinity.

Photograph focused at the hyperfocal distance (f/8).

Hyperfocal focusing is entirely a visual method and can be used with any adjustable camera. Follow either sequence below.

CAMERAS WITH DEPTH OF FIELD SCALES

1 / Select the smallest aperture permitted by exposure conditions.*

2 / Now set the focus so that the ∞ symbol is opposite the chosen aperture on the depth of field scale.

3 / The depth of field now extends between the distances opposite the same two aperture marks on this scale.

CAMERAS WITHOUT DEPTH OF FIELD SCALES

1 / Focus on **infinity** and look for the nearest object whose image is acceptably sharp. If you can stop down the viewing lens, use the smallest aperture you can for exposure and **then** select the nearest sharp object.*

2 / Next, **shift the center of focus** to that nearest sharp object. This is the **hyperfocal distance.**

3 / Your depth of field now extends from half that distance to infinity, and is the **maximum** depth of field obtainable at that aperture.

*Remember that stopping down the lens reduces the amount of light for exposure, and requires a longer shutter time to compensate for this light loss.

Hyperfocal focusing is only one of several useful ways to increase depth of field. In Marion Post Wolcott's photograph of the Shenandoah Valley in Virginia, the nearby field and the distant hills appear with equal clarity because a small aperture was used and because nothing in the view is very close to the camera. The resulting richness of detail conveys the fertility of this prime agricultural region. Larry Ferguson's photograph on page 200 shows another way that depth can be produced by substituting a lens of *shorter than normal focal length* (if your equipment will permit this) and then placing the camera close to an important element of the picture.

Still another factor affecting depth of field is how critical we are of the image itself. Although important, this question has no simple answer. If the print must be greatly enlarged from its negative and still look sharp, focusing that image in the camera and getting sufficient depth of field should be done very carefully. The photograph by Brett Weston on page 128 is a case in point; it is enlarged from a 120-size (6 × 6 cm) negative to an 11 × 12½ in. (28 × 32 cm) print. On the other hand, the photographs by Wolcott and Evans were printed from 4 × 5 and 8 × 10 in. negatives, respectively. When little enlargement is required, extreme sharpness is not always necessary to preserve the picture's impact.

Let's summarize the factors that affect depth of field.

For *maximum* depth of field, we should:

1. Use the smallest practical aperture.
2. Focus on the hyperfocal distance.
3. Enlarge the negative as little as possible.

Marion Post Wolcott: Shenandoah Valley, Virginia, c. 1941. The Library of Congress

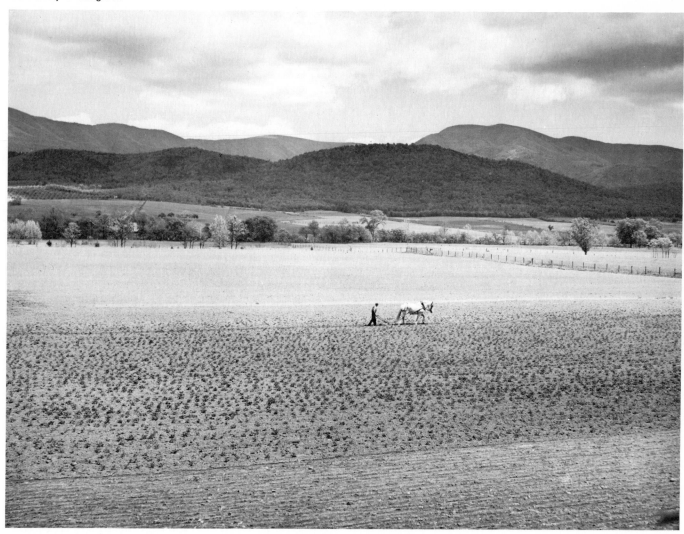

For *minimum* depth of field, we should:

1. Use the largest practical aperture.
2. Get as close as possible to our subject.
3. Enlarge the negative liberally.

In practice, not all of these factors can be optimized, and one may cancel others out. For instance, you may have to get close to your subject, use a small aperture because of bright light conditions, and moderately enlarge the negative. Moreover, although it directly affects depth of field, the focal length of your lens should be selected for other reasons such as image size and framing. *Adjusting the aperture* usually is the most convenient way to control the depth of field.

PERSPECTIVE

It seems hardly necessary to mention perspective, that familiar pattern of projected outlines that helps us perceive three dimensions on a two-dimensional plane. In *central perspective* we rep-

resent what is infinitely large by a mark that is infinitely small. A vanishing point on the horizon line (see photograph on page 132) signifies unlimited space. And because the camera lens focuses light to form projected outlines of objects, it produces its direct image the same way.

This, of course, isn't new to us. Ever since the Renaissance our way of seeing has been conditioned by the camera lens. For nearly a century now, photomechanical reproduction has made possible accurate and unlimited duplication of pictures, and more recently the electronic media have conveyed them everywhere. Thus overwhelmed by this spatial concept in printed and televised images, we have to put forth some effort to see things any other way.

Other ways of representing space in pictures, though, are very much a part of our visual experience. Joe Deal, for example, minimizes the importance of central perspective by choosing a high viewpoint and eliminating the horizon line. His resulting landscape is essentially the flat plane of the picture surface, on which the elements of his scene are itemized without ordering their importance.

Angelo Rizzuto: *Third Avenue and East 41st Street, New York, 1956.*
The Library of Congress

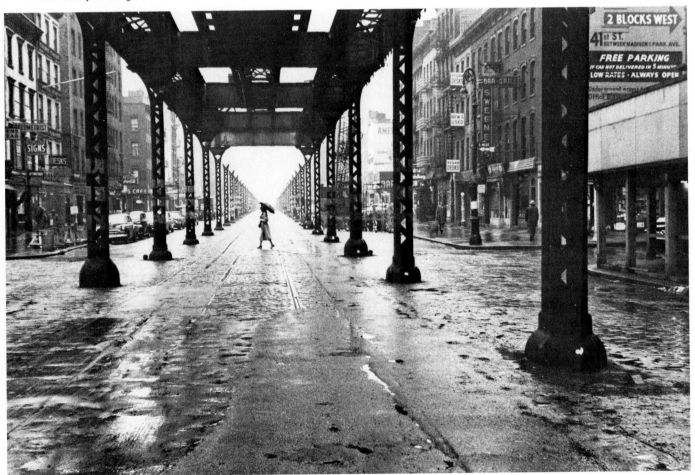

Joe Deal: View, Rapid City, South Dakota, 1977.

The square format further equalizes these elements by adding its own static form to the balance.

We see a scene in perspective or perceive depth in a picture, then, because we readily notice change. If we can sense a gradual change in space or in the relative size of similar objects, we know immediately that we are not looking at a flat, perpendicular plane. But once that change is not apparent, we're not so sure. Should the picture plane be a window or a panel? Photography permits it to be either one; our own vision, rather than the camera's, defines the difference.

TIME AND MOTION

Nothing attracts our attention to change more strongly than *motion* does. We sense an object to be in motion when it changes its relation to other objects that are stationary, or that do not change in space relative to one another. As an object moves, it changes the space around it. It also changes in *time* as well as space, and thereby creates a happening or event. *Time*, then, is the interval between events and, as such, the dimension on which we measure all change.

Time and motion, as Einstein reminded us, are relative concepts. We can show them graphically in various ways. A blurred image seen against a sharp, clear background, for example, will strongly suggest movement. This can be created by leaving the shutter open longer than usually would be done. Since the exposure time must be related to the object's relative motion, no simple rules apply. Times of $\frac{1}{15}$ second to several seconds provide a useful range for experimenting, and they often will reveal visual images that cannot be seen with the eye alone.

When we experiment with shutter times for this purpose, we must remember that *longer exposures require smaller apertures*: more time must be balanced by less light to avoid over-exposing the film. Slow films (Agfapan 25, Ilford Pan F, or Kodak Panatomic-X) may be helpful, especially in bright sunlight.

PANNING

Although *motion* is clearly suggested by the preceding technique, the moving object itself may be difficult to identify. Reversing the relationship between still and moving elements, however, usually clarifies the situation. For example, *panning* the camera (tracking a moving object so that its image is held still in the viewfinder), as Ron Stewart has done in *Stop the World*, renders the *object* more clearly than the background, which then blurs.

Panned pictures contain an unmistakable feeling of movement, yet the object usually remains identifiable. The technique is often used in sports photography, and can capture both the fact and feeling of a rapidly moving event. *Sports Illustrated* and similar magazines provide many examples of this technique.

If the moving object and the space around it are both important to the picture idea, it may be necessary to "freeze" the action by using a very short exposure, perhaps the shortest time that shutter settings will permit. A great deal of action can be stopped momentarily at ⅕₀₀ or ⅟₁₀₀₀ second. But *shorter exposures require larger aperture settings;* less time must be balanced by more light for proper exposure of the film. A high-speed film (Agfapan 400, Ilford HP5, or Kodak Tri-X Pan) may be useful, especially if the light is not ideal for brief exposures.

All this concern for time and movement does not mean that space can be neglected, for it is inseparable from time. A moving figure, as Stewart is aware, needs space to move in. Simple enough, it seems. But framing that space *ahead* of the figure leads him onward—it gives him someplace to go. On the other hand, framing it *behind* the child would suggest that he is moving away from something. Thus the way we include space around a moving figure can affect the meaning of our picture.

*Ron Stewart: Stop the World. . . . ,
1978.*

*John Rooney: Ali KOs Liston, 1965.
Wide World Photos.*

THE DECISIVE MOMENT

Because time and space are inseparable, the moment of exposure will affect our visual statement as much as any other factor. Selecting that moment, then, means that we must try to anticipate when the image in our viewfinder will convey the most intense moment of an event through the most dynamic or favorable arrangement of its space. That is what Henri Cartier-Bresson has called the *decisive moment*. His photograph of Abruzzi shows only a few figures walking; all others are still. No rapid movement is suggested, but the balance of elements in the picture creates a delicate rhythm of lines and spaces, much like the visual impression of notes on a music staff. It gives the picture an arresting and unifying quality. Another moment of time, or another point of view, and this feeling would have been lost. A 35 mm camera, used as an extension of the eye, is ideal for such quick response.

Although not every moment is decisive, it is irretrievable. Everything changes, and as we have already seen, photographers long ago realized that the camera was an ideal tool for recording such change. Moreover, a few, such as Jacob Riis and Lewis Hine, even used the camera to bring about social change (Chapter 2).

Henri Cartier-Bresson: Abruzzi, Italy, 1953. Magnum.

DOCUMENTARY PHOTOGRAPHY

No one called these pioneers of the reportorial approach *documentary* photographers, but the idea was well-established by the early thirties when America's great depression was being felt across the country. Thousands of small farmers were forced from their land by falling prices, growing mechanization, and record drought. As dust storms swept the plains, the U. S. Department of Agriculture began a controversial program to relocate these dispossessed people. In those days federal aid was not looked upon as a cure-all for society's problems; urban people, particularly, had to be convinced that a massive effort was needed.

To do this persuading, the Farm Security Administration formed a team of thirteen top-flight photographers under the direction of Roy Stryker, then a Columbia University economist. For seven years these men and women assembled one of the most remarkable documents of the human condition that has ever been produced by any government. That collection of 170,000 images, now in the Library of Congress, is a classic example of how photographs can convince.

Many of the photographers on the FSA team have since become legendary. Walker Evans—refined, educated, very much the outsider looking in—was able to reveal the dignity of a people as well as their poverty. Arthur Rothstein, whose memorable photographs from the Oklahoma dust bowl showed the need for soil conservation, later became director of photography for *Look* magazine. The nomadic people that Dorothea Lange so compassionately photographed in California were the source of John Steinbeck's great novel, *The Grapes of Wrath.* But for all the power and conviction of their images, Steinbeck and Lange only defined the problem and pointed the way: the grape strikes of the late sixties and early seventies attest that in human terms, solutions have been slow to mature.

Today we see these documentary photographs in a different light. They cannot compete with the power of television, which bombards us daily with talking and moving images. And today, of course, we are more mobile: we have seen much more of our world, and understand it much better. Riis photographed the squalor in a community just a few miles across town and it was a revelation. The plight of Walker Evans's southern sharecroppers and Dorothea Lange's migrant farm laborers in California and the West must have seemed equally unreal to people in the urban Northeast. In our modern world of instant communication, we've become

Arthur Rothstein: Farm in Dust Bowl, Oklahoma, 1936. The Library of Congress.

Dorothea Lange: *Refugees from Oklahoma Camping by the Road, Blythe, California, 1936. The Library of Congress.*

Ted Wathen: *Couple Holding a Portrait of Their Son (standing in front of the car he drowned in), Clay County, Kentucky, 1977. From the Kentucky Documentary Project.*

inured to "eyewitness" accounts. Nonetheless this does not diminish the value of these documentary pictures in their own time. They were forceful then, and are exemplary now, because they represent a compassionate and dignified point of view. Looking back over the FSA project on the eve of his eightieth birthday, Stryker selected nearly 200 of the pictures for a remarkable book, *In This Proud Land*. The compassion and the dignity show through.

In recent years a younger generation of photographers has pursued several more sharply defined documentary projects with state and local funding as well as federal help. Arizona, Colorado, Kentucky, Nebraska, and Washington are among the locations of these projects to date. Other photographers have retraced the steps and sought again the viewpoints of pioneering cameramen like O'Sullivan and Jackson (Chapter 2) to show the evidence of a century of change. Additional projects will un-

doubtedly follow. All attest to the continuing value of photography as an aid to the future historian, sociologist, and planner.

What, then, distinguishes documentary photographs from others made with a reportorial approach? The documentary photographer is first of all a *realist with a point of view*. Whether that perspective is sympathetic or antagonistic depends not on what the camera can do but rather on the values and judgments of the photographer using it. The basic intelligence, education, perceptive and interpretive abilities of the mind behind the camera—these are the factors that make the difference. A documentary photographer seeks understanding, not art; honesty, not objectivity. Most photographs look believable, but it takes an honest photographer to enhance them with the dignity of truth, and a dedicated one to give them a sense of purpose. To those of us who would photograph our fellow humans, this is a challenge and a responsibility of the highest order.

PHOTOJOURNALISM: The Picture Story

Essentially, the *picture story* is a sequence of images produced and selected according to a predetermined plan. Although it evolved from the documentary work of the thirties, the picture story was brought to a focus by the editorial direction of two great magazines, *Life* and *Look*, which appeared in the middle of that decade. As the concept matured, it was given a name: *photojournalism*.

To Wilson Hicks, executive editor of *Life* during its formative years, photojournalism was "good headlines plus good photographs plus good captions," and the crux of the matter was how they all were put together. The key to successful picture stories, as *Life* was to demonstrate again and again, was *planning the essay in advance*.

The photographer's outline for a picture story is known as a *shooting script*, usually researched and prepared by the editors before assignment of the story. It keeps the photographer close to the story line and thus helps establish a series of *related images*. It also helps insure adequate material for a cohesive unit with a beginning, a middle, and an end.

Actual shooting may involve dozens or even hundreds of exposures as the photographer interprets the story line and searches for those elusive moments that lay it out yet bring the story together. After processing to contact sheets, the pictures are *edited* to select the most important images from the lot, and to sequence them for effective presentation. The result is a photographic essay, or picture story.

Perhaps there are no finer examples of the photographic essay than the classic stories for which

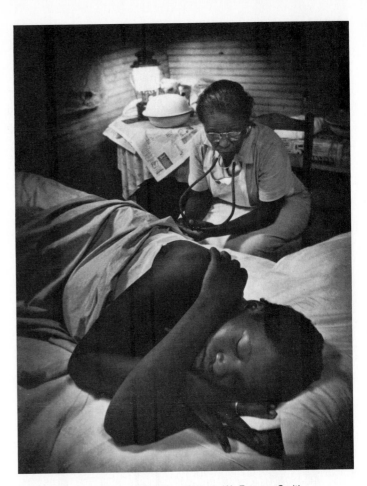

W. Eugene Smith: Nurse Midwife, 1951. © W. Eugene Smith. Print from the Center for Creative Photography, University of Arizona.

the late W. Eugene Smith is famous. The first of these to appear in *Life* was "Country Doctor" (September 20, 1948). The story depicts the trauma, strain, and exhaustion that are part of a rural general practitioner's typical day. "Spanish Village" (April 9, 1951) is another benchmark. "Nurse Midwife" (December 3, 1951) is a sensitive and moving portrayal of Maude Callen, a black midwife in the backwoods of North Carolina. For many years Smith was to consider this essay "the most rewarding experience photography has allowed me."

Unlike most photojournalists who are content to observe, Smith was often a compassionate participant in the stories he photographed. In 1975, after living for more than three years in Minamata, Japan, Smith and his wife, Aileen, completed his most famous essay, one that nearly cost him his sight. "Minamata" is the story of a city and its people who were poisoned by industrial waste. The mother and her dying child, as critic Susan Sontag notes, form a Pietà for pollution victims everywhere.

W. Eugene Smith: Tomoko in the Bath, from Minamata, 1972. © *Aileen M. Smith.*
Print from the Center for Creative Photography, University of Arizona.

OTHER PRINTED MEDIA

Many consumer magazines are gone, victims of a fundamental change that television and shorter working hours have produced in our buying and reading habits. The photographic essay, however, is still very much alive. It appears today in hundreds of publications tailored to a select and responsive audience. *Playboy, National Geographic Magazine, Sunset, Car and Driver, Smithsonian,* and *Nature Conservancy News* are just a few of the many periodicals devoted to special interests, leisure pursuits, regional concerns, etc. The list also includes hundreds of corporate news publications (house organs, annual reports, and consumer relations pieces) such as *TWA Ambassador, Small World* (Volkswagen), and *We* (Western Electric Co.).

Reportorial photography is in demand by other printed media too. Greeting cards, posters, and record jackets represent a market that is accessible to the beginning photographer as well as the established professional.

The basic believability of direct and reportorial photography has accounted for an increasing use of these approaches in advertising illustration. In the studio, of course, the photographer can arrange all the elements of his picture, but once outside that studio he is generally inclined to work with the world as he finds it. Thus the difference between editorial and advertising photography, once readily apparent in the pictures themselves, today can best be discerned from how those images are used.

ELECTRONIC MEDIA

In recent years the printed picture has been seriously challenged by the electronic one. Television has shown itself to be the ideal visual medium for quickly responding to news events: it can be immediately broadcast to its audience. And the TV image is a moving image; it is super-realism, conveniently packaged and delivered to the home. When competently presented it *compels* attention.

TV is a superb delivery system, and its ability to market goods and to entertain has been amply demonstrated. But the TV image, as customarily broadcast, is fleeting; it must be grasped in an instant. Its quick response, however, does not have to be its

Achilles' heel. Electronic media can not only keep their images moving but can also store and recall them on demand. Such flexibility has tremendous implications for the educational process, and television journalism frequently uses this feature to explain complex or rapidly breaking news events. The *instant replay* has become a part of our language.

Television is rediscovering the still photograph, too. TV's technology usually makes its presence obvious, and thereby exerts an influence on the event it reports merely by being there. *Still photography* is less intrusive; its technology often allows the photographer to blend into the scene, or to observe it while remaining unobserved. Television has also borrowed the picture magazine format: programs such as "Sixty Minutes" group several short but substantive visual stories together in a manner familiar to magazine readers.

The enormous complexity and expense of the mass media, both printed and electronic, impose certain restrictions on anyone using them. The photographer and filmmaker must contend with government regulation of the public airwaves presently required by television broadcasting; they may sometimes be required to chart a course between their own honest response to a controversial situation and what the regulated media will permit them

to show. Magazine photographers, too, have long complained about editors who butcher their stories to fit space that is controlled by advertising budgets. But advertising sales reflect readership, and readers choose a magazine for its editorial content, not its ads. All who work with the printed media must understand this important relationship.

EXHIBITIONS AND BOOKS

Faced with these restricting aspects of the mass media, many photographers have predictably turned to exhibitions and books to convey their views to an increasingly sensitive public. W. Eugene Smith's *Minamata* is a case in point: although one photographic magazine published the story, its full impact came through an unforgettable book that remains a warning to us all.

Equally compelling was an earlier photographic essay assembled in the sixties by Maisie and Richard Conrat from the records of World War II. Executive Order 9066, which resulted in the internment of 110,000 Japanese-Americans in 1942, was an affront to the Constitution and an outrage to the citizens it victimized. This long-hushed story of injus-

Dorothea Lange: Japanese Americans Awaiting Relocation, Hayward, California, 1942. War Relocation Authority Records in the National Archives.

tice and fear will forever be a blemish on the conscience of this country. Two exhibitions of greatly enlarged photographs from the book brought the guilt-ridden message to an even wider audience, with greater impact. In San Francisco, where many of the victims had lived, people stood before these images and wept.

On the other hand, Bill Owens's books, *Suburbia* and *Working*, give us a penetrating look at ourselves. For some, this confrontation has been a shocking experience; others have found it gently amusing. Almost everyone can identify with Owens's people, and he wisely lets them speak for themselves.

There seems to be little doubt that future dissem-

ination of printed media will increasingly be by electronic means, but that does not mean that paper is obsolete. Is there any form of printed communication more convenient than a book or magazine? It gives us a permanent rather than a transitory impression, and we don't need electricity or a machine to look at it: books and magazines go anywhere. Furthermore, we can read faster than we can speak or listen to the spoken word, and a good photograph can be "read" in a fraction of the time that an equivalent verbal description would take. Ink-on-paper communication will continue to be an indispensable cultural force, and reportorial photography in its various forms will remain a vital part of it.

Bill Owens: We Like to Watch the Traffic Go By, 1971.
© *Bill Owens,* from Suburbia.

9 THE SYMBOLISTIC APPROACH

Photographs have long been used in place of the real objects they represent, and whenever we substitute them for actual things in this way, those images function as convenient windows to the external world of objects, events, and experiences. But while a photograph portrays the real, the physical, it can simultaneously stand for something else, such as an emotion or idea. While showing us an impression of one object or event, it can represent a feeling about an altogether different experience. In other words, while it *signifies* one thing, it can *symbolize* another.

In the *symbolistic approach* we give the photograph this dual role. This approach communicates a visual impression of the real world as other approaches do, but what is more significant, it *also transforms* that impression to convey another, quite different meaning. In this latter regard the photograph functions as a catalyst: it makes possible a change through it without becoming altered itself in the process.

THE PHOTOGRAPHIC METAPHOR

Most of us are familiar with the figure of speech called the *metaphor*. As a literary device we use it to speak of one thing as if it were another, unrelated thing: "Beauty is a witch," wrote Shakespeare, "against whose charms faith melteth into blood." Or "all the world's a stage." Words, of course, are one kind of symbol, and if they can be used in this manner, photographs—another kind of symbol—can too. The photographic metaphor may be less familiar to us, but it functions the same way as the literary one does. It operates as if it were something else: the picture becomes a *symbol* of something unrelated to it.

Minor White's photograph of peeled paint is direct and arresting, but it probably holds little interest for us as a factual record. Instead we are more likely attracted to it by the tensions that it so strongly portrays, and by the conflict represented through light and dark elements brought so carefully into balance by the photographer's perceptive eye. The photograph speaks of things that are durable yet perishable; it symbolizes intensely human qualities while showing us a bit of insignificant reality. Although it seems to be saying several things at the same time, its emotional message—what it says about feelings—is more engaging for many viewers than its record—what it conveys about facts.

For all its symbolism, however, this photograph is still an image of peeling paint, devoid of color. Whatever *else* it conveys to us must depend, in large measure, on what each one of us who looks at it brings to that encounter. Perhaps the image will remind us of certain experiences in our own past. What we find in the picture, of course, will condition our response to it. Just as different people do not see the same things in an inkblot, each of us reacts to the experience of this photograph in our own way because we don't get an identical message from it. The *transforming role occurs not in the photograph but in the mind of the viewer*, who thereby becomes an essential element in equating the image with its symbolic message.

Perhaps we are more accustomed to looking for such symbolism elsewhere. Painters and

151

sculptors, of course, have employed it since ancient times, and from the early twentieth century on they have been submerging detail and identity to reveal underlying truths. More slowly, perhaps, photographers realized that they, too, could see beneath the surface. In nineteenth-century camera work, symbolic vision was extremely rare: a few of Brady's images, such as the *Ruins of the Gallego Flour Mills* (page 22), seem to possess this attribute. In the early twentieth century, however, it gradually emerged.

ALFRED STIEGLITZ: Equivalence

The first to champion the symbolistic approach, almost single-handedly, was Alfred Stieglitz. On a voyage to Europe in 1907, one day he tired of the company in first class, and chanced upon the for-

ward end of the upper deck. There he looked down upon the steerage, where passengers paying the lowest fare were herded together like cattle. In the interplay of shapes between the funnel and stairway, straw hat and winch, mast and suspenders, Stieglitz sensed a picture charged with emotion. "I stood spellbound for a while. . . . I saw shapes related to each other. . . . a picture of shapes and underlying that the feeling I had about life." Rushing back to his stateroom for his camera, he returned to find all as he had left it, and exposed his plate. His resulting picture, *The Steerage*, is one of the great humanistic statements in photography, a powerful reminder of the immigrant experience in American history. Can anyone looking at this picture today not be reminded of all "boat people," enduring hardships to escape to a better life? Ironically, the Stieglitz photograph does not show immigrants coming *to* America, but disillusioned settlers returning home. Although *The Steerage* symbolizes one thing, it actually shows the opposite.

Alfred Stieglitz: The Steerage, 1907.
Collection: The International Museum of Photography.

Published in Stieglitz's quarterly, *Camera Work* in 1911, *The Steerage* attracted much attention, as did his intense portraits in subsequent years. When critics accused Stieglitz of hypnotizing his sitters, he turned to photographing clouds to see if he could express his feelings through them. Stieglitz called these cloud photographs *equivalents;* through their shapes and tones he tried to convey his feelings, and when others who had not shared his original experiences were able to get a similar feeling from those photographs, Stieglitz knew he had succeeded.

With his photographs of clouds Stieglitz demonstrated what many others have subsequently rediscovered: that if we can respond as *photographers* to the objects and experiences we bring before our camera, and transform what they mean to us through equivalency, then we can also respond as *viewers* to a photograph and transform its meaning in the same way. Moreover, almost anything we find can be used to make a photographic metaphor: if it suggests an idea otherwise unrelated to the actual object, then the transformation is possible.

Minor White, in his writing and teaching, suggested that there are various levels or degrees of equivalence at which photographic images can function. Emmet Gowin's images often seem to operate this way. His photograph here, for example,

evokes not only a child's playful innocence but also a deep reverence for life. Gowin is able to combine the spontaneity of a snapshot with an intensity of feeling that can only come from a deep and honest involvement with the people in his pictures. If we can recognize a parallel experience in our own life, then we can easily get emotionally involved with his images.

THE PHOTOGRAPH AS A MIRROR

Whenever we identify with a picture and feel our way into it like this, we transfer a bit of our own personality to it. So it isn't surprising that *a photograph functioning as an equivalent acts to some degree as a mirror in which we see ourselves.* We're likely to sense this in any picture with which we can easily get involved, and identifiable elements usually help. Test this idea with photographs in the previous chapters, especially those which show familiar locations, or which show people in familiar roles.

We can also get similarly involved with pictures that are arranged or directed by the photographer. Arthur Tress, for example, directs the people in his images to create fantasies and interrelationships

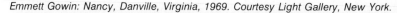

Emmett Gowin: Nancy, Danville, Virginia, 1969. Courtesy Light Gallery, New York.

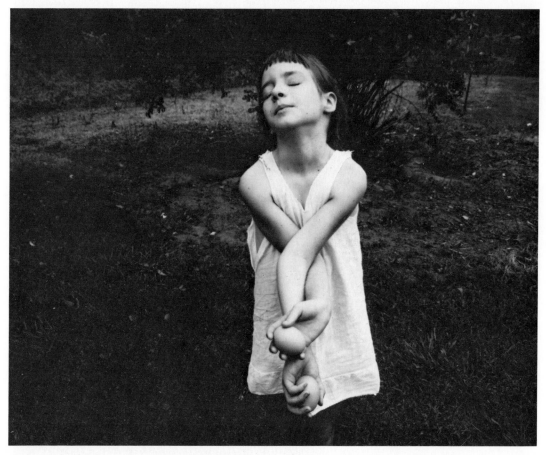

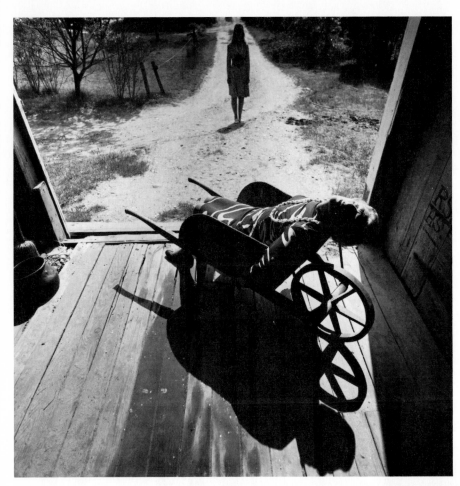

Arthur Tress: *Hannah Stuart and Her Mother, Sag Harbor, New York, 1975.*

Christian Vogt: [untitled], 1972.

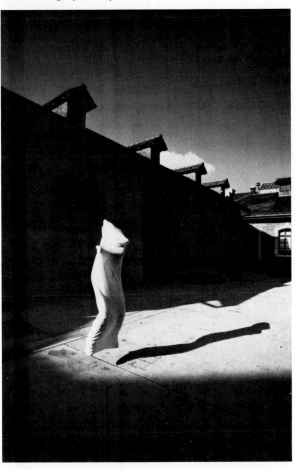

which often border on the occult. And Christian Vogt's stark photograph of a leaping figure shielding itself, perhaps, from the blinding light, invites us to ask questions about its mysterious drama.

Photographs like these point out another value of the *equivalent* or *metaphor* to the expressive photographer: its power to evoke a response about something that *cannot* be photographed through other things that *can*. Olivia Parker, for example, combines objects and images with different visual characteristics to give us a fresh look at an age-old riddle. Her whimsical dancing pea pods, full of energy at the prime of their life, are framed with other symbols of age and maturity. And Michael Bishop (page 170) combines objects with different visual characteristics and functions to give us a fresh viewpoint on the human dimension of man's increasing dependence on a complex technological world.

Jerry Uelsmann combines a lexicon of symbolic images to construct a world of fantasy all his own. Uelsmann is no apologist for photography's insistence on a foundation of realism. Instead he not only acknowledges this base but also employs its suggestion of authenticity to intensify our involvement with his fantastic world. Even if we feel like strangers in his world, we cannot ignore it. Uelsmann's way of working is briefly outlined in Chapter 10.

Olivia Parker: Dance, 1977.

Jerry N. Uelsmann: [untitled], 1969.

PERSONAL CONCERNS
AND PRIVATE MYTHOLOGIES

If a photograph can mirror its viewer, it can also reflect the thoughts and feelings of the photographer who made it. Such introspection characterizes much contemporary work, and it ranges from obvious symbolism to deeply personal imagery that may have meaning only to the photographers themselves. The better photographs in this vein, however, transcend such private concerns to communicate their symbolic content. Marsha Bailey, for example, echoes feminist concerns in her "Withdrawal Series," and Arno Minkkinen's photographs comment metaphorically on the thin line between life and death.

In another recent series of photographs by Michael Semak, an egg-shaped rock appears as a central metaphoric element. What does this rock, held here by a woman in a phone booth, represent? And to whom is the man in the adjoining booth listening? The deep shadows of the background in this picture only intensify its mysterious qualities, inviting us to ask questions, and to supply our own answers.

Michael Semak: Toronto, 1976.

Marsha Bailey: Woman Bound, 1976.

Arno Rafael Minkkinen: Pachaug, Connecticut, 1973.

CONCEPTUAL PHOTOGRAPHY

Although most photographers use the camera to record or interpret the visual world, an increasing number of them use it to convey ideas without such reference to actual objects or events. Paralleling conceptual movements in other art media, *conceptual photography* surfaced in the late sixties and early seventies as an outgrowth of the photographic metaphor.

In the usual metaphoric photograph, the *content* of the picture contains the symbolism: it shows one thing, as we have seen, but stands for another. In conceptual work, the photograph itself generally is less important than the idea behind it. It usually *suggests* the underlying idea or thought, rather than *illustrating* it, and in accordance with its mini-

mized role, the print occasionally may be the antithesis of the fine print associated with the direct approach (Chapter 7).

Paul Berger's "Mathematics" photographs pose a multitude of questions about the nature of perception and of photography as a language. They introduce the symbols of one language into the syntax of another, extending our perception of what photographs can be and how they function. Inevitably, they raise as many questions as they answer.

Robert Cumming is a sculptor who also uses photography conceptually. Like Berger and others, he is concerned with photography itself in his ideas, as his recent photograph here suggests. His metaphoric image cleverly makes reference to a phe-

Paul Berger: Mathematics No. 27, 1976.

Robert Cumming: *Quick Shift of the Head Leaves Glowing Afterimage
Posited on Pedestal*, 1978

nomenon of human vision that photography does not replicate, but as photographer and author James Alinder observes, "for Cumming, illusionism and artifice are fundamental, and as with the magician, we are advised not to pose technical questions, but simply to enjoy."

Looking at photographs such as these, and trying to engage the photographers' ideas associated with them, may well expand our own perceptive and communicative skills. It may also help break down the mental and emotional separation which often occurs between us and the photographs we make, and that should enable us to become more involved with our images. Increasingly sensitive and expressive photographs should result.

What ultimately separates the expressive photograph from the mere record, then, is what also makes a sensitive musical performance different from a mechanical reading of the score. It's the same thing that makes literature stand apart from mere writing, and makes poetry a special form of both. There may be no single word that adequately describes this essential difference, but one that Alfred Stieglitz used certainly comes close: *spirit*.

Whatever we choose to call it, *spirit* is the moving force behind the photographic experience that we call *equivalence*, and it nourishes the ideas which dominate conceptual work. Its evocation is therefore essential to the symbolistic approach.

AWAY FROM REALISM

In the preceding chapters we discussed several attitudes about making photographs that have become fundamental to contemporary work. All involve visualizing subject matter that is broadly based on a personal yet realistic view of the world, and all make general use of the conventional silver bromide print. We considered the strongly visualized appeal of the direct approach, the importance of context in reportorial work, and the dual meaning of symbolistic photographs. All such photographs make factual statements. In other words, they are *pictures of* something, whatever else they might suggest or mean. Even snapshots, the most common photographic images, are momentary records of a relentlessly factual world.

In recent years, however, photographers increasingly have refused to be bound by realistic representation. They have recognized that although the camera is a superb device for recording visual information, it can also be employed for other kinds of imagery. Although most photographs typically resemble a bit of the real world, that likeness may sometimes be obscure and unimportant. Indeed, photographers have convincingly argued that whatever resemblance to reality we see occurs only to a degree, and that in any case, a photograph does not recreate the real world at all.

It is not surprising, then, that many photographers have sought opportunities to move away from this grip of realism and find other modes of expression. In each case their images are made by the action of light on a surface that is sensitive to it, and hence are photographs. But they often bear little resemblance to the conventional photographic image.

The methods most frequently used seem to depart in several well-defined directions from the traditional photograph. One trend *combines images* to produce new visual statements. This group of variations includes such well-known methods as multiple exposures and the combination of separate images, both negative and positive, into a silver bromide print that ultimately is a visualization of the photographer's imagination.

Another general trend involves *reducing* or *eliminating* the *detail* and familiar *tonal scale* that are the conventional photograph's stock in trade. This is done by reducing the gray scale to a few arbitrary steps, by eliminating all tones except black and white, by producing a negative image where we would ordinarily expect a positive one, or by greatly exaggerating the grain structure of the film, thereby reducing the amount of detail it can record.

A third direction encompasses photographic images produced *without a camera*. Light, modified in a variety of ways, falls directly on the final sensitive surface to create a picture. This group of images includes photograms and refraction prints, and they trade on the most fundamental role of light in the photographic process: its mark-making ability.

A fourth trend includes numerous other methods that *do not yield a conventional silver image* as a final product. Among these processes are the cyanotype (blueprint), gum bichromate, photographic screen printing, and xerography. In addition there are many others.

Each of these non-silver processes retains some characteristically photographic advantages. For example, the basic image can

be formed quickly and accurately by a camera, and the final print can easily be duplicated. All are at least as permanent as the silver image, and most produce some reduction of detail. But each of these methods offers other advantages too. Cyanotype, gum bichromate, and photo screen printing allow the introduction of *color* to the photographic picture while retaining the simplicity of black-and-white processes. Screen printing lends itself to bold colors, while gum printing permits a softer, more pastel palette encompassing an entire spectrum. And whereas conventional photography is pretty much restricted to paper and film-base materials, the non-silver processes mentioned here can be used on other material such as fabrics, wood, and metal. This opens the way to combine the photographic image directly with other art forms such as painting and sculpture.

Many of these techniques and processes can be freely combined with each other. This makes possible a bewildering variety of contemporary methods, and from this mixture of photographic media we can select a means of image making that appeals to our own subjective and technical interests. In this chapter we will discuss those various departures from traditional work that are simple enough

for anyone to attempt with a foundation of the methods discussed in previous chapters of this book. Few of the procedures outlined here are new, but all of them are enjoying renewed popularity.

MULTIPLE IMAGES

Multiple images, like other types, have been made for almost a century. The photograph by Thomas Eakins (page 34) pointed the way. With some cameras, you can plan and make several successive exposures of objects against a dark background on the same frame of film. If the images overlap each other very little, a full, normal exposure can be given each one. If much overlapping is intended, however, try giving each image half or a third of its normal exposure, and if the resulting negative is too low in contrast, repeat the process but develop the film 50 percent longer than before. A little experimenting will acquaint you with the variables involved.

Multiple exposures lead to images that are uniquely and unquestionably photographic. Imogen Cunningham's photograph of the poet and filmmaker James Broughton demonstrates this potential.

Imogen Cunningham: Poet and His Alter Ego, 1963.

Multiple images can also be produced by combining several images to form a single print. The most celebrated contemporary photographer who works in this manner is Jerry N. Uelsmann. While acknowledging our predisposition to directly made photographs that are visualized before exposure and produced by a standard technique, Uelsmann views the darkroom as a "visual research lab, a place for discovery, observation, and meditation." He terms his method *post-visualization*, insisting that the photographer remain free to revisualize his image at any point along the way to its completion. This way of making photographs combines the analytic methods of conventional photography with the synthetic ones of painting and drawing: images made initially by selective elimination through the camera are then revisualized and combined through an elaborate printing exercise. Several enlargers may be used, with each negative set up separately and masked or shaded so that only desired areas print.

In *Small Woods Where I Met Myself* we can see how Uelsmann works. The initial images portray a woman. She was photographed three times, each time in a different position, in the shade of a small clump of trees. These three images were then combined side by side into a single picture. A dense, negative (tonally reversed) image of this combined state was then made and flipped top to bottom. On this image, the central figure was blacked out (by a local exposure to light); with only two figures and

some trees remaining, it was added to the print below the three-figure positive exposed earlier. Finally, a less dense, tonally reversed image of that same earlier state, somewhat out of focus and carefully offset with regard to the three-figure image, was printed in the blank white spaces between the trees in the upper half of the combined picture.

Any such analysis of Uelsmann's complex method risks overlooking the more personal and vital component of his photographs, and that, of course, is his superb imagination. For his is the vision of a fantast, admirably served by his skillful use of the photographic process. Although this vision is unmistakably his own, Uelsmann's basic technique was demonstrated by Oscar Rejlander and H. P. Robinson in England more than a century ago (Chapter 2). But few photographers have so thoroughly explored the medium as he has, evolving from the total experience a personal, dynamic style.

The freedom to construct non-representational images that is inherent in *combination printing* and *photomontage* work has appealed to numerous photographers. Shirley Fisher (page 160) combines differences in scale, perspective, time, and tone to construct a contemporary metaphor. Allen Dutton's photomontage, also a bit of fantasy, functions on a similarly complex graphic level. The worldly yet otherworldly appearance of images like these demonstrates that photography can indeed move beyond the confines of realism to include the surrealistic as well.

Jerry N. Uelsmann: Small Woods Where I Met Myself, 1967.

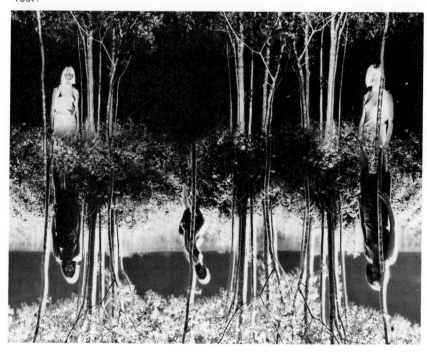

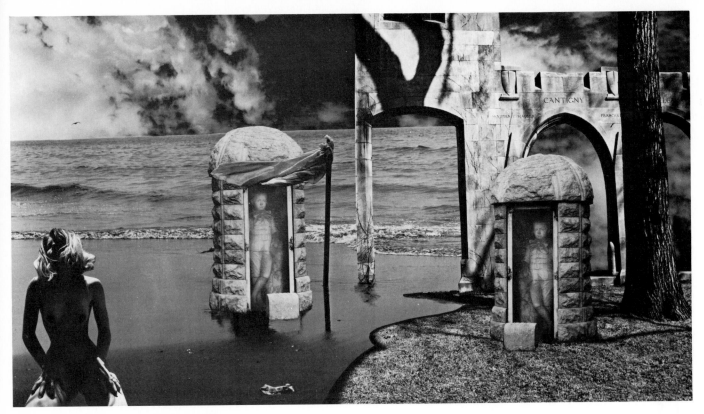

Allen A. Dutton: Up a Lazy River, 1977.

Robert Heinecken, whose work and teaching have influenced a whole generation of younger photographers, has demonstrated the visual possibilities of *found objects* used as "negatives" to expose the final image. For example, he has discovered a new order in superimposed, unrelated images that occur back to back on magazine pages. Their positive-to-negative tone reversal removes them farther from their sources and gives them stronger identities. Heinecken refuses to take seriously any definition of photography that erects limitations on the medium, preferring instead an open-ended rationale and the wider area for continuous exploration and discovery that it gives him.

Robert Heinecken: Erogenous Zone System Exercise, 1972.

Ray K. Metzker uses yet another combining method to assemble his large images from carefully related smaller ones. His composite photograph of a nude, measuring 190×96 cm (75×38 in.), creates a dynamic design by bringing together numerous high-contrast images. The resulting photograph contains only three tones: black, white, and a single shade of gray where the others overlap.

Ray K. Metzker: Nude, 1966. Collection: Dr. and Mrs. Harold Schwartz.

HIGH CONTRAST

Alternatives to conventional photography need not be complex. One of the simplest of all is the high-contrast image or *dropout*, so called because gray tones are dropped out or eliminated, leaving only black and white. Barbara Crane's *Human Form* is an example.

Special films, obtainable from most photographic dealers, can be used to obtain this effect. For 35 mm cameras, Kodak High Contrast Copy Film 5069 is available in familiar 36-exposure cartridges and also in 50 ft rolls (the latter must be cut and loaded into reusable cassettes in a darkroom). The film is panchromatic—sensitive to all colors of light—and must be loaded into its developing tank like other pan films, in total darkness. Its ISO (ASA) rating is 64/19°. It should be processed according to the instructions supplied with it; Kodak D-19 developer is recommended.

With rollfilm cameras, use Kodak Verichrome Pan film, but rate it ISO (ASA) 250/25° instead of its nominal speed of 125/22.° Develop the exposed film in Kodak D-11 developer for 5 to 6 minutes at 20°C (68°F); rinse, fix, wash, and dry it in the usual manner.

Another way to get a high-contrast result is to take any regular black-and-white negative and transfer its image to a special high-contrast sheet film in the darkroom.

Barbara Crane: Human Form, 1965.

USING LITHOGRAPHIC FILMS
IN THE DARKROOM

The trademark *Kodalith* designates a special family of films that yield images of extremely high contrast. Although intended primarily for the printing trade and similar photomechanical work, several of these lithographic films are useful in general photography when images of extreme contrast are desired. Kodalith Ortho Film 6556, Type 3, is the one for general use; a similar product is made by a few other film manufacturers.*

Generally these films are *orthochromatic* and can be handled under a *red* photographic safelight such as the Kodak Wratten 1A. In such illumination *the emulsion side appears lighter than the base.*

Rollfilm can be printed on Kodalith Ortho and similar films using a contact proofing frame and the enlarger as a light source. Set up the enlarger exactly as you would for making contact sheets (pages 100–102) but use no printing filter, only white light. With the lens stopped down about halfway, make a series of test exposures of 1, 2, 4, and 8 seconds by the familiar test-print method.

Kodalith and similar films may be processed in a tray like photographic paper. Any of several Kodalith developers will produce excellent results when mixed and used as directed on their packages. Note that these developers are prepared as two separate solutions; parts A and B must be stored separately because they deteriorate in a few hours when combined. Mix together enough of each part to fill the developing tray about one-half inch deep. Like other film developers, it should be about 20°C (68°F).

A second tray should contain a stop bath like you make for print processing, while a third tray is needed for a similar quantity of any standard film fixer.

Slide the exposed film into the developer *face up*, then lift it and tap its edge sharply against the tray to dislodge any bubbles of air that may be clinging to it. From this point on, *agitate the film constantly* by rocking the tray. Handle the film as little as possible until development is completed. The exact developing time depends on the type of developer used, but will usually be about three minutes. Stop development and fix as you would a paper print (lithographic films fix quickly; twice the time required to clear the unexposed emulsion is sufficient). Then wash the film for about five minutes in running water (a tray siphon works well), bathe it in Photo-Flo, and hang it up to dry.

*View cameras and others accepting sheet film can use these films directly. Try an ISO (ASA) rating of 5 or 6 in daylight.

A correctly exposed Kodalith or High Contrast Copy Film image—negative or positive—will look different from an ordinary negative or print. Hold your litho film image up to the light and look for these points:

1. Black areas should be even-toned and so dense that virtually no light gets through them. Weak, gray tones here indicate too little exposure; streaks signal uneven development.
2. Blacks should be free from pinholes. These are caused by dust particles and are most numerous in underexposed images.
3. Clear areas should be clean-edged; any veiling indicates too much exposure.
4. Examine the width of any lines in the image. If black lines are too thick and clear lines are broken or poorly defined, the image is overexposed. If thin, clear lines appear too wide, and thin, black lines are broken, the image is underexposed.
5. The shape of small image areas should look correct. Clear areas that are too large indicate underexposure; black areas that seem "puffy" indicate overexposure.

This visual checklist may be helpful because exposure of lithographic film is rather critical: as its threshold point is approached, small increases in exposure rapidly make the image darker. Make a note of the enlarger setting, f/ stop, and time that give best results.

Small negatives (such as 35 mm) may be enlarged onto litho film instead of being printed by contact. Either way, of course, litho-film images printed from ordinary camera negatives will be high-contrast *positives*. If a high-contrast *negative* is needed, simply transfer the image again by the same process, exposing a new piece of lithographic film through the positive you just made. Wait until the first litho film has dried (don't try to print from it wet), and keep the two emulsions face to face for sharp results. The final negative can always be placed in the enlarger upside down to give a correctly reading image.

On any litho-film image, pinholes in solid black areas may be removed by painting them with photographic *opaque*. This is a thick watercolor paint, available in red or black, that is applied with a sable brush to the emulsion. The red is easier to see when you apply it. When touched up, the negative may be printed like any other.

Polaroid Type 51 material can also be used for high-contrast images (see Appendix). Weston Andrews produced his picture here by rephotographing two high-contrast images that were made earlier from a regular photograph.

Weston M. Andrews: Portrait, 1972.

TONE-LINE OR SPIN-OUT IMAGES

An extension of the high-contrast treatment just described is the *tone-line* or *spin-out process*, which converts any major *difference* in image tone, such as a line in the picture where dark and light areas meet, to a thin black line on a white ground. Any sharp negative can be used, but one with a strong graphic arrangement of light and dark areas will usually yield a more successful result.

Two litho-film images, one positive, one negative, must be made from the original photograph. Use the method described in the preceding section. If the original negative is smaller than 4×5 in., the first litho image (a positive) should be enlarged to at least that size, since it is very difficult to control

the line formation with smaller ones. Best results are obtained if the lithographic image is made as large as the final print, but any size from 4 × 5 in. up is usable. The second lithographic image (a negative) can then be contact printed from the first.

It is essential that both litho images be *exactly the same size*. They must next be *registered* on the underside of the contact proofing frame glass so that the two images are *back to back*. Tape either image to the underside of the glass so that its emulsion is *against the glass*. Thin transparent tape (the so-called "magic" variety) works best. Next, tape the other litho image over the first so that the two are *exactly aligned* in register. Use care to get all parts of the image perfectly aligned, or very uneven line formation will result. The emulsion of this second lithographic image must *face away from* the first one. Properly assembled, the sandwich will look uniformly dark when viewed by transmitted light, since each lithographic image masks out the clear areas of the other.

This sandwich will permit a thin band of light to pass through it along the tone edges of the two images, but only if that light strikes it at an oblique angle. Perpendicular rays, as you can easily see, are virtually blocked. Since the tone edges in the image lie in all directions on the picture plane, the exposing light must strike the sandwich from all sides but always at an oblique angle to the film itself.

The easiest way to do this is to place the printing frame on a turntable in the darkroom. A phonograph set for 33⅓ rpm works well, or a kitchen turntable or "lazy susan" may be used. The exposing light can be a bare bulb in the ceiling. It must be situated at about a 45° angle from the turntable **[10-1]**.

High-contrast image and tone-line variation.

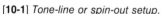

[10-1] *Tone-line or spin-out setup.*

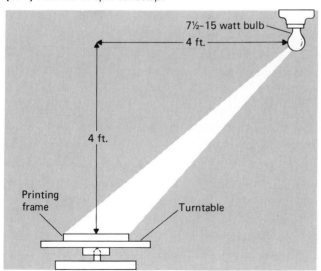

7½–15 watt bulb

4 ft.

4 ft.

Printing frame

Turntable

With only a red safelight on, place a sheet of unexposed litho film in the contact frame so that its emulsion *faces* the sandwich taped there. Close the frame, start it spinning, and expose the film for several seconds. A few trials may be necessary to establish the correct time, but it must *never* be less than one complete revolution of the frame.

Process the exposed film by the usual Kodalith method. Thin, weak lines mean a longer exposure is needed, but if thick, bleeding lines result, shorten the exposure time or use a weaker light bulb. The resulting image, of course, can be tonally reversed by contacting again on litho film. This will yield a negative that will produce dark lines on a white ground in the print. The final image may resemble a detailed ink drawing, but it is thoroughly photographic and can be directly combined with other photographic images.

NEGATIVE IMAGES

Since 1835 virtually all photographic processes have utilized a reversal of values: exposure darkens the sensitive material, and processing produces a negative. We persist, however, in regarding the negative image as a step to the positive one, and in reverting values to their original relationship.

While this return from negative to positive obviously is useful in representational work, it is not always essential in recording or in personal expression. When we store printed information on microfilm, for example, a negative image contains just as much useful and retrievable data as its positive counterpart. Other first-state images such as those on X-ray films are used commercially in their negative aspect. And today any visual image produced or transmitted electronically can be flipped between negative and positive states at will. We prefer the positive, it would seem, as much by custom as by necessity.

By leaving the image in its negative state, we create another visual dialect in the language of photography. Michael Bishop, for example, has combined dissimilar images to create his photograph here. Its negative state helps keep the visual emphasis on his theme rather than its construction. We have also seen how Robert Heinecken (page 164) portrays a human element rather than a specific individual through negative images, using them to deflate the factual authority of positive ones. He often finds them a useful antidote to the gospel of realism.

PHOTOGRAMS

Negative images, of course, are almost as old as photography itself. Talbot reproduced botanical specimens and lace as negative images in 1835, calling them "photogenic drawings." In the early 1920s, the Hungarian painter László Moholy-Nagy and the American painter Man Ray also pursued the technique, and many others have since experimented with it. Moholy-Nagy named his pictures *photograms*, and the term generally has been applied ever since to describe similar, cameraless images.

The photogram requires nothing more than those indispensable photographic elements: light and a substance sensitive to it, with various objects or substances that will absorb some of the light placed between them. Anything will do: the range of creative possibilities is almost limitless. Henry Holmes Smith's refraction print, *Meeting*, utilizes fluid material to modulate the exposure to light. The process is purely photographic, even though the result may appear to be closer to painting than to traditional camera imagery.

Michael Bishop: [untitled], 1971.

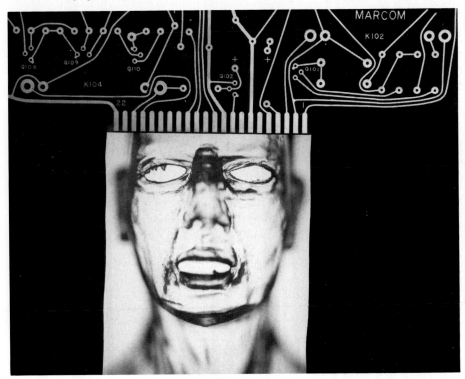

László Moholy-Nagy: Photogram c. 1926. Shadowgraph, 13³/₈ × 10¹/₂ in.
(34 × 26.7 cm). Collection: The Museum of Modern Art, New York.

Henry Holmes Smith: Meeting, 1972. Refraction print in negative. From Portfolio II, Henry Holmes Smith Archive, Indiana University Art Museum. © Henry Holmes Smith.

SOLARIZED IMAGES

Solarized prints, as they are popularly but incorrectly called, appear to have a combination of negative and positive tones.* This effect, discovered in 1860 by Armand Sabattier, is caused by interrupting the development of a print with a brief exposure to raw light, and then continuing development of the print until the desired effect is obtained. Adjacent highlights and shadow areas in such images are often separated by thin, light-colored lines called Mackie lines, which add to the distinctive effect. Either negative or positive images can be used as a starting point, and the technique works with color print materials as well as black-and-white. Jim Millett's photograph illustrates the general effect.

Four variables determine the result:

1. The initial exposure to a negative or positive, as with any other print.
2. How long this first exposure is developed.
3. The time, intensity, and color of the raw light exposure.
4. The conditions of the second development (time, formula, etc).

The suggestions which follow are intended to establish a simple trial procedure for further experimenting with black-and-white materials. They can be expanded or adapted as desired to others.

Begin with a moderate-to-high-contrast negative, and a high-contrast graded paper (No. 4, 5, or 6).

Jim Millett: Cimetière Montmartre, 1977.

*The correct name for the effect described in this section is the *Sabattier effect*. Solarization, on the other hand, correctly names a partial reversal of highlight values that can occur after processing in a negative that was given a single, massive overexposure. The two effects are not similar.

Make a trial print in the usual manner with various exposure times. Develop this print in the usual way, then rinse the print in water (do not use an acid stop bath). Carefully squeegee or blot the excess water off the print surface.

Now expose the same test print to raw enlarger light for a few seconds, in a test pattern uncovered at right angles to the original exposure test strips. For this exposure the negative should be removed from the enlarger, and the lens closed down two or three stops. The best exposure times will tend to be shorter than those used for the initial exposure.

Now develop the print again, and when the result seen in the tray is acceptable, stop development with an acid stop bath. Fix, wash, and dry the print in the usual manner for the type of paper used.

Many variations of the above procedure are possible, and you may wish to explore them. Different developers (page 110) can be used for each immersion; subtle changes in color tones (warm to cool) can thus be produced on some black-and-white papers. Some workers suggest exhausted developer for the second development. By keeping careful notes of your procedures with each of the four variable steps, you can quickly determine useful ranges for each. More detailed information on solarizing prints can be found in Jim Stone's excellent guide, *Darkroom Dynamics* (see bibliography, under Technical Manuals).

ENLARGED NEGATIVES AND POSITIVES

Today we generally think of a negative as a small image from which we enlarge a positive, since the prevailing trend in camera design is toward smaller rather than larger formats. But many of the photographic images being made today are possible only with larger negatives. There are three reasons for this. First, the manual alteration, masking, and retouching that some photographs require are virtually impossible on small negatives; there simply isn't space to work cleanly and accurately. Second, large negatives are used as intermediate, step-up images to produce extremely large prints such as photomurals. Third, some of the photographic processes that are being re-explored today do not rely on silver bromide chemistry but instead use other salts that are less sensitive to light. These emulsions require intense light sources for exposure and must be printed *by contact*; this, in turn, requires film negatives or positives as large as the final print.

There are several practical ways to make enlarged negatives and positives. Two simple ones are briefly outlined here for those readers who wish to work processes requiring them.

1. Kodalith Diapositives. Kodalith Ortho film, described earlier in this chapter, can be used to get an enlarged *positive* image, from which a negative can then be made by contact printing. Litho-film diapositives and the negatives made from them will have high contrast, and this method is therefore useful to enlarge small, original negatives of very low contrast. Refer to the section, *Using Lithographic Films in the Darkroom*, page 167, for working procedures. In this application, however, try developing both the enlarged positive and its contact-printed negative in Dektol diluted 1:8 (one part stock solution to eight parts water) for about 60 to 90 seconds. The dilution ratio can be varied somewhat; more dilution will produce lower image contrast.

2. Paper Negatives and Diapositives. Single weight, fiber-base paper prints can be used to make intermediate negatives by contact on a sheet of Kodalith or similar film. Some brands of paper have the manufacturer's name lightly printed on the back, and these should be avoided, but other brands of smooth, glossy paper are useful. This procedure offers a somewhat less expensive route to larger size Kodalith negatives, since size for size, paper is cheaper than film.

Paper prints (positives) may also be used to make *paper negatives* by contact. To insure good image definition, uniform contact is important, and this is easily obtained if both sheets of paper are wet.

In the darkroom, under a safelight, soak the positive print and a sheet of *unexposed* enlarging paper in water until they are limp. Drain them and press them together with a roller in a clean, flat-bottomed tray so that they are emulsion to emulsion with the positive print on top. Next expose this wet sandwich under the enlarger to white light as you would a contact print (a larger aperture might be necessary). Then separate the two prints and process the undeveloped one. If your enlarger has a wooden baseboard, be sure to protect it from getting wet. It can easily be covered with a plastic dropcloth, saran wrap, or butcher paper, and this will prevent the baseboard from warping.

NON-SILVER PROCESSES

Most non-silver printing processes we use today have been inherited from photographers of the late nineteenth century, when a flurry of experimenting resulted in numerous alternatives to albumen and silver chloride paper. Very few of these methods have remained commercially viable, but some have recently become popular again, resulting in images like that by Kenneth Steuck shown here. Moreover, new processes based on long-established principles adapted to modern materials have been introduced.

Non-silver processes offer several advantages to the contemporary photographer. Color may be freely introduced, for example, without getting involved in the complex chemistry and materials of modern color photography. Photographic images may be

Kenneth Steuck: "I don't think we're in Kansas anymore"—Dorothy. 18 × 24 in. gum bichromate. 1977.

transferred to and duplicated on surfaces that are not sensitive to light, and prints carefully made on good materials by non-silver processes usually are more permanent and less fragile than conventional photographs.

In recent years another situation has also spurred development of non-silver systems, and that is the rapidly diminishing supply and increasing value of silver itself. The United States Bureau of Mines has estimated that America has reserves of something over a billion ounces, enough to last about ten years at current rates of consumption. Photography accounts for about one-third of this use; hence the search for processes and systems less dependent on this valuable metal. For more than two decades, much of the silver used in photography has been recycled from processing systems whose volume permits practical treatment, and more recently it has been found desirable to remove silver from processing effluents for ecological as well as economic reasons: silver is harmful to biological treatment systems and marine life.

It is not our intent here to provide step-by-step guidance for making prints by these processes. Sources for such information are listed in the bibliography. Our purpose instead is to point out that the familiar silver bromide print is not only a final

state of the contemporary photographic image, but also a bridge to several others. Let's look at some of them.

Iron Processes

In 1842 Sir John Herschel discovered that certain organic iron salts are reduced when exposed to light, and from his investigations came the *cyanotype*—the familiar blueprint known to engineers and construction people everywhere. Blueprint paper contains a coating of ferric ammonium citrate and potassium ferricyanide; exposing it to ultraviolet light forms a weak, green image that turns bright blue when rinsed with water. The water washes unexposed iron salts away, so no fixing is required.

Other iron-based processes are less familiar. *Platinum printing*, which binds a platinum salt to an iron one, gives rich, long-scale prints that have an uncanny sensation of depth. They are expensive to make, but unassailably permanent. Turn-of-the-century photographers like P. H. Emerson, Frederick H. Evans, and the Photo Secessionists (Chapter 2) used the platinum process. Among contemporary photographers, George A. Tice has produced exemplary prints. But it is impossible to reproduce the subtleties of a fine platinum print in an ink-on-paper

process; you simply have to see the original to appreciate it.

Gum Bichromate

Gum bichromate is a non-silver process that has had a remarkable revival by contemporary artists. Gum bichromate uses a colloid, *gum arabic*, which is made light-sensitive by potassium bichromate. The gum carries a pigment—watercolor or poster paint; it can be manipulated to produce varied color combinations. Although using black pigment can yield a print similar to a conventional photograph, the attraction of gum printing to contemporary photographers like Gayle Smalley lies in its capacity to blend textures and colors with a monochromatic photographic image.

Light hardens the sensitized gum arabic, making it less soluble; unexposed areas are then carefully removed with water, leaving the harder image on the support. A print may be recoated and locally reprinted in a different color several times, adding to the creative opportunity of the process.

Both the gum emulsion and the paper or cloth on which it is coated must be prepared by the photographer. It is a slow process, not well suited to making multiple editions, but ideal for combining multiple exposures of different colors in a single image. The process was patented in 1858 and it first became popular around the turn of the century. Like the iron processes, gum printing requires a negative large enough to make a contact print.

Kwik-Print

Kwik-Print is a modern contact process for making colored prints on white polyester or vinyl plastic sheets, or on certain fabrics or papers to which sizing is first applied. In some respects it is similar to gum bichromate, and like other contact processes, Kwik-Print requires a negative the same size as your desired print. Fourteen colors are available in liquid form for coating the various materials, and they can be applied by brushing, by wiping, or with an airbrush. When this colored coating dries, it becomes sensitive to ultraviolet light, and is then printed through the negative, which renders the exposed areas insoluble. After exposure the print is washed in water to remove the unexposed, still soluble color. Then the sheet is dried.

The procedure must be repeated on the same sheet for each color desired. Single colors can be

Gayle Smalley: Starset over Bodyscape (with dead planet), 1971. Gumprint.

used, or combinations of them can be successively built up to form the image. The colors can be *registered*, that is, carefully positioned with respect to each other, so that combinations of colors and tones can be constructed. Line, halftone, or continuous-tone negatives may be used; a good deal of image manipulation is thereby possible.

Procedures for Kwik-Print are relatively simple, and inexpensive starter kits of all required materials are available. Complete instructions for this and several other non-silver processes are included in *Breaking the Rules* by Bea Nettles (see bibliography, under Technical Manuals). Darryl Curran's photograph (Plate 2) was made by this process.

Photo Screen Printing

This process is well suited to making large prints with bold colors. The final image is in ink and can be printed on almost any kind of surface to which it will adhere: T-shirts, glass bottles, wood, metal, and plastic objects have been used. No light-sensitive materials are used in the final stage.

Photographic screen prints require a *positive* image as a starting point; as with other methods described here, it must be as large as the desired final print. Any photograph that can be reduced to a black-and-white, high-contrast image by the previously described litho-film method may be printed by the screen process. However, if the photograph contains gray tones that are important to its image, these tones must first be changed to black through a *halftone* process.

Halftone refers to a procedure by which gray tones are converted to a pattern of *tiny dots* that vary in size but are uniform in tone. In a half-tone litho film, for example, all dots are solid black, but their varied size permits differing amounts of clear film between them, allowing the eye to blend the two values into shades of gray (see illustration). Examine any reproduced photograph in this book through an 8X magnifier, and you'll see this half-tone pattern. Halftone conversion is not difficult with modern materials. For screen printing, original

Detail of halftone image.

photographs on sharp, small-camera negatives such as 35 mm can be directly used as source material because they can be enlarged in this preliminary operation.

Here is how photo screen printing works. A film positive is used to expose a negative gelatin image on a temporary plastic support called *screen process film*. This material is available either unsensitized or presensitized and ready to use, but the two types must be exposed and developed in different ways. With either type, the negative image on screen process film is then imbedded in a fine, screen-like material (traditionally silk but now more commonly nylon, polyester, or other material) that has been stretched over a wood frame. Then the temporary support is stripped away, leaving a negative image in gelatin on the screen.

Ink made specially for this process is placed above the screen within the frame. Finally, the paper or other material on which the image is to be printed is placed under the screen and the ink forced through its mesh. The open areas, of course, are situated wherever there is no gelatin, and thus a positive final image is obtained.

Screen inks come in brilliant, even fluorescent colors, and since no special preparation of the paper (or other final material) is necessary, a large edition of identical prints can be produced. Illustrated, step-by-step directions for photo screen printing are in the Time-Life book, *Frontiers of Photography*; additional instructions are included in the Gassan *Handbook* (see bibliography, under Technical Manuals and Works in Series).

Photolithography

This is another important ink-on-paper process. In its offset form it accounts for most of the printed material we use today, including this book. Direct photolithography, although not so widely used commercially, is more feasible for the artist-print-maker since it does not require elaborate printing equipment.

In photolithography a flat plate of zinc, aluminum, or other suitable material is sensitized, usually with a commercially available *resist*. The photographic image is contact printed onto the plate from a litho-type (high-contrast) negative, and the plate prepared for printing by various means according to its type. A litho plate is essentially a flat surface composed of printing areas that accept ink but repel water, and nonprinting areas that retain water but repel ink.

The prepared plate is positioned on a press, wet, and then inked. Paper is then placed in contact with the inked plate, and both are drawn under a pressure roller that helps insure an even contact between them. In this manner the ink impression is transferred directly to the paper. Many colors of ink and paper may be used, and the process is well suited to editions of moderate quantity.

Diazo Materials

Diazo materials have been commercially available for about forty years. They have the advantage of producing a positive directly from a positive; no intermediate negative is needed. Diazonium salts are decomposed by ultraviolet light, and in such a state these salts are colorless. But when they are not exposed, as under the black lines of a positive drawing, these salts can produce an azo dye when brought in contact with a strong alkali. The usual practice is to include the dye-forming chemical in the diazonium coating of the paper; after exposure, the paper is fumed with ammonia and this produces a visible image.

The diazo process is a relatively dry substitute for the traditional blueprint (in this application it is known as the whiteprint process.) Diazonium compounds are now combined with numerous other materials. Many produce no dye at all but alter the hardness of a resist, change the wetting properties of a lithographic surface, or form a latent image for some other subsequent purpose.

Electrostatic Systems

These systems depend on the fact that light will increase the electrical conductivity of amorphous (non-crystalline) selenium or zinc oxide. Such materials, when properly charged electrically and exposed to light through an image, can retain an electrical charge pattern corresponding to the image that was printed on them.

The best known of these processes is *Xerography*. For this process, an electrically conductive metal plate or cylinder is permanently coated with a very thin layer of amorphous selenium. This coating is electrically resistant in the dark but conductive when exposed to light.

Most of us have experienced the sensation of walking across a nylon carpet in a dry room and getting a shock when we touched a metal object like a door knob. A similar electrostatic charge is first uniformly applied to the Xerographic plate or drum. Exposure to light then permits this charge to leak from the coated surface to its underlying base metal, where the charge is grounded. This step leaves on the drum surface an electrostatic charge directly corresponding to the original image.

Next, the plate or drum surface is covered with finely ground resin particles that can carry charges electrically opposite to the drum surface itself. These particles stick only to the charged image areas on the drum. At a later point in the operating sequence, a piece of paper or other material is given an electrical charge opposite that of the particles on the drum, and when this paper is brought into contact with that surface it picks up the resin image from it. The paper is then briefly heated and pressed to fuse the resin and bond it to the sheet. A positive copy of the original results.

Since its public announcement in 1948, the Xerox process has been developed into a widely used, high-quality document reproduction system. Packaged into a variety of convenient, automatic machines, it has become a standard, dry, office-copy process capable of reproducing its image on almost any kind of surface. These unusual properties have led some photographers to explore its reproduction capabilities with material other than the printed matter for which it is ideally suited.

Max J. A. Fallon has demonstrated this capacity of the process to reproduce high-contrast photographic material. But some peculiar characteristics are quickly evident. The electrostatic charge does not seem to distribute itself evenly over large areas of uniform tone. Tone edges (between light and dark) become charged more strongly than the central areas; an uneven tone in such areas seems to be typical of a Xerox image. Some machines that operate with cut sheets of paper (rather than a continuous roll) permit the operator to introduce colored paper and other materials in place of the typical white sheets. This is what Fallon has done to reproduce his images.

Other electrophotographic copy systems make color reproduction possible. Some reproduce single colors directly; others can make enlarged prints from color slides through a halftone screen in the

Max J. A. Fallon: First Kathi, 1968. Xerox print.

machine. Colors are controllable and multiple exposures are possible.

Ellen Land-Weber has produced a significant body of such work using marine plant material and other vegetation from the Northern California coast where she lives. She has assembled these objects and their images into a variety of poetic works that are further enhanced by her skillful manipulation of the processes she uses. The photograph reproduced in Plate 1 is indicative of her fascinating work.

PHOTOSCULPTURE

Jerry McMillan is another artist who demonstrates that photography cannot be limited to its traditional image forms. A decade ago he astounded the photographic community by exhibiting photographs mounted on the inner walls of small paper bags. These photographs usually presented an outward expanse of space; they were made all the more enigmatic by their arrangement to form an inner space or environment.

More recently, McMillan has carried his sculptural sensibilities full circle by carefully recreating illusions of them in two-dimensional photographs. Beginning with brown kraft paper, he created reliefs by tearing and crumpling it. Then he photographed the paper forms, lighting them to accentuate the reliefs. Finally, a 16×20 in. print was made and toned to match the brown color of each original paper construction. The original paper forms thus existed only to be photographed, and McMillan's photographic prints come very close to closing the gap that separates object from image.

Al Souza has combined two photographic images into a three-dimensional piece through the familiar device of the jig-saw puzzle. In a framed series of images, one view is metamorphosed into the other.

Commercially available light-sensitive materials are no longer limited to film and paper. Liquid emulsions that can be coated by the photographer on various materials have opened new areas to explore. Any substance to which the emulsion will adhere, and which can withstand wet processing, can be used. Directions for using liquid emulsions and other procedures for integrating photographic images with ceramic, metal, and other materials can be found in *Alternative Photographic Processes,* an excellent resource book by Kent Wade (see bibliography, under Technical Manuals).

In this chapter we have noted the more important alternative photographic processes, and we have also pointed out that many of them, in their contemporary forms, can be combined with one another and with other media. The quantity of inventive work that photographers are now producing by these methods suggests that alternatives to the traditional silver image will continue to be a major influence on creative photographers in the years ahead.

Jerry McMillan: Self-portrait, 1978. 16 × 20 in. sulfide duotone from black-and-white print.

Al Souza: Corsica-Hallstatt Puzzle, 1978. Sixteen color photographs and puzzle parts in a wood and glass box, 24 × 29 × 2 in.

COLOR PHOTOGRAPHY

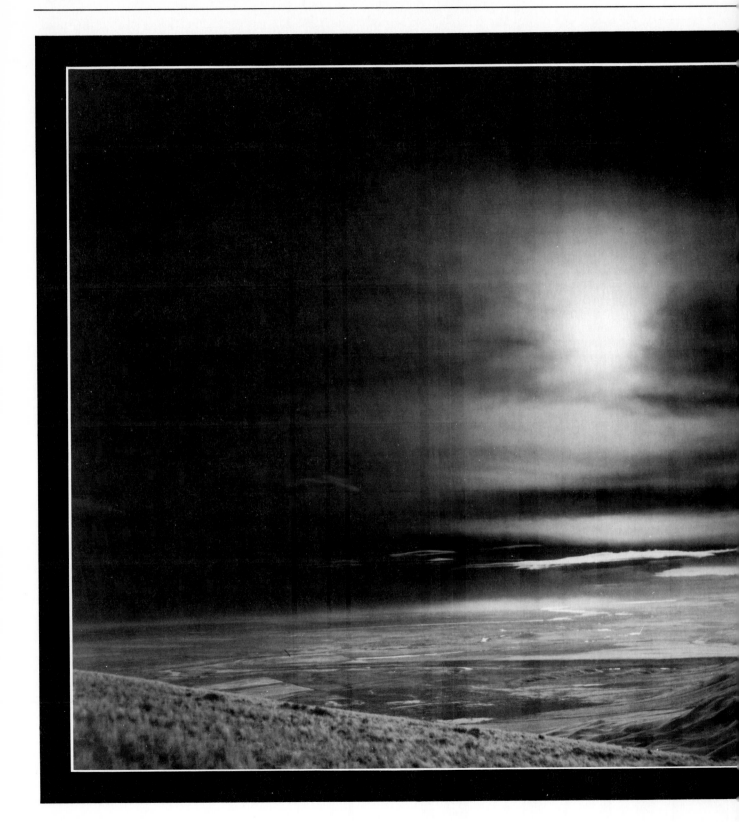

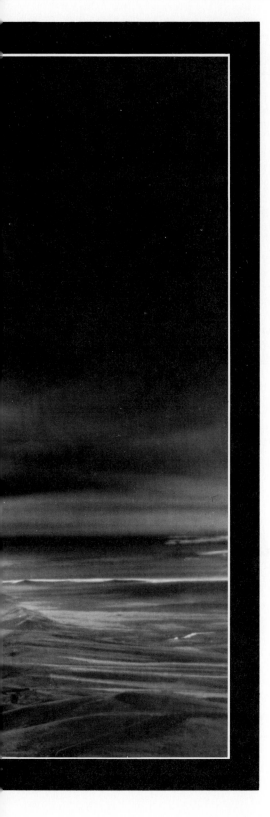

John Clement: Solar Eclipse, February 26, 1979. Courtesy Battelle Pacific Northwest Laboratories. See also Plate 11.

A world without color is a song out of tune. Most of us are accustomed to seeing in color, not in black-and-white, and so a concept of photography that will record the colors of nature as we experience them can easily be taken for granted. Many of us, in fact, took our first photographs in color, and nearly all of us get our daily visual diet of TV, magazines, billboards, and packaging in color. Even daily newspapers occasionally contain it. In the face of all this, black-and-white photographs today seem almost anachronistic.

Unfortunately, color photography, as remarkable as it is, cannot reproduce the hues that we see in nature as easily as we might wish. There are problems with the way we perceive color and the way it can be photographed. Some of these are peculiar to human color vision, while others have to do with the nature of photographic materials. Moreover, color engages our senses in a very special way. The appeal of color in pictures is very strong, and photographs are no exception. It intensifies realistic representation, which has long been one of photography's most important and useful tasks. But color is also an emotional language, one which easily can dominate the other content of a picture's message. And because of this visual power, color in photography can be seductive, inviting us to substitute its own peculiar hues for those of the real world.

Most people who make color slides or snapshots, however, are not too concerned with these problems. For them, a reasonable likeness is sufficient, and the heightened sense of reality that color provides is reason enough to choose it over black-and-white.

Up to here this book has concentrated on black-and-white pictures and methods, because the techniques are simpler, the materials less expensive, and most essential ideas that are fundamental to making photographs can easily be learned in black-and-white. Obviously, the same cameras are used for both kinds of photographs, and since most of the ideas behind the styles and approaches discussed in Chapters 7, 8, and 9 can be applied to color as well as to monochrome, you should study these sections before beginning serious color work.

Nevertheless, certain aspects of light, vision, image organization, and photographic materials combine to make photography in color a different experience from working in black-and-white. This chapter will consider these differences; the next chapter will explain how color materials are handled and processed.

WHAT COLOR IS

All color originates in light, as Sir Isaac Newton discovered in 1666 when he used a colorless glass prism to split a beam of light into a spectrum of colors, and another such prism to recombine the spectrum into a single beam. Prior to Newton's experiment, color was thought to exist in objects themselves, a reasonable premise since nearly all objects contain pigment, and pigment is a selective reflector of light. A green leaf, for example, contains chlorophyll, a pigment which reflects green light and absorbs other colors. Paints and dyes are other substances which use pigments to color many things. A red plastic toy contains pigment which reflects red.

Color can also be produced in other ways. Some objects appear to be colored because their thin surfaces reflect light unevenly. Soap bubbles, for example, or gasoline spilled onto a wet pavement will both appear iridescent or multi-colored. Each of these substances forms a very thin layer on the water, and light waves reflecting at an angle from the top and bottom of this thin layer are slightly misaligned, strengthening some wavelengths and weakening others. The result is a spectrum of colors instead of a colorless liquid surface.

Color can sometimes be formed by scattering light waves. This is why the sky appears blue: the air contains gases which scatter shorter wavelengths of light. If there were no atmosphere to scatter the light, the sky would appear black, as it does in photographs made near or on the surface of the moon (page 244). On earth, however, when we make a photograph near sunrise or sunset, the low angle at which the sunlight reaches us requires that it travel farther through the atmosphere. During these early and late hours, most light is scattered by the atmosphere, and only the longest wavelengths (red and orange) get through unimpeded. Hence daylight changes in color with the time of day, and with the clarity or pollution of the air.

HOW WE SEE COLOR

Human color vision is far from uniform. The retina of the eye contains millions of light-sensitive cells or receptors connected through optic nerves to the brain. There are two kinds of retinal cells: rods and cones. Rods are more sensitive and more numerous, but they cannot by themselves distinguish one color from another. Cones, which respond to color, are concentrated near the center of the retina. Our color perception, then, is best when we look directly at objects, using our central vision, and when there is adequate light. Cones appear to be selectively sensitive to red, green, or blue rays, and all color photography is based on this three-color theory of visual perception.*

Totally color-blind people are rare, but mild deficiencies in color perception occur in about eight per cent of men and fewer than one per cent of women. Since these defects are inherited, many people who have them are unaware of their problem because they have never seen things any other way. The problem is caused by abnormalities in the retina and its nerves, and therefore no cure is possible, but an optometrist can identify any deficiency and the individual can then learn to compensate for it.

As we noted earlier, our eyes are marvelously adaptive (page 63). A simple experiment will demonstrate this point. Place a black-and-white TV set in a darkened room with no other light sources. Watch the TV picture for a few minutes under this condition, and then step into a room illuminated by ordinary tungsten light bulbs. At first, these lights will have a distinct reddish glow that will disappear as your eyes adjust to them and you perceive them, as you did the TV picture, to be "white." Our eyes, then, are preconditioned by our brain to perceive certain colors as we expect them to appear. Couple this phenomenon with the variable color of daylight and the variety of colors available from artificial light sources such as tungsten and fluorescent lamps, and you have some idea of how adaptable our eyes can be. Unlike our eyes, films cannot adapt to changing light conditions. Instead, color films are manufactured to record a specific mixture of light as "white." This response is called *color*

*Investigations by Dr. Edwin H. Land, reported in 1959, produced evidence that only *two* channels of color information are required for the human eye to perceive all colors in objects. The two channels, however, must be properly spaced apart on the electromagnetic spectrum, one on either side of 588 nanometers. Nevertheless, all current systems of color photography are tricolor in nature.

PLATE 1 *Ellen Land-Weber: [untitled], 1977.*
3M Color print.

PLATE 2 *Darryl J. Curran:*
Hollywood Tease Shirt, 1978. Four-
color Kwik print on vinyl, 18 × 22 in.

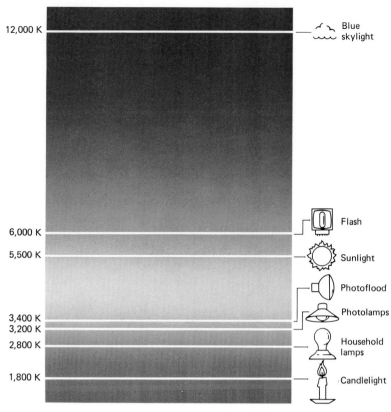

12,000 K

6,000 K
5,500 K

3,400 K
3,200 K
2,800 K

1,800 K

Blue skylight

Flash

Sunlight

Photoflood

Photolamps

Household lamps

Candlelight

PLATE 3 *Color temperature scale. See page 185.*

PLATE 4 *Louis Ducos du Hauron: Angoulême, France, 1877.*
Collection: The International Museum of Photography.

RED

MAGENTA

YELLOW

BLUE

GREEN

CYAN

PLATE 5 *Photographic color circle. Courtesy Eastman Kodak Company. This photographic color circle represents the entire visible spectrum. The six designated colors—red, green, blue, cyan, magenta, and yellow—are single points equidistant from each other on the continuously changing band of light. The three* **additive primaries** *(connected by solid lines), if combined in equal amounts, produce white light. The* **subtractive primaries** *(connected by dashed lines) similarly combine to form black.*

Each color of light on the circle can be produced by combining its adjacent ones. Magenta is thus a combination of red and blue, yellow a combination of red and green light. Colors directly across the circle from each other are **complements;** *together they form* **neutrals**—*white, gray, and black. The relationship of the six designated colors is fundamental to all color photography.*

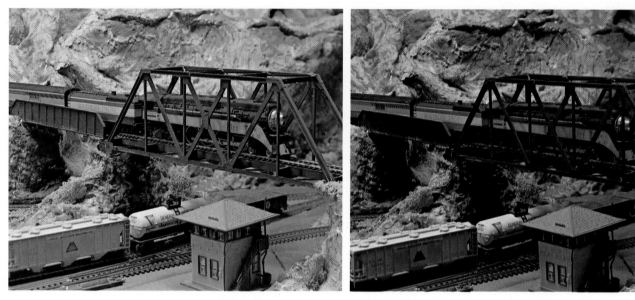

PLATE 6 *Photographs made on daylight film with fluorescent light.* **A:** *without filter,* **B:** *with FL-D filter.*

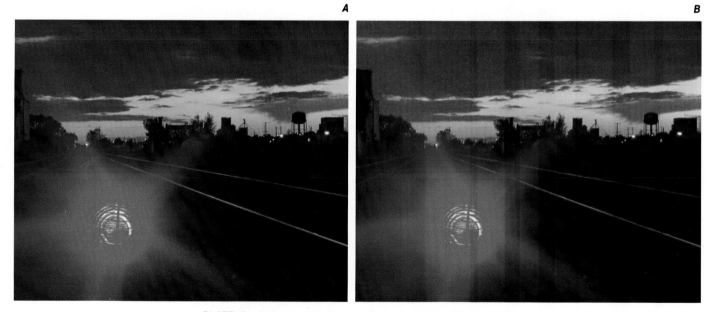

PLATE 7 *Dodging in color.* **A:** *Normal, "straight" print.* **B:** *Print dodged with color filter, as described on page 196.*

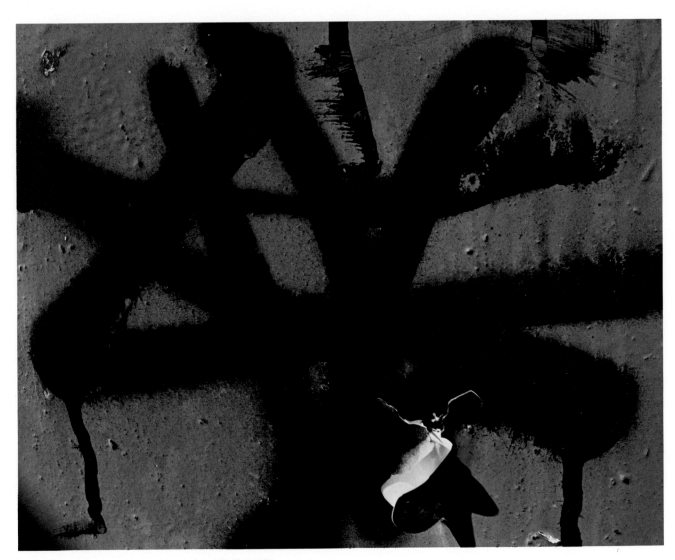

PLATE 8 Bernard Freemesser: [untitled], 1975.
Author's collection.

PLATE 9 *Freeman Patterson: [untitled], 1978.*

PLATE 10 *Stephen Shore: Cabin, Badlands National Monument, South Dakota, 1973. Courtesy Light Gallery, New York.*

PLATE 11 *John Clement: Solar Eclipse, February 26, 1979. Courtesy Battelle Pacific Northwest Laboratories. See also page 180.*

balance and it must be properly matched to the exposing light if faithful color rendering is desired (page 185).

HOW COLOR PHOTOGRAPHY EVOLVED

The desire to photograph in color is as old as photography itself. A direct color image eluded Niepce and Daguerre, but many daguerreotypists hand tinted their plates to complete a realistic illusion. Talbot also sought to reproduce colors in his photogenic drawings, but he had to content himself with white lines on a colored ground.

James Clerk-Maxwell, who first described the electromagnetic spectrum, was more successful. In 1861 he used three collodion plates to demonstrate that all colors could be created by combining light from the three major bands of the spectrum—red, green, and blue. Maxwell's experiment produced, by projection, a crude but recognizable color photograph, the world's first, and the principle he demonstrated, *additive synthesis*, became the basis of several early color processes.

Additive processes begin with darkness and produce their color by combining red, green, or blue light sources to produce all other colors of the spectrum. The three primaries together produce white light. The most practical of these early additive schemes was the Autochrome process, introduced by the Lumière Brothers of France in 1907. Autochrome plates used a mixture of red, green, and blue starch grains coated on the glass plate to filter the light before it reached the sensitive emulsion. After exposure, the plate was processed to a positive image with the starch grains intact, and then viewed as a transparency. Although the color was satisfactory, Autochrome plates were very slow: long exposures were required.

Meanwhile, other means of making colored photographs had been discovered. In 1869, Louis Ducos du Hauron and Charles Cros in France coincidentally proposed a *subtractive* system of color production. Pigments, they suggested, appeared colored by absorbing certain components from white light, while reflecting only their own color to the observer. Each color could thus be made by combining primaries to eliminate or subtract all others, but the additive primaries that Maxwell had used—red, green, and blue—would not work: their complements or opposites—cyan, magenta, and yellow—were required instead. In 1877 Du Hauron perfected a subtractive carbon printing process to demonstrate his theory. Three negatives, taken through primary filters, were printed on thin, sensitized tissues containing reddish-blue, bluish-green, and yellow carbon pigments. When the tissues were superimposed on a white base, a full-color image was created (Plate 4).

Unlike the additive systems, which proceed from darkness to light, subtractive systems for producing color begin with white light. In a subtractive scheme, each of the three colors absorbs a primary, thereby subtracting or removing it from white light. Magenta, for example, subtracts green, cyan absorbs red, and yellow removes blue. If all three subtractive colors overlap, all light is absorbed, and the result appears gray or black.

Little more was done with the subtractive principle until 1905, when Karl Schinzel in Germany proposed coating three emulsion layers, each sensitized to a different additive primary, but dyed the absorbent subtractive color, on a single base. Thus the idea of an integrated tripack or *monopack*, which later became the basic structure of all color films, was formed. Although Schinzel's idea was theoretically sound, the dyes available to him at that time would not survive the required processing and he produced no workable material.

In 1912, however, Rudolph Fischer of Germany discovered that certain developing agents, as they reduced exposed silver bromide, would react with other chemicals to form stable, insoluble dyes. This discovery, known as *dye coupling*, pointed a way to form the proper subtractive colors in the layers of Schinzel's monopack. But one major problem remained: the sensitizing dyes tended to move from one layer to another, invalidating the selective color response essential to monopack construction.

More than two decades elapsed before this problem was solved. In 1935, Leopold Mannes and Leo Godowsky, Jr., of Eastman Kodak Company, introduced a complicated but practical subtractive monopack film called Kodachrome. In Europe, Agfacolor film was introduced within months of the Kodak product. Both films produced transparencies, or color positives for projection. With these epochal achievements, modern color photography was born.

COLOR FILMS

Choosing a color film requires two simple decisions: (1) Do you want slides or prints? (2) What kind of light will be used: daylight, flash, incandescent (tungsten filament) lamps, or fluorescent lamps?

There are two basic types of color films. One kind produces color slides or transparencies that can be seen in a hand-held viewer or projected onto a screen, in a darkened room, for simultaneous viewing by many people. The other type of film produces color negatives from which prints on paper are made.

Color Slide Films

Color slide films produce their images directly: the same piece of film you load in the camera is re-

Color Slide Films	D/T*	Color Negative Films for Prints	D/T*	Instant-Print Films	D/T*
Agfachrome CT-18	D	Kodacolor 400	D	Kodak PR10	D
Ektachrome 400	D	Kodacolor II	D	Polaroid SX-70	D
Ektachrome 200	D	Fujicolor 400	D	Polaroid Time-Zero Super Color	D
Ektachrome 160	T	Fujicolor F II	D	Polaroid Type 108 Polacolor 2	D or T
Ektachrome 64	D			Polaroid Type 668 Polacolor 2	D or T
Kodachrome 64	D				
Kodachrome 25	D				
Fujichrome RD 100	D				

Color balance—Daylight or Tungsten

turned as the positive images. Slide films therefore let you see your results quickly and the cost per picture is less. Slides, or *transparencies* as they are also called, are convenient to store and easy to retrieve, transport, and sequence for showing. They also tend to record colors more objectively, so long as their fixed color response is properly matched to the light. And because slides are projected or viewed by transmitted light, richer, more intense colors can be obtained with them. This greater color intensity possible in slides helps to compensate for their diminished physical value: usually we do not see the slide itself but a much larger projected version of it.

Color slide films, also known as *reversal films*, are now universally designated by names ending in *chrome* (see table). You can process most of them yourself (as described in the next chapter) or have a commercial lab do them for you.

Color Negative Films

Color negative films, of course, must be handled twice after exposure: once to produce the negatives (as with black-and-white) and again to make prints from them. This takes longer and costs more, but the two-step process permits some manipulation of the color that is not practical with slides.

Negative films have names ending in the suffix *color* (see table). Like reversal films, they can also be processed in your own darkroom or sent to a commercial lab. The process involves a little more work than black-and-white films do, but not as much as color slides require. And if you enjoy darkroom work, you can also make your own color prints from your negatives. These can be enlarged, of course, and individually crafted just as black-and-white prints can. Instructions for processing color negatives and for making color prints from them are given in the next chapter.

Although each type of film—slide or print—can be used to produce the other type of picture (pages 197 and 199), results generally will be better (more predictable if others process the films, more controllable if you do your own) when you use a film primarily intended for the form of picture—slide or print—that you want.

STRUCTURE OF COLOR FILMS

Color films have three black-and-white light-sensitive emulsion layers in them **[11-1]**. The top layer is sensitive only to blue light, the middle layer to green, and the bottom layer to red. A yellow filter layer under the top layer prevents the blue light from reaching the two layers below (like all silver bromide emulsions, they are also sensitive to blue light). The rest of the structure is similar to black-and-white films (page 64).

[11-1] Basic structure of color films.

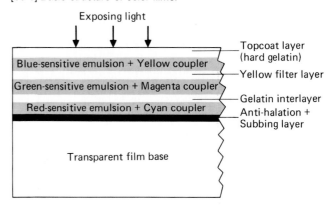

Almost all color films have color-forming ingredients called *couplers* in the three sensitive layers.* When the film is developed, these couplers react with other processing chemicals to form colored dyes in the light-sensitive emulsion layers. The dyes, of course, are those which absorb the primary sensitivity of each layer: yellow dye is produced in the top layer, magenta dye in the middle layer, and cyan dye in the bottom one. The yellow filter is removed by the processing chemicals.

*Kodachrome is an exception; its couplers are in the processing solutions instead of the emulsion layers. This requires a complex developing process provided only by the manufacturer and a few large commercial laboratories.

COLOR BALANCE

White light, as we have already noted, is a mixture of red, green, and blue wavelengths, but this mixture will vary according to the light source. The various sources that we perceive as "white" light can be compared by their *color temperature*, which is a way of designating the relative amounts of red, green, and blue in the mixture. Color temperatures are expressed as degrees on a Kelvin scale (Plate 3).* At lower temperatures, reddish light dominates the mixture; at higher ones the light is bluish.

Most color films are balanced for exposure by either daylight or by a type of tungsten lamp commonly used in photographic studios. Daylight films record the spectrum most accurately in average daylight (a mixture of sunlight and skylight) or by the light of flash lamps (pages 219–220), which closely resemble daylight in color. Tungsten films, on the other hand, give the best color rendering when the subject is illuminated entirely by 3200 K photographic lamps.

If other light sources, such as household lamps, are used, or if the light source and film are not correctly matched, a filter must be used over the camera lens to balance the light for proper color rendering. The table below lists the light and film combinations requiring filters for best color rendering. Note that the exposure must be increased when such a filter is used.

Filters will also be useful when you must make color photographs in fluorescent light. Fluorescent tubes emit a discontinuous or uneven spectrum, with much less red than is apparent to the eye. A fluorescent light filter (see table) will prevent the blue-green cast which the photographs otherwise would have. Compare the colors of objects in Plate 6A, made without a filter, to those in Plate 6B, made with an FL-D filter on the camera lens.

*The Kelvin scale designates the temperature to which a theoretical "black body" must be heated to give off light of this color.

In certain outdoor situations you will find other filters useful. When snow scenes. seascapes, views of mountains, or landscapes made at high elevations are photographed in sunlight, nearby shadows and very distant objects will often come out quite blue. This is due to a large amount of ultraviolet light present in these situations. Our eyes do not detect ultraviolet, but color films do and record it as blue. A skylight or ultraviolet filter (UV or 1A) will absorb this excessive ultraviolet and prevent it from reaching the film. Because these filters are very pale, they require no increase in exposure.

Balancing the light to the film with filters is most important when you are making color slides, for the film you expose in the camera is the same one you will project for viewing. All color correction must therefore be done when you expose the film. With negative film for prints, light balancing is less critical, since some corrections are possible at the printing stage. But a properly balanced negative, made with the indicated filter on the camera lens, will be easier to print.

THE LANGUAGE OF COLOR

It is not surprising that something as complex as color has a language all its own, and since color is a function of light, the nature of light should offer us some clues. In Chapter 4 we noted that different colors of light occur as different wavelengths on the electromagnetic spectrum, with red at one end and blue-violet rays at the other. Now if we bend a diagram of this spectrum so that its ends touch to form a circle, the three primary colors of light—*red, green,* and *blue*—will be equally spaced around it (Plate 5). Three other colors—*cyan* (blue-green), *magenta* (reddish-blue), and *yellow*—will now lie in between the primaries. *The relationship of these six colors is fundamental to all color photography.*

LIGHT AND COLOR FILM COMBINATIONS REQUIRING FILTERS FOR CORRECT COLOR RENDERING

Light Source	Film Type	Filter	Exposure Increase
Blue skylight	Daylight	81C	⅓ stop
Sunlight	Daylight	None	None
	Tungsten	85B	⅔ stop
Fluorescent cool white	Daylight	FL-D	1 stop
	Tungsten	FL-B	1 stop
Photofloods 3400 K	Daylight	80B	1⅔ stops
	Tungsten	81A	⅓ stop
Studio tungsten lamps 3200 K	Daylight	80A	2 stops
	Tungsten	None	None
Household tungsten lamps 2850 K	Tungsten	82C	⅔ stops

The eye, however, can distinguish many more colors than these, so a means of accurately describing colors is useful. The widely used Munsell System, for example, describes a color in terms of three characteristics to which names, numbers, or other identifying symbols may be attached:*

1. **Hue** is the name of a color. Red, green, yellow, and magenta, for example, are all different hues. Well over a hundred hues can be distinguished by the normal human eye.
2. **Lightness,** or **value,** is the degree of luminance a color possesses, and thereby a measure of how much light it reflects. Navy blue, for example, is low in lightness (dark); most yellows are high in lightness.
3. **Saturation,** or **chroma,** is the vividness or purity of a color. This is a measure of the dilution of a color with white light. Pink, for example, is a diluted version of red; a red traffic signal is not diluted.

Certain hues are complementary to each other; together they form white light, and will be found opposite each other on the color circle. Thus red and cyan are complementary hues, magenta and green are complementary hues, and so are blue and yellow.

As we have already seen, all colors of light can be produced by mixing the primary hues: red, green, and blue. Several early color processes, as we noted, were based on this principle, and today theatrical (stage) lighting and color television employ it. Virtually all color photography, however, is based on the subtractive primaries cyan, magenta, and yellow. These three dyes alter white light to give us the impression of all other colors in prints and slides. When none of them is present in a print or slide, we get the sensation of white. When all of them are present in full saturation, we see the result as black.

Colors adjacent to each other on the circle are often described in non-visual terms. For example, we tend to identify the blue-cyan-green section of the circle as "cool," and the yellow-red-magenta area as "warm." Warm, saturated colors, for instance, can intensify our level of emotional response, while cool or desaturated colors can have the opposite effect.

Adjacent hues on the color circle tend to harmonize, that is, to work together smoothly and maintain a sense of unity in a picture. Complementary hues, or ones that lie across the circle from each other, appear bold and decisive when framed together in a picture, especially when they occur next to each other. Used in this manner, they can contribute to a contrasting or dramatic effect. But if several complementary hues are present in the same picture, they can also clash with each other and rob a picture of much of its visual power and unity. A useful guideline, then, is to use complementary colors sparingly. One pair can contribute to a picture's strength. Two pairs of them, in effect, introduce a second theme which may compete with the first pair and weaken its visual effect. Three pairs of complementary colors in the same picture invite visual chaos.

We have other, familiar ways, however, to deal with color relationships. Two of the most effective hues a color photographer can work with are white and black. These are colors too, and they can often heighten the apparent intensity of other hues when they are present in an image but do not dominate it. Although blue dominates Bernard Freemesser's photograph (Plate 8), white and black are vital elements which relieve the weight of the blue and provide a counterpoint to it.

In Freeman Patterson's photograph (Plate 9), color plays a much more subtle role. Light refracted by water droplets on a plant close to the camera forms luminous, pearl-like circles arrayed across a background of contrasting hue and value. Had Patterson photographed this subject in black-and-white, most of this contrast would have been lost, and most of the picture's visual impact lost with it.

COLOR AS FORM

What we see working in the preceding examples is color as *form* and *substance* rather than as a surface quality alone. Earlier in this chapter we noted that color tends to dominate. In effective color photographs, hue and saturation usually are the dominant color characteristics, whereas value gradations (from light to dark) are similar to the tones of a black-and-white image. Such photographs function by treating the color itself as a major element of the picture, just as lines, shapes, and contrasting tones are considered. And because the sensation of color can easily eclipse other picture factors, anyone working seriously with it in photography must consider color as *form*, as a central element of the picture itself, and not as just another aspect of the detail that photographic images use to convey most of their informative content. Color adds to this informational function, of course, but in an effective photograph it accomplishes more than that. It attracts our attention, compels our emotional involvement with the picture, and conditions our response to it.

*The Munsell System uses a set of sample color patches numerically labeled to indicate these characteristics. A three-dimensional model in which the patches are arranged around a vertical *value* axis (like leaves and branches on a tree) also is available.

Nowhere is this more evident than in recent photographs by Stephen Shore, whose exquisite studies of grassroots America are memorable even though their subject matter is not (Plate 10). Shore's images are formal and direct; disarmingly simple in appearance, but not the least bit casual in execution. And they are elegantly crafted pictures.

John Clement's photograph of a solar eclipse (page 180 and Plate 11) demonstrates that working in color does not diminish the need for discipline that serious work in black and white requires. We still need to be selective, to edit what we see, and to recognize and respond to essential moments of changing situations. By comparing the black-and-white rendering to the color version, we can see that all of these concerns are just as pressing in color as in monochrome. Moreover, rather than merely adding another dimension to the problems of camera work, color often increases them. Carelessly composed pictures, for example, are likely to be even more discordant in color. It is therefore important to keep irrelevant objects out of your picture, since they are likely to be more intrusive in color than in black-and-white.

THE ULTIMATE REALISM?

A curious consequence of making color photographs is that the closer we get to representing reality with them, the more critical we become of their ultimate failure to do so. A photograph which makes no attempt to echo the real world makes no special demands on our senses for credibility. We take it as it comes, or invent our own rationale to justify what we see in the image. But let a color photograph try to closely resemble reality, and we make impossible demands upon it. We expect the photograph to show us what we see, although in actuality the world we see and the world our film can record are never quite the same.

Modern color films have their chromatic scale bred into them, a marvel of chemistry rather than a restatement of reality. Moreover, all brands of color films will not respond identically to a situation but will show characteristic minor differences. One brand may favor reds, another greens, and changes in processing (as from one lab to another) can add to or minimize these differences. Together these forces conspire to make color photographs questionable facsimiles at best. In spite of several generations of technological improvements which have aimed to make them replicas of the real world, color photographs have always fallen short of the mark.

This ultimate failure of color photographs to faithfully reproduce the real world is both a blessing and a paradox. We have grown so accustomed to seeing the world through color TV, slides, and other photographic reproductions that our perception of what is real often stems not from actual objects but from their reproduced images instead. Such varied visual experiences, of course, make us more tolerant of how things look both as objects and as images. When color photographs are asked to bear emotional or symbolic truths, they generally do these jobs rather well. But when we expect them to be conveyors of objective truth, as we frequently are tempted to do, color photographs may be among the most cunningly deceptive images in our visual manifest.

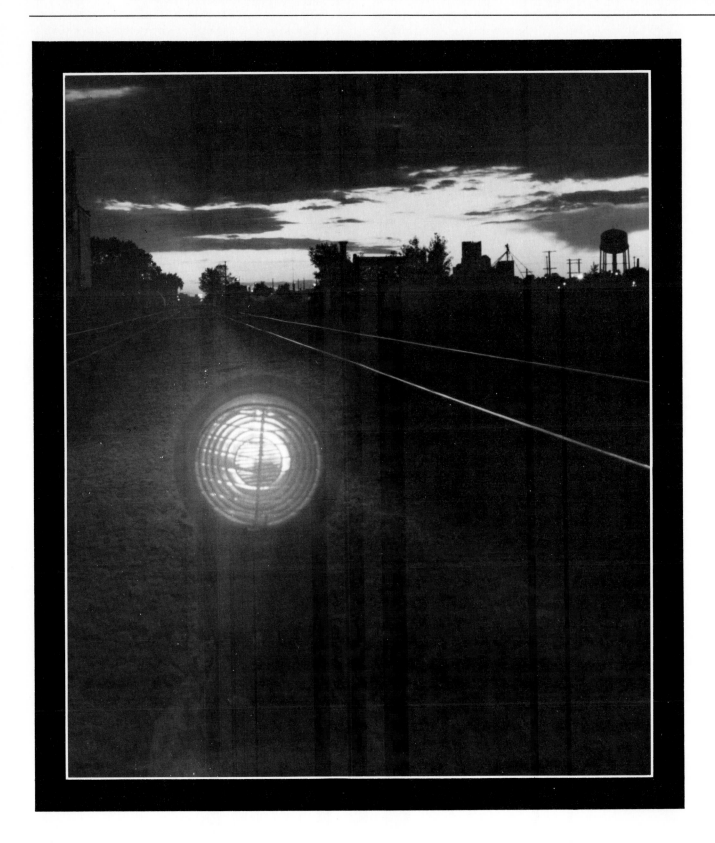

Processing color film is basically similar to processing black-and-white, but there are some important differences. Color processes require different chemicals, and most have more steps than black-and-white ones do. Materials and chemicals must be compatible, that is, made for each other; usually they cannot be interchanged. Temperatures are higher and are more critical for color than for black and white, and timing must be precise. Because of these differences, close attention to details and consistent working habits are a must; they will do more than anything else to insure good results for you, time after time.

When color film is exposed in a camera, a latent image is formed in each layer (page 184) wherever its primary color is reflected by the subject. Processing the film converts this latent image into a visible one, producing silver metal and forming appropriate dyes (colors) along with it. Then the silver and all soluble compounds are removed, leaving only the dye in the gelatin emulsion. Slide films, color negatives, and color prints each require somewhat different processes, but the similarities will be evident when you compare these processes to one another.

PROCESSING COLOR SLIDE FILM

To process color slide film you will need many of the same things you do for black-and-white (page 78). A stainless-steel, spiral-reel tank is recommended because it transfers heat efficiently and fills and empties quickly. Your thermometer must be accurate to within half of one degree at 38°C (100°F). You'll also need seven storage bottles with air-tight caps for the chemicals, and a plastic dishpan or similar container in which to immerse the tank and chemical bottles to keep them warm.

Slide films require chemicals for Process E-6; all required solutions are available as one-pint kits from Beseler, Kodak, Unicolor, and other suppliers. The developers in these kits can process about 4 rolls of film per pint. Other solutions can handle twice this number, so the kit usually contains 2 units of each developer. A totally dark place, of course, is needed to load the tank (pages 80–81), but you may do all of the processing in normal room light.

The process begins with a first developer, which forms black-and-white negatives in the three emulsion layers corresponding to the latent images of the camera exposure. Then the film is washed and treated in a reversal solution, which fogs all remaining light-sensitive silver halides throughout the film in much the same way that exposure to light would.

Next comes a color developer, which changes the fogged areas to silver and simultaneously forms complementary-colored dyes in them. Since these fogged areas constitute all of the film that was not affected by the camera exposure, they represent the opposite of a camera negative: in other words, a positive image. This step is followed by a conditioner solution.

Now the film is treated in a bleach, which changes the silver to a soluble compound (without affecting the colored dyes), and a fixer, which removes the silver compounds from the emulsion. Washing in running water then removes all dissolved chemicals, leaving only the dyes as a positive image. A stabilizer for the

dyes (which also contains a wetting agent) completes the process, and the film is hung up to dry.

To begin, preheat the chemicals to 38°C (100°F) by immersing the bottles in a container of hot water. The temperature of the first developer is very critical: it should not vary more than one-half degree; the color developer is almost as critical (±2°). Other solutions can be used at temperatures from 33 to 39°C (92 to 102°F). It is extremely important to keep the tank immersed in 38°C water at all times, except when briefly lifting it out to agitate or to empty it. Use a simple, repeatable agitation pattern, and always allow the last 10 seconds of each step to empty the processing tank. Once the film is in the color developer, the tank may be left open—but don't let the hot water get into it! Follow the instructions that come with the chemicals for precise timing, agitation, and other procedures.* The whole process takes about 37 minutes total "wet time." Make a note of how many rolls you process with the solutions, and the date you prepare them. Their storage life and capacity are limited. The E-6 Process is summarized in the chart below.

Some modification of film speed (ISO) is possible by changing the time in the first developer. For example, the nominal speed of a typical E-6 film can be *doubled* if the first developer time is increased by 2 minutes. When this is done, the time in all other solutions remains unchanged. A slight change in saturation and color balance may also be noticed.

When you process your own slides, you must also mount them in frames for projection—an easy and inexpensive process. Cardboard and plastic 2 × 2 in. slide mounts may be purchased from most photo dealers. Some mounts snap together; others are folded and sealed with their own adhesive or with the tip of a household iron.

Finally, orient and mark the slides for proper projection. Hold the slide exactly as you wish the picture to appear on the screen, then place a spot or similar mark in the *lower left corner* of the mount (see illustration). When the slides are loaded in the projector or tray with the index mark at the upper right, facing the rear of the machine, the image will be correctly projected.

Indexing slides.

*Chemicals and procedures may change from time to time as improvements are introduced. Always follow the instructions packed with the chemicals if they differ from information published elsewhere.

PROCESS E-6 FOR COLOR SLIDE FILMS

Step	Temperature °C	°F	Time in Minutes
1. First Developer	38 ± ½	100 ± ½	7*
2. Wash (running water)	33–39	92–102	2
3. Reversal Bath	33–39	92–102	2
Tank may be left open for remaining steps			
4. Color Developer	38 ± 1	100 ± 1	6
5. Conditioner	33–39	92–102	2
6. Bleach	33–39	92–102	7
7. Fixer	33–39	92–102	4
8. Wash (running water)	33–39	92–102	6
9. Stabilizer	33–39	92–102	1
10. Dry (remove film from reel)	to 49	to 120	

*For the first roll of film in fresh solutions. As additional rolls are processed in the same solution, this time must be increased. See instructions packed with the chemicals.

PROCESSING COLOR NEGATIVE FILM

The setup for processing color negatives is similar to that for slides: a steel tank, hot water, and an accurate thermometer are necessary. Color negative films require chemicals for Process C-41, available in one-pint kits from the same sources as slide film chemicals. The process is shorter than that for slides: only four chemical solutions are involved.

The color negative process begins with a color developer, which forms silver from the latent image and complementary-colored dyes in each of the three emulsion layers wherever the silver is produced. Next comes bleaching, which stops development and changes the silver image to a soluble compound but leaves the dyes alone. After a wash, the film is fixed to remove the soluble compound and all unexposed silver halides, just as with black-and-white negatives. Washing removes all soluble chemicals from the emulsion, leaving only the dyes. A brief bath in a dye stabilizer completes the process. The total "wet time" is about 25 minutes.

Color negatives have an orange-brown cast, even in unexposed areas which we would expect to find clear and colorless. This is because the magenta and cyan dyes used in negatives and color paper emulsions are not perfect; they actually transmit small amounts of wavelengths that they should absorb. To counteract this tendency, the middle layer is colored pale yellow and the bottom (red-sensitive) layer is colored pale red during manufacture. These colors remain in the film throughout the process wherever image dyes are not produced, and function as color-correcting masks in the developed negatives. Together the two colored layers appear orange-brown, giving color negatives their characteristic cast. The color does not appear, however, in prints made from the negatives.

You must preheat negative chemicals to 38°C (100°F) by immersing the bottles in hot water. The temperature of the developer is *very* critical; it should not vary more than ¼ degree. The other solutions and washes can be used at any temperature between 24 and 41 degrees C (75 to 105°F). As with slide film, it is very important to keep the tank immersed in warm water throughout the development step, lifting it out of the water bath only to agitate it. Use the last 10 seconds of each step to empty the tank. Note how many rolls of film you process in the same solutions, and when you prepared them. The instructions which accompany the chemicals will detail their capacity and useful life. The process is summarized below.

Unlike the slide film process, changes in film speed are not possible with negative color films. If you change the development time of the C-41 process, you will change the color formation in the negative. Such negatives will be difficult or impossible to print satisfactorily.

PROCESS C-41 FOR COLOR NEGATIVE FILMS

Step	Temperature °C	°F	Time in Minutes
1. Developer	38 ± ¼	100 ± ¼	3¼*
2. Bleach	24–41	75–105	6½
Tank may be left open for remaining steps			
3. Wash (running water)	24–41	75–105	3¼
4. Fixer	24–41	75–105	6½
5. Wash (running water)	24–41	75–105	3¼
6. Stabilizer	24–41	75–105	1½
7. Dry (remove film from reel)	24–43	75–110	

*For the first roll of film in fresh solutions. As additional rolls are processed in the same solution, this time must be increased. See instructions packed with the chemicals.

COLOR PRINTING FROM NEGATIVES

Color printing requires a light-tight darkroom. Although most color print materials can be handled under a Wratten No. 13 safelight (dark brown), this safelight provides little illumination and it is just as easy to work in the dark. Making color prints is a bit more complicated than making black-and-white ones, but if you are consistent in your work habits and keep careful notes of your procedures, color printing can be fascinating and fun.

To make color prints, you will need the same basic darkroom setup that black-and-white work requires (page 96), plus a few additional items:

1. A set of acetate color printing filters (Beseler, Ilford, and Unicolor have convenient sets).
2. Color printing paper (Beseler, Kodak Ektacolor 74, Ektacolor 78, or Unicolor RB).*
3. Chemistry to match the paper (Beseler 2-step Type A, Kodak Ektaprint 2 Processing Kit, Unicolor Ar Kit).

*Ektacolor 78 paper has slightly higher contrast than the others. In all other respects it handles the same.

4. Any black-and-white enlarger that will accept acetate filters in the lamphouse can be used. It should be equipped with a heat-absorbing glass between the lamp and the filter holder. Filters must be removed and replaced to make changes in color, but this arrangement is economical. Enlargers designed especially for color work are more convenient but more expensive (see illustrations below). Here the necessary filters are continuously variable and are built in. Color changes are made by simply turning dials, a more accurate and efficient procedure.
5. A dishpan or deep tray is needed to prewarm the chemicals. You'll also need some means of keeping the print and chemicals at the proper temperature during processing. A stainless steel or thin plastic tray will work if it is prewarmed and floated in a larger tray of warm water; various tubes or drums designed for this purpose may be used instead. A dependable supply of hot water is important, particularly if you are processing in an open tray, and an accurate thermometer is essential.

There are three phases to color printing: (1) exposure, (2) processing, and (3) evaluation. The basic method is similar to black-and-white printing, so only the differences will be stressed here.

Color heads for typical color enlargers. Courtesy Beseler Photo Marketing Company, Inc., and Omega Division, Berkey Marketing Companies.

Color printing filter set.
Courtesy Beseler Photo Marketing Company, Inc.

EXPOSURE

Start with the trial filter pack recommended by the paper manufacturer. This will include magenta and yellow filters (to control the color of the print) and an ultraviolet-absorbing filter (UV or 2B) which is always used with the others. Filter values of the same color can be added together (20Y + 05Y = 25Y) but try to use as few filters as possible in the pack.

Each color negative requires at least two trial prints: one for exposure, the second for color balance. Make the exposure test first. As in black-and-white, if you increase the exposure (time or aperture) you will make the print darker. Your first trial print should be exposed in sections or strips (5, 10, 15, 20, 25, 30 seconds) using the recommended trial filter pack. Also make a note of the magnification.*

Process this print (as described in the next section) and choose the trial exposure time that looks best. Use this time as a starting point for future trial prints.

*If the enlarger does not have a magnification scale on its column, insert a thin transparent plastic ruler in the empty negative carrier and measure its enlarged image on the easel below.

COLOR PRINT PROCESSING: TRAY METHOD

1 / prepare the chemicals

Measure and prewarm all required chemicals. For one 8×10 print in an 8×10 tray, 200 ml (7 oz) of each chemical is required. The developer should be used only once and discarded. Other chemicals can be used for three 8×10 prints if they are returned each time to their warming containers.

2 / prepare the trays

Arrange an 8×10 tray in a larger tray as shown here. A tray siphon is convenient for keeping warm water circulating in the larger tray without overflowing its rim. The larger tray can be used for washing during the process. Fill **both** trays with warm water to preheat them.

3 / verify the temperature

Check the temperature of the water bath and developer, and when it is within the required range, turn off the lights. If you have sensitive skin, it's a good idea to wear rubber gloves because some of the chemicals may irritate your hands.

/ continued ⟶

Empty the water from the small tray, pour in the developer, and immediately immerse the print **face down.** Then turn the print over and begin rocking the tray gently from corner to corner, permitting the developer to flow back and forth over the print. Rock lengthwise, then crosswise, alternating in a regular pattern. Keep the small tray in constant motion.* When the developing time is up, pour the used developer out of the tray into a discard pail or drain, but **leave the print in the tray.**

Immediately pour the stop bath over the print, rocking the tray as before for 1 minute. Then drain the solution off, returning it to its warming container.

Now move the print to the larger tray and rinse it for 1 minute in running water. While the print is rinsing, rinse out the small tray under the siphon.

Pour the bleach-fix into the small tray and return the print to it for the required time. Rock the tray as before. White light may be turned on at the end of this step.

Return the print to the larger siphon tray and wash as directed. Pour the used bleach-fix back into its warming container for reuse, and **thoroughly** wash out the small tray.

If the process includes a stabilizer, treat the print in it and hang it up to dry. If no stabilizer is used, the print may be hung up directly after washing. Thoroughly wash the small tray before it is used again.

*This agitation pattern is important for even development. It can be practiced beforehand in white light by using 200 ml of water and a discarded black-and-white RC print. Be sure all parts of the print are covered by the solution.

The tray method of processing color prints, using Kodak Ektaprint 2 chemicals, is summarized in the table below. Other brands of chemicals may require different times or changes in the sequence. See instructions packed with the chemicals.

PROCESSING EKTACOLOR 74, 78, AND SIMILAR PAPERS IN A TRAY WITH KODAK CHEMICALS

NOTE: Sequence or times may vary with other brands of materials. A No. 13 safelight or total darkness is required for the first four steps.

Step	Temperature °C	°F	Time in Minutes
1. Ektaprint 2 Developer	33 ± ½	91 ± ½	3½
2. Kodak SB-1 Stop Bath*	30–34	86–93	1
3. Rinse (running water)	30–34	86–93	1
4. Ektaprint 2 Bleach-Fix	30–34	86–93	1½
5. Wash (running water)	30–34	86–93	3½
6. Dry—air dry	to 107	to 225	

*1 part 28% acetic acid and 20 parts water

Drum or Tube Processing Method

Drum or tube processing is similar to the tray method but it usually begins with a prewet step before the developer and requires washing in a tray after the bleach-fix. Drum processing generally offers three advantages over the tray method. First, after the drum has been loaded in the dark, the entire process can be done in white light. Second, drums usually require less of each chemical than trays do, and thus use chemicals more economically. Third, drums are easier to handle than floating trays. Drums have two disadvantages, however. They are more expensive than trays, and most can handle only one print at a time.

Several types of drums are available. One that can be rotated in a warm-water bath is best. Because designs differ, follow the instructions that come with the drum you are using, and always include a 15-second drain time in each processing step. Also be sure to thoroughly wash the drum after each use.

Color print processing drums.
Courtesy Beseler Photo
Marketing Company, Inc.

EVALUATION

Chances are that your first color prints will not look right, so some corrections and reprinting will probably be required. This is typical, a normal part of the printing process. If you know exactly how the first print was made—which means keeping a record of exposure, filtration, and magnification—evaluation and correction will be easy. Two judgments must be made. The first is for exposure, the second for color. For both, the print should be dry.

Exposure is judged the same as in black-and-white. If the print is too light, increase the exposure; if too dark, decrease it. Using the initial trial print as a guide, adjust the time for small changes, the aperture for large ones.

Judging color is a bit more difficult but it can be learned with practice. The procedure involves two questions:

1. Which color in the print is excessive?
2. How excessive is it?

It is easier to detect too much of a color than too little, so look at the print and decide which color dominates the others. This judgment is best made in the highlights or lighter values of a picture, those areas between white and the middle tones.

The next question, a quantitative judgment, is more difficult, and the guides or brochures supplied by paper manufacturers will be useful here. Another way to judge the amount of excessive color is to view the trial print through a printing filter of the *complementary* color (page 186). Find the filter value that neutralizes the excess color (makes it gray) in the highlight areas noted above.

To make the correction, *add* to the filter pack *half* of the excessive color. For example, if a print is judged to be 20 too yellow, add a 10Y filter to the pack.

Alternatively, the *complementary* color may be *removed* from the pack. If the trial print appears 30 too green, for example, remove *half* that much magenta (15M) from the pack.

If two colors appear to dominate the print, correct for the more dominant color first. The table below is a guide to the changes required.

CORRECTING PRINTS
MADE FROM COLOR NEGATIVES

If trial print appears too	Make this change in the filter pack
Red	Add Magenta + Yellow
Green	Remove Magenta
Blue	Remove Yellow
Cyan	Remove Magenta + Yellow
Magenta	Add Magenta
Yellow	Add Yellow

Whenever you change the filter pack you must also recalculate the exposure. Most filter sets contain a calculator for this purpose; follow the instructions with it. Changes in magenta filters affect exposure more than changes in yellow, but in general, the greater the filtration change, the greater the exposure change. In some cases, a new trial print may be needed.

Also, be sure your pack contains only two colors (plus the UV filter). If all three colors (cyan, magenta, and yellow) are present, you have neutral density in the pack, and this will only increase the exposure without changing the color.*

When you have evaluated the trial print and recalculated the exposure and filter pack, write the old and new data on the back of the trial print and repeat the exposure→processing→ evaluation sequence.

*To eliminate neutral density, subtract the cyan value from all three colors. This will reduce the cyan value to zero.

DODGING AND BURNING

Dodging and burning can be used to improve color prints by lightening or darkening local areas. The technique is the same as in black-and-white (pages 114-116).

Colors can also be intensified or subdued locally in the print by these techniques. For such changes, color filters can be held under the lens for part of the exposure or for additional time as needed. Use a filter of moderate value, such as 40 or 50, for a brief period. To intensify a color, use the complementary filter. To soften or subdue a color, use a filter of the same color. Plate 7A, for example, is printed in the normal manner. In Plate 7B, however, the sky has been dodged with a 50Y filter for part of the exposure time. In some cases you might have to use two filters of different hues to produce the desired effect (to soften green areas, for example, use cyan and yellow filters together). As in black and white, some practice will be needed to use these techniques with confidence.

SPOTTING AND MOUNTING COLOR PRINTS

Color prints are spotted in much the same way as black-and-white ones. Small, white areas should be spotted out with color retouching dyes intended for the type of paper used. Convenient sets of dyes are available from photo dealers. The dyes should be applied just as Spotone is applied to black-and-white prints (page 119), but instead of diluting the dye with water, use a working solution of stabilizer. This will help the dye penetrate the hard RC emulsion, and insure compatibility with the image dyes already there. Tiny white spots on color prints not intended for long life can often be hidden by simply darkening the spot with the appropriate tint of Spotone. By matching the brightness with the area around it, the tiny spot will blend and be unnoticed by the eye. Dilute the Spotone with stabilizer.

Color prints are mounted just like black-and-white ones on RC paper (pages 117-118), but the temperature of the mount press for materials requiring heat should not exceed 99°C (210°F). More detailed instructions will be found with the mounting material used; Kodak Dry Mounting Tissue Type 2, or Seal Colormount Tissue, are recommended. Cover sheets must be absolutely clean.

Most color prints look best on mount boards of moderate brightness, and neutral tints such as tan, gray, or gray-blue will generally look better than white or black. White tends to desaturate the colors it surrounds unless it is used sparingly, that is, as a narrow border. Similarly, large areas of black surrounding a color print can overwhelm it rather than enhance it. Brightly colored mounts of any hue should be avoided. The suggestions for protecting finished black-and-white prints apply equally to color. See page 119.

Because color printing involves so many visual judgments and strict attention to processing times and temperatures, it requires a skill that can only be learned by sufficient practice. There are no magic solutions or short cuts to good work. Sophisticated equipment is helpful, but it can't make creative decisions for you. Only you can do that. Many of the materials used in color printing are available in convenient "starter" kits containing just enough paper and chemicals to let you discover what is involved. After a few prints, you'll know whether color printing is for you. For if you like the work, the pleasure you'll get from making your own enlarged color prints will more than reward you for all the effort required.

PRINTS FROM SLIDES

Slides and prints are both *positive* images, so making a print from a slide without an intermediate negative requires a different printing system than prints from negatives do. Two such systems are available. One involves a reversal printing paper that processes much like slide films do, with the dyes formed by the color developer during processing. Kodak Ektachrome 2203 Paper works like this. It can be processed in Kodak R-500, Beseler RP-5, or Unicolor RP-1000 chemicals.

Another system, which works on a different principle but is simpler to use, is Cibachrome, outlined here. Cibachrome is a dye-bleach or dye-destruction process. As we have already noted, almost all other color materials have their dyes formed during processing. The dyes in Cibachrome, however, are manufactured in the materials rather than formed by development. They have excellent color purity and are more permanent than those of most other materials.

Cibachrome materials are exposed in an enlarger just like other papers, but processing is different. Three solutions are involved: developer, bleach, and fixer. Because the print is exposed from a positive color slide, the latent image will be a negative one. The developer converts this to a black-and-white silver negative, much like the first processing step for slide films. In the next step, the bleach destroys the silver image and the dyes positioned with it. Dyes elsewhere in the three emulsion layers are not affected. Fixing dissolves all silver compounds, and washing removes the dissolved chemicals. Then the print is dried.

There are two groups of Cibachrome materials, each with its own associated chemical process. The Type A material is processed in P-12 chemicals and is the easier of the two methods to use. Cibachrome II materials, which have superior rendition of blue, green, and yellow hues due to a built-in masking feature, require Process P-3 chemicals. This method has more stringent temperature and handling requirements.

None of the Cibachrome materials and chemicals are interchangeable with those of other systems. The bleaches used in these processes contain a strong acid, so a fourth chemical, a neutralizer, is provided in the kit to permit its safe disposal after use. The chemicals are used once and discarded.

Exposure

Place the slide in the negative carrier of your enlarger and be sure no raw light comes through sprocket holes or around the outside of the film. Carriers which accept 2 × 2 in. slide mounts are available for some enlargers, or the slide can be unmounted and handled like a 35 mm negative. The initial exposure should follow the instructions packed with the Cibachrome material. Heat-absorbing glass and a UV filter should be used along with the indicated filter pack. *Handle Cibachrome material in total darkness.*

Processing Type A Materials

The P-12 process runs at 24° ± 2°C (75° ± 3°F). Either trays or drums may be used. Allow 10 seconds in each step to drain a tray, or 15 seconds to drain a drum. As each step is completed, discard the chemical into a pail to which neutralizer has been added. *Wear rubber gloves when handling the chemicals.*

Cibachrome Discovery Kits.
Courtesy Ilford, Inc.

CIBACHROME PROCESS P-12 FOR TYPE A MATERIALS

The temperature of all solutions is 22–26°C (72–78°F). Total darkness is required for steps 1 and 2. Wear clean rubber gloves for the first three steps.

Step	Agitation	Time in Minutes
1. Cibachrome P-12 Developer	As directed in chemical kit	2
2. Cibachrome P-12 Bleach	As directed in chemical kit	4
3. Cibachrome P-12 Fixer	Continuous	3
4. Wash	Running water	3
5. Dry—air dry, not over 107°C (225°F).		

Wash all equipment thoroughly after use, and be sure to neutralize the bleach before discarding the used solutions.

Processing Type II Materials

The P-3 process should be used only at 30°± ½°C (86°±1°F). Only drum processing is recommended. Use the last 15 seconds of each step to drain the drum into a pail to which neutralizer has been added. *Wear rubber gloves when handling the chemicals.* For the first wash (step 2), use the same measured amount of water as you use of chemicals in the other steps; do *not* use running water here, and do *not* agitate. Subsequent washes can be accomplished by letting running water flow through the drum or by removing the print and washing it in a tray.

CIBACHROME PROCESS P-3 FOR TYPE II MATERIALS

Wear clean rubber gloves through the first five steps.

Step	Agitation	Temperature °C	Temperature °F	Time in Minutes
1. Cibachrome P-3 Developer	Rotate drum 20–25 rpm	30 ± ½	86 ± 1	3
2. Wash (measured amount of water)	No agitation	30 ± ½	86 ± 1	1
3. Cibachrome P-3 Bleach	Rotate as above	30 ± 1	86 ± 2	3
4. Wash (running water)	Continuous	28 – 32	82 – 90	1
5. Cibachrome P-3 Fixer	Rotate as above	30 ± 1	86 ± 2	3
6. Final wash (running water in tray)	Continuous	28 – 32	82 – 90	4½
7. Dry—air dry (wipe surfaces with soft rubber squeegee)		up to 70	up to 160	

Wash all equipment thoroughly after use, and be sure to neutralize the bleach before discarding the used solutions.

Evaluation

As with other color printing methods, first judge the exposure, then the color balance. Because Cibachrome printing is positive-to-positive, corrections for exposure and color balance are just the opposite of negative-positive systems. Reducing exposure makes the print darker, increasing it makes it lighter. Color corrections are reversed, too, as the table here indicates.

Cibachrome prints tend to have somewhat more contrast than the original slides from which they were made. This will usually be advantageous to an original image that is soft, or low in contrast, but might be troublesome if the contrast of the original slide is high. In such cases, a different method of making a print might give a better result. This involves making a special color negative—an *internegative*—from the slide and then printing it like any other color negative (page 192) Making the internegative is best left to commercial laboratories, since the special film required is perishable and not available in convenient sizes.

CORRECTING PRINTS MADE DIRECTLY FROM COLOR SLIDES

If print appears too	Make this change in the filter pack
Red	Add Cyan
Green	Remove Cyan + Yellow
Blue	Add Yellow
Cyan	Remove Cyan
Magenta	Add Cyan + Yellow
Yellow	Remove Yellow

Larger changes in filter values will be required than with negative-positive materials.

INSTANT COLOR PRINT MATERIALS FOR THE DARKROOM

Kodak has recently announced a new system for making color prints that is based on certain aspects of instant color film technology. Known as the Kodak Ektaflex PCT Color Printmaking System, it uses only one chemical solution which is contained in a compact, table-top, manually operated machine. The process is simple to use, and dry color prints can be made in minutes from either color negatives or slides.

Because this new system differs significantly from conventional color print materials and methods, it is discussed with other instant-print materials in the Appendix.

SLIDES FROM NEGATIVES

Although the best slides are made on slide films with original camera exposures, they can also be made from color negatives. The process is not practical to do in small quantities in your own darkroom, but the service is available from Kodak and other commercial laboratories, which also mount 35 mm slides for projection.

BLACK-AND-WHITE PRINTS FROM COLOR NEGATIVES

Black-and-white prints can be made from color negatives just as they can from black-and-white ones, but ordinary black-and-white enlarging papers distort the tonal values since they are not sensitive to all the hues of color film. Reds in the subject will print too dark, and blues too light. Exposure times, moreover, may seem unreasonably long.

Kodak makes a special paper, Panalure II RC, which is *panchromatic*, or sensitive to all colors of light. It must therefore be handled and developed in *total darkness*, without a safelight. You expose it just like other graded black-and-white papers (without filters), and develop it in Dektol 1:2 like any other black-and-white RC paper. Once it is fixed, of course, the light may be turned on. Panalure II RC paper shows each original subject color in its proper shade of gray, resulting in a more natural-looking print. The slight inconvenience of working in the dark is offset by the superior print quality obtained.

HOW STABLE ARE COLOR PHOTOGRAPHS?

As every box of color film and paper reminds us, dyes used in these products can change in time, so the question of color photographs fading is one that needs to be discussed. The sad truth is that color photographs begin deteriorating the moment they are made; the only questions are how quickly, and how can this irreversible change be minimized?

The major causes of such change are absorbed energy from heat and light, chemical reactions with polluted air, and chemical changes in the acidity or alkalinity of the film caused by variations in processing.

Chemical deterioration can be minimized by proper processing, and since the time in various processing steps has an important bearing on the resulting stability of the film or print, manufacturers' recommendations should be carefully observed. Photographs should not be handled or displayed in polluted air, and they should be stored only in properly designed envelopes or packages under the most favorable conditions possible. *Collection, Use, and Care of Historical Photographs* by Weinstein and Booth (see bibliography, under General Works) is an excellent reference for detailed information on this topic.

Once the aforementioned risks have been minimized, further efforts should be directed to keeping undesirable energy—heat, light, and humidity—from reaching the materials.

At this point the problem becomes complex, because light-fading and dark-fading characteristics differ for each different type of color material, and a film which may have good stability in the dark, for instance, will not fare well with repeated exposure to light. On the other hand, products with complete dye molecules in their emulsions, such as Cibachrome materials, have light-fading characteristics superior to most films and papers whose colors are formed during processing.

A few guidelines, however, appear to be generally applicable. Exposure to light, especially daylight or fluorescent light, should be minimized. Ideally, color prints should be displayed only in tungsten light, which is generally free from destructive ultraviolet radiation. Slides should be projected only for brief periods—one minute or less. If longer, sustained projection is required, such as for continuous display, duplicate slides (available from commercial labs or through photo dealers) should be used and the originals stored in the dark.

In dark storage, color photographs must be protected from excessive heat and humidity. Over long periods, high humidity is more destructive to color photographs than heat, but the two conditions together are worse than either alone. A relative humidity of 20–30% and a temperature of 20°C (68°F) is ideal for dark storage of most color films and prints. Lower temperatures, down to 2°C (35°F), will extend this safe storage life considerably, but only if the photographs are properly sealed against the high humidity which often accompanies such temperatures. Ultimately, the cost of maintaining such long-term conditions must be balanced against the value of the photographs and the need to preserve them.

13 INTERCHANGEABLE LENSES AND FILTERS

©Larry S. Ferguson: Mara, near Hansen, Nebraska, 1978.

In Chapter 3 we examined the major types of cameras and noted that each type has a feature which gives it advantages over the others: low-cost simplicity for most viewfinder cameras; easy, accurate framing and focusing for the single-lens reflex; the rugged, dependable performance of a twin-lens reflex, and the precise adaptability of the view camera to many different situations.

Another feature which commonly separates better cameras from the simple snapshot variety is the *interchangeable lens*. Being able to remove one lens from the camera and substitute another that will form a different image greatly increases the camera's usefulness. It also demands a basis for intelligent choice, particularly with camera systems that offer lenses in wide variety. Making the best use of a camera or lens, like any other tool, requires that its fundamental properties be adequately understood and correctly applied to the situation at hand.

No other part of a fine camera is more important than its lens, nor is any other part so shrouded in mystery. The names we find on lenses today—Xenar, Tessar, Elmar, Symmar, Planar, Sekor, Rokkor, Takumar, Heliar, Nikkor (and there are many others)—are not very informative. How do they differ from one another? And what kinds of images are they best suited to make? One purpose of this chapter is to shed some light (if you'll pardon the pun) on the mystique of photographic lenses; another is to explain how camera filters are used with them.

HOW A LENS FORMS AN IMAGE

The function of any camera lens is to form an image, and it does this by bending rays of light that pass through it. In Chapter 4 we noted that when light passes from one material to another, its waves are bent. When a ray passes from air into a denser material such as glass, for example, the ray is bent toward a line perpendicular to the surface of that material. When light leaves a dense material and enters a less dense one, the opposite occurs: thus a ray passing from glass into air is bent away from the perpendicular to the surface as it passes through.

In the example just described and diagramed here, if the two glass surfaces are parallel, as in a rectangular block, the entering and emerging rays will be parallel too.

Light wave passing through air and glass.

But if they are not, as with a *prism*, the rays will be *bent*, in this case toward the base of the prism.

Light ray being bent by a prism.

Now visualize two identical prisms base to base; rays passing through them are all bent toward the baseline and ultimately cross one another, as shown here.

Light rays being bent by two prisms, base to base.

If we add more surfaces to these prisms at the correct angles, all the emerging rays will converge and cross at the same point. An infinite number of such surfaces—a spherical surface on the prisms—would cause all light rays emanating from one point and passing through the prisms to converge at another point beyond them. Now we would have a simple lens.

A simple lens.

POSITIVE AND NEGATIVE LENSES

Lenses cause light rays to come together or spread apart. Lens elements that cause light rays to converge, or come together, are called *positive* lenses; they are thicker in the center than at the edges. Lens elements that make light rays diverge, or spread apart, are *negative* lenses. They are always thicker at the edges than in the center, and they cannot form an image by themselves as positive lenses can do. In all but the simplest lenses, positive and negative elements are combined. This helps to disperse the image evenly over the film plane and to improve its sharpness and overall quality. Regardless of how various elements are combined, the aim is to produce a lens that will form a clear, flat, sharp image the size of the film to be used with it, and to do that over a range of lens-to-subject distances for which the camera is intended.

Electronic computers have dramatically shortened the time formerly required for lens designing. Lenses of superb quality are now found on relatively inexpensive, mass-produced cameras, and distinctly inferior lenses have virtually been banished from the market. With computer programs now available, any optical manufacturer can produce a variety of interchangeable, high-quality lens designs. Understanding their basic characteristics, then, should help us choose such lenses more wisely.

FOCAL LENGTH

The most fundamental characteristic of any lens is its *focal length*. Generally speaking, this is the distance from the center of that lens to the film plane, when the lens is focused on infinity.* With

*This is an adequate but inexact explanation. The measurement is properly made from a point within the lens system called the *emerging nodal point*. All rays that travel through the optical center of the lens appear to leave the lens from that node.

any lens, the longer the focal length, the larger the image of an object at a given distance. Focal length and image size are therefore directly proportional: if you replace a lens of 50 mm (2 in.) focal length with one of 100 mm (4 in.) focal length, the latter image will be exactly twice the size of the former.

With interchangeable lenses, then, we may vary the size of our image on the film, but not all of that image may be usable. That depends on another important characteristic of a lens—its coverage.

LENS COVERAGE

Light passing through a lens forms a circular image, but practically all cameras are designed to make rectangular pictures within that circle. Each lens is designed to cover a particular size field, a requirement usually dictated by the format and construction of the camera for which it is intended. Lenses designed for a 35 mm camera, for example, will have fairly narrow cylindrical mounts since the image circle they must form is less than 3 in. in diameter. A lens to be used on a 4 × 5 in. view camera, however, must form a circular image at least 6 in. (150 mm) wide. This is why different lenses of the same focal length cannot be interchanged among all types of cameras. Although a 135 mm lens for a 35 mm camera and one of identical focal length for a 4 × 5 in. camera will form images of the same magnification, the two lenses are not interchangeable since the one designed for the 35 mm camera will not cover the larger film area of the other. Thus *focal length*, which governs image size, and *angle of coverage*, determined by the film size that the lens is designed for, are key factors in understanding what a particular lens can do.

The focal length of a lens is usually marked on its mount, as is the ratio of its maximum usable aperture. Thus a typical lens may be marked as follows: Schneider Xenar 1:3.5 f = 80 mm. In this example, *Schneider* is the manufacturer, *Xenar* the trade name of the lens design, its largest aperture is f/3.5, and its focal length is 80 mm (about 3¼ in.). Lens coverage is not similarly indicated but often can be inferred from the design of the mount; as a rule that mount will readily permit its attachment only to the type of camera for which that lens is suited.

The *maximum aperture* of a lens used to be considered a key identifying feature along with its focal length. Today's highly sensitive films, however, have made this aperture designation a less important factor when selecting interchangeable lenses.

CLASSIFYING LENSES

Lenses are conveniently classified according to their focal length and covering power. Those used in general photography fall into three broad categories:

1. **Normal lenses,** also known as medium-focal-length or normal-angle lenses. This is the type commonly found on most cameras; they are suitable for general use.

2. **Long-focus lenses,** also designated long-focal-length or narrow-angle lenses. These lenses produce larger images than normal ones do and are therefore useful over greater distances. A *telephoto* lens (page 204) is a special kind of long-focus lens.

3. **Wide-angle lenses,** also called short-focal-length lenses. These enable the camera to record a larger area while being confined to a close distance, as in a small room, and they have other useful applications.

NORMAL LENSES

A lens is considered *normal* when its focal length is *slightly greater* than the diagonal of the film size being covered. A 50 mm (2 in.) lens, for example, is a normal or medium focal length for the 35 mm format, whose diagonal is 44 mm.* The table on page 204 gives the focal lengths of normal lenses for frequently used film formats.

The focal length and coverage of a normal lens are similar in proportion to the average focal length and visual field of the human eye.† Thus the image produced by a normal lens has a perspective within it that we find familiar. Normal lenses are suitable for most types of general photographic work, and should be used unless there is a good reason for choosing a different kind.

LONG-FOCUS LENSES

A lens is considered to be a *long-focus* lens when its focal length is *much greater* than the diagonal of the film size being covered. Long-focus lenses produce larger images at a given subject distance than normal ones do on the same film size. In general photography they are useful for framing a smaller area or a more distant subject than a normal lens can do; although they "see" less area, they enlarge it more. Long-focus lenses are also useful to reduce distortion of the third dimension that comes from too close a point of view. For example, in head-and-

*The 35 mm designation for format and focal length may be confusing. The *35 mm format* uses a strip of film 35 mm wide. Allowing for the two rows of sprocket holes, its typical image frame is a rectangle 24 × 36 mm with a 44 mm diagonal. A 50 mm focal length is therefore considered normal for this format, but a lens of 35 mm focal length would be a wide-angle lens on such a camera.

†The *visual field* of the eye is the area it can see from an immobile position. Because the eye moves, however, we usually refer to its *field of view*, a greater area describing the limits of its visual field in all orbital positions.

TABLE OF NORMAL FOCAL LENGTHS FOR POPULAR FORMATS

Format Name	Film Size Designation	Image Size	Diagonal	Normal Lens Focal Length
Pocket instamatic	110	13 × 17 mm	21 mm	25 mm
Instamatic	126	28 × 28 mm	40 mm	45–50 mm
35 mm	135	24 × 36 mm	44 mm	50 mm
645	120	45 × 60 mm	74 mm	80 mm
6 × 6 cm (2¼ × 2¼ in.)	120	60 × 60 mm	76 mm	80 mm
6 × 7 cm	120	60 × 70 mm	92 mm	105 mm
4 × 5 in.	4 × 5	95 × 120 mm	152 mm	150 mm

shoulders portraiture, a long lens enables the camera to remain farther away from the subject, yet still fill the frame; a normal lens requires a closer camera position, from which the subject's nose and ears appear disproportionate in size.

Long-focal-length lenses have their problems, though, and one of them is that image movement from a shaky or unsteady camera is magnified along with the picture. A tripod may be needed to control this. Another problem is the increased distance necessary between the lens and film. This requires a more expansive bellows or a longer lens mount on the camera, and there are practical limits of space and weight to such apparatus.

Telephoto Lenses

A solution to this latter problem is the *telephoto* lens, constructed with two groups of elements separated by a substantial air space. The front group is positive, or converging; the rear group negative. This arrangement permits the lens to focus its image at a much shorter lens-to-film distance than a normal lens of equal focal length would require. For example, a 300 mm telephoto lens mounted on a 35 mm camera may require only 145 mm of space between its rear element and the film plane. This saves considerable space and makes the camera and lens easier to hold and balance.

Incidentally, all telephoto lenses are long-focus lenses, but the converse is not true. A telephoto lens must focus at a lens-to-film distance *shorter* than its actual focal length. If it doesn't, it's merely a long-focus type. The photograph of the Santa Clara Valley in California (page 66) was made with a 380 mm (15 in.) telephoto lens on a 4 × 5 in. format.

Mirror Lenses

When extremely long focal lengths are needed for small-camera lenses, a *catadioptric* system may be employed. This type of lens combines reflecting mirrors with refracting elements, enabling the light rays to be bounced back and forth within the lens system before being passed on to the film. Such a lens can save considerable space and weight in focal lengths beyond 400 mm (for a 35 mm format), but it has two troublesome features. If the view being photographed has a highly reflective background, such as the sunlit surface of a lake, the lens will produce circular, out-of-focus highlights in the image from uncontrolled reflections in its mirrors. A more serious problem with mirror optics is that they have no diaphragm (aperture) because it would obstruct the passage of light through the mirror system. Exposure must therefore be controlled entirely with shutter settings or filters, and depth of field cannot be varied. Nevertheless, mirror optics represent a compact alternative to telephoto lenses that are too long and difficult to handle.

WIDE-ANGLE LENSES

A lens is called a *wide-angle* lens when its focal length is much *shorter* than the diagonal of the film size it covers. Examples include lenses of 35 mm focal length or less for a 35 mm format (see footnote on page 203), and lenses of 40 to 65 mm focal length for a 6 × 6 cm (2¼ × 2¼ in.) format. Wide-angle lenses typically have an angle of coverage twice that of a normal lens. They are useful in confined locations where a normal lens would frame too small an area. The wide angle of coverage permits a larger area to be included, as Larry Ferguson

Ted Benson: On the California Zephyr, *1970.*

has done (page 200). Such lenses are particularly helpful for photographing architectural interiors, and their great depth of field (compared to a normal lens) also makes them useful in reportorial photography. Ted Benson's wide-angle lens allowed him to capture some of the excitement evident among the passengers of the *California Zephyr* on one of its last runs.

Due to their short focal length, wide-angle lenses must be placed closer than normal to the camera's film plane. In some 35 mm reflex cameras, where a mirror must move up and down in that same space, such a lens would interfere with this movement and render the mirror unworkable. A neat solution to this problem is the *retrofocus* lens, a reverse telephoto design. In a retrofocus lens, the negative group of elements precedes the positive group, resulting in an effective focal length shorter than the actual distance required between lens and film to focus the image. This design thereby lengthens the optical path to make room for the reflex mirror.

ZOOM LENSES

Zoom lenses are *variable-focal-length* lenses. We're familiar with their use on television and motion-picture cameras where they permit uninterrupted changes in image size from a fixed camera position. This flexibility is less useful in still photography, where the zoom feature more commonly is a convenience providing several focal lengths in one lens. It is useful in reportorial and sequence work (see series of photographs on page 206). Focal length, and thereby image size, is varied by moving certain components within the lens in relation to others, which are fixed. Notice, however, that although the size of the image (and thereby the area framed by the camera) changes in this series, the perspective does not. This is because the camera remained in the same place for all exposures in the series. Perspective changes only when the camera position does, regardless of the lens focal length.

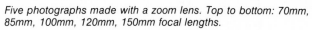
Five photographs made with a zoom lens. Top to bottom: 70mm, 85mm, 100mm, 120mm, 150mm focal lengths.

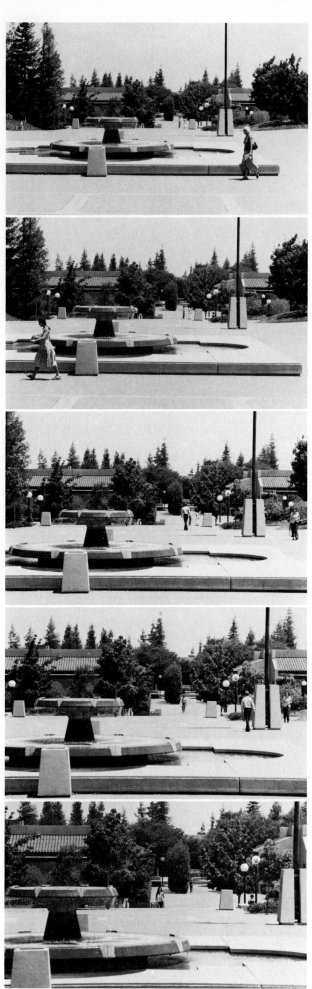

Zoom lenses are complicated and expensive, but they can produce special effects not possible with lenses of fixed focal length. Some can also function as micro lenses for extreme closeup work: these are known as close-focusing zoom lenses. At any given focal length, however, zoom lenses cannot produce image definition and sharpness equal to that of a high-quality lens of fixed focal length.

Special effect possible with a zoom lens by changing its focal length during exposure.

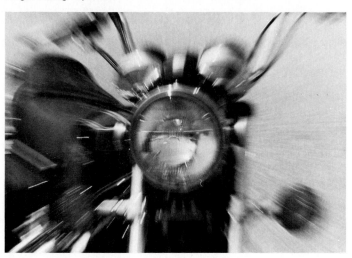

SPECIAL-PURPOSE LENSES

Most ordinary camera lenses are intended to focus sharply over a range of distances, usually from 3 feet to infinity. When the circumstances under which a lens is used vary significantly from those conditions, the lens can be designed to form its highest-quality image within the special conditions of its use. Four such types of special-purpose lenses are encountered frequently enough in general photographic work to warrant some explanation of their nature here.

Enlarging Lenses

Camera subjects are generally three-dimensional in nature and are located some distance away, but an enlarger's "subject" is flat and close—a negative located just inches away from the lens. The enlarging lens is designed to form an image from a nearby flat plane, and to project that image on another flat plane not far away. In an enlarger it always functions under these conditions, and need not be concerned with any others. Enlarging lenses are therefore not well suited to general camera use.

Micro and Macro Lenses

These lenses are designed for closeup work—photography at very short distances to the subject, where the image produced in the camera may often be as large as the object before the lens. Although they produce their best image quality at such short object distances, some of them are also suitable for general work at longer distances. Most have features to make routine closeup work more efficient. Technical photographers will find a *macro lens* unsurpassed for making same-size photographs of small, three-dimensional objects and specimens. *Micro lenses,* on the other hand, are designed to reproduce flat fields—two dimensional subjects. Artists and educators find them useful to make slides of larger materials. Such lenses usually contain the prefix *micro* in their names.

Closeup Attachments

These are not complete lenses in themselves, but rather are usually single elements designed to be added to existing lenses so that the latter may focus shorter distances. For example, a typical twin-lens reflex camera in the 6×6 cm format focuses down to 1 meter (3½ ft). By placing a suitable closeup attachment in front of the regular lens, it is possible to produce reasonably sharp images with that same camera as close as 30 cm (12 in.). Such a camera may then be used to photograph small objects such as ceramic pottery, small drawings and paintings, and anything that a close point of view will not distort beyond useful limits. Closeup attachments represent an economical way to vary the effective focal length of fixed camera lenses for such purposes.

Closeup attachments for certain twin-lens reflex cameras come in pairs: a thin element for the lower (taking) lens, and a thick one for the upper (viewing) lens of the camera (see illustration). The thicker attachment contains an optical wedge or prism, and a reference mark on its rim. This unit must be attached to the *upper* lens of the camera, with the reference mark at the *top.* In this position the prism will aim the camera viewing system at the closer lens-to-subject distances involved, conveniently eliminating most errors due to parallax.

Process Lenses

These are lenses specially designed for the ultimate in image quality and sharpness, but those conditions are attained at the expense of light-gathering ability and depth of field. Process lenses are slow; they have relatively small maximum apertures, but they evenly illuminate their focal plane. Like enlarging lenses, they are designed to reproduce a flat field, but usually over a greater range of distances such as 3 to 30 feet. If the lens is intended for color reproduction, as most process lenses are, great care is taken to insure that it focuses all colors or wavelengths of light in precisely the same plane with equal sharpness. Process lenses have long been used in photography for the printing crafts, where high orders of definition and sharpness are required. In recent years they have also seen wide application in the electronics field. There they are used to reduce printed-circuit layouts and to make optical masks for integrated circuits and other microelectronic devices which have revolutionized that industry.

Closeup lens attachments on Yashica 124G Camera.

HOW FILTERS WORK

Filters are thin layers of transparent gelatin, plastic, or glass which contain a substance that will absorb certain wavelengths of light. Fundamentally, all filters work the same way: they *absorb* some wavelengths of light while they *transmit* others. Thus they function as selective valves, controlling the wavelengths and the quantity of light that passes through them. There are four general types: colored filters, polarizers, neutral-density filters, and interference filters. Colored filters and polarizers have numerous uses that are considered here. The other types are for specialized uses not encountered in general photographic work.

Photosensitive materials such as film and paper respond to light in different ways. We call their overall sensitivity to white light their *speed*, using ISO (ASA) ratings for films and comparable data for most photographic papers. But as we also noted earlier, films and papers respond differently to various colors or wavelengths of light. To designate this kind of response we use labels such as *orthochromatic* and *panchromatic*. Whenever a photosensitive material responds to more than one color of light, we can change that response by using colored filters.

COLORED FILTERS

How these filters work can be understood by referring to the color circle (Plate 5). This circle is the key to understanding what any colored filter will do. Filters function by absorbing one or more colors of light and transmitting or passing the remaining ones. The basic principle is that *a filter passes or transmits its own color and absorbs its complement,* which is opposite its own color on the circle. Let's take the example most often used in black-and-white photography. A yellow filter freely transmits yellow light, but absorbs blue (which is oppo-

site yellow on the circle). A pale or medium yellow filter will transmit other colors adjacent to yellow, and will effectively block out only blue rays. Similarly, a red filter will transmit red but will absorb cyan (bluish green). Intensely colored filters will also absorb some colors adjacent to the complementary hue. Thus a deep red filter will not only absorb cyan but most of the blue and green light as well.

Filters, of course, are not selective of subjects: they only respond to colors of light, and will absorb not only the individual colors but also their components from mixtures as they occur. Thus a green filter will absorb the magenta component of any light containing it, and some of the adjacent red light and blue light as well.

From this behavior, then, we may infer another guiding principle of colored filters in black-and-white photography. When a filter *absorbs* a certain color of light, anything that reflects that color to the camera will be recorded weaker on the negative and therefore *darker* in the positive, or print. For example, when Tom Gore used a yellow filter to make the accompanying photograph, the filter absorbed much blue light from the sky and prevented it from reaching the film. The sky therefore recorded weaker (thinner) on the negative, and came out darker than normal in the print. Thus a yellow filter darkens the tone of blue sky in a black-and-white photograph, and makes the clouds more visible.

Similarly, a green filter will darken the rendering of magenta (reddish blue) objects in a black-and-white positive, and a red filter will darken the tone of blue and green ones. In each case, however, objects that are the same color as the filter will not be darkened, and thus will appear lighter by comparison. We may therefore more fully describe our preceding examples by noting that a yellow filter lightens the rendering of yellow objects (in the print) and darkens the appearance of blue ones; a green filter lightens green objects and darkens reddish-blue ones; and a red filter lightens red objects (by comparison) and darkens those that are green and blue. The photographs here illustrate these effects.

Tom Gore: [untitled], 1977.

A: No filter used

B: Yellow filter

C: Orange filter

D: Green filter

E: Red filter

These five photographs illustrate how colored filters change the lightness, or value, of colored objects photographed on black-and-white film. Photograph **A** was made without a filter; compare the others to it. **B** was made with a yellow filter on the camera lens, **C** with an orange filter, **D** with a green filter, and **E** with a red filter. Note how each filter tends to lighten the rendering of its own color, but darken the tone of complementary hues.

FILTER FACTORS

Because it absorbs some wavelengths or colors of light, a filter invariably *reduces* the total amount of light that passes through it to the lens and film. Unless the absorption is slight, an *increase in exposure* will be required. This may be accomplished by increasing the exposure time, or by opening the aperture to allow more of the filtered light through.

The amount of exposure increase necessary will vary with each filter, with the spectral sensitivity of the film (ortho or pan), and with the color content of the light itself (daylight or artificial). The increase required is usually designated as a *factor* by which the normal exposure must be multiplied. Because of the three variables just mentioned, the literature accompanying a particular kind of film will usually give two separate factors for each filter listed; one factor is for *daylight* and the other is for *artificial* (tungsten) sources. Likewise, a particular filter may require separate factors not only for daylight and tungsten sources, but also for *ortho* and *panchromatic* films. Never assume that the factor for a particular filter is the same under all conditions; it is not. Red filter factors, however, apply only to pan films; since ortho films are not sensitive to red light, red filters cannot be used with them.

The table here gives the factors for typical filters used in black-and-white photography with *panchromatic* film.

Remember that these *factors* are for increasing exposure. When the red filter is used in daylight, for example, its factor of 8 may be applied to the exposure in several ways: by increasing the time 8 times (example: 1/250 to 1/30 sec), by opening the lens 3 stops (example: f/16 to f/5.6), or by any equivalent combination of these two methods.

EXPOSURE FACTORS FOR TYPICAL FILTERS USED IN BLACK-AND-WHITE PHOTOGRAPHY WITH PANCHROMATIC FILM

Filter Color	Exposure Factor in	
	Daylight	Tungsten
Medium Yellow	2	1.5
Orange	3	2
Green	4	3
Red	8	4
Deep Blue	5	10

POLARIZING FILTERS

As a normal light wave travels outward from its source, it is considered to be vibrating *transversely* in all planes, that is, in all directions *perpendicular* to the path of its travel. Most of the light we can see is thought to behave in this manner. It is possible, however, by either natural or optical means, to eliminate most of those transverse vibrations so that the light vibrates perpendicular to its direction in only one plane. Such light is said to be *polarized*.

There are two common sources of polarized light in nature. One is the light coming from a clear blue sky, at an angle of 90° to the sun. Such light is strongly polarized, although the only indication of it to our eyes is that the sky may appear a little deeper blue than usual. At other angles, natural skylight is less strongly affected, until at 180° and near the sun itself no polarization occurs. Natural light reflected at an angle of about 35° from nonmetallic surfaces such as wood, plastic, glass, paint, or water, also is polarized. Again the effect is less apparent at other angles, disappearing completely at right angles to the surface, and parallel to it.

Polarized light appears to the eye much like any other kind, but a frequently seen effect of it on glass windows, for example, is the glare that obscures our vision through them. We have seen this on our car windshield when driving toward the sun; light reflecting from a smooth, concrete roadway on a bright day can also produce such glare.

Polarizing filters provide a way to control such reflections when they would otherwise obscure something we're trying to photograph (see illustrations). They are also useful to darken a blue sky in outdoor photographs, without changing the appearance of other colored objects in the view. Polarizing filters contain a material that works like a louver, *absorbing light that is already polarized while polarizing any that is not.* Since polarized light looks the same as unpolarized to the eye, only the blocking of already polarized rays is noticed.

We can see the effect of a polarizing filter on already-polarized light simply by looking at such light through the filter, and rotating it until its polarizing plane is at right angles to that of the light. At that point the filter turns dark and the polarized light is blocked. To photograph the effect, slip the filter over the lens so that it is oriented *the same way.*

Small reflective objects such as glass-covered pictures may be photographed without troublesome reflections by this method. Artificial light may be used, but it is necessary to polarize the *light* before it reaches the shiny surface. Polarizing material similar to that in the filter must be used over the light fixtures, and this can be an expensive procedure. Such material will polarize the light falling on the reflective surface; a polarizing filter at the lens will then block the reflection that reaches the camera. Using the camera filter alone will not work, since the light reaching it will not be polarized and therefore cannot be filtered out.

Like other filters, the polarizer absorbs some of the light reaching it and thus affects exposure. Most types require three times the normal exposure for the full polarizing effect.

A

B

*The effect of a polarizing filter on the camera. **A:** without the filter, **B:** with the filter.*

FILTER GUIDELINES

Filters for use on camera lenses usually come as thin squares of dyed gelatin, lacquered on both sides; they also come as glass circles, mounted for easy attachment to the lens. *Gelatin filters* are available in many colors for general and technical work. Because they are very thin, they seldom interfere with image sharpness. Gelatin filters are also inexpensive, but easily soiled. They should be handled with great care, and only near their edges. Clean gelatin filters by whisking them lightly with a lens brush or air syringe; never rub them with anything. A scratched or soiled gelatin filter should be discarded and replaced.

Glass filters are more convenient to use than gelatin ones, but they are more expensive. Because they are thicker, they may soften the sharpness of an image when used on extremely short or long focal length lenses. If kept clean and properly positioned in front of the lens, though, glass filters can be useful camera accessories. Clean them as you would a fine lens.

Some filters, like the ones used in the enlarger with variable-contrast papers, come as thin, plastic wafers and as even thinner acetate sheets. These are not intended for use on cameras. The plastic ones can be cleaned with a mixture of water and denatured alcohol, or with lens-cleaning fluid used very sparingly. Discard soiled acetate filters.

Let's summarize this discussion of how filters work by listing three brief guidelines for using them. They apply to any light filter, with any black-and-white film, in any photographic situation:

1. *If you don't need a filter, don't use one. A filter never adds anything to a picture; it only takes something away.*
2. *Any colored filter renders its own color lighter (in the print) and its complement darker. Refer to the color circle (Plate 5).*
3. *Increase the exposure by the appropriate filter factor.*

ARTIFICIAL LIGHT
Flood and Flash

In Chapter 4 we defined natural light as coming from the sun. Daylight, of course, is its most familiar form. From that simple definition we may argue that any light not so produced is not natural, and therefore artificial. However we choose to label it, though, we must recognize that light is a tool, a designing element in picture making. A functional definition of artificial light, then, may be more useful to photographers than a physical one: photography, like politics, is an art of the possible.

To a photographer, *artificial light is light that can be controlled at its source.* Other light, though it may not come from the sun and may be produced artificially, may be functionally regarded as natural light by the photographer if he cannot control it before it reaches his camera. Admittedly these definitions are arbitrary, but they are also useful.

Broadly considered, two types of artificial light are of particular interest to photographers. One type emits its rays *continuously*: this includes most forms of electric lighting that are part of our daily life. The other type is *intermittent*, producing its light in brief pulses or flashes. We are familiar with two such forms, the flashbulb and the electronic flash lamp used by photographers everywhere.

Continuous light offers several advantages over the intermittent type, and some of these are particularly valuable to anyone not familiar with the use of continuous light in camera work. We will therefore consider it first, and later apply the rationale behind its use to photoflash. Flash may be a more convenient photographic light source, but its brief duration makes it difficult for an inexperienced photographer to study its behavior.

CONTINUOUS LIGHT

Continuous artificial light is readily available wherever electricity is. Its most familiar forms, the *tungsten filament lamp* and the *fluorescent tube*, are usable just as they come. Thanks largely to modern, high-speed films, intense photoflood lamps on which photographers relied not long ago are no longer essential. For most still photography, ordinary household lamps will suffice. Where the existing light is dim, however, photographic lamps are useful, and for color photography they offer definite advantages (page 185).

PHOTOGRAPHIC LAMPS

Continuous photographic lamps are usually called *photofloods.* These are simply regular light bulbs whose tungsten filaments burn at an abnormally high rate. They give more light than regular bulbs, but burn out much sooner. Photographic light bulbs have ASA code designations for easy identification. The two most popular are the No. 1 Photoflood (code BBA), a 250 watt, screwbase lamp with about a three-hour life, and the No. 2 Photoflood (EBV), a similar 500 watt lamp lasting six hours. Two other lamps preferred by photographic studios are also available from many photo dealers. These are the 250 watt ECA lamp and the 500 watt ECT. Although not quite as bright as the first pair mentioned, these have much longer lives and are suitable for color photography as well as black-and-white. All four lamps fit regular

screw-base sockets but should be used with good reflectors. Do not use more than three 500 watt lamps on a single 115 volt electrical circuit.

Some photographic lamps are available with their own reflector built into the bulb. They are more expensive than ordinary lamps but more convenient: they need only be screwed into simple, clamp-on sockets. The 500 watt EAL lamp is recommended.

Many varieties of *tungsten-halogen* lamps also are used in photographic work. These lamps are compact and operate at very high temperatures. They have a high, stable light output over a long, useful life, and do not darken with age as regular tungsten lamps do. Tungsten-halogen lamps must be used in equipment designed for them; adequate ventilation is essential. These lamps require extremely careful handling: *the quartz tube must not be touched by the skin under any circumstances.* Mere traces of skin oils or perspiration on the lamp will cause it to heat unevenly and fail.

LIGHT FUNCTIONS

The key to using artificial light is to *consider its function first.* Although some lamps are more useful than others in a particular role, almost any kind of light source can perform several tasks equally well. Four functions are fundamental:

1. Key light This is the main source of illumination; it dominates all other lights wherever it is used. Key light is the artificial equivalent of direct sunlight in nature. Being the most important light, it casts the most important shadow; its directional quality unifies a picture and determines the mood of a scene.

2. Fill light A fill light illuminates the shadows cast by the key light, replacing their inky darkness with enough light to record detail with tone or color. Thus it functions like skylight on a clear, sunny day. It must never equal the key light in intensity on the subject, for then it would be another key light and not a fill. Likewise important, the fill light should cast no significant shadows of its own.

3. Accent light As its name implies, this one adds small, local highlights to an otherwise evenly lit area. It is commonly used in portraiture, for example, to highlight the hair, and in commercial photography to make details of objects more visible. An accent light may appear as bright as the key light or even brighter, but it never dominates a picture as the key light does. It is strictly a local touch, never the main show. The highlights it makes, when carefully placed and sparingly used, will add brilliance to the finished print.

4. Background light This light illuminates the background, that is, *the space beyond the subject* being photographed, and not the subject itself. Its purpose is to provide tonal separation in the print between the subject and the space around it.

For good results, two principles overshadow all others: *keep the lighting simple,* and *build the lighting one function at a time.* Check the lighting as you go, always from the camera position. It will look slightly different from any other angle, but the way it appears at the camera, of course, is the way it will look in your photograph. Suggested procedures for photographing people and inanimate objects are given below. They should not be considered rules but simply starting points for your own further experimenting.

SIMPLE PORTRAIT LIGHTING

Here is a suggested procedure for simple portraits. It will work equally well with floor and table lamps at home, with portable floodlamps of any kind, or with studio lamps designed for professional use. The kind of lamp you have is less important than how you can use it. You may have to remove the shades from home lamps or equip them with brighter bulbs (150 and 200 watt bulbs are available wherever housewares are sold; or the screw-base photoflood lamps described earlier may be used). In any case, be sure that no part of the lampshade touches any of these bulbs, for they get quite hot.

1. Always begin with the **key light**. For a typical head-and-shoulders portrait, it should be a few feet higher than the face, and to one side of the camera. When you have the effect you want on the face, check the shadow to see that it doesn't dominate the picture frame or call attention to itself.

2. Next, add the **fill light**. Usually this should be on the opposite side of the camera from the key light. Keep it at about your subject's eye level. It should be much less intense than the key light; use a dimmer light or move it back from the subject until the balance of shadow to highlight is to your liking. Another technique that usually helps is to *feather* the light—that is, to swing it away from the subject's face so that only part of its beam falls there. This is useful with reflector-type lights, and if you swing the light toward the camera (where it may illuminate the camera more than the subject), it usually will not spill onto the background as it fills the shadows of the key light.

3. Third, try using an **accent light** to add a highlight to the hair. This can be from a gooseneck desk lamp, a reading light, or any small lamp designed for such use. Place it opposite the key light, somewhat behind and above the subject, and aim it toward the hair. Check it very carefully from the camera position, preferably through the viewfinder, and adjust it until it gives a suitable highlight. Remember, it must not dominate the lighting on your subject; it should only add an accent.

4. The **background light** is optional; not necessary, but usually helpful. Keep in mind that your picture is a two-dimensional frame. The background light helps give your image a stronger feeling of depth within that frame, and makes your subject appear to be in three-dimensional space. Try making a pair of otherwise identical exposures, with and without the background light, to see its effect. This light may be placed low, behind the subject, or well off to one side. Aim it at the background. Its effect should be seen just over the subject's shoulders. Keep it subdued; it must not be brighter than the key light, and in fact should not call attention to itself at all.

SIMPLE PORTRAIT LIGHTING

1 / begin with the key light

2 / next add the fill light

3 / add an accent (hair) light

4 / last add a background light

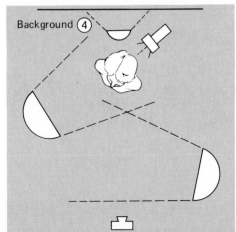

Try angling one shoulder of your subject toward the camera just enough to hide one ear from its view. This will give the picture more depth and a less mechanical appearance. Allow enough space between your subject and the background—at least 4 feet—for shadows to fall outside the frame of your picture and for a background light to do its job. If possible, use a light meter to calculate the exposure, and take care that a strong accent light doesn't fall directly on the cell of the meter when you take your reading. Remember that the face you are photographing may not be medium gray (review the section on using exposure meters, pages 71–72, for more suggestions). Work as briskly as you can; keep in mind that you have a live, warm human being under those lights. Don't bake the last traces of emotion out of your sitter! And don't forget the basic rule: *keep it simple.*

In simple head-and-shoulders portraits such as these you will generally want to show your subject in a pleasing way. You can call attention to a person's more attractive features or minimize your subject's unattractive ones by careful location of the key light. For example, this light is most often directed at the side of the face away from the camera. Known as *short lighting,* this popular arrangement is also useful to slim a fuller face.

Alternatively, the key light can be directed at the same side of the face as the camera is. This is called *broad lighting,* and it is occasionally used to make a thin face look fuller.

A third arrangement is known as *butterfly lighting.* Here the key light is aimed squarely at the front of the face from a position above the camera. From there it produces a small, butterfly-like shadow under the subject's nose. This lighting arrangement tends to emphasize cheeks and play down a prominent nose.

Short lighting. Key light illuminates side of face away from camera.

Broad lighting. Key light illuminates side of face toward camera.

Butterfly lighting. Key light illuminates front of face from above camera.

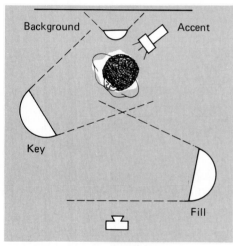

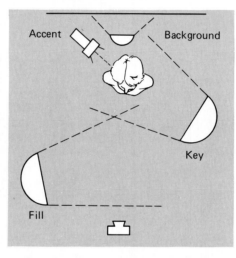

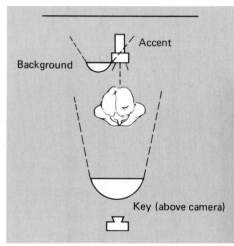

INANIMATE OBJECTS

The procedure with inanimate objects is basically the same as with portraits, although we now must consider a couple of additional shapes. People's heads are basically *spherical*; inanimate things may be *cubic* or *cylindrical* as well as spherical. Regardless of their actual structure, most objects may be regarded as having one of those three basic shapes. The major difference in lighting them has to do with where the key light is placed.

Cubes

For things that are fundamentally cubic, try placing the key light behind the object, high and off to one side, so that it throws a shadow of the object toward a lower corner of the picture as you view it in the camera. The fill light can now be directed at the side of the object facing the camera. Use enough illumination here so that details can be clearly seen, but not so much that this side becomes as bright as the key-lit top. A second fill light, less intense than the first, or an accent light, should illuminate the third side of the object visible to the

camera. Keep this third side less bright than the other two.

A background light may be added for separation just as in portraiture. Its effect should be visible in the viewfinder just over the profile of the object and not on the object itself. Because the key light in this suggested arrangement comes from behind the object, however, a background light may not be needed.

Cylinders and Spheres

Cylindrical objects are easier to light. The key and fill lights should generally be opposite each other, but both slightly toward the camera position. There's no point in illuminating what is not visible to the camera. For example, if you first place the key light at two o'clock and the fill at eight (in relation to the object being photographed), try moving the key to the two-thirty or three o'clock position. Other arrangements of these two lights, of course, are possible; a little experimenting will show you the possibilities. Keep the key and fill lights more

Lighting cubic objects.

Lighting cylindrical objects.

Lighting spherical objects.

or less level with the object so that the round side is evenly lit. Add an accent light to the top of the cylinder, if needed, and perhaps place the background light as before.

Lighting of spheres is much the same. Key and fill lights at opposite sides of the object and camera usually are adequate, although a background light may help reveal the form. With both spheres and cylinders, a terminator or "day-night" line may be visible on the rounded surface. As a rule, this will not call attention to itself if the key and fill lights are placed so that this line appears off-center and does not bisect the object. Of course, you can easily emphasize this shadow line if you wish by centering it.

SHADOWLESS LIGHTING

Some photographers regard an indirect type of illumination called a *bounce light* as a fifth major function. Actually bounce light combines key and fill functions to produce a larger, more diffused light source than a comparable direct light could

do. This is accomplished by aiming the light source at a large reflecting surface such as a white board, sheet, or a milky plastic umbrella. If several such indirect lights are positioned around a subject, they will provide an aura of light that is essentially directionless, and therefore shadowless. They effectively simulate diffused skylight of overcast days.

Shadowless light, as this is sometimes called, illuminates an *area* rather than an object within it. It is ideal for photographing shiny-surfaced objects and things that have important black parts. It minimizes contrast between black and chrome, for example, on small appliances and similar objects (see illustrations). Indirect lighting is also useful when a small object must be photographed from an extremely close viewpoint. If there isn't enough space between the object and the camera for direct light placement, indirect light may fill the bill.

Once set up, shadowless or indirect light is easy and efficient to use, requiring very little adjustment for various kinds of objects. But it is not well suited to render the shape of objects or the texture of surfaces; direct light can perform those tasks much better.

Bounce (shadowless) lighting.

Shadowless and key light combined.

Shadowless and Key Light Combined

This apparent contradiction of terms offers yet another solution to the problem of photographing small objects with a minimum of time and trouble. It is particularly useful for objects whose shape is important to the purpose of the picture, but whose surfaces are highly reflective and therefore troublesome with direct lights. The basic lighting setup is a *shadowless* or bounce one, described in the preceding section. Two or more lights will be needed to create the bright, diffused environment. A white table or background paper under the object may also be helpful.

Position the object so that three planes of it (if a cube) are visible to the camera, and then add a weak key light from a position above and to the rear of the object, a bit off to one side, as if you were lighting the object directly (see illustrations). Note that the key light this time should be added *after* the bounce or shadowless lighting aura is arranged, and it should not destroy the shadowless effect. The key light, in effect, is a strong accent light. It will cast a shadow, but it should be a very soft one. Reduce its intensity, or increase its distance from the object until the desired balance is obtained.

For calculating exposure, a gray card may be helpful. Place the card in the bounce-lit area, and carefully read it with the meter held on the lens axis about a foot in front of the card.

INTERMITTENT LIGHT: PHOTOFLASH

Photoflash has become a popular source of artificial light that has made photography possible almost anywhere. That is one of its two great advantages over the continuous light just described: flash is *portable*—it goes wherever the camera does. But equally important, the flash of modern photographic lamps is *brief* enough to stop or "freeze" movement in a wide variety of picture situations. Bill Owens has used these advantages of flash to make his photograph of a young working girl.

There are two popular sources of photoflash illumination. One is the *chemical flashbulb*, a modern, safe version of a photographic light that was invented nearly a century ago. The other source is the repeating *electronic flash* lamp invented in 1931 by Dr. Harold E. Edgerton of the Massachusetts Institute of Technology.

Bill Owens: My Dream Is To Be an Airline Stewardess, 1975. © Bill Owens, from Working: I Do It for the Money.

The most convenient and popular form of flashbulb today is the *flashcube*. It contains four separate flashlamps grouped around a common core with a multi-sided reflector. The entire unit is packaged in a housing of transparent blue plastic that acts as a filter to match its light to the spectral response of daylight color film. Variations of the flashcube for certain kinds of cameras include the flashbar and flip-flash.

Each segment of a flashcube produces a sudden flash of light by the precise burning of zirconium wire in an atmosphere of oxygen. Firing an ordinary flashcube or bulb involves a chain reaction that begins when a voltage is applied to the bulb by a synchronizing circuit in the camera shutter. This heats a tiny filament, thinner than a human hair, to touch off a bit of explosive primer built into the bulb. The primer, in turn, ignites the zirconium wire, which quickly oxidizes to produce the flash of light we see.

SYNCHRONIZATION

All this takes time—about 10 to 15 milliseconds (thousandths of a second)—so the camera shutter must delay its opening that long for the firing sequence to be completed. A *synchronizer*, built into the shutter, provides that delay. If the camera is designed for only one type of flashbulb, the proper delay is automatic. Other cameras are equipped with a two-position switch, usually labeled X–M, that controls this feature. In the X position the flash circuit is fired as soon as the shutter blades are fully open; switching to the M position delays the shutter for about 20 milliseconds, allowing the flashbulb ignition sequence to run its course first.

The flashcube is a more convenient version of a fingernail-sized flashbulb, the AG-1. This all-glass bulb was introduced in 1958 to replace a variety of older, larger lamps. Some of these older flashbulbs are still in use with obsolete snapshot cameras and with portable lighting equipment used by commercial and industrial photographers in situations where other illumination is less practical.

Ordinary flashcubes and all-glass (AG-1) bulbs, like older types, are ignited by low voltage from a battery. This gives rise to the most common cause of flashbulb failure—weak batteries. Recently, however, flashbulb manufacturers have come up with an ingenious solution to this chronic problem. A new cube designated *Type X* or "*Magicube*" eliminates the battery problem by substituting a *mechanical* ignition system for the electric one. Each of the four lamps in a Type X cube has a percussive primer in its base. That primer is fired when struck by a small, tensioned spring, much like a child's toy cap pistol. No electricity is used. The primer

blast ignites the shredded zirconium just as in other flashcubes.

Because the firing system is a simple mechanical one, these cubes can be used only on cameras with synchronized mechanical triggers in them. Operating the shutter of such a camera momentarily pushes a small probe up into the base of the Magicube, tripping one impact spring. An added dividend: a spent cube with all of its springs released can signal the camera mechanism that it needs replacement. Type X Magicubes and regular flashcubes are not interchangeable. Although they look very much alike, neither will fit equipment designed for the other.

ELECTRONIC FLASH

Although the electronic flash lamp was invented as a scientific tool to analyze motion, it was soon adapted as a repeatable source of photoflash illumination. Using an electric flash to arrest motion so that it might be photographed was not new in the thirties: W. H. F. Talbot was granted a patent for such a device in 1851. Where Talbot had used an open-air spark, however, Edgerton's device substituted a charge of alternating current in a glass tube full of inert gas.

In modern units, a high-voltage electric charge is applied to electrodes in each end of a helical glass tube filled with xenon gas. Triggering the unit ionizes the xenon, and in this state it conducts the high voltage charge across it with a brilliant flash of light. The gas is not consumed in the process, and as soon as another electric charge can be placed on the tube, another flash is possible.

This feature alone suffices to make the electronic flash an attractive alternative to the chemical flashbulb. Although its initial cost is higher than that of conventional bulb equipment, an electronic flash unit is much less expensive to operate. But the electronic unit has another advantage that is even more valuable: its flash has an extremely short duration. Typical times ranges from $1/500$ to $1/70,000$ second in modern units, short enough to "freeze" virtually any action taking place while the film is exposed.

Electronic flash units need no shutter delay to synchronize their light, and leaf shutters that are compatible with them will fire the flash as soon as their blades are fully opened. If a shutter is synchronized for both electronic and chemical flash, the "X" position of the M–X lever will give correct electronic response. But focal-plane shutters, found on many 35 mm cameras, present a special problem: the flash duration is much shorter than the time required for the shutter opening to travel across the film frame. To avoid the partial frame ex-

Flash setting on focal-plane shutter dial.

Electronic Flash Setting

posure that would result, the flash must be used only with shutter settings that expose all of the frame simultaneously. Usually this means times of ⅟₆₀ second or longer, and many shutter dials indicate the shortest time setting where the frame is entirely open (see illustration).

EXPOSURES WITH FLASH

Exposures with flash are affected by the same factors we noted for natural light: intensity, film sensitivity, aperture, and shutter time.* But other factors also apply: with older equipment, the shape of the reflector may alter the light output of the bulb, and since the light source is usually used indoors, the proximity of reflecting surfaces such as light-colored walls and ceilings must be considered.

Most important, however, is the *distance from the light to the subject*. The inverse square law, a basic principle of physics, states that as light spreads out from a source, its intensity diminishes as the *square* of the distance increases. In other words, at twice the distance from a source of light there is only one-fourth of the intensity. Small changes in light-to-subject distance, then, will produce large changes in illumination on that subject. Since this distance has a significant effect on exposure, it should be estimated with care.

Most modern flash units contain a simple calculator that correlates the *light distance with the aperture*. This is the critical relationship. Users of

*Shutter settings do not affect *flash* exposures in the same direct way they do other light. Flash illumination rises to a peak and then falls; it does not maintain even intensity. Increasing the time that the shutter stays open will therefore not increase exposure by the same amount.

older units that do not have such devices on them must refer to a *guide number*. This will be found in the instructions supplied with electronic units or on the packages of larger conventional flashbulbs. *Divide the lamp-to-subject distance (in feet) into this guide number to obtain the correct aperture setting.* For example, if your subject is 15 ft. away from the lamp and the guide number is 165, set the aperture at f/11.

AUTOMATIC EXPOSURE CONTROLS

Two recent developments in the evolution of electronic flash units have addressed themselves to this exposure problem. The first was the automatic electronic flash unit, a development of the mid 1960s. Such units contain a small sensor that measures the luminance of the flash reflected by the subject in the same manner that a conventional exposure meter does. The sensor is connected through a transistorized circuit to the charge on the xenon tube, and when enough light has been reflected to the sensor (according to the ISO or ASA film rating for which it has been preset), the remaining flash charge is sidetracked to a "quenching" tube where it is dissipated. The closer to such a unit the subject is, the shorter the duration of the flash. Exposures as brief as ⅟₇₀,₀₀₀ second are reported to be possible.

Such units expend the entire charge with each release, regardless of how much is used to produce light; a full recharging cycle is therefore necessary. A subsequent improvement in electronic flash design has allowed the unneeded charge to be stored rather than wasted. At close distances between light and subject, where only partial discharging capacity is needed, the newer circuit cuts off the light at the proper instant and retains the remaining charge for the next use. Recycling time is thus shortened, and battery life is increased.

STROBOSCOPIC LIGHT

Over the years, some electronic flash units have been designed to recycle and reflash with great rapidity, making it possible to capture numerous flashes by a single time exposure with the camera. Dr. Harold E. Edgerton's experimental photograph of a tennis player demonstrated this effect in 1939. Such a light is called *stroboscopic*. As electronic circuits became more sophisticated, with greater ability to recycle at ultra-fast rates of speed, photographs made in a millionth of a second became possible. Today stroboscopic light is used in engineering, photography, and other applications.

Harold E. Edgerton: *Swirls and Eddies of a Tennis Stroke, 1939. Courtesy Dr. Harold E. Edgerton, MIT, Cambridge, Massachusetts.*

FLASH TECHNIQUES

Because photoflash is often chosen over other forms of lighting for its simple convenience, it follows that techniques for using it should be simple, too. The most obvious and convenient methods, unfortunately, are not always the best from a photographic standpoint. But a resourceful photographer can alter them to get superior results with a minimum of effort.

Single Flash

A guiding thought we mentioned for continuous light deserves to be echoed here: *keep it simple.* And what is less complicated than a single flash placed on the camera? This, of course, is where the vast majority of flash units are used, and for sheer convenience, you can't beat it. But for photographic effectiveness, it's hard to imagine a poorer location: the light is so close to the lens axis that faces and objects flatten out under its even illumination, and shadows often add a grotesque dimension to the figures. With a single flash, your only light is a key light, so careful placement of it will make all the difference.

If the situation demands quick recording, as fast-breaking news events often do, convenience and quick response outweigh all else. And with many simple cameras it isn't possible to move the flash-cube to another location. But in most other situations the picture will be greatly improved if the lamp is lifted a foot or two above the camera and slightly to either side. Bill Owens used this technique to make many photographs for his books *Suburbia* and *Working.* In his photograph of a pneumatic tie-wrap gun operator (page 219), the light was held high above the camera. There it did not wash out the subject (as it would have done had it been on the camera instead), and the exposure is nearly equal throughout the room. Similarly, Eric Kronengold placed his key light off to one side, creating a dramatic and mysterious portrait.

Many flash units have a connecting cord that will permit them to be held a few feet off the camera, as shown here, and fired by the shutter release. Watch out for mirrors, windows, or shiny surfaces that will kick the flash right back to the camera lens. Place the light so that its reflection will go somewhere else. People with eyeglasses present a similar problem: ask them to tilt their head downward ever so slightly; reflections will then be directed below the camera instead of into it. Finally, an important point about exposure: always figure the exposure on the subject's distance from the *light*, not the camera.

Eric Kronengold: [untitled], 1974.

Flash unit with extension cord.

Bounce Flash

Another technique for using a single flash, and one that is particularly effective in rooms with light-colored ceilings, is *bounce flash*. Instead of aiming it directly at your subject, hold the flash above the camera or over your shoulder, and bounce its light off the ceiling as Bill Owens has done to create a large, diffused source of light in a very natural position. In this photograph we see Owens himself at work: his light falls softly on the dressing table and is not blasted back to the camera by the mirror.

Bounce flash is well suited to close-ups of people and interior details: its soft light from above avoids the unpleasant shadows and risk of over-exposure that accompany direct flash at close range. And bounce flash often is the only way to illuminate the entire field of a wide-angle lens with a single light-

ing unit. Similar effects may be obtained with some older flash units by removing the reflector and using the flashbulb "bare."

Bounce flash requires an adjustment in exposure due to the longer distance that the light must travel, and because the reflecting surface always absorbs and scatters some light. *Two or three f/ stops more exposure should suffice in most indoor situations,* but it's wise to *bracket* your exposure until experience indicates the proper increase. Electronic flash units with built-in exposure sensors will not require this adjustment.

Multiple Flash

Just as better pictures usually result from using several continuous lights for different functions, better flash pictures can often be made with more than one light source. Multiple flash takes more

Bill Owens: Self-portrait with a Friend. © *Bill Owens, from* Suburbia.

time to prepare than single flash, but it softens the blunt, intrusive effect of a single flash on the camera and gives the subject a more natural look. As with continuous light sources, a second unit allows you to use *key* and *fill* lights for better modeling and more even illumination.

A simple yet effective setup was used by Kosti Ruohomaa to photograph a group of local residents in a Maine country store (page 212). One flash was placed high and well off the camera to the left. From there it served as a *key* light, shaping forms and creating shadows. A second flash, on or near the camera, was used as a *fill* light to soften the harsh shadows from the off-camera key. This on-camera fill light was less intense than the key, as both Ruohomaa's and Russell Lee's photographs illustrate. If a smaller flashbulb or electronic unit is not available, drape a single thickness of a white linen handkerchief over the fill light. That will cut

its intensity about in half. Another method that works well, especially at close range, is to use a standard lamp with a reflector for the off-camera key, but a bare bulb for the fill light near the camera. *Don't place a bare bulb close to anyone's face (including the photographer's).* Flash bulbs have been known to shatter in rare circumstances.

Lamps used in multiple flash setups should be connected electrically so that they fire simultaneously. Most larger electronic units and many older flashbulb holders provide for such circuits; or clamp-on lamp sockets with reflectors, available from any hardware store, can be used. Where distances do not exceed 50 ft. or so, ordinary lamp-cord wire with soldered connections is reliable. This makes it possible to synchronize the flash with the camera's shutter, as Ted Benson did to photograph the Sierra Railroad locomotive at night. Photographs like this take time to set up (see illustra-

Russell Lee: Lunchtime at the Nursery School, FSA Mobile Camp, Odell, Oregon, 1941. The Library of Congress.

tion), but the results usually are worth the effort. Equipment should be tested before going into the field; misfires can be costly.

Another method that works well with electronic flash units over moderate distances (10 to 50 ft.) is to use "slave" units. These devices catch the *light* from the "master" flash connected to the camera, and trip their own flashes in response. Thus they need no wires strung between them and the master unit, and are therefore useful where crowds are encountered (dances, sports events, etc.). No delay occurs with electronic units, but those designed for flashbulbs produce a time lag caused by the firing sequence in the remote lamp. Slow shutter times, such as $\frac{1}{30}$ second, must be used to catch both flashbulbs.

The simplest multi-flash method of all is the time-honored *open-flash* technique. No synchronizers or wires are needed for this. There are three steps: *open* the shutter (it should be set on "Bulb" or "Time"), *fire* the flashbulbs, and then *close* the shutter. It's not the best method for stopping action, but it is an easy way to fire a multiple-lamp setup without synchronizing problems.

Exposures in multiple flash are no different than with a single light, so long as each light performs a different function. As with continuous light, *exposure is based on the key light*, not the fill. Use the distance between the off-camera lamp and your subject to calculate the proper aperture.

Synchro-Sunlight

Photoflash can also be effectively used as a fill light to soften shadows cast by the sun. When people are posed outdoors, for example, they can turn their backs to the sun so that their faces are in the shade. This eliminates squinting. A flash on the camera then lightens the facial shadows.

Exposure with this technique is based on sunlight, just as it is with other natural light situations. Once the shutter time and aperture have been determined, use the guide number or the flash unit's exposure calculator to find the correct light-to-subject distance. For example, imagine that you're photographing a group of people outdoors, and you've arranged them with their backs to the sun. Let's say your daylight exposure would be $\frac{1}{125}$ at f/16, and the guide number for your flash unit is 120. Dividing 16 into 120 gives a lamp-to-subject distance of 7½ feet; at that distance, the flash would balance the sunlight. But you only want the flash to *fill* shadows, not be a second key light (like the sun). Moving it back a couple of additional feet (from the subject) will give you the desired balance.

If the light cannot be moved from the camera, or if you wish to keep the camera in close for tighter framing, try a handkerchief over the bulb, or remove its reflector. Either method will help preserve a proper, natural-looking balance between the flash unit and the sun.

Lighting setup for "Sierra Railroad Locomotive No. 28." Five flashbulbs in 7 in. and 10 in. reflectors were placed as shown in the diagram. The bulb by the sandhouse was a No. 5; all others were No. 22s. They were fired by a DC battery-capacitor power box connected to the camera shutter, but any 6-volt lantern battery or auto battery would also work (most camera shutter contacts can safely handle six volts). The exposure was 1/30 at f/8 on Tri-X film.

Note how each light covers a different area or comes from a different direction. Outdoors at night, Benson prefers large flashbulbs to strobes for their extra power; they can deliver more light to the subject over a greater distance. Here they are placed about 50 ft. from the objects each illuminates. "And always let the train crews or subjects know what you're going to do in advance," he cautions.

Ted Benson: Sierra Railroad Locomotive No. 28, Jamestown, California, 1976.

 # CAREERS AND
EDUCATIONAL OPPORTUNITIES

Photography touches our lives in so many ways that it would be hard to describe all of the opportunities it presents to someone seeking a career. In a society that makes such widespread use of visual communication, the opportunity for employment in some form of photographic activity is limited only by how willing we are to seek it out. Here, as in other fields, new careers continue to grow from new technological developments. More people than ever before are now employed in photographic work, and the number and variety of opportunities continue to increase.

PHOTOGRAPHY AS A CAREER

Taken as a whole, the photographic career field is primarily a *service business*, although an important manufacturing one lies at its heart and makes that service possible. Photography is the keystone of other major industries too. Printing, electronics, and information storage systems, for example, rely heavily on it for their manufacturing processes. Photographic skills are also a valuable asset to many people in other fields such as medicine, education, and engineering. But as a service business, photography is fundamentally oriented to *people* and their needs; it aims to satisfy their desires to express themselves, to learn, to communicate with others, and to get more enjoyment out of life. Certain areas of photographic work have become well defined by practice, and it may be helpful to one considering such a career to describe some of the more important areas here.

INDUSTRIAL PHOTOGRAPHY

An industrial photographer's work generally supports that of colleagues in the research and development, production, marketing, and public relations areas of a corporation's activity. Thus the industrial photographer is an important member of a team, a communications specialist whose assignments vary from routine reproduction to imaginative problem-solving. Some of the photographic services rendered may represent the best way to gather certain data; others may be the only way to accomplish a particular task.

Scientists and engineers use photography constantly. When allied with the proper devices, the camera can reveal things too small for the human eye to see (such as the lunar breccia section on page 230) and events too brief for it to observe. Through time-lapse techniques, an event that occurs too slowly for humans to perceive can be seen in its true relationship. As several photographs in this chapter indicate, the nature of industrial and corporate photography is as varied as the businesses themselves are. In recent years this has been one of the fastest-growing segments of the field, supporting the rapid and imaginative expansion of our technological society. Frequently this type of work offers the additional benefits of employment with a large and well-established concern.

Lunar Breccia Section, 1 to 3 microns thick, magnified 700 times, 1971. From Apollo 14. Photograph courtesy Battelle Northwest Photography.

Grumman/NASA V/STOL Model in 40 × 80 ft. Wind Tunnel, 1980. NASA.

COMMERCIAL PHOTOGRAPHY

This is another wide-ranging category of photographic work. Generally the commercial photographer serves the needs of other businesses much like the industrial photographer serves a corporate or governmental employer. The typical commercial studio business is small by corporate standards, and specialization is common in this area: architectural views, advertising illustrations, product photographs (for instruction booklets, service manuals, and catalogs), educational and training materials, photographs to support legal proceedings—these all are examples of work loosely categorized as commercial photography. The computer illustration here is typical of commercial work.

In recent years a concerted effort by photographers and photographic manufacturers to keep business management aware of photography's usefulness has made this a steadily expanding market. But it is also a highly competitive one, difficult for a new person to break into without an apprenticeship to gain the relevant experience.

Success in commercial photography and in portraiture (described below) rests heavily on a number of factors, but three broad ones seem crucial. First, a successful photographer must be able to *empathize with the client and understand the client's needs*. Second, the photographer must have *imagination* plus the artistic and technical ability to pro-

Product photograph: Apple II Computer. Courtesy Apple Computer, Inc.

Tom Wyatt: Food illustration, 1977.

duce pictures that communicate the client's ideas or show his products to best advantage. The photographer must be able to work under *external* as well as internal direction, and to deliver the photographs on time. What a commercial photographer sells, then, is primarily *service*, not merchandise; if a good working relationship with clients (who are business people themselves) can be built and maintained, a photographer should be able to capture an impressive part of this competitive field.

A third critically important factor in the success of a commercial or portrait studio is the *owner's profit motivation*. In order to remain in business, a driving business incentive is necessary, and it is particularly relevant to a photographer who frequently will be tempted to sacrifice good business practice for artistic excellence. A balance between these critical factors is necessary to survive, and since a new commercial or portrait photographer can rarely afford to hire a business manager, he should possess *management skills* himself.

PORTRAIT PHOTOGRAPHY

Because they are oriented toward a local consumer market, portrait studios represent a highly visible segment of photographic work. They are also one of the most traditional. Portraiture, of course, means dealing with people, and a high percentage of successful portrait studios do well because they cater to the wants and life styles of their local communities. Portraiture includes the photography of weddings and school groups, the latter a lucrative segment which neatly introduces the studio product to the community.

A great deal of portraiture for today's consumer market is done by regional and national chains with portable setups in department stores and shopping centers. Orders are processed at centralized laboratories and returned to the local outlets for delivery. The rest of this business is done by independently owned studios, and about 80% of these are individual proprietorships with few employees. As a rule, then, the field offers a career opportunity primarily to a man or woman starting an independent business, but because this trade is easily entered it is fiercely competitive and rarely lucrative to a newcomer. A knack for dealing with people in a friendly, open manner and the ability to produce and sell a high-quality product are vital to success.

GRAPHIC ARTS PHOTOGRAPHY

This field is part and parcel of the printing trade, where offset lithography now dominates all other ink-on-paper processes. Offset uses photography for its basic production methods, and wherever printing is done, graphic arts photography will be found. Some segments of this area, such as newspaper, magazine, and book production, are well established, and the manufacture of printed packaging is one of the most rapidly expanding segments of the field. Precision applications such as map making and the reproduction of engineering drawings are also included.

Jerry Costanzo: Portrait, 1979. Courtesy The Open Shutter, Santa Clara, California.

Graphic arts photography is exacting mechanical work. Recent advances in printing technology have required greater skill of technicians in this field, especially in those aspects of the work that precede camera operations. Computers are widely employed in this area, so prospective entrants to the field should have some knowledge of their use.

PHOTOGRAPHS FOR THE MEDIA

What was once a well-defined career field in newspaper and magazine photography has been re-shaped by television. Motion picture production accounts for a large share of this market, and publications now rely heavily on free-lance photographers who sell their work to any media that will buy it. Although easily entered, free-lancing is a highly speculative business, often conducted part-time by people who are otherwise employed. Photographic ability in these fields is almost always more salable if it is coupled with reportorial skills and the ability to put a story together.

Entry opportunities are more frequent on small-town and weekly publications and in public relations work; there is less turnover on the staffs of metropolitan dailies. Media photography today includes the production of stills, films, and video-tapes for television and motion-picture use. This is another highly competitive area, frequently requiring specialized training and an apprenticeship.

PHOTOGRAPHIC RETAILING

This field is part of a larger consumer market that has grown as a result of shorter work weeks and the mushrooming popularity of recreational activities. The retailing scene for photographic goods, like many other consumer products, is moving to the mass-merchandising operations with their familiar chain and "discount" stores. Some independent dealers are organized to sell service and advice along with their merchandise, but most are geared to reach a product-oriented market built by heavy consumer advertising in TV and print media. A pleasant personality and an effective selling technique are prime requirements for this work. Photographic knowledge is helpful, of course, but your ability to sell will be valued more than your knowledge of products and their uses. The field is often used as a step to other kinds of work.

PHOTOFINISHING

This highly automated area of photographic work has two major segments. One is closely related to the retailing business just described, and is geared to process the thousands of rolls of film dropped in mailboxes and left each week at drug stores, photo shops, and other retail counters everywhere. *This field is almost exclusively color.* Competition for both new and repeat business is very keen, and the work is profitable only in large volume with highly mechanized handling. What manual work remains is done largely by unskilled people trained on the job. Skilled openings in photofinishing go to people with demonstrated managerial ability and a working knowledge of color photographic processes, chemistry, electronics, or computers. The retail finishing business is highly seasonal, although consumer advertising is helping to spread its volume over more of the winter months.

The other segment of this important field is related to the commercial and portrait studio businesses discussed earlier. This aspect is known as *trade* or *custom finishing.* Here the emphasis is on

Pako Hipak Photo Processor. Courtesy Pako Corporation.

a quality product that will be resold under a photographer's own name. Such clients demand salable quality and prompt service at fair prices. Trade finishers tend to employ more skilled people than other finishers do. They are located in every metropolitan area of the country, and the field is still expanding.

PHOTOGRAPHIC MANUFACTURING

The manufacture of photographic supplies and equipment is of course fundamental to all the other industries mentioned here. For years, most American photographic manufacturing was located in Rochester, New York, and in a few other northeastern cities. While a great deal of it still is concentrated there, it has recently spread to the midwest and west coast as well.

As every photographer soon discovers, many products come from abroad. American manufacturing is concentrated most heavily on sensitized goods (film and paper), processing supplies, snapshot cameras, and some highly specialized and sophisticated photographic apparatus used in commercial, industrial, and photofinishing work. Other products are most often imported.

Relatively few jobs in this manufacturing industry require photographic skills. However, they do require various technical abilities common to many other industries: chemistry, optics, accounting, business management, marketing, technical writing, and a variety of engineering skills. Photographic skills *are* needed, however, by people who represent the industry to its ultimate customers, especially to the commercial, industrial, and media segments of the field. These manufacturer's representatives, or "tech reps" as they are called, must know their company's products thoroughly, and also how those products can solve a studio's or client's problem. Much of the work these tech reps do is educational—showing photographers how to get better results for their customers. Other requirements are similar to sales work.

PHOTOGRAPHY IN EDUCATION

A major premise of this book is that photographic images have an unparalleled power to convey information and ideas. In education they are indispensable tools. Yesterday's *visual aids* have become today's *visual language*, vital to the instructional process at every level. Opportunities exist for both academically and technically trained personnel, and the stimulation of helping other people shape their lives is a major factor for many who choose this area for a career.

OPPORTUNITY FOR ALL

Our brief look at the photographic career field is by no means complete; only its major segments are described. Relatively few people engaged in photographic work are *photographers* in the sense of creating original images. Many, many more are technicians, variously trained and qualified in one or more aspects of this field. The final chapter of this book, in fact, is addressed primarily to those who will have more occasion to look at photographs than to make them. But because photography plays such an important part in so many different areas of human endeavor, it deserves serious consideration by anyone who is planning his future, whether or not he intends to make it a career.

Photography has opportunities for physically limited people too, particularly for the blind. Some operations demanding varied levels of skill must be performed in total darkness, where lack of sight is no obstacle. Manual dexterity, however, is necessary, but many people otherwise handicapped can find rewarding work in a photographic career.

Although some segments of photographic work are covered by organized labor contracts, the field as a whole is not. Some industrial photographic technicians may be included in agreements that also apply to workers in other skills. But because the photographic industry is populated by a large number of very small businesses, compensation generally reflects the usual factors of supply and demand, education and experience. As a rule, people who have specialized training and some college education begin with higher wages or salaries and tend to advance more rapidly than those who do not. And many mid-management positions in industry require at least a two-year college degree.

PHOTOGRAPHIC INSTRUCTION IN COLLEGES AND UNIVERSITIES

Photographic instruction is offered by more than 800 American colleges and universities. It tends to be concentrated in art and journalism departments, reflecting its major expressive and communicative functions. Some programs and many individual courses also are found in departments of industrial arts, physical science, and photography or motion pictures alone. In 1977 more than 250 college and university departments offered a major photography program leading to a bachelor's degree, and there is every indication that the number has grown since then. More than a hundred community colleges offer an associate (two-year) degree, while nearly 70 universities have graduate programs leading to master's degrees in art, fine arts, and science.

A closer look at the programs in these institutions shows that they vary widely in aims and means. Like the career field itself, photographic instruction has no standardized content in the United States. Even at the entry level, courses with such common titles as "basic photography" differ markedly in objectives, content, and means of evaluation. This is healthy for you if you are willing to shop around before applying for admission; you'll be much more likely to find a program suited to your own particular interests and needs. But it also makes evaluation of programs on any basis other than individual achievement rather difficult.

Community-college programs in photography tend to be closely related to local and regional employment opportunities, although many of them also offer fine arts instruction as well. Most community colleges offer you the chance to begin your academic study there and then transfer the work completed to a university for credit toward a four-year degree. Again there is no standard pattern, and *transferability should not be assumed, but ascertained in advance.*

Programs at four-year colleges and universities· show the greatest variety of both objectives and resources. Most reflect the expertise of their instructional staffs and the capabilities of their equipment and facilities. In still photography, art-department programs dominate this undergraduate level, with communications and journalism-related ones a close second. Numerous other programs are related to educational technology and the development of instructional materials, while in recent years both still photography and filmmaking have become important units of broadly conceived curriculums in the humanities and interdisciplinary studies.

Graduate programs in photography, according to a recent survey, are primarily centered in the fine arts, but many are offered in motion-picture production and graphic arts as well. Some are intended to prepare candidates for teaching and other academic careers, and entrance to these programs, as a rule, is limited.

In addition to these established academic programs, numerous independent organizations and art centers offer short courses and workshops from time to time that cater to individual interests or specialized needs. Many of these offer an outstanding opportunity to learn from a distinguished photographer in an informal atmosphere, and they are widely available during the summer months internationally. Information on workshops and similar courses can be found in *Afterimage* (see bibliography, under Periodicals).

FURTHER INFORMATION

An excellent source of additional information on formal educational programs in the United States and Canada is a periodic assessment compiled by faculty members of Southern Illinois University, and published by Eastman Kodak Company. *A Survey of Motion Picture, Still Photography, and Graphic Arts Instruction* lists more than 800 colleges, universities, and technical institutes which offer some kind of photographic instruction beyond the high-school level. It notes the general types of courses offered by each responding school and indicates the departments in which they are located; it also extracts various tabular data from the survey replies. Single copies of this publication are available without charge from Eastman Kodak Company, Department 412-L, Rochester, NY 14650. Ask for Publication No. T-17.

The best way to determine whether a particular program is what you are looking for, of course, is to visit the department where it is offered. Talk to the staff and the students, look at the work being done, and ask what the graduates of that department are doing. Also ask about entry requirements, openings (many departments have limited space), and costs. These vary widely, and in most programs you must furnish part of your equipment and materials in addition to paying tuition and fees. The more first-hand information you can obtain in this manner, the better equipped you will be to choose the best opportunity available to you.

Good hunting, and good luck!

16 IMAGE AS OBJECT
Responding to Photographs

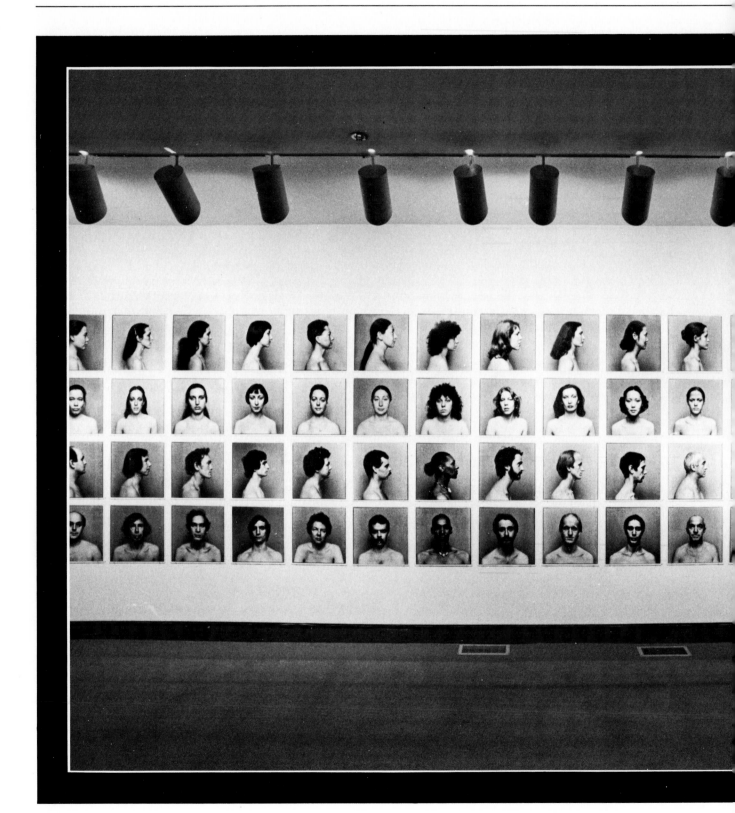

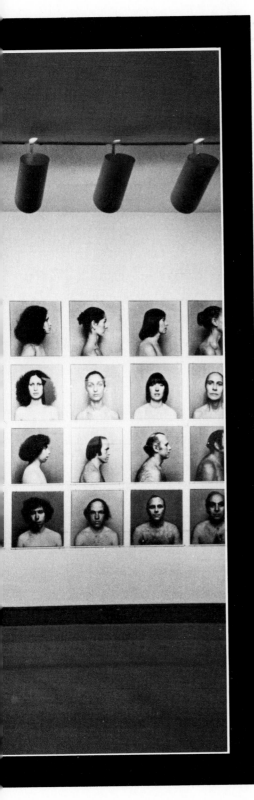

Arnaud Maggs: *Sixty-four Portrait Studies,
1976–78. Installation photograph at the
David Mirvish Gallery, Toronto, Canada.*

We began this book by describing how the photographic image differs from other types of pictures, and how making a photograph can be quite an uncommon experience. Usually we create a photograph by perceiving what is before us with the help of what is within us, and then we gradually limit our response to that entire, constantly changing experience. When empathy and distillation have functioned in full measure, we select a moment and record the image. Post-visualization, with its additional synthesis and selection processes, may follow, but at some point or other the image is cast free: it begins a life of its own. Exit now the photographer, the image maker. Enter here the viewer and the critic.

HOW WE LOOK AT PHOTOGRAPHS

We make a photograph one way, but we look at it another. The image does not evolve before us step by step, but instead confronts us all at once. Unlike a movie, a still photograph exists complete in a single moment of time.

We come to know the picture, as a rule, much more slowly. It usually contains more than we can grasp in a single glance, so we need time to perceive it. The still photograph, of course, has an advantage in this respect over the moving one: it isn't fleeting; it doesn't go away.

If the image states its theme vigorously, if it has sufficient *impact,* it will compel our attention. And if the picture presents itself in an expressive manner, it usually will retain our interest. Walker Evans's Bethlehem scene (page 136) has these qualities, as does Joseph Pennell's richly de-

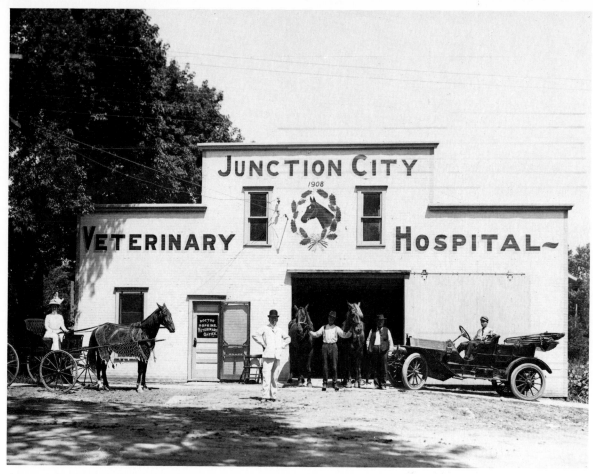

Joseph J. Pennell: Veterinary Hospital, Junction City, Kansas, 1909. J. J. Pennell Collection, Kansas Collection, University of Kansas Libraries.

tailed photograph of the Junction City Veterinary Hospital. On this summer day in Kansas the young veterinarian (center stage, hands on hips) shares top billing with a young woman in a buggy, and with a motor car parked prophetically by his door. Perhaps we too can share Doc Hopkins's mixture of admiration and apprehension for the automobile.

Reading these rich images for the stories they contain can be rewarding in the same way that a good literary narrative is absorbing. Many other photographs in this book likewise have been chosen for the quality of visual experience they offer. Not all of these photographs tell a story, but each has something to say to us if only we can see it.

WHAT WE SEE IN PHOTOGRAPHS

New photographers are often surprised to learn that what people see in a photograph may be quite different from what the image maker thinks he is showing them. People, being human, *see what they want to see* in a photograph, as in anything else they experience. This may or may not be what actually is there, for what people will allow them-

selves to see in a photograph is conditioned by numerous external and internal factors.

Automatic behavior, for example, often governs our reaction. If three or more dissimilar sounds reach us simultaneously, we tend to respond to the loudest and screen out the others. Likewise, we tend to see moving objects more readily than static ones, and bright reflections in a picture more easily than darker values. But photographs which look simple are often complex, demanding more from us than a single-level response. Consider, for example, Jan Saudek's image of the young Czechoslovakian woman here. In spite of the picture's romantic, old-world quality, we are confronted with a woman posed in the act of baring her body and soul, yet acknowledging that her freedom is restricted. Is this just a charming, erotic portrait, or does it also symbolize the political situation in which the Czech people find themselves?

Margaret Bourke-White's photograph here illustrates another important point: a photograph divorced from its original context may convey a new or different meaning. Sent by *Life* magazine to photograph the great Ohio River flood of 1937, Bourke-White found these black refugees from an inundated section of Louisville waiting in line for food.

Jan Saudek: Woman in Black Sweater and Tiara, 1976.
Courtesy Jacques Baruch Gallery.

Margaret Bourke-White: At the Time of the Louisville Flood, 1937. LIFE Magazine
© 1937, Time Inc.

However, the billboard against which she photographed these victims makes the scene convey an ironic social comment to today's viewer.

Another example is provided by the picture on page 148. In 1972, San Franciscans wept openly as they viewed this and other similar photographs of Japanese-American citizens being interned under Executive Order 9066 thirty years earlier. But would they have reacted the same way in 1942? The war was not going well for America then, and the public sentiment which supported the war effort would not permit widespread criticism of the internment. Had the photographs been exhibited at the time, they would probably have aroused little indignation.

The way we respond to any photograph, of course, is as individual as we ourselves are. We're forever comparing what we see with what we know, assimilating the external experience of a picture with everything that has meaning in our life. This process is different for each one of us, and tends to explain why two people can look at the same picture and get completely different messages from it.

OBSTACLES TO SEEING PHOTOGRAPHS

Because photography is a cognitive art, a way of knowing, we tend to make certain demands on photographers and their images. One of these is our frequent insistence that a photograph should resemble something real, that it should present such a convincing illusion of reality that we need not consider it an illusion at all. *Identity* is a very pervasive element in photography, one that isn't easily set aside. Yet we must be prepared to do this on occasion if we are going to see photographs with open eyes and allow ourselves to be touched by them. We must be able to get beyond the ''picture of'' syndrome to see what else might be there. Even a simple, direct image like Oliver Gagliani's photograph might suggest to us something quite different from its subject matter.

Such awareness does not come easily; too many things get in the way. A few of these obstacles are familiar photographic ones: technical flaws that obscure the photographer's intentions before anyone else can encounter his image. But the great majority

Oliver Gagliani: Crockett, California, 1970.

of these obstructions lie with us as viewers, not with the photographs, and they are therefore harder to recognize. Personal experiences which are vivid in our mind, for example, may steer us sharply to one interpretation of a picture that inadvertently excludes other, equally valid, ones. Or what we think a photograph should look like, a generalized preconception of the image, may not square with the example before us. These are perfectly human shortcomings, but they are obstacles nonetheless. Discarding such visual and mental constraints at the outset will let us explore beyond them.

Christian Vogt's photograph here provides a useful example. Through the simple device of one frame within another, Vogt successfully interjects a note of fantasy into an image taken directly from the real world. The photograph functions on several levels; on one, dynamic tension between the inner area and the elements outside it contributes to a sense of ambience or mystery. To perceive this we must be able to feel whatever stimulation to our senses his image offers. If we try to empathize with it, more of the photographer's message will likely come across to us.

Christian Vogt: Frame Series, 1974–75.

APPROACHES OR STYLES

Once we establish rapport with an image, the various approaches presented in this book may help us understand what a photograph seems to be doing, and to judge how well it succeeds. We discussed the direct approach first, because it is easy to understand and also because most other approaches evolved from it. Other major directions or approaches—reportorial, symbolistic, conceptual— were then presented in that order, corresponding to the increasing difficulty most people seem to have in dealing with them. Non-representational images and color photography, although fitting all of the approaches mentioned above, were treated separately because of the different techniques involved.

Any stylistic labels such as the approaches we have designated are only guidelines at best. Many photographs will appear to fit several categories, because they are complex images which function on different levels for different viewers. Criteria that we established for the symbolistic approach in Chapter 9, for instance, can be applied to numerous photographs elsewhere in the book. Much contemporary work, however, remains difficult to categorize, for American photography is now going through a period of intense experimentation and broad stylistic growth. Such activity is bound to produce images that challenge traditional values and even question the very nature of photography itself. Although often confusing to the novice, such ferment can eventually reward both photographers and viewers alike, and any definitions of approaches in photography must remain open-ended to deal with it.

VIEWING PHOTOGRAPHS

The only way to experience what photographic images have to offer, of course, is to look at them. Ink-on-paper reproductions, such as those in this book are a useful step in that direction, and well-made photographic copies, such as properly projected slides, are even better. But *original prints are the best of all*. What a photographer tries to convey can often be communicated best through the subtle detail, color, and tones that are possible only in a fine print.*

*The rapidly growing public interest in photography, attested by an unprecedented rise in the monetary value of fine prints to collectors and museums, has created a more subtle but important distinction, and that is the difference between a vintage and a modern print. Increasingly, the work of photographers no longer living is being reprinted from their original plates or negatives by others using modern materials. Sophisticated collectors, of course, can tell the difference, but the novice needs to be wary.

Most American and Canadian art museums and galleries display fine photographs from time to time just as they do other media, and a growing number do so on a continual basis. Foremost in this regard are the International Museum of Photography at George Eastman House in Rochester, New York (where working exhibits of equipment also are on display); The Museum of Modern Art and the International Center of Photography in New York City; the Smithsonian Institution, Washington; the Art Institute of Chicago; the Minneapolis Institute of Arts; the Museum of Fine Arts, Houston; the Oakland, California Museum; the San Francisco Museum of Modern Art; and the National Gallery of Canada, Ottawa. Each of these institutions has an extensive permanent collection of fine photographs.

A number of universities also have similar resources. Among the most important are the Center for Creative Photography at the University of Arizona, Tucson, which also serves as a research center and archive for the work of numerous major photographers; the Art Museum of the University of New Mexico, Albuquerque; the Sheldon Memorial Art Gallery of the University of Nebraska at Lincoln; the Humanities Research Center, University of Texas at Austin; and the Visual Studies Workshop, Rochester.

In New York, the Light Gallery, the Neikrug Gallery, and the Witkin Gallery have been representing major photographers for many years. Other well-established galleries include the Lunn Gallery in Washington, D.C.; the G. Ray Hawkins Gallery in Los Angeles; the Stephen Wirtz Gallery, the Grapestake Gallery, and the Focus Gallery in San Francisco; The Friends of Photography Gallery in Carmel, California; the Yuen Lui Gallery in Seattle; and the Open Space Gallery in Victoria, B.C. Many other galleries where original photographs may frequently be seen are located in most metropolitan areas.

Traveling exhibitions of historic and contemporary work are circulated by many of the above-mentioned organizations. These, together with locally originated shows, often may be seen in college and university galleries and museums across the country. Additional public collections of fine photographic prints are indicated in the sources of many illustrations in this book. Wherever you live or travel, go to these galleries and museums, and look for photographs that are interesting to *you*.

If there is a better way to experience fine photographs than on the gallery walls, it is living with them at home. Galleries exist primarily to sell work by the artists who exhibit in them. Fine photographs, unless they are rare, vintage prints, are no more expensive than similar-size prints by artists of equivalent ability and reputation in other media.

The extent of a gallery's patronage (in sales, not merely traffic) will largely determine how long and how well it is able to present art for public enjoyment. Displaying photographs in our home, however, is a personal act: what we hang there reflects our feelings as well as our taste, and quality photographs, along with other works of art, should be accorded this honor.

REVIEWERS AND CRITICS

People who go to museums and galleries comprise only a part of the photographer's audience. There are others living far from metropolitan areas, for instance, who depend on someone else to see the photographs for them, and then to report on and react to what they have seen. Serving the needs of those people, as well as the gallery-goers, are the reviewer and the critic.

It may be useful at this point to draw a distinction between *reviewing* and *criticism*. Constructive criticism must review the work at hand, but not all reviews need be critical. *Reviews*, in fact, are largely informational. They describe the exhibition or event, add some background information about the artist, and tell where and when the work may be seen. Reviewers often comment on what they believe are the photographer's intentions, but such remarks should be labeled what they are—opinion and comment rather than fact. Informational reviews should be written for the viewer; they aid the photographer being reviewed to whatever extent they enlarge the size and sharpen the interest of his audience.

Once a reviewer makes *a judgment or evaluation* about an image or exhibitor, however, he crosses a thin line and becomes a *critic*. The distinction is an important one, because with that step a reviewer claims the privilege of publicly expressing his own opinion about a photographer's work or worth. With this privilege go certain responsibilities to his audience or readers, to the photographer or artist, and to the critic himself.

First, he has a responsibility to the artist and the reader to demonstrate that he knows what he is talking about. Both should expect him to be familiar with major images from the past, to recognize and relate the important styles and approaches that photographers have used over the years, and to understand the major directions of contemporary photographic work. A good critic will call the viewer's attention to the strengths of a work as well as its weaknesses, and he will refrain from taking issue with a photographer's point of view merely because it differs from his own. A conscientious critic should attempt to understand the photographer and his images, even though he may personally feel little rapport with them. He is entitled to be subjective as long as he is honest, but he has an obligation to define and defend his critical standards, and to explain his conclusions to both artist and audience alike.

The art of criticism is a different kind of exercise than the arts it examines. It has always been a difficult task. François Arago had trouble reviewing daguerreotypes in 1839 because he had only the language of painting to rely on, and he found it quite inadequate to describe those novel images. P. H. Emerson fared better half a century later, and Alfred Stieglitz provided a model that many others since have tried to emulate. Today's commentators include many thoughtful, well-educated writers who are contributing constructive ideas to the growing dialogue about this young but lively art.

Because so much of the world has already been photographed and rephotographed, it is fair game to ask photographers to defend their personal vision. This, too, should be part of a responsible critic's role, for perhaps more than anyone else, critics of photography are suitably posed to help photographers recognize and improve on their own best efforts. Such encouragement can be nourished by what the reviewer brings to his writing from the carefully considered thoughts of others, and from his own sensitivity as a human being. His response can draw on collective thinking, yet be a strongly personal one that makes constructive criticism, enjoyable reading, and perceptive viewing. Yet all the obstacles to seeing a photographic image that we mentioned earlier in this chapter can ambush the unwary critic. Avoiding these obstacles is only a small part of his task.

The critic of photography also has an obligation to his readers to speak to them clearly. Lucid, responsible assessment attracts a discriminating audience, but obscure and irresponsible criticism turns such people away.

Finally, each one of us who looks at pictures—for we are the photographer's audience—has a duty to both the artist and the critic to see the work for ourselves. Our rejoinder to the critic, regardless of whether we endorse or reject his views, must begin like our response to the artist: from a firsthand appraisal of the latter's images. Only then can the critic, the photographer, and the audience help one another to grow and mature.

Looking at fine photographs firsthand can be a rare and exhilarating experience and a stimulating contribution to creative and joyous living. Isn't such a life, after all, the ultimate purpose of education and of art, the affirmation of all that we value most highly?

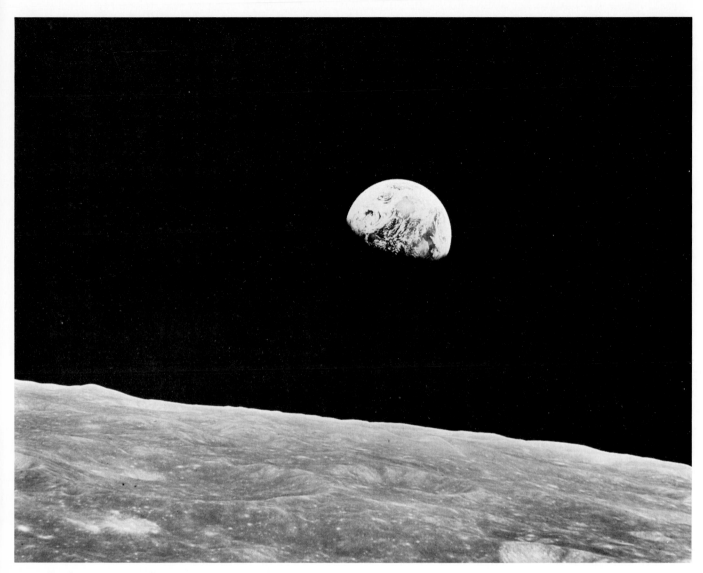

The Earth from Lunar Orbit, Apollo 8, 1968. NASA.

APPENDIX
INSTANT-PICTURE MATERIALS

Instant pictures first appeared in 1948, when the Polaroid Corporation introduced a revolutionary picture-making system developed by Dr. Edwin H. Land. A guiding principle behind the development of these materials was to place nothing between the photographer and the image except a quick process that would deliver a print while the original motivation for the picture was still fresh in mind. Rapid feedback from the image to the photographer was the primary goal; instant processing initiated in the camera or film holder helped insure it. The value of this feedback for teaching people of all ages to be more perceptive has been amply demonstrated over the last quarter century, and this remains one of the most important uses for instant-picture materials today. Many other business and industrial applications for these products have been discovered over the years, and most, like scientific recording, have been suggested by their rapid-access feature.

Instant-picture materials are based on light-sensitive silver halide emulsions, but are otherwise significantly different from conventional films. All instant film units include three essential parts: a photosensitive emulsion which is exposed in the camera; a receiving layer or sheet on which the positive image is produced; and a pod of chemicals that process the image when spread within the film unit after exposure. Opaque layers or envelopes protect the light-sensitive emulsion from unwanted exposure to light. With the single exception of positive-negative films that provide both prints and finished negatives, only the positive print is retained as a usable, permanent image. Certain materials are designed to be peeled apart after development, while Kodak Instant Color Film units and Polaroid SX-70 film units are integrated packages that require no timing or stripping apart.

EXPOSURE

Instant-picture films must be exposed in cameras designed for them or in special adapter backs which permit their use with other cameras or scientific instruments. The CB-100 Land Camera Back adapts Polaroid film packs to many types of equipment. Adapters or backs are also available for Hasselblads and other popular cameras in the 6×6 and 6×7 cm (120) formats. Special film holders adapt Polaroid $3\frac{1}{4} \times 4\frac{1}{4}$ in. packs or 4×5 in. films to most 4×5 in. cameras, and the Kodak Instant Film Back adapts Kodak Instant Color Film to some cameras of this type. Polaroid 4×5 in. sheet film packets can be used in almost any 4×5 in. camera with the 545 Land Film Holder.* Polaroid 8×10 in. sheet films and processors (for larger format cameras) have recently been introduced.

PROCESSING OF POLAROID PACKS AND PACKETS

After exposure, you grasp a paper tab and pull the film unit between two closely-spaced steel rollers in the camera or adapter (see diagrams). These rollers rupture a sealed pod that contains a viscous developing solution, and they spread the viscous reagent between the negative and the receiving sheet, laminating them together, face to face. In the black-and-white films a negative image of silver develops (corresponding to the negative image developed in conventional films), and unexposed silver ions are delivered to the specially prepared receiving layer through an ingenious chemical transfer system that takes place in the viscous reagent. A fully developed positive print or transparency is separated from the negative 15 to 30 seconds later. Some types of black-and-white prints are further treated by swabbing with a print coater, which removes traces of reagent and deposits a clear polymer layer. The paper negative is discarded.

The mechanism in instant color films is similar but much more complex. As in conventional color films, three negative, light-sensitive image layers are incorporated in the material, each controlling a dye developer in an adjacent, underlying layer (see diagrams, page 247). Unlike the developers used with conventional color films, however, these dye developers are able to act both as photographic developers and as image-forming dyes. Wherever the negative image layers are exposed, light-sensitive silver halides are reduced to silver metal, and the dye developers are oxidized and trapped within the negative. Where no exposure occurs, however, the dye developer molecules migrate through the reagent to the positive image-receiving layer. There they are trapped to form a positive image of excellent brilliance and great stability. The complex reaction normally takes one minute, and no coating of the end product is required.

*Kodak film cannot be used in the various Polaroid adapters, and vice versa.

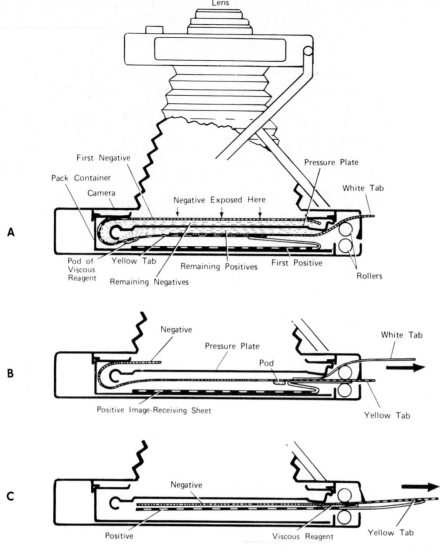

Construction of Polaroid-Land pack films. Courtesy Polaroid Corporation. **A:** Film pack positioned inside camera ready for exposure. **B:** Pulling white tab after exposure draws negative around into position next to positive image receiving sheet. **C:** Pulling yellow tab then draws both negative and positive materials between rollers, which break the pod and spread the viscous reagent between the negative and positive sheets.

BLACK-AND-WHITE FILMS

Black-and-white Polaroid materials are available as 3¼ × 4¼ in. rollfilms, 3¼ × 4¼ in. film packs, and as individual 4 × 5 in. sheets and packs. Most of the films designated below are film packs, but similar materials in other forms are noted where available.

Type 42 rollfilm yields a high-quality, long-scale print 20 seconds after removal from the camera. It has an ISO (ASA) rating of 200 and is panchromatic, making it ideal for general photographic use. A similar material for 4 × 5 cameras is designated **Type 52** in sheets and **Type 552** in 8-exposure packs. Both have an ISO rating of 400.

Type 107 material yields a medium-contrast print with 15 seconds development. It has an ISO rating of 3000, and its images are somewhat shorter in scale than those on Type 42 film. A similar material is available in rollfilm as **Type 47** and in 4 × 5 sheets as **Type 57. Type 667** is a 3000 speed pack film which develops in 30 seconds but needs no coating thereafter.

Type 51 material produces a high-contrast print, similar to those from litho film negatives, with 15 seconds development. A blue-sensitive material, it has a speed of 320 in daylight or 125 with tungsten lamps. It is available only as individual 4 × 5 sheets.

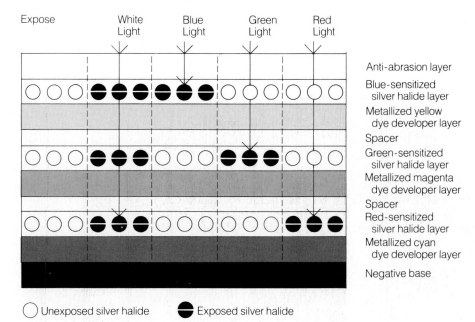

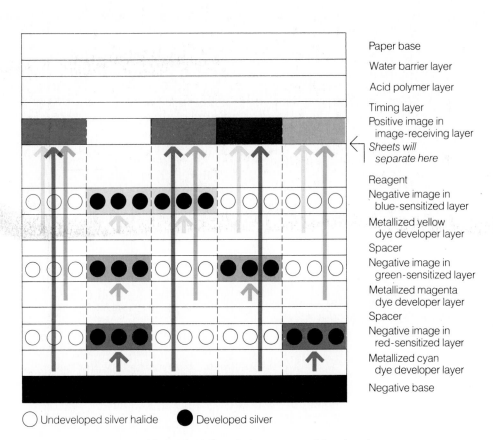

Schematic cross-section of Polacolor 2 films during exposure (above) and processing (below). From Polaroid Land Photography *by Ansel Adams. © 1978 by Ansel Adams. By permission of Little, Brown & Co. in conjunction with the New York Graphic Society.*

Types 665 and **55** produce the only usable negatives among instant-picture films, but what superb negatives they are! Image quality is comparable to that obtainable with the best thin-emulsion conventional films, grain is virtually indistinguishable, and the image can be enlarged as much as 25 times. A medium-contrast print is also produced along with the negative. Type 665 film has a speed of 75 and develops in 30 seconds. Type 55 is a similar material in 4×5 packets; it has a speed of 50 and develops in 20 seconds.

After exposure and processing in the usual Polaroid way, these materials are separated to yield a print and a film-base negative that is fully developed and fixed. Within a few minutes of its removal from the pack, however, this negative must be cleared, washed, and dried.

Clearing is accomplished by immersing the film for about one minute, with continuous agitation, in an 18% solution of sodium sulfite. This solution can easily be prepared by dissolving 180 grams of anhydrous (dessicated) sodium sulfite in 1 liter of water at 25°C (77°F).* Cool the solution to 21°C (70°F) before using. After clearing, wash the negative for several minutes in running water, then rinse in a wetting agent, as you would ordinary film, and hang it up to dry.

All Polaroid black-and-white prints (except those made on Type 667 film) must be coated after processing. The Polaroid Print Coater fluid cleanses the print surface of residual reagent chemicals and protects the images from damage by abrasion and from deterioration by contact with air. Place the print on a smooth, hard surface (the film package is convenient) and give it several wiping strokes with the print coater supplied with the film. Make certain to completely coat all of the image area, and permit the coating to dry completely before handling the print.

COLOR FILMS

Type 108 Polacolor 2 film comes in 3¼×4¼ in. packs and has a speed of 75 in daylight, for which it is balanced. As the exposure time is increased beyond 1 to 2 seconds, however, the film shows a slightly decreasing sensitivity to light and a color shift toward blue. At about 4 seconds exposure, this blue shift nicely balances the increased red and yellow content of tungsten light, so that the film can be exposed in such light without filters. At shorter exposure times, however, some filtration may be necessary for proper color rendition (a guide is packed with the film). With tungsten light, the film has a speed of approximately 25.

Type 668 is a similar color film in 3¼×4¼ in. packs, but it has a somewhat better color response with electronic flash units. **Type 58** is a corresponding 4×5 in. material in sheets; **Type 558** is in 4×5 in. packs.

Standard development time for these films is 1 minute at 24°C (75°F), although some manipulation is possible. At shorter times, the colors are warmer but less intense; longer development up to 1½ minutes gives increased color saturation but a cooler color balance. Processing at temperatures much above or below 24°C will produce similar changes.

Polaroid SX-70 Film is one of the most remarkable achievements of photographic technology (see diagrams, page 249). The negative and positive layers are combined in a single, integrated unit, and the negative is exposed through the layers in which the 3⅛ in. square print will later be produced (upper diagram).

Immediately after exposure, the camera ejects the film. A pair of steel rollers within the camera spreads an opaque processing reagent between the negative and positive layers as the film leaves the camera. Special opaquing chemicals protect the negative layers from fogging exposure as the film is ejected into the light, and the rest of the process safely proceeds outside the camera. As with Polacolor 2 film, dye developers in exposed areas are trapped by the developing negative, and those in unexposed areas are free to migrate to the print layer above. Even more remarkable, these dye molecules diffuse up through a layer of white pigment which forms the reflective viewing base for the positive image (lower diagram). Two more layers above the positive receiving layer pace the end of development reactions and trap alkali ions in colorless, transparent, stable form. During this stabilizing period the opaque dyes of the reagent slowly disappear. The positive image gradually appears against the white pigment layer, while the negative image and reagent remain trapped below, stable and invisible.

It takes about three minutes for the image to develop and stabilize to a point where the print can be judged for exposure and color balance. Minor changes occur for about seven minutes more as stabilization of the integrated package continues.

Polaroid Time-Zero Super Color SX-70 Film is outwardly similar to the SX-70 film described above. However, the internal structure and the chemical properties of certain components together provide for an accelerated process. The emerging image becomes visible within a few seconds, and the picture is virtually complete within a minute.

Kodak Instant Color Film PR10 is an integrated instant material which functions somewhat like the Polaroid SX-70 films. The negative layers of PR10,

*If only Type 665 film is cleared, a 12% solution of sodium sulfite (120 grams in 1 liter of water) may be used for 30 seconds.

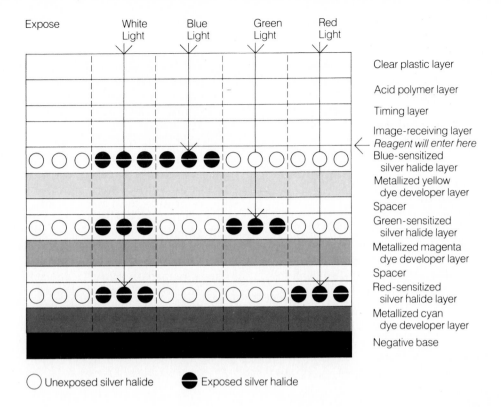

Expose | White Light | Blue Light | Green Light | Red Light

Clear plastic layer

Acid polymer layer

Timing layer

Image-receiving layer
Reagent will enter here

Blue-sensitized
 silver halide layer

Metallized yellow
 dye developer layer

Spacer

Green-sensitized
 silver halide layer

Metallized magenta
 dye developer layer

Spacer

Red-sensitized
 silver halide layer

Metallized cyan
 dye developer layer

Negative base

○ Unexposed silver halide ⬤ Exposed silver halide

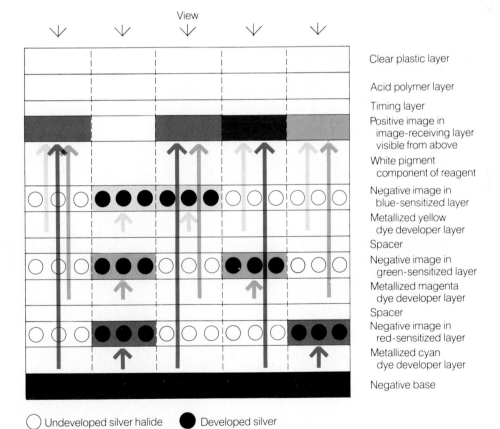

View

Clear plastic layer

Acid polymer layer

Timing layer

Positive image in
 image-receiving layer
 visible from above

White pigment
 component of reagent

Negative image in
 blue-sensitized layer

Metallized yellow
 dye developer layer

Spacer

Negative image in
 green-sensitized layer

Metallized magenta
 dye developer layer

Spacer

Negative image in
 red-sensitized layer

Metallized cyan
 dye developer layer

Negative base

○ Undeveloped silver halide ⬤ Developed silver

*Schematic cross-section of a Polaroid SX-70 film unit during exposure (above)
and processing (below). From* Polaroid Land Photography *by Ansel Adams
© 1978 by Ansel Adams. By permission of Little, Brown & Co. in conjunction with
the New York Graphic Society.*

however, are exposed from one side of the unit and the finished print is viewed from the other (like a conventional color transparency). The Kodak film is used in Kodak instant cameras and is also usable in any camera to which the Kodak adapter can be attached. Processing begins as soon as the exposed film is ejected from the camera or adapter, and the exposure can be judged in about 1½ minutes. Kodak PR10 film has a speed of about 160.

COLOR PRINT MATERIALS FOR DARKROOM USE

The Kodak Ektaflex PCT Color Printmaking System offers a quick and easy method for making color prints from either slides or color negatives. The system is based on image-transfer technology similar to that used in Kodak Instant Color Film.

The Ektaflex system uses two special films, one for color slides, the other for color negatives. Ektaflex PCT paper works with either film and is available in glossy (F) or matte (N) surfaces. The entire process runs at room temperature, 18–24°C (65–75°F). It uses only one chemical solution, Ektaflex PCT activator, and requires no washing.

Exposure

As with conventional color print materials, a light-tight darkroom and a set of color printing filters (see Chapter 12) are required. The negative or slide is printed onto Ektaflex film in a regular enlarger in much the same way that conventional color paper is handled, except that the negative or slide is placed in the enlarger *emulsion side up*. Use Kodak Ektaflex PCT negative film for prints from color negatives, or Ektaflex PCT reversal film for prints from slides. Suggested exposure and filtration data come with the films.

Kodak Ektaflex Printmaker, model 8. Ektaflex PCT film and paper are peeled apart to reveal a color print. Photographs courtesy Eastman Kodak Company.

Processing

Processing is accomplished in an Ektaflex Printmaker (see illustration) on the darkroom table. Follow this sequence:

1. Carefully pour the activator solution into the Printmaker. The solution is caustic; avoid contact with skin or eyes (see warning on label). Next, place a sheet of Ektaflex PCT paper, emulsion side *down*, on the paper shelf of the Printmaker. The emulsion side is white, the back is light gray, and the paper is not light-sensitive. Now turn off the room light.

2. *In the dark*, expose a sheet of Ektaflex PCT film in the enlarger.

3. Place the exposed PCT film, emulsion side *up*, on the ramp of the Printmaker. One edge of the film is notched; this notch should be at the top of the ramp, toward the right of the sheet. Make sure the film is under the edge guides on both sides.

4. Slide the film from the ramp into the activator bath and let it soak there for 20 seconds.

5. Laminate the film and paper together. About five seconds before the soak time is up, begin turning the crank. At the end of the soaking time, move the film advance handle on the Printmaker smoothly to the right. This feeds the film and paper into the laminating rollers. Continue turning the crank until the sandwich is completely out of the Printmaker; then set it aside. The laminated materials form a light-tight unit, so if the film package is closed, room light may be turned on again.

6. After 6 to 8 minutes (depending on the temperature) have elapsed, peel the film and paper apart as shown in the illustration, revealing your color print. The print surface is damp but will dry completely in a few minutes, or it can be dried faster with a hair dryer. If desired, the print may be trimmed to remove the film edge marks (Ektaflex paper is made slightly oversize for this purpose).

As with other color print processes, the exposure → processing → evaluation sequence is used to improve the result. To correct prints made from color negatives, see pages 195–196. For prints made from color slides, see page 198. Laminating time is not critical; it can be extended by several minutes if needed (see information packed with the processor and films). The three quarts of activator solution will process about 75 8 × 10 prints and will last up to 12 months if drained from the Printmaker and rebottled after each working session. The Ektaflex PCT films should be refrigerated between uses, but the paper does not require it.

The system offers flexibility for experimenting, too. One sheet of paper, for example, can be laminated to several films in succession for multiple exposure effects. Ektaflex PCT films also can be reused to give different transfer effects. When this is done, the soak time in the activator should not exceed 2 seconds to avoid contaminating the activator solution.

BIBLIOGRAPHY

This annotated guide to additional reading and picture study has been chosen to expand and develop the discussions presented in this book. The literature of photography is now so extensive that any useful bibliography must necessarily be selective, and several guidelines have been employed to choose the titles included here. First, primary sources which have bibliographies themselves have been selected over secondary works and sources without them. Most titles listed will therefore guide you to numerous additional sources of information. Second, non-technical works have been favored over those which rely on scientific language or notation. Third, books published during the last decade have been preferred to earlier works, and wherever possible, titles available in paperback have been selected and indicated by an asterisk (*).

Nearly every important nineteenth- and early twentieth-century photographer is now the subject of a monograph or book, and this has made the selection of titles on the history of photography and on contemporary work particularly difficult. The year 1930 was selected as a convenient date to divide the historic from the contemporary (few living photographers were active before then), and photographers well-served by serial titles are generally not duplicated in these sections. Of the remaining books on contemporary photographers, only recent titles on the most important people have been listed. The selection is admittedly arguable, and regrettably it omits many works of lasting value.

Popular titles on cameras and darkroom equipment, as well as "how to" titles of every description, are not included in this bibliography. Many of these are available at public libraries and camera shops, and much of their similar content is periodically repeated in the popular photographic magazines.

Two excellent sources for purchasing most of the books listed here are Light Impressions Corporation, P. O. Box 3012, Rochester, NY 14614, and the Focus Gallery Bookshop, 2146 Union Street, San Francisco, CA 94123. Both dealers issue annual catalogs.

The following classifications are used:

> REFERENCE WORKS
> GENERAL WORKS
> HISTORY OF PHOTOGRAPHY
> CONTEMPORARY ARTISTIC PHOTOGRAPHY
> PHOTOGRAPHY FOR THE MEDIA: JOURNALISTIC AND
> DOCUMENTARY
> PHOTOGRAPHIC TECHNOLOGY
> TECHNICAL MANUALS
> WORKS IN SERIES
> PERIODICALS

REFERENCE WORKS

BONI, ALBERT, ed. *Photographic Literature* (1727–1960). New York: Morgan & Morgan, Inc., 1962.

BONI, ALBERT, ed. *Photographic Literature* (1960–1970). Hastings-on-Hudson, NY: Morgan & Morgan, Inc., 1972. The only comprehensive bibliography in this field. Volume two (covering only the 1960s) contains more entries than volume one, which spans the preceding 233 years.

*Index to Kodak Information. Rochester, NY: Eastman Kodak Company. Revised annually. An indispensable checklist of lucid, accurate information on a wide range of practical photographic topics. Particularly useful on the application of photographic techniques to other fields such as advertising, law, medicine, science, and engineering.

JOHNSON, WILLIAM, ed. *An Index to Articles on Photography, 1977–78*. Rochester, NY: Visual Studies Workshop. The first two volumes of a proposed annual series emphasizing the use of photography as creative expression and communication. More than 80 international periodicals are indexed, but technical articles are not included.

PITTARO, ERNEST M., ed. *Photo-Lab-Index*. Dobbs Ferry, NY: Morgan & Morgan, 1979. 37th Lifetime ed.

*PITTARO, ERNEST M., ed. *Photo-Lab-Index*. Dobbs Ferry, NY: Morgan & Morgan, 1979. 2nd compact ed. The standard manual of internationally collected data on current photographic materials, formulas, and processes from major manufacturers. Quarterly supplements are available by subscription to update the loose-leaf, lifetime edition. The compact edition, which contains the seven most useful sections of the larger volume updated to 1979, is particularly useful to students.

*STROEBEL, LESLIE, and TODD, HOLLIS. *Dictionary of Contemporary Photography*. Dobbs Ferry, NY: Morgan & Morgan, Inc., 1974. A dictionary of words and technical terms used in still and motion-picture photography. The emphasis is on terms used in professional and commercial work, with few chemical and no historic references.

GENERAL WORKS

*ARNHEIM, RUDOLPH. *Art and Visual Perception*. Berkeley: University of California Press, 1966. A standard reference on the perception of visual experiences by a noted psychologist. His more recent thesis, that *all* thinking is perceptual in nature, is set forth in *Visual Thinking* (Berkeley: University of California Press, 1969).*

*BOORSTIN, DANIEL J. *The Image*. New York: Harper Colophon Books, 1964. This lively essay on the art of self-deception in America includes an excellent discussion of how photography has affected our taste and culture.

*CHERNOFF, GEORGE, and SARBIN, HERSCHEL. *Photography and the Law*. 5th ed. Garden City, NY: Amphoto, 1977. Written for the lay person rather than the lawyer, this book sets forth the rights and responsibilities of both the photographer and the photographed. Very clear on questions of image ownership, copyright, privacy, and libel.

COLEMAN, ALLAN D. *Light Readings*. New York: Oxford, 1979. A critical assessment of contemporary photography that has been exhibited in New York during the last ten years. Coleman's broad social perspective brings much insight to his discussion.

GILBERT, GEORGE. *Collecting Photographica*. New York: Hawthorn Books Inc., 1976. A profusely illustrated guidebook for collectors of cameras and other photographic equipment. It is especially useful for identifying and dating early twentieth century rollfilm cameras.

*GREEN, JONATHAN. *The Snapshot.* Millerton, NY: Aperture, Inc., 1974. The first serious attempt to define and clarify one of photography's most venerable, traditional, and ambiguous styles.

KOZLOFF, MAX. *Photography and Fascination.* Danbury, NH: Addison House, 1979. Thirteen essays on the social, moral, and esthetic implications of photography. The title essay and the last two pieces on color photography contain the most important arguments.

LIEBLING, JEROME, ed. *Photography: Current Perspectives.* Rochester, NY: Light Impressions, 1979. A well-illustrated selection of arguments which explore the differences between the photograph as an external object and an internal event.

*LYONS, NATHAN, ed. *Photographers on Photography.* Englewood Cliffs, NJ: Prentice-Hall, Inc., 1966. A superb anthology of writings by 23 photographers on their vision and their craft. Extensive biographical and bibliographical data.

NILSSON, LENNART. *Behold Man.* Boston: Little, Brown, 1975. The inner landscape of our bodies in color, by the first photographer to document the growth of a human embryo inside the womb.

Photographs: Sheldon Memorial Art Gallery Collections, University of Nebraska at Lincoln. Lincoln, NE: Nebraska Art Association, 1977. A well-produced, illustrated catalog of a major university collection of fine photographs, rich in contemporary work.

REEDY, WILLIAM A. *Impact.* Garden City, NY: Amphoto, 1973. A rich overview of photography in American advertising illustration, a major use of color photography today.

*SONTAG, SUSAN. *On Photography.* New York: Farrar, Straus & Giroux, 1977. Six essays that discuss the effects of photographs on our society and sensibility. The questions she raises are important and provocative.

*SZARKOWSKI, JOHN. *Looking at Photographs.* New York: The Museum of Modern Art, 1973. One hundred photographs from the Museum's outstanding collection, each discussed with perceptive insight by this eminent curator.

WEINSTEIN, ROBERT A., and BOOTH, LARRY. *Collection, Use, and Care of Historical Photographs.* Nashville, TN: American Association for State and Local History, 1977. The first authoritative and instructive book on the collection and preservation of photographic images. Equally useful to the private collector and the professional curator. (For a similar guidebook on cameras and other equipment, see Gilbert, G.).

ZAKIA, RICHARD D. *Perception and Photography.* Englewood Cliffs, NJ: Prentice-Hall, Inc., 1975. The gestalt theories of Arnheim (above) and others are more sharply focused for photographers in this well-illustrated discussion. Available in paperback (Rochester, NY: Light Impressions, 1979).

HISTORY OF PHOTOGRAPHY

NOTE: Additional titles will be found under *Works in Series.*

ALLAND, ALEXANDER, SR. *Jacob A. Riis.* Millerton, NY: Aperture, Inc., 1975. An excellent biography of this crusading New York reporter who took up photography when his words alone were unconvincing. It complements Riis's 1890 classic, *How the Other Half Lives.*

*BECKER, HOWARD S., SOUTHALL, THOMAS, and GREEN, HARVEY. *Points of View.* Rochester, NY: Visual Studies Workshop Press, 1979. See Darrah, William Culp, below.

CURRENT, KAREN. *Photography and the Old West.* New York: Harry N. Abrams, Inc., 1979. A superb collection of photographs by pioneer Western American cameramen, selected with insight and printed with loving care for publication.

DARRAH, WILLIAM CULP. *The World of Stereographs.* Gettysburg, PA: W. C. Darrah, 1977. Stereographs were the mass entertainment of a bygone era. This volume and Becker, *et al.* (above) are the most authoritative and comprehensive references to this fascinating three-dimensional world.

*FRASSANITO, WILLIAM A. *Gettysburg,* 1975; *Antietam,* 1978. New York: Charles Scribner's Sons. Two excellent examples of the use and misuse of photography by historians. Each underscores the importance of documenting the photographs themselves before they are used as historical evidence.

GERNSHEIM, HELMUT, in collaboration with GERNSHEIM, ALISON. *The History of Photography from the camera obscura to the beginning of the modern era.* New York: McGraw-Hill, 1969. The best reference to nineteenth century photography in Europe, especially in England and Scotland, and to the Gernsheim Collection in the University of Texas at Austin.

*GREEN, JONATHAN, comp. *Camera Work: a Critical Anthology.* Millerton, NY: Aperture, Inc., 1973. The best articles and illustrations from the monumental avant-garde quarterly published by Alfred Stieglitz from 1903–1917.

HAAS, ROBERT BARTLETT. *Muybridge: Man in Motion.* Berkeley and Los Angeles: University of California Press, 1976. The best single volume on the life and work of this extraordinary and inventive photographer.

HOMER, WILLIAM INNES. *Alfred Stieglitz and the American Avant Garde.* Boston: New York Graphic Society, 1977. A primary reference to Alfred Stieglitz and his era, and a valuable adjunct to the Green anthology from *Camera Work.*

*IVINS, WILLIAM M., JR. *Prints and Visual Communication.* Cambridge, MA: The M.I.T. Press, 1969. A lucid, scholarly analysis of how *reproduced* images have affected human perception and learning, and how the advent of photography changed our cultural vision. Engagingly written. A republication of the 1953 edition by Harvard University Press.

JENKINS, REESE V. *Images and Enterprise: Technology and the American Photographic Industry, 1839 to 1925.* Baltimore, MD: The Johns Hopkins Press, 1975. The first comprehensive study of the photographic equipment and supply industry in the United States, a long neglected area of photographic history.

MADDOW, BEN. *Faces.* Boston: New York Graphic Society, 1977. A lively, narrative history of photographic portraiture that is a unique history of photography itself.

*MARGOLIS, MARIANNE FULTON, ed. *Camera Work: a Pictorial Guide.* New York: Dover Publications, Inc., 1978. An illustrated index to all the illustrations and plates in the Stieglitz series (1903–1917).

*NAEF, WESTON J., and WOOD, JAMES N. *Era of Exploration: the Rise of Landscape Photography in the American West, 1860–1885.* Buffalo, NY: Albright-Knox Art Gallery, and New York: Metropolitan Museum of Art, 1975. A well-documented and beautifully produced study of the major landscape photographers of the American territorial West.

*NEWHALL, BEAUMONT. *The Daguerreotype in America.* New York: Dover Publications, Inc., 1976. A revised and expanded version of the original 1961 edition, with extensive technical, biographical and bibliographical notes. A definitive work.

*NEWHALL, BEAUMONT. *The History of Photography from 1839 to the Present Day.* 4th ed., 1964. The 7th printing, 1978, is paperback. New York: The Museum of Modern Art. The best illustrated and most readable general history of photography up to the mid-twentieth century. Although much in need of revision and expansion, this continues to be a very popular work. Excellent bibliography and notes.

*NEWHALL, BEAUMONT, *Latent Image.* Garden City, NY: Doubleday & Company, Inc., 1967. A readable account of the discovery of photography, with excellent source notes.

*NEWHALL, BEAUMONT, ed. *Photography: Essays and Images.* New York: The Museum of Modern Art, 1980. Contains 53 readings and 200 classic photographs carefully selected from original sources of photographic history. A fine complement to this renowned author's *History of Photography.*

*ROSENBLUM, WALTER; ROSENBLUM, NAOMI; and TRACHTENBERG, ALAN. *America and Lewis Hine.* Millerton, NY: Aperture, Inc., 1977. A handsome essay on this social reformer and photographer who confronted America's collective conscience on the issue of child labor.

SCHARF, AARON. *Pioneers of Photography.* New York: Harry N. Abrams, Inc., 1976. New insights into photography's early years, attractively written for the general reader.

*TAFT, ROBERT. *Photography and the American Scene.* New York: Dover Publications, Inc., 1964. This has long been the best general history of how the camera was used in nineteenth-century America. Inadequate illustrations but superb notes. An unaltered reprint of the 1938 Macmillan edition.

CONTEMPORARY ARTISTIC PHOTOGRAPHY

NOTE: Additional titles will be found under *Works in Series.*

ADAMS, ANSEL. *The Portfolios of Ansel Adams.* Boston: New York Graphic Society, 1977. All 90 photographs from the seven portfolios in very satisfying reproductions. If a single volume can define this master photographer's work, this is it.

*ARBUS, DIANE. *Diane Arbus.* Millerton, NY: Aperture, Inc., 1973. The definitive work on this tragic and legendary figure who was much admired by younger photographers. Eighty fine reproductions.

BALTZ, LEWIS. *The New Industrial Parks near Irvine, California.* Rochester, NY: Light Impressions, 1975. Cool, direct views of anonymous facades which are penetrating comments on both the architecture of rapid technological growth and the people who inhabit it.

EGGLESTON, WILLIAM. *William Eggleston's Guide.* New York: The Museum of Modern Art, 1976. The essay herein by John Szarkowski, and the book's related exhibition, have generated more controversy about color photography than anything else in decades.

ENYEART, JAMES, ed. *Heinecken.* Carmel, CA: The Friends of Photography, in association with Light Gallery, New York, 1980. The first major book on Robert Heinecken, whose work and teaching have had an enormous influence on contemporary photography.

FRANK, ROBERT. *The Americans.* 3rd ed. Millerton, NY: Aperture, Inc., 1978. A new edition of a classic photographic book first published in 1958. This singular view of America in the fifties resulted from Frank's epic journey across the United States.

*GOWIN, EMMET. *Emmet Gowin Photographs.* New York: Alfred A. Knopf, 1976. The first book by a sensitive young photographer of major stature.

LYONS, NATHAN, ed. *Vision and Expression.* New York: Horizon Press, 1969. The best single-volume overview of artistic photography in the sixties, it is a useful extension of Newhall's *History of Photography.* Brief biographies of each photographer are included.

MADDOW, BEN. *Edward Weston: Fifty Years of Photography.* Millerton, NY: Aperture, Inc., 1973. An elegant tribute to this great American photographer. An abridged version containing 70 photographs was published in paperback as *Edward Weston* (Boston: New York Graphic Society, 1978).

MELTZER, MILTON. *Dorothea Lange: A Photographer's Life.* New York: Farrar, Straus & Giroux, 1978. The best of several recent books about Lange, whose courage and commitment continue to make her an important role model for young women today.

*MEYEROWITZ, JOEL. *Cape Light.* Boston: Museum of Fine Arts, and New York Graphic Society, 1978. A fine example of how color photography's mechanistic spectrum can be made personally responsive and expressive.

*SISKIND, AARON. *Places: Photographs 1966–1975.* New York: Light Gallery and Farrar, Straus & Giroux, 1976. Paperback 1977. A decade of recent work in which ordinary subjects are transformed into extraordinary photographs by this major American artist.

*STRAND, PAUL. *Paul Strand: Sixty Years of Photographs.* Millerton, NY: Aperture, Inc., 1976. The most important single volume on this major photographer, and the first book which adequately covers the full range of his life and work. More than 130 reproductions.

SZARKOWSKI, JOHN, ed. *Callahan.* Millerton, NY: Aperture, Inc., in association with The Museum of Modern Art, New York, 1976. The best book to date on Harry Callahan, with 130 photographs and illuminating testimony from this major artist about the value of efforts which fail.

*SZARKOWSKI, JOHN. *Mirrors and Windows: American Photography since 1960.* Boston: New York Graphic Society, 1978. The illustrated catalog of a major exhibition at The Museum of Modern Art, New York, chosen largely from the Museum's collection to fit the author's modernist construct. Direct photographs from the late sixties dominate the choices, and much innovative work from the seventies is not included.

*SZARKOWSKI, JOHN, and YAMAGISHI, SHOJI. *New Japanese Photography.* New York: The Museum of Modern Art, 1974. The first major study of contemporary work from this camera-conscious society.

*UELSMANN, JERRY N. *Silver Meditations.* Dobbs Ferry, NY: Morgan & Morgan, 1975. A handsome monograph that is the best single volume on his remarkable work.

*WESTON, BRETT. *Voyage of the Eye.* Millerton, NY: Aperture, Inc., 1975. Fifty years of photography by this major artist who has pursued a classic interest in form, light, and landscape, undiluted by stylistic excursions and undiminished by his father's long-abiding shadow.

WHITE, MINOR. *Minor White: Rites and Passages.* Millerton, NY: Aperture, Inc., 1978. A stunning volume of quotations and images by the late photographer who was one of the most influential teachers of the twentieth century.

PHOTOGRAPHY FOR THE MEDIA: JOURNALISTIC AND DOCUMENTARY

NOTE: Additional titles will be found under *Works in Series.*

*CONRAT, MAISIE and RICHARD. *Executive Order 9066.* San Francisco: California Historical Society, 1972. A fine example of picture *selection* to portray the story of this ugly scar on the American conscience.

EDEY, MAITLAND, ed. *Great Photographic Essays from LIFE.* Boston: New York Graphic Society, 1978. Twenty-two stories which defined the photographic essay and greatly influenced the course of photojournalism between 1936 and 1971 are reassembled here.

EDOM, CLIFTON C., ed. *Photojournalism: Principles and Practice.*

Dubuque, Iowa: William C. Brown, 1976. A textbook which is particularly valuable for its interviews with leading professional magazine photographers, their agencies, and their syndicates.

*HURLEY, F. JACK. *Portrait of a Decade.* Baton Rouge, LA: Louisiana State University Press, 1972. Paperback (New York: Da Capo Press), 1977. The most informative and readable account of how Roy Stryker shaped the Farm Security Administration project of the thirties into a classic example of documentary photography. Stryker's own choice of 200 key photographs from this huge collection has been published as *In This Proud Land* (Greenwich, CT: New York Graphic Society, 1973). These are the faces of Americans who survived a historic depression only to face an epochal war.

KERNS, ROBERT L. *Photojournalism: Photography with a Purpose.* Englewood Cliffs, NJ: Prentice-Hall, Inc., 1980. A new textbook by a noted teacher in this field. Many illustrations.

KOBRE, KENNETH. *Photojournalism: The Professionals' Approach.* Somerville, MA: Curtin & London, Inc., 1980. A working photojournalist "tells it like it is," quoting more than forty other professionals to make the discussion fresh and authentic. Excellent illustrations and much practical advice.

McCULLIN, DONALD. *Is Anyone Taking Any Notice?* Cambridge, MA: The MIT Press, 1973. Powerful and stormy photographs of our systematic self-destruction by war, famine, and political pressure. An important book for every future photojournalist to ponder.

*OWENS, BILL. *Suburbia.* San Francisco: Straight Arrow Books, 1973. In this modern classic, middle-class California looks at itself from the comfort of its two-car garage.

*OWENS, BILL. *Working: I Do It for the Money.* New York: Simon and Schuster, 1977. A collective self-portrait of Americans earning their living. This book and *Suburbia* are good examples of contemporary photographic publishing.

*SCHUNEMAN, R. SMITH, ed. *Photographic Communication.* New York: Hastings House, 1972. An overview of photojournalism edited from conference tapes by 53 leading photographers, editors, and art directors.

*SMITH, W. EUGENE. *W. Eugene Smith: His Photographs and Notes.* Millerton, NY: Aperture, Inc., 1969. The most comprehensive single volume on the work of this great photojournalist.

*SMITH, W. EUGENE and AIELEEN M. *Minimata.* New York: Holt, Rinehart, and Winston, 1975. Produced with the help of his wife, this is Smith's last and most important photographic essay.

PHOTOGRAPHIC TECHNOLOGY

COSTIGAN, DANIEL M. *Electronic Delivery of Documents and Graphics.* New York: Van Nostrand Reinhold, 1978. An excellent overview of a highly-developed form of communication that conveys photographs and other images to a wider audience. Wirephoto transmission and more recent innovations in facsimile communication are fully described.

EATON, GEORGE T. *Photographic Chemistry in Black-and-White and Color Photography.* Hastings-on-Hudson, NY: Morgan & Morgan, 1965. A lucid explanation of photographic chemistry for the non-scientist and general reader.

EDGERTON, HAROLD E., and KILLIAN, JAMES R., JR. *Moments of Vision: the Stroboscopic Revolution in Photography.* Cambridge, MA: The MIT Press, 1979. A beautifully illustrated account of the development and application of electronic flash technology by its inventor and a close associate.

NEBLETTE, C. B. *Neblette's Handbook of Photography and Reprography Materials, Processes, and Systems.* 7th ed., edited by John M. Sturge. New York: Van Nostrand Reinhold, 1977. Written by the late Neblette, Sturge, and 24 other specialists,

this volume updates the 1961 edition and reorganizes the material as systems. Its authority and clarity guarantee its preeminence as the best reference to photographic technology in the English language.

NEBLETTE, C. B., and MURRAY, ALLEN E. *Photographic Lenses.* Dobbs Ferry, NY: Morgan & Morgan, 1974. A practical, non-mathematical guidebook to modern photographic lenses, a topic not included in *Neblette's Handbook* (above). Many diagrams.

TODD, HOLLIS N., and ZAKIA, RICHARD D. *Photographic Sensitometry.* Dobbs Ferry, NY: Morgan & Morgan, 1969. Especially useful as a guide to process control and precise tone reproduction.

WALL, E. J., and JORDAN, FRANKLIN I. *Photographic Facts and Formulas.* Revised by John S. Carroll. New York: Amphoto, 1974. A revision of a classic photographic formulary and a useful reference to many older processes of continuing contemporary interest.

TECHNICAL MANUALS

ADAMS, ANSEL. *The Camera.* The New Ansel Adams Photography Series / Book 1. Boston: New York Graphic Society, 1980. The first volume in Adams's revision of his classic *Basic Photo Series* of 1948–1956. Completely rewritten, this is again an authoritative work.

ADAMS, ANSEL. *Polaroid Land Photography.* Boston: New York Graphic Society, 1978. An extensive revision of Adams's 1963 manual with added material by other authors. All contributors stress the system's capacity for immediate feedback to reinforce visualization. This is the definitive reference on Polaroid materials and equipment.

BLAKER, ALFRED A. *Field Photography.* San Francisco: W. H. Freeman, 1976. A thorough guide for students and practitioners of the natural sciences outdoors. Written by a noted biological photographer long associated with the University of California, Berkeley.

BLAKER, ALFRED A. *Handbook for Scientific Photography.* San Francisco: W. H. Freeman, 1977. The best guide for photographing subjects and events that occur in the laboratory, with valuable advice on preparing scientific photographs for publication.

*CRAWFORD, WILLIAM. *The Keepers of Light.* Dobbs Ferry, NY: Morgan & Morgan, 1979. A guide to photographic processes used in the nineteenth century, with practical suggestions for re-creating them with modern materials.

*CURTIN, DENNIS, and DE MAIO, JOE. *The Darkroom Handbook.* Somerville, MA: Curtin & London, Inc., 1979. A guide to darkroom planning and construction which combines a sensitivity to human concerns and working conditions with the means for efficient production of fine photographs.

*GASSAN, ARNOLD. *Handbook for Contemporary Photography.* 4th ed. Rochester, NY: Light Impressions, 1977. A fine extension of *Object and Image,* with good instructional advice for carrying your sensibilities through silver and non-silver photographic systems. Well-illustrated procedures.

*KELLY, JAIN, ed. *Darkroom II.* Rochester, NY: Lustrum Press, 1978. Nine well-known photographers including Judy Dater, Emmet Gowin, Robert Heinecken, and Neal Slavin reveal the methods of their craft and share their "darkroom psychology."

Kodak Black-and-White Darkroom Dataguide. Rochester, NY: Eastman Kodak Company, 1979. A convenient and popular handbook of up-to-date information on films, developers, printing and enlarging papers, and other chemicals and formulas widely used in black-and-white photography. Although limited to Kodak products, the information is widely applicable to products from other manufacturers as well.

Kodak Color Darkroom Dataguide. Rochester, NY: Eastman Kodak Company, 1980. A very useful and convenient reference book

on all of the most popular color films, their processes, and their printing procedures. It also includes a gray card, gray scale, print exposure calculator, color print viewing filters, and various tables. Since most brands of color films and papers (except Cibachrome) are compatible with Kodak processes, this is virtually a universal color guide.

*LEWIS, ELEANOR, ed. *Darkroom*. Rochester, NY: Lustrum Press, 1977. Thirteen famous photographers including Wynn Bullock, Linda Connor, Ralph Gibson, W. Eugene Smith, and Jerry Uelsmann discuss their craft techniques. Like *Darkroom II* (above), the book underscores the value of sound craftsmanship to the realization of visual ideas.

*NETTLES, BEA. *Breaking the Rules: a Photo-media Cookbook*. Rochester, NY: Light Impressions, 1977. A fine resource book for making photographs with non-silver materials.

Professional Photographic Illustration Techniques. Rochester, NY: Eastman Kodak Company, 1978. A well-illustrated reference manual on the production of photographic illustrations for business and advertising. The advice is thoroughly practical.

*SHAMAN, HARVEY. *The View Camera: Operations & Techniques*. Garden City, NY: Amphoto, 1977. The best of several current handbooks on this classic type of camera.

STONE, JIM, ed. *Darkroom Dynamics*. Marblehead, MA: Curtin & London, Inc., and New York: Van Nostrand Reinhold, 1979. A well illustrated resource book for exploring non-representational imagery and techniques.

*WADE, KENT. *Alternative Photographic Processes*. Dobbs Ferry, NY: Morgan & Morgan, 1978. Clear, step-by-step directions for printing photographic images on glass, ceramic, wood, metal, and other non-paper surfaces.

*WHITE, MINOR; ZAKIA, RICHARD D.; and LORENZ, PETER. *The New Zone System Manual*. Dobbs Ferry, NY: Morgan & Morgan, 1976. Unsurpassed as a guidebook to this important photographic rationale. Extensive graphs, charts, and technical data.

WORKS IN SERIES

Aperture History of Photography. Millerton, NY: Aperture, Inc., 1976 to date. An exemplary series of books on major nineteenth- and twentieth-century photographers. The photographs are carefully selected and well reproduced, and the texts concise but authoritative. Each volume contains an excellent bibliography and biographical data, and is an outstanding value for its price. Titles to date include:

1. *Henri Cartier-Bresson*, 1976.
2. *Robert Frank*, 1976.
3. *Alfred Stieglitz*, 1976.
4. *Wynn Bullock*, 1976.
5. *Jacques-Henri Lartigue*, 1977.
6. *André Kertész*, 1977.
7. *August Sander*, 1977.
8. *Weegee*, 1978.
9. *Edward Steichen*, 1978.
10. *Erich Salomon*, 1979.
11. *Clarence H. White*, 1979.
12. *Walker Evans*, 1980.
13. *Frank Meadow Sutcliffe*, 1980
14. *Eugene Atget*, 1980.
15. *Man Ray*, 1980.

Life Library of Photography. New York: Time-Life Books, 1970–1972. Seventeen volumes on many aspects of photography. Among the best of the series are *The Great Themes* (1970), which explores six major subjects that have concerned photographers over the years; *Photography as a Tool* (1970), which clearly shows how photography is used to reveal things too fast, too slow, too far, and too small for humans to see otherwise; and *Frontiers of Photography* (1972), which offers fascinating glimpses into photography's future.

Masters of Contemporary Photography. New York: Thomas Y. Crowell, 1974–1975. Eight volumes on photographers whose work is media-oriented. Although out of print, several books are still valuable references.:

KANE, ART. *The Persuasive Image*, 1975. The best book on this New York illustrator who has revitalized advertising photography.

MICHALS, DUANE. *The Photographic Illusion*, 1975. A master of photographic surrealism who has worked extensively with photographs in sequences.

ZIMMERMAN, JOHN, and others. *Photographing Sports*, 1975. Excellent advice on this topic by experienced professionals associated with *Life* and *Sports Illustrated*. They have been talented and innovative in a field where repetitious subjects and treatments abound.

PERIODICALS

Afterimage. Nine issues per year. Visual Studies Workshop, 31 Prince Street, Rochester, NY 14607. A lively tabloid that contributes substantially to discussions of contemporary photographic thinking and criticism, while reporting on recent historical research, publications, and exhibitions worldwide. For serious, creative photographers, it is the most important periodical in the field.

American Photographer. Monthly. CBS Publications, 1515 Broadway, New York, NY 10036. The emphasis is on contemporary artistic and media photography rather than on equipment and techniques.

Aperture. Quarterly. Aperture, Inc., Elm Street, Millerton, NY 12546. Since 1952, this elegant quarterly has been at the forefront of photographic thought and imagery. Stimulating articles and handsome reproductions of contemporary work.

Camera 35. Monthly. UEM Publishing, Inc., 714 Fifth Avenue, New York, NY 10019. A popular magazine which features contemporary photographs and technical articles.

Modern Photography. Monthly. Billboard Publishing Company, 165 W. 46th Street, New York, NY 10036. This popular magazine emphasizes new developments in cameras, darkroom equipment, materials, and other products.

Petersen's Photographic Magazine. Monthly. Petersen Publishing Company, 8490 Sunset Boulevard, Los Angeles, CA 90069. Similar to *Modern Photography* (above), it occasionally shows a West Coast point of view.

Photo Communique. Quarterly. Fine Art Photography Publications Ltd., P. O. Box 129, Station M, Toronto, Ontario, Canada M6S 4T2. A Canadian journal which offers a lively forum for the discussion of contemporary photographic ideas. The emphasis is on photographic art and criticism, with reviews of new books and shows, and announcements of Canadian exhibitions.

Photographer's Forum. Quarterly. Photographer's Forum, 25 West Anapamu Street, Suite E, Santa Barbara, CA 93101. A well reproduced magazine featuring student work from college and university photography departments. Regular features profile these departments; many articles appeal to undergraduate students.

Photomethods. Monthly. Ziff-Davis Publishing Company, 1 Park Avenue, New York, NY 10016. A journal of interest to commercial and industrial photographers, along with film and video technicians and producers. Its articles always emphasize practical solutions to photographic, technical, and business problems. Regular columns and departments by expert writers and practitioners in the field.

Popular Photography. Monthly. Ziff-Davis Publishing Company, 1 Park Avenue, New York, NY 10016. Similar to *Modern Photography* and *Petersen's Photographic Magazine* (above), it has the largest circulation of any periodical in the field.

GLOSSARY

accelerator Alkaline component of most developers which speeds up their action.

accent light Used to add a small highlight to an evenly lit area. Commonly used in portraiture to brighten the hair.

acetic acid Commonly used in diluted form as a bath to stop development of films and prints. See *stop bath*.

acutance Objective measurement of the sharpness of a photographic image.

additive color synthesis Method of combining red, green, and blue light to form all other colors. Television uses such a system.

agitation Way to keep fresh processing solutions in contact with an emulsion, and simultaneously disperse products of the reaction.

angle of view See also *lens coverage*.

antifoggant Component of developers which prevents them from acting on unexposed silver halides. Also called a *restrainer*.

aperture Opening, usually adjustable, which governs how much light passes through a lens. Also called the *diaphragm* or *stop*. See *relative aperture*.

aperture-priority exposure system Through-the-lens exposure meter coupled to the camera controls in such a way that when you set the desired aperture, the meter selects the proper exposure time. Often found in cameras with electronic shutters. Compare with *shutter-priority exposure system*.

apron Crinkle-edged, plastic strip spiraled in Kodak 35 mm and rollfilm processing tanks to position the film. Also, the continuous belt of a rotary print dryer for fiber-based photographic paper.

archival processing Processing methods that produce photographic images of maximum stability. Properly stored, such images will last many, many years without fading or deteriorating.

artificial light In practice, light that a photographer can control at its source. Most is electrically produced.

ASA American Standards Association, the former name of the American National Standards Institute (ANSI). Until recently, ASA designated *film speed*, but it has now been replaced by an international designation, ISO. See *ISO*.

background General term for what lies behind the main subject in a picture.

background light Light source which illuminates an area behind the subject in a picture but not the subject itself. Often placed behind the subject and thus hidden from the camera by it.

back lighting Light coming toward the camera from behind the subject. It sometimes produces a silhouette effect and is a technique often used with accent lights.

barndoors Pair of adjustable metal baffles which can be fastened onto an artificial light source to restrict the spread of its illumination.

base Support of a photographic film or paper on which the emulsion and other layers are coated.

between-the-lens shutter Any shutter located between elements of a lens. Usually a leaf shutter.

bleach Chemical bath which oxidizes a black-and-white silver image to a silver halide, thereby making it soluble or redevelopable.

bleed mounting Mounting a print without a surrounding border; that is, to the edge of the mount board.

blix Combined bleaching and fixing bath used in some color processes.

blueprint Blue-and-white photographic print made with light-sensitive iron salts. Also called *cyanotype*, it has long been used by architects, engineers, and contractors to reproduce technical drawings.

bounce flash Diffused source of flash illumination produced by aiming the flash unit at a reflecting surface (wall, umbrella, or ceiling) rather than the subject. Especially useful at close lamp-to-subject distances. See also *shadowless lighting* and *umbrella*.

bracketing Taking a series of exposures of the same subject, changing the aperture or shutter time with each, to produce the indicated exposure, some less, and others more. For example: 1/500 f/8, 1/500 f/11, 1/500 f/16, 1/500 f/5.6, etc.

brightness Appearance of light reflected from a subject or surface and seen by the eye. It is thus subjective and not measurable. Compare with *lightness* and *luminance*.

brightness range Difference between the lightest and darkest areas of a subject as perceived by the eye. Compare with *luminance range*.

broad lighting Portrait lighting arrangement with the key light illuminating the side of the face closest to the camera. Compare with *short lighting*.

bulb (shutter setting) Shutter setting (B) which keeps the shutter open as long as the release is depressed. Often used for times of 1–10 seconds.

burning in Darkening an area within a print by an additional, localized exposure. Compare with *dodging*.

butterfly lighting Portrait lighting arrangement with the key light placed in front of and higher than the subject, thereby casting a small, butterfly-shaped shadow below the nose.

cable release Flexible cable that can be screwed into the shutter release, and which releases the shutter when pressed. Used primarily to minimize undesirable camera movement.

candela See *intensity*.

caption Any brief identifying or descriptive written statement placed near a photograph or its reproduction.

cartridge Any factory-loaded container of film designed to make camera loading quick and easy while protecting the film from light. Typically used for sizes 110, 126, and 35 mm. Cartridges are not reusable. Compare with *cassette*.

cassette Any reusable, light-tight film container designed to make camera loading quick and easy. Typically used for 35 mm films to permit loading from bulk rolls (27.5, 50, or 100 ft. lengths). Compare with *cartridge*.

catadioptric lens Lens which includes mirrors and refracting elements, used to reduce bulk, weight, and cost in optical systems of great focal length. Also called *mirror lens*, it lacks a diaphragm within the lens.

Celsius (°C) International temperature scale on which 0° and 100° represent the freezing and boiling points, respectively, of water.

center-weighted meter Through-the-lens luminance (exposure) meter which determines its reading more from the center of the field than from the areas near the edges.

chroma Measurable characteristic of a color which designates its vividness or purity. Also called *saturation*.

chromogenic systems Films or papers and their associated chemical processes which, taken together, produce image color during processing. Non-chromogenic systems employ

materials whose colors are formed during manufacture, and thus are less dependent on processing conditions for accuracy and stability.

clearing time Time required for a fixing bath to dissolve all silver halides in an emulsion, and thus make unexposed areas of a film transparent. The preferred fixing time for most emulsions is twice the clearing time.

closeup attachment Supplementary lens element which attaches to the front of a normal camera lens, effectively shortening its focal length and thereby allowing it to focus objects at closer distances from the camera.

cold mounting Method of mounting or backing prints with pressure-sensitive tissue rather than heat-sensitive materials. Advantageous with color prints and others which cannot safely withstand high temperatures.

cold-toned Black-and-white photographic print which is bluish-black in appearance. Compare with *warm-toned*.

color balance Specific proportion of red, green, and blue sensitivities in a color film that enables it to closely reproduce the colors of objects illuminated by light of a designated *color temperature*. Typically, color films are made with daylight or tungsten light color balances. The term is also used to describe the appearance of relative amounts of cyan, magenta, and yellow in a color transparency or print.

color cast Overall excess of one color in an otherwise acceptable color photograph.

color circle Colors of the spectrum arranged in a circle so that primary colors are equidistant and complementary colors are opposite each other. Useful in understanding color relationships.

color-compensating filter Filter of a single color and density, used to change the color balance of prints and transparencies.

color temperature Way of designating the specific proportions of red, green, and blue wavelengths in "white" light, expressed as degrees on the Kelvin scale (K).

commercial photography Business of making photographs primarily for advertising, sales, and other business uses. Includes various specialties such as architectural, fashion, food, and product illustration.

complementary colors Any two colors of light or dye which will combine to form white or a neutral color. They are located opposite each other on the color circle.

conceptual photography Style in which the photographs stand for the ideas behind their making, rather than illustrating or actually showing those ideas.

condenser enlarger Projection printer which uses condenser lenses to evenly concentrate the light on the negative. Compare with *diffusion enlarger*.

condenser lens One or more positive lenses which concentrate light into a beam of parallel rays. Often used in enlargers and projectors to improve contrast and efficiency.

contact print Print made by placing the sensitive paper in actual contact with the negative, and exposing the former to light through the latter. The print is thus the same size as its negative. Compare with *projection printing*.

continuous tone Describes an image with a smoothly changing series of tones from light to dark, a scale typical of many silver-halide emulsions. Compare with *line* and *dropout* images, which have no gray tones.

contrast Perceived difference in tone between the lightest and darkest areas of a subject or an image. Primarily controlled in subjects by lighting, in negatives by development, in black-and-white prints by paper grade or filter choice, and in color printing by choice of materials and masking techniques.

conversion filter Filter used to change the color temperature of light to match the color balance of a film. Filters No. 80A and 85B are typical. Light-balancing filters are similar, but the change they make is much smaller.

copying General term for duplicating or reproducing a two-dimensional image. More specifically, the process of duplicating a photographic print when no negative is available.

critical aperture Aperture at which a lens produces the greatest resolution of a two-dimensional subject. Usually about two stops down from the maximum aperture.

cropping Making the area of a view or an image smaller by eliminating part of it.

cyan Bluish-green, subtractive, primary color, the complement of red.

cyanotype See *blueprint*.

darkroom Room in which all light can be controlled or excluded to permit the safe handling of photosensitive materials.

densitometer Device for measuring the *density*, or ability to absorb light, of a photographic tone.

density General term for the amount of silver or dye present in an exposed and processed image tone. More precisely, a measurement of *opacity*, expressed as its logarithm.

depth of field Distance between the nearest and farthest planes in the subject which focus acceptably sharp at any one setting of the lens. It varies directly with the relative aperture and the lens-to-subject distance, and inversely with the focal length.

developer General term for a chemical solution or bath which makes latent images on film or paper visible by reducing the exposed silver halides to silver metal.

developing agent Any chemical which can reduce silver halides to silver metal. One ingredient of a *developer*. The most useful developing agents are Metol, Phenidone, and hydroquinone.

diaphragm See *aperture*.

diazo print Non-silver, direct-positive print made by the destruction of diazonium salts with ultraviolet radiation, and the subsequent conversion of unexposed salts to azo dyes.

diffraction Spreading of light waves after they pass an aperture or diaphragm edge, which limits the image quality of a lens at apertures smaller than its critical aperture.

diffusion Any scattering of light, generally lowering the acutance and contrast of images produced with it.

diffusion enlarger Projection printer employing only diffused light. Compare with *condenser enlarger*.

DIN Deutsche Industrie Norm. German system of expressing film sensitivity on a logarithmic scale. It has recently been combined with *ASA* ratings to form *ISO* ratings. See *ISO*.

documentary photography Photographs made to record or interpret a subject, usually with a preconceived purpose or viewpoint in mind.

dodging Lightening an area within a print by blocking the light from that area for part of the exposure time. The opposite of *burning in*.

dropout image See *line image*.

dry mounting Method of mounting or backing prints which uses heat-sensitive tissue rather than wet adhesives. It is clean, wrinkle-free, and permanent. Compare with *cold mounting*.

dye coupler Chemical which reacts with certain by-products of silver-halide development to form a colored dye. This is the basic mechanism of most color film and print processes.

dye destruction system Color printing process in which dyes existing in the sensitive paper are chemically destroyed in the presence of a negative silver image. The unaffected dyes remaining thus constitute a positive image.

easel Device usually placed on the enlarger baseboard to hold paper flat and still during exposure. Most easels also produce a white border on the print.

edge numbers Numbers printed photographically on one edge of roll and 35 mm film by the manufacturer to identify individual negatives or transparencies after processing.

edition In photographic printing, a quantity of prints, each an exact duplicate of the others, usually made at the same time by the same person or persons.

electronic flash Lamp and related circuitry which repeatedly produces very brief flashes of brilliant light. Usually requires a brief recharging period between flashes. Compare with *stroboscopic light* and *flashbulb*.

electrostatic systems Non-silver imaging systems widely used for document reproduction. They work by altering the electrical charge of a surface in response to light, and then transferring the pattern of that charge to other non-light-sensitive surfaces. See *xerography*.

emulsion Layer of gelatin usually containing a dispersion of light-sensitive silver halides, coated on a film or paper base. This is the layer of photosensitive materials in which the image is formed.

enlarger Projection printer (the preferred name) which is the basic photographic printing tool. Although typically used to make prints larger than their negatives, it can also be used to expose contact prints, to reduce images in size, and to make negatives from certain positive images.

enlarging lens Lens made especially for use on a projection printer. It gives its best resolution with flat image and subject planes at relatively close distances, and usually has click stops for setting the aperture in the dark.

equivalence Style of image making in which the photograph functions as a visual metaphor, showing one thing but symbolizing another.

exhibition print Print made expressly for direct viewing rather than for photomechanical reproduction. It will often have a greater depth of tone and be more carefully finished than a *reproduction print*.

exposure Act and effect of light striking a material sensitive to it. Also used loosely to designate the shutter time and relative aperture controlling it.

exposure index (EI) Similar to *film speed*, but it is sometimes altered to account for reciprocity effects, filter absorptions, and other such adjustments indicated by typical uses. Film speeds, on the other hand, reflect no such adjustments.

exposure latitude Extent to which a film or paper can be over- or underexposed and still produce acceptable results.

exposure meter Device which measures *luminance* and relates the measurement to film sensitivity to indicate shutter and relative aperture settings for exposure.

exposure scale Range of exposures required to produce a range of tones from minimum to maximum density in a particular photographic paper. The greater the exposure scale of a paper, the greater the number of gray tones it can produce, and the lower the contrast.

exposure value (EV) Single whole number used to designate the product of various equivalent shutter and aperture settings. Some exposure meters and cameras are marked with EV numbers.

feathering Aiming a light in front of a portrait subject rather than directly at the person, thereby decreasing the brightness on one side of the face. The technique is also useful with product photography to give tone separation to different sides of an object.

field of view Area in front of a camera from which its lens can form an image on the focal plane. See also *lens coverage*. Pertaining to the eye, the maximum limits of the area it can see from all orbital positions.

fill light Light source used to illuminate the shadows from a key light. Less intense than the key light.

film Light-sensitive, flexible material typically used in cameras. Its most important layers are the emulsion and the base. The three most important types produce black-and-white negatives, color negatives, and color transparencies.

film speed Basic sensitivity to light of a film, expressed as an ISO number or rating. The higher the number, the greater the sensitivity. See *ISO*.

filter Device which transmits or passes some colors of light while absorbing others. Used on camera lenses to change the tone or color of selected parts of an image, on projection printers to control contrast or color balance of images, and in safelights to absorb undesired wavelengths from white light. Typically a disc or sheet of acetate, gelatin, or glass.

filter factor Number by which an ordinary exposure must be multiplied when a filter is used. The factor compensates for the absorption of the filter.

fisheye lens Extreme wide-angle lens which produces somewhat distorted images.

fixing Processing step which chemically destroys the sensitivity to light of a film or paper by dissolving its remaining silver halides.

flare Uncontrolled reflection of light within a lens, camera, or enlarger, which produces irregular, non-image exposure of film or paper. Image contrast and shadow detail are reduced by it, and colors desaturated. Lens shades and clean lens surfaces will minimize the problem.

flashbulb Small glass bulb containing various shredded metals and oxygen. When ignited electrically or percussively, it gives a single, bright flash of light useful for exposure. Sometimes grouped into cubes or rows of identical lamps (flash bars, flip flash) for successive use. Compare with *electronic flash*.

flat Low in contrast.

f/ number scale Series of numbers, usually on the lens barrel, which indicates the size of the lens aperture and thereby the amount of light it can transmit or project. See also *relative aperture*.

focal length Distance from the rear nodal point of a lens to its focal plane when it is focused on an infinitely distant object.

focal plane Plane normally perpendicular to the lens axis, on which its sharpest image is formed. The ground glass or film are normally located here.

focal-plane shutter Camera shutter typically containing two movable curtain sections, positioned just ahead of the focal plane. An adjustable gap between the two sections exposes the film when the sections pass successively in front of it.

fog Any density caused by non-image exposure of film or paper. Usually caused by light, but it can also be caused by undesirable chemical reactions or exposure to X-rays.

format Size and shape of the picture area of a camera, film, or print.

free lancing Making photographs for sale, on order or on speculation, as an independent photographer. The term implies an irregular pattern of sales to varied customers rather than a steady or contractual arrangement.

gelatin Animal protein which is the main ingredient of film and paper emulsions.

gelatin-silver print General term used to identify any photographic print containing a silver image in a gelatin emulsion, and to distinguish such prints from non-silver types such as electrostatic, gum bichromate, cyanotype, etc.

glossy Smooth, shiny surface or finish on photographic paper. Such papers can produce richer, deeper blacks and shadow tones than matte-finish papers can.

gradation Change in density of silver or dye, and hence tone, of an image, from white through medium values to black. We perceive gradation as *contrast*.

grade Numerical and verbal designation of the exposure scale of a photographic paper. Higher number grades produce shorter exposure scales and greater contrast.

grain General term describing the appearance of the tiny particles of silver metal which form a developed photographic image. They are often clumped together and when magnified several diameters, give the impression of graininess.

graphic arts General term applied to those aspects of photographic work which are part of the production of ink-on-paper printing. The term includes photomechanical reproduction work but usually excludes typesetting unless it is done photographically.

gray card Standard gray cardboard widely used for luminance readings with exposure meters. Its gray side reflects 18% of the light falling on it; its opposite white side similarly reflects 90% of the incident light. Its photographed image is also useful to ascertain proper color balance in color printing.

gray scale Series of neutral print tones which vary by equal density differences, sequenced from light to dark. It can be photographed with other subjects and its image used to measure exposure and development with a densitometer.

ground glass Glass plate etched to a translucent finish on one side, and used to form a visible image at the focal plane of a camera lens. Sometimes also used in diffusion enlargers to scatter and soften the light.

guide number Number used to determine relative aperture set-

tings (f/ stops) from lamp-to-subject distances in flash work. It takes into account various characteristics of the light source, reflector design, and film sensitivity, all of which affect exposure.

gum bichromate Non-silver system which forms images by the hardening action of light on pigmented gum arabic which has been made light-sensitive by the addition of potassium bichromate.

halation Diffused, halo-like effect surrounding the image of a bright light source in some photographs. Caused by light rays reflecting from the rear surface of the emulsion or the film base, at an angle other than 90°, and thus slightly re-exposing the film. The effect is minimized by the anti-halation layer coated on the base of most films to absorb such reflections.

halftone Photomechanical image or process in which shades of gray are represented by dots of varied size but uniform color. It makes possible the simulation of *continuous tone* in reproductions using one color of ink. Photographs in this book are reproduced in this manner.

hard High in contrast (describing negatives or prints).

hardener Component of many fixing baths and some color processes. It limits the softening or swelling of wet gelatin emulsions. Potassium aluminum sulfate and formaldehyde are commonly used.

highlight Very light, bright parts of a subject, which reproduce as dense, dark areas in a negative and light, bright areas in a print. The opposite of a *shadow*.

hue Name of a color which distinguishes it from other colors, and which varies with the *wavelength* of the light producing it. For example: red, green, yellow, etc.

hyperfocal distance Distance from the front nodal point of a lens to the nearest object whose image is acceptably sharp when the lens is focused on infinity. By focusing on the hyperfocal distance, maximum *depth of field* is obtained.

hypo Common name for the fixing agent sodium thiosulfate, but loosely applied to any fixing bath.

hypo clearing agent Mixture of salts which, in solution, increases the solubility of fixing agents, and thus decreases the washing time for their removal from photographic materials. Not a *hypo eliminator*.

hypo eliminator Mixture of hydrogen peroxide and ammonia which converts any remaining fixer in an emulsion to highly soluble compounds. Sometimes used in archival processing.

incident light Light coming from a source and falling on a surface or object. Compare with *reflected light* and *luminance*.

industrial photography General term which describes photographs made for businesses or industries by their own employees. Also called corporate photography. Compare with *commercial photography*, in which similar photographs are sold to clients in other businesses rather than made for other employees of the same business.

infinity Great distance (for most lenses, more than 50 meters) beyond which objects focus as a unit even when at different distances from the camera. Also, the lens setting (∞) for such distant focusing.

infrared radiation Invisible radiation of certain wavelengths longer than red light. Special films sensitive to these wavelengths are used for making various scientific, landscape, and pictorial photographs.

instant-picture photography Camera and film systems which produce processed photographs within a minute (more or less) after exposure.

intensification Chemical treatment for increasing the density of a processed negative, usually by bleaching and redeveloping it. The treatment is most effective on highlights, least effective on shadow areas. It will not produce image density where none existed originally.

intensity General term for the strength of light coming from a source. Unit of measurement is the *candela*.

internegative General term for a negative made from a positive or print for the purpose of making other prints directly from it. Used for making color prints from color transparencies.

inverse square law Law stating that illumination on a surface decreases by the square of its distance from the light source. Flash *guide numbers* are based on this calculation.

ISO International Standards Organization. ISO designates a system of *film speeds* now universally used. The higher the number, the greater the sensitivity to light. Example: 125/22°. The first number represents the former *ASA* rating, the second the equivalent *DIN* rating.

Kelvin (K) International scale of units designating temperature. In photography it is used to designate the *color temperature* of light.

key light Dominant source of light in an artificial lighting setup. It casts the strongest shadows and influences other visual aspects of a scene.

latent image Invisible image formed in an emulsion by exposure to light, to be made visible later by development.

latitude Ability of a film to tolerate changes in exposure or development and still produce a usable photographic image. Usually expressed in f/ stops or a percentage of the normal exposure or development time, it varies with the film, process, and application.

leaf shutter Shutter consisting of overlapping metal leaves, usually located between the front and rear element groups of a lens. Also called a *between-the-lens shutter*.

lens Device of transparent glass or plastic which refracts (bends) light. Usually consists of several pieces of glass or plastic called lens elements, arranged together on a common axis. Elements can be positive (center thicker than edge) causing light rays to converge, or negative (edge thicker than center) spreading light rays apart. Various configurations of these elements comprise a typical lens. *Camera*, and en*larger lenses* form images on their focal planes; *condenser lenses* do not form images but control the direction and other qualities of light.

lens coverage Area of the focal plane over which a lens can project an image of satisfactory quality. It thus corresponds to the size and format of the film and camera with which it is used.

lens speed Maximum relative aperture of a lens, and thus a measure of its light-gathering ability.

light Radiant energy that can be detected by the human eye. Comprising the visible part of the electromagnetic spectrum, it is the energy which makes photography possible.

light-balancing filter See *conversion filter*.

lightness Measurable characteristic of a color which describes its ability to reflect light. Also called *value* and (inaccurately), *brightness*.

line image High contrast image consisting of black and white or clear tones only. Gray tones are absent.

litho film Very high contrast film designed to make *line* or *halftone* images. Requires a special developer for maximum contrast. Used for black-and-white images of extreme contrast and for photomechanical reproduction.

logarithm An exponent or power of a given number. Used in photography to designate certain exposure measurements, and in the DIN system of film speed.

long-focus lens Lens with a focal length much longer than the diagonal dimension of the format with which it is used. Long-focus lenses include *telephoto lenses* and *catadioptric* (mirror) *lenses*.

luminance Measurable strength of light reflected from a surface or subject. Exposure meters measure this. Compare with *brightness*.

luminance meter See *exposure meter*.

luminance range Difference between the lightest and darkest important areas of a subject as measured by an exposure meter. Compare with *brightness range*.

magenta Reddish-blue subtractive primary color, the complement of green.

mask Any opaque material cut out to protect an area of a film or paper from exposure. Also, a weak negative or positive image made by contact from another image, and used to change the contrast or color of the latter.

mat Cardboard cut to form a wide-bordered window, which is placed over a photographic print. It isolates the image, enhances its appearance, and helps protect the print surface from abrasion.

match-needle meter Luminance (exposure) meter built into

some cameras, which requires the user to adjust shutter and aperture controls until a moving pointer or needle centers on a scale or target. Compare with *aperture priority* and *shutter priority exposure systems*, both of which have automatic functions.

matte Dull, non-glossy surface on photographic paper.

media (mass media) Any system by which aural, verbal, or visual ideas or information can be simultaneously communicated to large numbers of people. Examples include newspapers, magazines, radio and television broadcasting, etc.

microphotography Photographs made at a great reduction in size, as in microfilm images of business records. The opposite of *photomicrography*, which uses microscopes to make photographs greatly enlarged from their original sources.

miniature Term distinguishing the 35 mm camera and film format from rollfilm and smaller sizes. Compare with *subminiature*.

mirror lens See *catadioptric lens*.

monochromatic Term describing light of a single wavelength, but commonly used to describe images of a single hue, such as black-and-white photographs.

montage Process of assembling several images on a single sheet of paper by multiple exposures on the same print, or by cutting and mounting several separate prints adjacent to each other on a common support.

mount Cardboard used to back a photograph with thicker supporting material. It holds the photograph flat and often extends beyond the image to provide an isolating border. See also *bleed mounting, cold mounting, dry mounting,* and *mat*.

M synchronization Control setting on leaf shutters which permits them to be used with Class M flashbulbs, which require 20 milliseconds to reach peak light intensity after ignition. When so set, the opening of the shutter blades is delayed this long to permit the flashbulb to reach its peak output.

multiple-contrast paper See *variable-contrast paper*.

nanometer International unit (abbreviation *nm*) for measuring the wavelength of light. Equal to one billionth of a meter, it has replaced the equivalent millimicron.

narrow-angle lens See *long-focus lens*.

negative Any photographic image whose tones are reversed from the corresponding ones of the subject. Thus subject highlights appear dark in a negative, shadows appear light.

negative-positive system Any photographic material and process in which the image is produced first as a negative, and then subsequently as a physically separate positive. Most black-and-white materials and processes work this way, but many color systems do not. Compare with *reversal system*.

neutral-density filter (ND) Filter which absorbs equal amounts of all wavelengths or colors of light. Primarily used to control exposure, especially in circumstances where the shutter and aperture are inadequate for this purpose.

neutral test card See *gray card*.

Newton's rings Rings of colored light caused by interference between two wave patterns reflected from surfaces in partial contact. The effect is sometimes noticed in glass-mounted slides and in glass negative carriers of enlargers. Using similar glass-free devices eliminates the problem.

nodal point Either of two reference points in a lens. They are so located on the axis that light rays passing through the center of the lens appear to enter at one nodal point and leave from the other. *Focal length* is measured from the rear or emerging nodal point.

non-representational image Any image which bears little recognizable resemblance to the subject of its content. Compare with *representational image*.

non-silver systems Materials and related processes which do not use silver halides for light sensitivity. Examples include cyanotype, gum bichromate, and electrostatic systems.

normal lens Lens with a focal length equal to or slightly greater than the diagonal dimension of the format with which it is used. A normal lens is standard on most cameras and forms an image with a field of view similar to that of the human eye.

opacity Light-blocking ability of a substance, expressed as the ratio of the light falling onto a surface to the light transmitted by it. *Density* is its logarithm.

opaque Unable to transmit light; having infinitely great opacity.

open flash Technique which uses the entire light output of a flashbulb, unlike synchronized flash which uses only the peak intensity. Three manual operations are required in sequence: opening the shutter, flashing the bulb, and closing the shutter.

open shade Outdoor light condition where there is no direct sunlight, but where shadows are illuminated by a mixture of direct skylight and light reflected from the immediate surroundings.

open up To increase the size of a lens aperture.

orthochromatic Sensitive to ultraviolet, blue, and green light, but not to red. Compare with *panchromatic*.

overdevelopment Development for too long a time, at too high a temperature, or in too strong a solution. Causes excessive density, contrast, and color saturation in the film or paper.

overexposure Exposure for too long a time, at too large an aperture, or by too intense a light. It makes negatives too dense (dark) and too low in contrast, prints too dark in all areas, and reversal images too light and diluted of color.

panchromatic Sensitive to all colors of light (plus ultraviolet). Most films have panchromatic emulsions. Compare with *orthochromatic*.

panning Tracking or following a moving object by moving the camera to keep its image relatively stationary in the viewfinder. When used with long shutter times, it tends to show a well-defined object against a streaked or blurred background, and thus suggest rapid movement.

paper negative Negative image made on photographic paper, usually as an intermediate step to a contact positive. A useful preparatory step to several non-silver systems which are limited by their low sensitivities to contact printing methods.

parallax error Inability of a camera's viewing system and taking lens to frame the same area of a subject because they view it from different angles. This problem is common to most viewfinder and twin-lens reflex cameras.

perspective Means of representing three dimensions of an object on a two-dimensional surface so as to create an illusion of depth.

photoflash lamp See *flashbulb*.

photoflood lamp Tungsten-filament lamp designed to operate at 3400 K. It gives a more intense light but has a much shorter life than a regular photographic tungsten lamp, which operates at 3200 K.

photogram General term used to identify photographic images made without a camera. Typically, translucent or opaque objects are placed on photographic paper, which is then exposed to raw light and processed to reveal a pattern of light and dark areas.

photojournalism Reporting with a camera, typically as published in newspapers, editorial sections of magazines, and television newscasts. See also *media* and *picture story*.

photomacrography Photography with a camera, the images from which are approximately the same size (or slightly larger) as the objects photographed. Compare with *photomicrography* and *microphotography*.

photomechanical reproduction General term identifying methods of reproducing photographic images in ink on non-sensitive paper. *Line* and *halftone* processes are commonly used.

photomicrography Process of making photographs which are greatly enlarged from their subjects, by joining a camera with a microscope. Compare with *microphotography*, which involves great reduction in size, and *photomacrography*, which often involves slight enlargement in the camera.

photomontage See *montage*.

photoresist Non-silver, light-sensitive photographic material which is changed physically or chemically by exposure to light. Used in several photomechanical and industrial processes.

photo screen printing Combination of photography and screen printing using a photoresist to produce or reproduce an image

on a screen-like material of nylon or silk. The image is then printed on paper, cloth, or other materials by forcing ink through the screen with a squeegee.

photosculpture Photographic materials and techniques directed to the production of three-dimensional objects.

picture story Series of related photographs made to tell a narrative or story. See also *photojournalism* and *media*.

polarized light Light waves or rays which vibrate in a single plane rather than in many directions from a source. They can be absorbed or blocked by polarizing filters. Such light is found in daylight at certain angles to the sun, and in the reflections from glossy, non-metallic surfaces at certain angles to the incident light. Polarizing filters are useful to reduce the glare from such reflections.

positive Any photographic image whose tones are similar to those of the subject. Subject highlights thus appear light, and shadows dark, in the image.

postvisualization Method of producing photographs wherein the image is planned and created primarily in the darkroom, rather than in the camera or when the original exposures are made. Separate camera images, for example, may be combined into single images by multiple printing or other techniques. Compare with *previsualization*.

preservative Component of developers and fixers which retards oxidation and thus extends the useful life of these processing solutions.

previsualization Procedure whereby a scene or subject is studied, several final print interpretations possible from it are mentally noted, and the technique then selected to produce a chosen visualized result, all before the original exposure is made. See also *Zone System*, and compare with *postvisualization*.

primary colors Group of three colors from which all others can be produced. The *additive* primaries of light are red, green, and blue. *Subtractive* primaries (dyes) are cyan, magenta, and yellow.

print Photographic image usually made on paper. Typically a *positive* image produced by exposure from a negative on film, although negative images on paper are also prints. See also *paper negatives*.

process camera Large format camera used for photomechanical reproduction. Typically it includes its own lighting system and frame for the material to be reproduced, is rigidly constructed, and has a lens of long focal length, small apertures, and high resolving power (process lens).

processing Sequence of operations with photographic materials that follows exposure. In general, the purpose of processing is to make latent images visible, permanent, and useful.

professional photography Business of making photographs for a profit, usually on direction from a client or customer. It includes commercial and industrial photography, portraiture, photojournalism, and other specialized areas.

projection printing Preferred term for *enlarging*. It applies to any printing operation where the print material is exposed by an optically projected image rather than by contact, and includes reduction in size as well as enlarging.

pushing Increasing effective film speed by increasing the development time or concentration. Sometimes used to compensate for known underexposure. Pushed images typically have little shadow detail, excessive contrast, and, with color films, an altered color balance.

quartz-halogen lamp Tungsten lamp whose filament is surrounded by a halogen gas and contained in a bulb of fused silica or quartz. This permits higher operating temperatures, longer life, and a more stable or uniform color temperature throughout the life of the lamp. The construction of these lamps requires special handling precautions.

rangefinder Device on some viewfinder cameras by which the lens can be accurately focused on a given distance. Common types show overlapping or split-field images, which must be aligned or superimposed to focus the lens.

rapid access General term identifying materials, processes, or systems which produce usable images quickly after exposure.

RC See *resin-coated paper*.

realism In general, an image style in which the content bears a strong visual resemblance to the objects photographed. To many people, the term implies a stronger resemblance than many *representational images* possess. Compare these terms.

reciprocity effect Reason why equivalent exposures do not produce equal densities when the exposure time is extremely short (as with some electronic flash units) or long (several seconds or more). The effect is characteristic of silver halide emulsions and varies with their sensitivity. It is often referred to as *reciprocity failure*.

reducer Chemical bath which removes some silver from a processed emulsion, thereby lightening the image and lowering its density.

reflection Changing the direction of light without passing it through another material, as with a white card or mirror. Compare with *refraction*.

reflex camera Camera containing a mirror at a 45° angle to the lens axis, and a ground glass above it for viewing the reflected image. Some reflex cameras also contain a prism for correct lateral orientation of the image and for eye-level viewing. See also *single-lens reflex camera* and *twin-lens reflex camera*.

refraction Changing the direction of light by passing it from one material to another dissimilar material, as from air to glass or vice versa. This is how lenses work, bending light rays to form an image. Compare with *reflection*.

register Correct alignment of superimposed images, as in photomechanical and certain non-silver systems, to create a desired visual effect or unified image. Images so aligned are said to be "in register."

relative aperture (f/) Diameter of a lens aperture or opening expressed as a fraction of its focal length. Designated by the symbol f/. See also *aperture* and *f/ number scale*.

replenisher Solution added to a processing bath to maintain its uniform activity with repeated use. A replenisher thus replaces ingredients in the bath consumed or altered by its action on the material being processed, and thus greatly extends the useful life of the bath.

representational image Any image which bears a recognizable resemblance to its subject. Compare with *non-representational* image and *realism*.

reproduction print Photographic print made expressly for reproduction by a photomechanical process. Ideally, its exposure scale and tonal range will match the requirements of the reproductive process. Compare with *exhibition print* and *workprint*.

resin-coated paper Photographic paper made with a highly water-resistant base. This feature permits less chemical penetration and therefore faster washing and drying. Other economies are also obtained.

resolving power Ability of a lens or film to produce fine detail in an image. More specifically, its ability to image very closely spaced, sharply drawn, parallel lines as separate tones. Measured in lines per millimeter. Compare with *acutance* and *sharpness*.

restrainer See *antifoggant*.

reticulation Fine, random pattern of wrinkling of the gelatin emulsion, usually caused by sudden temperature changes during processing. The effect is not reversible.

retouching Manual alteration of negatives or prints after processing by the addition of dye, pigment, or chemicals to add or remove selected parts of the image. Portrait negatives, for example, are sometimes retouched to remove or obscure skin blemishes, stray hair, etc. Compare with *spotting*, which removes processing defects such as dust marks and scratches.

retrofocus lens Special wide-angle lens design which allows it to be positioned farther from the focal plane than its effective focal length would permit. The space thus formed can accommodate the mirror of a single-lens reflex camera. Sometimes called a *reverse-telephoto lens*.

reversal systems Films, papers, and related processes designed to produce a *positive* image on the material originally exposed. Most work by exposure in the usual manner, process-

ing first to a negative and then continuing the process to produce the ultimate positive. Most color transparency films and some color print materials work this way, although a few produce their positive images more directly. Compare with *negative-positive systems* and *dye destruction system*.

rollfilm Long strip of film wound on a spool, with opaque backing paper extending beyond both ends to permit daylight loading and unloading. The most popular sizes are 120 and 620.

Sabattier effect Partial reversal of image tones caused by interrupting development with a re-exposure to light. The effect is popularly but erroneously called *solarization*.

safelight Darkroom lamp filtered to emit only a color of light that has a minimal effect on the photographic materials used with it.

saturation Purity or vividness of color, the opposite of gray. Also called *chroma*. Compare with *hue* and *lightness*, a color's other attributes.

selective focus Limited or shallow depth of field obtained with large apertures. It is used to separate objects at different distances by focusing on the most important one and letting the others stay out of focus.

shadow Dark part of a subject, which reproduces as a weak, low density area in a negative and a dense, dark area in a print. The opposite of a highlight. Also, a dark area in the subject caused by interrupting a direct light source. See *key light* and *fill light*.

shadowless lighting Soft, indirect lighting that appears to be non-directional rather than coming from a single main source. It is useful for photographing objects at close range, and for avoiding uncontrollable reflections when photographing objects with shiny surfaces. See also *bounce flash* and *umbrella*.

sharpness Subjective term describing the appearance of lines, edges, and similar adjacent tones in images. Sharpness is lost by imperfect contact of negative and paper in contact printing, and by improper focusing of camera and enlarger lenses. See also *acutance*, which describes a similar, measurable aspect of an image.

sheet film Film made in flexible, flat sheets of standard sizes, primarily for use in large format cameras. Single sheets can be exposed and processed separately, and many types of film are available in this format. A darkroom is required for handling. Compare with *rollfilm*.

shift (color) Change in color or color balance of an image. The term usually designates an unintended or undesirable change, as from improper processing.

short lighting Portrait lighting arrangement with the key light illuminating the side of the face farthest from the camera. Compare with *broad lighting*.

shutter Part of a camera or lens that is opened by the user and closes by mechanical or electronic means, to control the time of exposure. The two main types are *leaf shutters* and *focal-plane shutters*.

shutter-priority exposure system Through-the-lens exposure meter so coupled to the camera's controls that you set the desired shutter time and the meter then selects the proper aperture for exposure. Useful when photographing sports events or similar action. Compare with *aperture-priority exposure system*.

sign Visual image that has a single, specific relationship to the object or event represented, and that often resembles it. Compare with *symbol*.

silhouette Effect produced by back lighting alone. It shows a subject as a dark, two-dimensional shape against a lighter background. See *back lighting*.

single-lens reflex camera Reflex camera which permits the user to view the subject through the taking lens by means of a movable mirror behind it and (usually) a prism above the ground glass to correctly orient the image.

skylight Bluish light reflected from the atmosphere. Together with sunlight it forms daylight.

skylight filter Colorless, ultraviolet-absorbing filter used to avoid an excessive bluish cast in color photographs made with skylight alone (in open shade), or on clear, sunny days at high elevations.

slave unit Electric or electronic device which senses a flash unit fired by the camera, and then in turn fires other flash units as a result. Useful where it is inconvenient to connect all lamps with wires.

slide General term for a 35 mm or smaller positive transparency, usually mounted in a 2 in. square frame for projection. Also, an opaque shield which can be inserted into a film holder to permit its attachment to or removal from the camera without exposing the film.

snapshot Any photograph casually made with a hand-held camera. Most snapshots are made as remembrances of people, places, or events.

snoot Cylindrical attachment to a spotlight used to limit its light to a small area or spot.

soft Low in contrast (describing negatives or prints).

soft focus Deliberately unsharp. A diffusion disk placed over the camera lens will produce this effect primarily in highlights, where it is often used in portraiture. On the other hand, setting the enlarger lens out of focus with a sharp negative will produce a soft-focus effect primarily in shadows, where its effect is less noticeable or useful.

solarization Reversal of image tones caused by a single, extreme overexposure. Compare with *Sabattier effect*, to which this term is often incorrectly applied.

speed See *film speed* and *lens speed*.

spin-out process See *tone-line process*.

spotlight Artificial light source that focuses or concentrates its illumination into a definite beam, usually of narrow width.

spot meter Exposure meter which measures luminance from only a very narrow angle, and hence from a much smaller area of the subject than the camera normally frames. Useful for readings of selected areas of a subject rather than its entirety.

spotting Manual print-finishing process of covering or coloring with dye or pigment the small defects in an image usually caused by dust in the printing system or scratches on the negative. The treatment blends the "spot" with its surrounding tone, thus hiding it. Compare with *retouching*, which is concerned with altering the recorded image.

squeegee Soft, flexible device used to remove excess surface moisture from films and papers prior to drying. A similar device is used in photo screen printing to force ink through a screen.

stabilization papers and processes Print materials and related processes which produce moderately stable, non-permanent images a few seconds after development. The images are stable enough for many uses such as photomechanical reproduction, but they are not as permanent as conventionally processed ones.

stabilizer Chemical solution or bath used in some color processes to retard change in a photographic material over a long period of time. It reduces the tendency of dyes to fade or the color balance to change.

stain Undesirable, permanent color, usually yellow or brown, in black-and-white prints and negatives. Caused by contamination of the material or by exhausted processing chemicals. In color prints, it may also appear as a cyan color cast in all white areas including unexposed ones.

stock solution Any processing solution which is moderately concentrated and which must therefore be diluted before use. Compare with *working solution*.

stop See *aperture*.

stop bath Chemical bath used in processing to stop development. Most stop baths are diluted acetic acid, but some contain a dye which changes color when the acidity is neutralized, and these are known as *indicator stop baths*.

stop down To reduce the size of a lens aperture.

straight photograph Photograph made without manipulation or other non-photographic alteration. Also applied by extension to include the entire process of visualization and camera work when direct photographs are made.

stroboscopic light Illumination produced by an electronic lamp which flashes repeatedly in a rapid sequence. Used to analyze or suggest movement in photographs by multiple exposure. Compare with *electronic flash*.

subminiature Camera and film format smaller than 35 mm.

subtractive color synthesis Method of superimposing cyan, magenta, and yellow images to form all other colors. Most color photography is based on this principle.

supplementary lens Lens element or assembly which is placed in front of a camera lens for use, and which changes the effective focal length of the regular camera lens. See also *close-up attachment*.

symbol Visual image that represents or stands for an object or idea without resembling it. Compare with *sign*.

synchronizer Device often built into a camera shutter to make its fully open position coincide with the peak light intensity of a flashbulb or electronic flash. See also *M synchronization* and *X synchronization*.

synchro sunlight Outdoor flash technique using sunlight as a key light or accent light, and flash as a portable fill light.

Système International d'Unités (SI) International system of measurements derived largely from the metric system, which it has replaced.

tacking iron Heating tool used in dry mounting to temporarily fasten dry mounting tissue to the back of a photograph and the front of a mount board.

telephoto lens Long-focus lens with a lens-to-film distance much shorter than its effective focal length, saving space and weight compared to a lens of normal construction. See also *catadioptric lens*.

test strip See *trial print*.

thin Lacking sufficient density in a negative or print. Thin shadow areas in a negative are usually due to underexposure, thin highlights to insufficient development. In a print these causes are reversed.

time (shutter setting) Shutter setting which requires two separate operations of the release. The first opens the shutter, which remains open until the release is pressed again to close it. Useful for exposure times longer than a few seconds.

time-temperature development Method of determining the time of development according to the temperature, with other factors such as agitation and contrast held constant. This is the typical method for most black-and-white films and virtually all color materials.

tone General term for a single shade of gray or a color in a negative or print. Also used to designate the normal image color of black-and-white printing papers.

tone-line photograph Photograph in which all boundaries between areas of different tones are converted to lines. The result resembles a line drawing.

toner Chemical solution or bath used to change the color of a black-and-white print, as from black to a brownish or bluish hue. It works on the silver in the emulsion, leaving the whites unaffected.

translucent Describes a material able to transmit light, but one which scatters the light so that objects are not clearly visible through it. Ground glass is translucent.

transparency Positive image on film, intended for viewing or reproducing by transmitted light. In the 35 mm size, when mounted, it is called a *slide*.

trial print Preliminary test print usually exposed in sections with increasing times, and used to establish the best overall exposure time for that print. If the trial print includes only part of the image, it is often called a *test strip*.

tripod Camera support with three legs, usually adjustable for length.

tungsten-filament lamp Any lamp which produces its illumination by electrically heating a tungsten filament or wire to incandescence in a glass or similar enclosure from which the air has been removed. A basic source of continuous artificial light for photography.

twin-lens reflex camera Reflex camera with a pair of matched lenses, one above the other, which focus together. The user views the subject through the upper lens via a mirror, and records the photograph with the lower lens. Simpler in construction than a single-lens reflex camera of the same format.

type A color film Color reversal film balanced for exposure by artificial light of 3400 K color temperature. Photoflood lamps supply this illumination.

type B color film Color negative and reversal films balanced for exposure by artificial light of 3200 K color temperature. Many tungsten-filament photographic lamps supply this illumination.

ultraviolet radiation (UV) Invisible radiation similar to light, but of shorter wavelengths, from 10 to 400 nanometers. Most light-sensitive materials are also sensitive to ultraviolet radiation. See also *light* and *skylight filter*.

umbrella Large, concave reflector for indirect lighting, with a white or aluminum-colored inside surface. It is used for shadowless light.

underdevelopment Development for too little time, at too low a temperature, or in too weak a solution. It causes insufficient contrast and highlight density in negatives, insufficient contrast and shadow density in prints, and desaturated colors in color materials.

underexposure Exposure for too short a time, at too small an aperture, or with insufficient light. It produces negatives that are too thin (not dense enough), especially in shadow areas. Underexposed prints are too light, with insufficient highlight detail. Underexposed color reversal materials have good color saturation but the image is too dark.

value See *lightness*.

variable-contrast paper Black-and-white printing paper whose contrast or grade is changeable by using different colored filters in the enlarger. Two emulsions of different color sensitivity and exposure scale are mixed together and coated on the base as a single layer. Such papers offer economy and convenience in printing.

variable focal length See *zoom lens*.

verification print Print which is made following a trial print or test strip, and used to verify the time or color balance selected from the trial print. The first in a series of workprints. See also *workprint*.

view camera Large format, sheet-film camera for use on a tripod or stand. Typically it has a ground glass for focusing and framing, interchangeable lenses, and various adjustable parts.

viewfinder Part of a camera by which the user frames the subject, and which shows the approximate field of view of the camera lens.

viewing screen See *ground glass*.

vignetting Making a negative or print in which the edges of the image fade to white or black. Used primarily in portraiture. Also, a darkening of the corners of an image caused by a lens barrel or hood extending into the angle of view.

warm-toned Black-and-white photographic print which is brownish-black in appearance. Compare with *cold-toned*.

washing Processing step which removes all soluble chemicals from the emulsion and base of photographic materials.

washing aid See *hypo clearing agent*.

water jacket Container of temperature-controlled water surrounding one or more tanks or trays of processing chemicals, in order to stabilize their temperature for effective use.

water spot Processing defect caused by uneven drying of a film or print. Rewashing and redrying will not eliminate this problem, but use of a wetting agent or squeegee will minimize future occurrences.

wavelength Distance between two adjacent crests of a wave of radiant energy, and the major identifying characteristic of such radiation. Wavelength distinguishes one color of light from another, and light from other forms of radiant energy such as infrared, ultraviolet, etc. It is thus related to *hue*, and is measured in *nanometers*.

weight Thickness of the base of photographic paper. Single, medium, and double weight are typical.

wetting agent Chemical or bath which reduces the surface tension of water and thus permits it to run freely off a film or print. Films and prints so treated after washing dry cleaner and faster. Wetting agents are helpful in avoiding water spots.

white light Light containing all colors of the visible spectrum. Compare with light from a safelight, whch does not.

wide-angle lens Lens with a focal length much shorter than the diagonal dimension of the format with which it is used. Such lenses are helpful when photographs must be made in confined spaces, or when large areas must be included in the field of view.

working solution Chemical solution ready to use, requiring no further preparation. Compare with *stock solution*.

workprint Any of several photographic prints showing various degrees of refinement between a trial print and a final exhibition print or reproduction print from the same negative. Final prints thus evolve by improvement through workprints.

xenon Inert gas used in electronic flash lamps.

xerography Non-silver, electrostatic reproduction process widely used for document and office copy work. It is positive-positive and uses non-sensitive paper, but does not reproduce continuous tone.

X radiation Radiation with wavelengths of .00001 to 100 nanometers, located between gamma and ultraviolet radiation on the spectrum. All unprocessed films and papers are sensitive to it. X-rays pass freely through many opaque substances, but special X-ray films are able to absorb these rays to some degree.

X synchronization Control setting on a camera shutter which permits it to be used with electronic flash lamps. At this setting, the shutter blades open first and the lamp is flashed when they have fully opened. Compare with *M synchronization*.

yellow Subtractive primary color, the complement of blue.

zone focusing Practice of estimating the nearest and farthest distances for which the camera needs to be focused, setting the lens between them, and then using the camera without further adjustment of the focus. Useful in sports, action, and reportorial work.

Zone System Method of combining previsualization, film exposure, processing, and printing procedures to predetermine a desired photographic result and to select the precise means to accomplish it.

zoom lens Lens whose focal length, and therefore image size, is continuously variable over a given range, while the distance focused upon and the relative aperture remain constant. It is thus a convenient substitute for interchangeable lenses. Many zoom lenses also have close-focusing capability in addition to their variable focal length, which makes them useful for some kinds of photomacrography.

INDEX

Boldface numbers refer to illustrations.